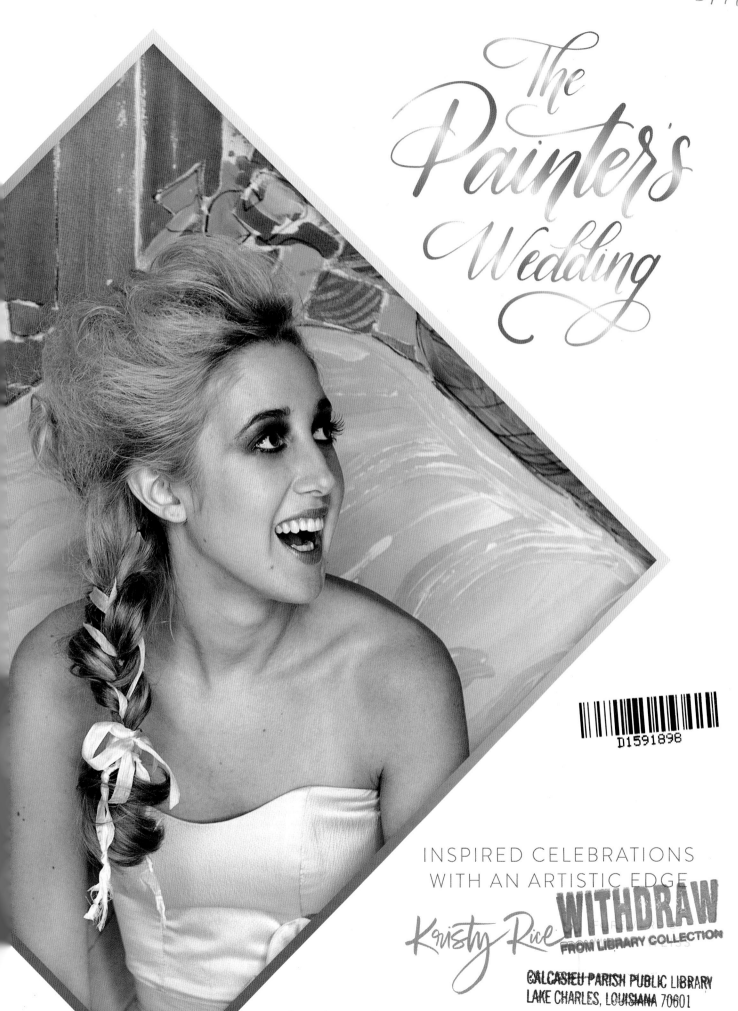

The Painter's Wedding

INSPIRED CELEBRATIONS
WITH AN ARTISTIC EDGE

Kristy Rice

For Kelle Anne McCarter.
You left us far too soon, but made your beautiful
mark on the world and our hearts.

We are the clay, you are the potter; we are all the
work of your hand.

Isaiah 64:8 (NIV)

Contents

FOREWORD BY MINDY WEISS 4

A LETTER FROM THE AUTHOR 5

ACKNOWLEDGMENTS 6

PREFACE 7

1 — GEORGIA O'KEEFFE'S WHITES AT GRAND DEL MAR 9

2 — ANDREW WYETH'S PAINTERLY PASTORAL 25

3 — PANTONE'S RADIANT ORCHID WITH MUCHA 43

4 — JOHN SINGER SARGENT AT BILTMORE ESTATE 59

5 — OUR MUSE, MR. SALVADOR DALI 79

6 — MONET'S WATERCOLOR GARDEN 103

7 — MAXFIELD PARRISH IN RED ROCK COUNTRY 121

8 — THIRTEENTH CENTURY-INSPIRED WITH GIOTTO 137

9 — FRIDA KAHLO IN BLOOM 157

10 — EDWARD HOPPER AT CONGRESS HALL 177

11 — A SPIROGRAPH LOBSTER BOIL WITH ANDY WARHOL 197

12 — MORAN'S YELLOWSTONE 215

13 — DOROTHY DRAPER'S GREENBRIER 235

14 — SOFT BOTANICALS WITH THE BAUER BROTHERS 261

15 — THE ANATOMY OF AN ARTFUL CELEBRATION TABLE: A WATERCOLOR HARVEST 279

16 — INVITING ARTFUL STATIONERY DESIGN 291

CREATIVE TEAMS 299

REFERENCES 304

FOREWORD
BY MINDY WEISS

As a child, I remember wanting to be a painter. There are days when I need to revisit that dream, if only for a few minutes—to breathe and take a moment to sketch a little something or pull out my watercolors and splash some color on the page.

As a wedding planner, I spend almost every day filling my brides' and grooms' lives with colorful and exciting inspiration. By the end of the day, my own palette turns black and white—so yes, even the wedding planner needs a creative recharge! Over the years, I've experienced the uplifting effects of art. I see art everywhere, in my couples' inspiration boards, on flea market tables, and while quickly flipping through interior design magazines. I've learned to really pay attention to my surroundings, making note of details I love, trends I don't, and finding ways to take what gets me excited to design and incorporate it into unforgettable events.

Kristy's work reminds me of my love for stationery and invitations, of course, but even more, the power that painters have to rescue us from the "black and white" moments of our lives. Watercolor, for example, has a way of revealing to me the gift of relaxation and what it feels like to unwind for a time. Being aware of how the small moments of art make us feel can lead to endless opportunities to dream up innovative wedding design ideas.

xox

Mindy Weiss

Celebrity event planner and three-time best-selling author | Mindyweiss.com

A LETTER FROM THE AUTHOR

Weddings are a cultural phenomena and as a stationery artist, stylist, and maker of all things paper, I am somewhat of a spectator. Friends, let me be clear, you are about to embark on a visual journey I've crafted not based on wedding planning skills, because a wedding planner I am not. The grueling work of schedules, knowing how much ice to order, when the cake should arrive, and how to scale the details on the following pages to suit one hundred real guests is not my expertise and I do not take this fact lightly. I can, shall I say, "make pretty"; but in the real, messy, grueling tedium of wedding planning's behind-the-scenes chaos, there is a gifted planner.

So I raise a proverbial glass to the countless planners, event designers, and coordinators I've had the joy of working alongside over the years. You are simply . . . irreplaceable.

TO THE READER

For most of my life, I've looked to painters. From my art teacher mentor in grade school and a favorite high school instructor to books full of Georgia O'Keeffe prints and countless museum visits, fine artists and their influence have been ever present. I realize, however, that your exposure to the arts may be less . . . intense, shall we say?

There are many ways to enjoy this book and it is unlikely just one flip through the pages will reveal all *The Painter's Wedding* has to offer. So let me point out a few ways to get the most out of the chapters to follow:

Pretty images and editorial inspiration from cover to cover—this one is simple, flip and enjoy!

Artful advice in each chapter from some of the world's most renowned wedding planners, designers, and magazine and blog editors, including Abby Larson of Style Me Pretty!

The anatomy of an artful celebration table in chapter fifteen will reveal individual components of producing an artful event full of mindful details. Editorial images and fine art examples are referenced throughout.

Each chapter features an introduction to the artist who inspired the editorial, with commentary designed to reveal a peek into how painters think.

The "Think Like a Painter" section includes visual maps in each chapter where I break down the thought process behind decisions made when styling.

And so I send you off to indulge in the pages to follow. Avoid the urge to pick up your device. Just look and dream, scribble notes (on paper) and see where the pages take you!

Kristy Rice

ACKNOWLEDGMENTS

To my husband Adam, my first and only love, my high school sweetheart, my best friend, and personal math genius. You make me stronger, wiser, and more loving than I ever thought possible.

To Mama T and our son Isaac: Isaac, I pray I can be the best of what you need me to be. Mama T, I'm grateful that our son has two Mamas who adore him and each other.

To Kelley, Steph, Katie, Jillian, and all #themomentals for making every day full of laughs and for making our couples' paper dreams come true.

To Kristen for working tirelessly alongside me in the final days of the deadline.

This book is the result of tireless collaboration between artists and newly discovered friends. Without the focus and dedication of each artist involved in every chapter, there would be nothing to acknowledge here. The pages to follow are from a collective of imagination, passion, and persistence.

To my parents, Jake and Linda, for being wherever, whenever, however to support all my crazy dreams. All my thank-yous will never be enough.

To Unkie for always reminding me to keep my nose to the grindstone.

Preface

If we open our eyes, we can see so much more. Maya Angelou said, "Be present in all things and be thankful for all things." Indeed.

I've learned to use fine art as a means of communicating styles and stories. With each passing week I see trends come and go, color palettes change, gown silhouettes evolve, and all the while style continues to be subjective. One detail remains, however; we hope our celebrations leave a mark and tell our one and only love story.

As a fine artist, I've learned to see opportunity in the smallest of moments, like a one-inch portion of a painting, or in the way the field grass sways and catches the sunlight. I've become conditioned to really see—to essentially be hyper-present in my daily surroundings.

I want to teach you. Are you a bride just beginning your planning journey without a clue for discovering your aesthetic? Perhaps you're amidst wedding decisions, feeling torn in a million tiny directions, or lost among the many opinions coming at you from well-

meaning friends and family? Maybe you are this close to scrapping it all and eloping? Stop for a moment. Breathe.

You can find a way to calm, with a focus on making meaningful decisions.

I'm not here to plan your wedding and I won't be there on the day to calm your nerves, but right now, I promise to give you a reprieve. You deserve a new perspective. You need a break from the chaos. You'll feel freedom by walking away from the screen and the millions of pixels vying for your attention, waving their beautifully alluring, but often done-before ideas in your face.

YOUR ARTISTIC VOICE NEEDS TO BE DISCOVERED!

In this book, we'll uncover ways to authentically tell one of the stories you'll be most proud to tell for years to come.

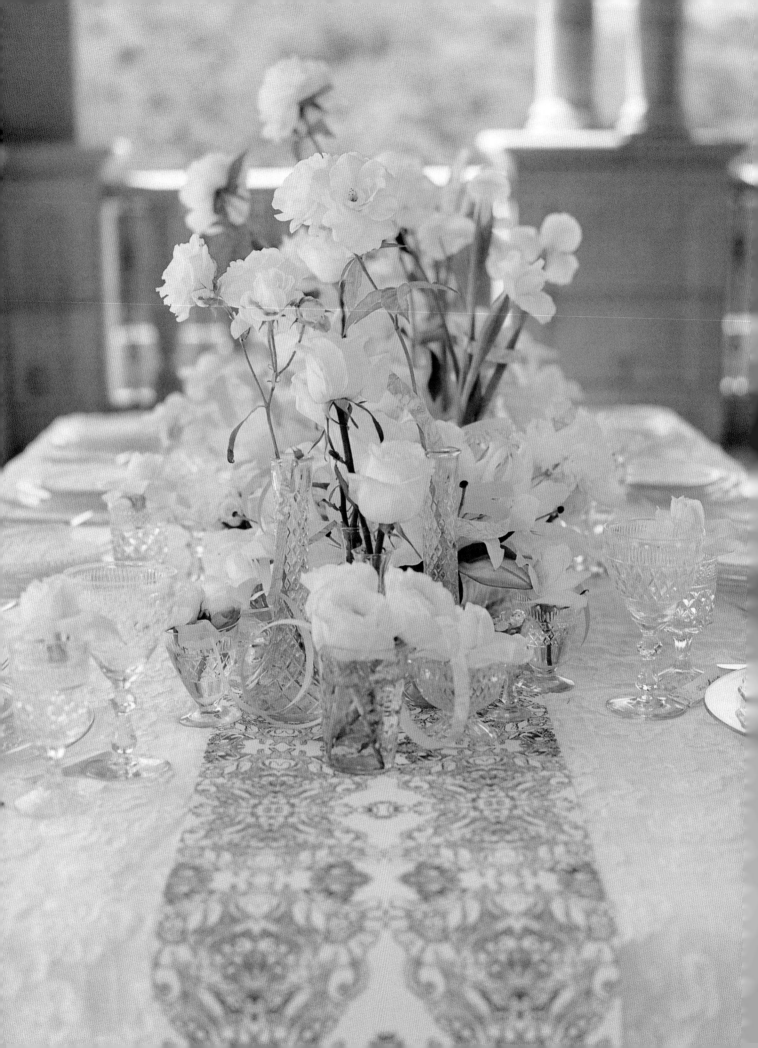

Georgia O'Keeffe's

WHITES AT GRAND DEL MAR

San Diego, California

Georgia O'Keeffe (1887–1986) saw the world differently.

She wanted to capture and distill the best of what stood before her eyes. Flowers specifically were O'Keeffe's most well-known subject matter and muse. Often large, bold, and intensely lush, her floral compositions seemed to weed out the unnecessary and focus on the most iconic portions of a bloom. In her paintings, she didn't elaborate but exaggerate, she didn't eliminate but encapsulate her subject matter. She simplified beautiful details to ensure you saw the true essence of a flower. She wanted us to see through her eyes, without distraction, without fuss.

Your wedding is a composition—a collection of what, at times, seems like endless visual details you've

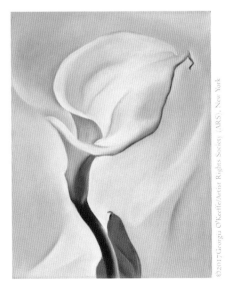

Calla Lily Turned Away, 1923,
Georgia O'Keeffe

©2017 Georgia O'Keeffe/Artist Rights Society (ARS), New York

curated to communicate a particular feeling. But it becomes so difficult to edit or eliminate the unnecessary and focus on the visual moments that matter most.

In this chapter, we'll look at ways to whittle down an idea to its most essential, leaving only the most powerful and impactful of impressions. Do you need a color palette dripping with every hue under the sun? Doubtful. Can shades of white speak of excitement and anticipation? Indeed. Do an abundance of flowers need to be present to convey a lush atmosphere? Not always.

Teach us, Georgia.

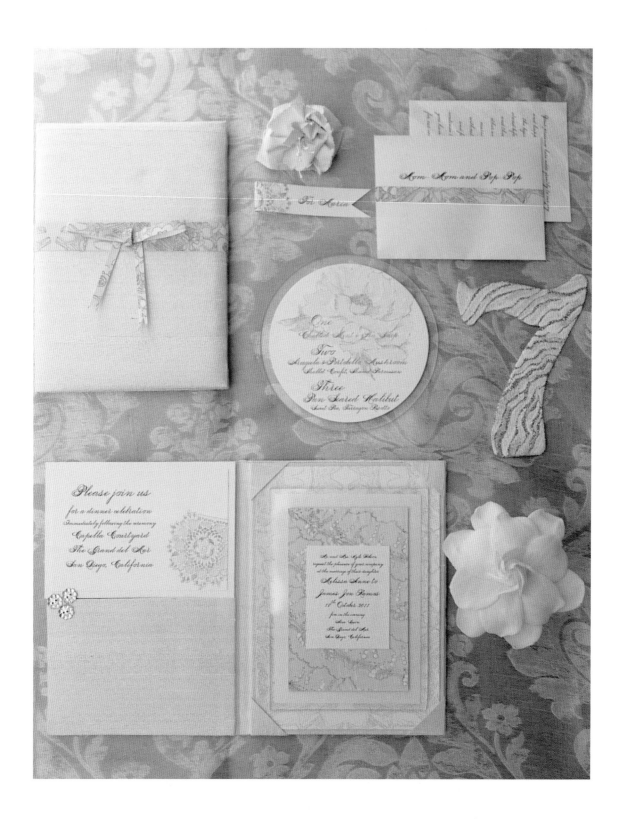

We've heard it a million times . . . inspiration is all around us. That phrase has almost become a cliché. And yet for those of us lucky enough to call ourselves creators, inspiration cannot simply be found in life's most obvious moments. Inspiration is found in the subtleties. In the way a flower drapes on a vine, in that first bite of homemade chocolate cake, in the silhouette of a gown that you never want to take off. The weddings and celebrations that are truly magical are so often built upon a single, quietly meaningful piece of inspiration. Like how the weight and texture of a silk ribbon set in motion an entire wedding story: elegant and refined, with a bit of raw intimacy around the edges.

–ABBY LARSON

Editor and founder of Style Me Pretty

 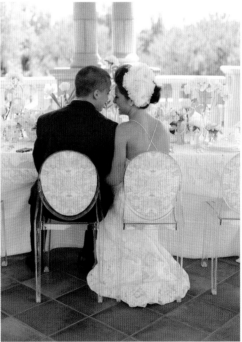

Don't fuss, just savor

Fussing with a thing is really just a nervous response to not quite knowing what to do next. You can fuss with your color palette, you can fuss with the details of your gown, you can fuss with making changes to your invitation's artwork motif. But usually the fussing muddies the message more than anything. Savor the reliability of your instincts. First reactions, gut feelings, and intuition are more powerful than we often admit.

When you take a flower in your hand and really look at it, it's your world for a moment. -Georgia O'Keeffe

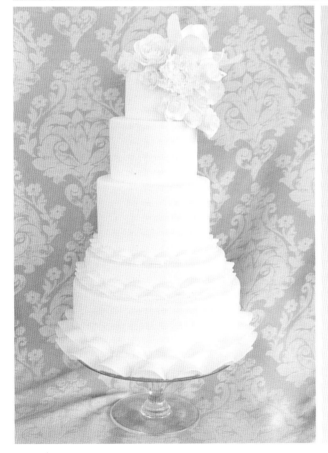

Fine art invitations consider balance, contrast, and composition just like an artist's canvas would. O'Keeffe's compositions often used large-scale subject matter to make a statement just like the flowers on each menu above.

O'Keeffe could tell a captivating tale with the painting of a simple white flower—more frills and bright color aren't always needed to make a powerful statement.

SEE THE VISUAL POWER
IN A FLOWER PETAL.

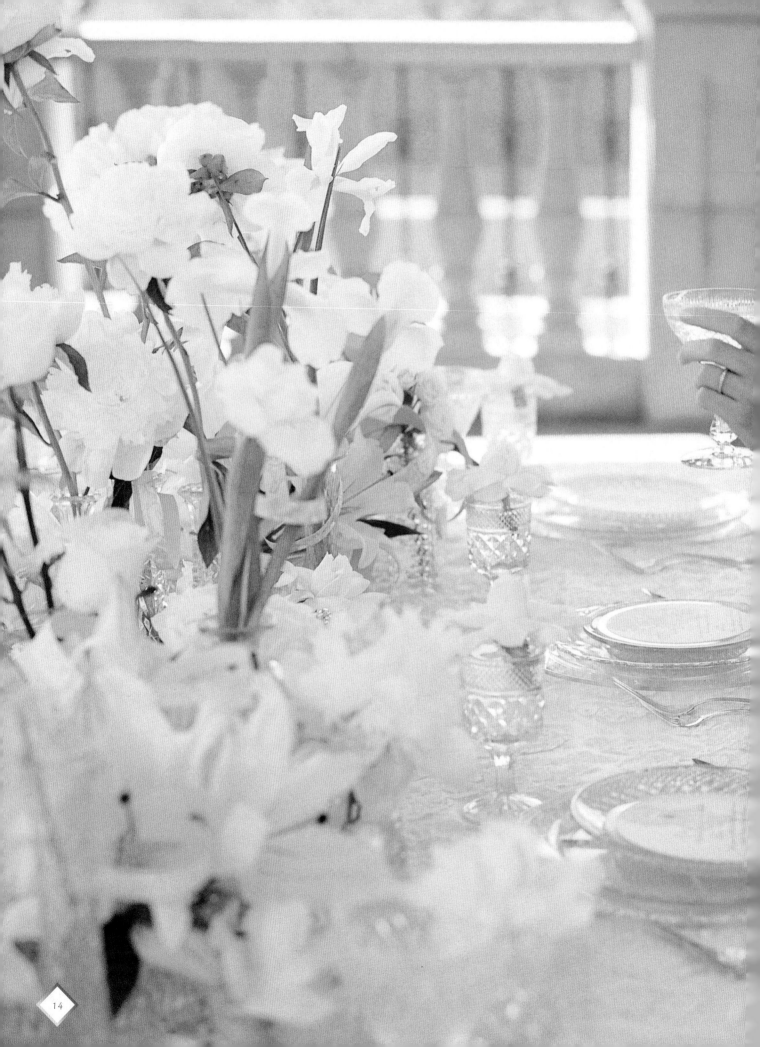

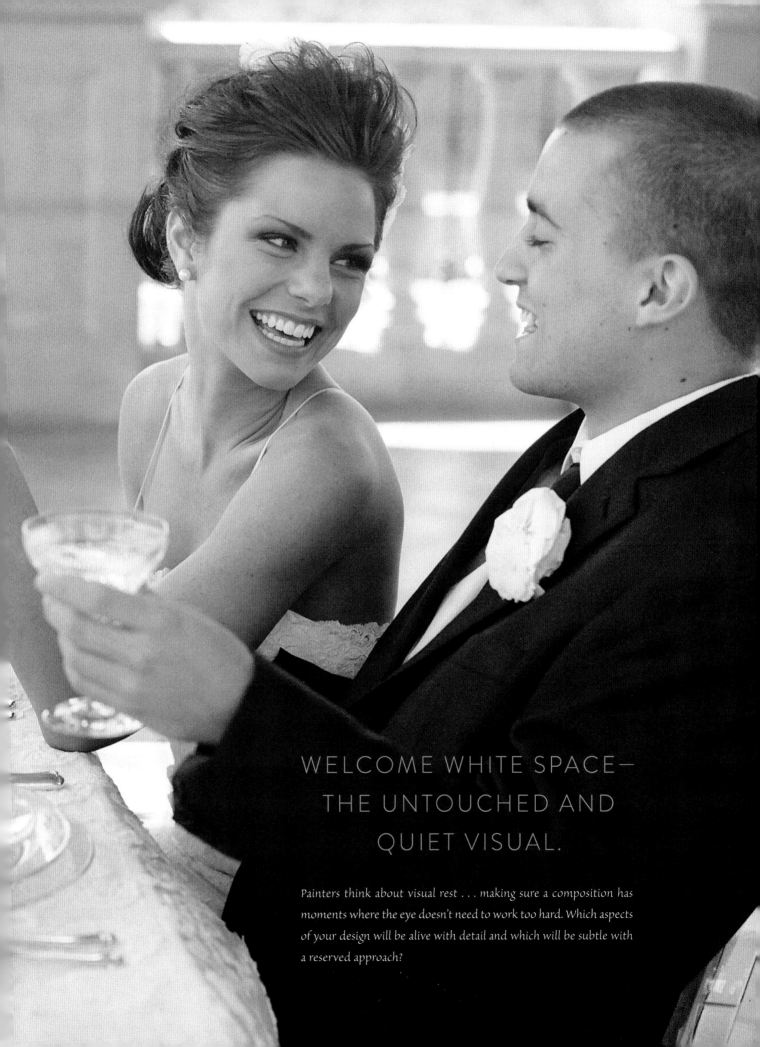

WELCOME WHITE SPACE— THE UNTOUCHED AND QUIET VISUAL.

Painters think about visual rest . . . making sure a composition has moments where the eye doesn't need to work too hard. Which aspects of your design will be alive with detail and which will be subtle with a reserved approach?

O'Keeffe had the uncanny ability to reveal just what was needed in a painting. Think like she might, considering your celebration space. Is it simple enough to let the most powerful elements of the day really shine?

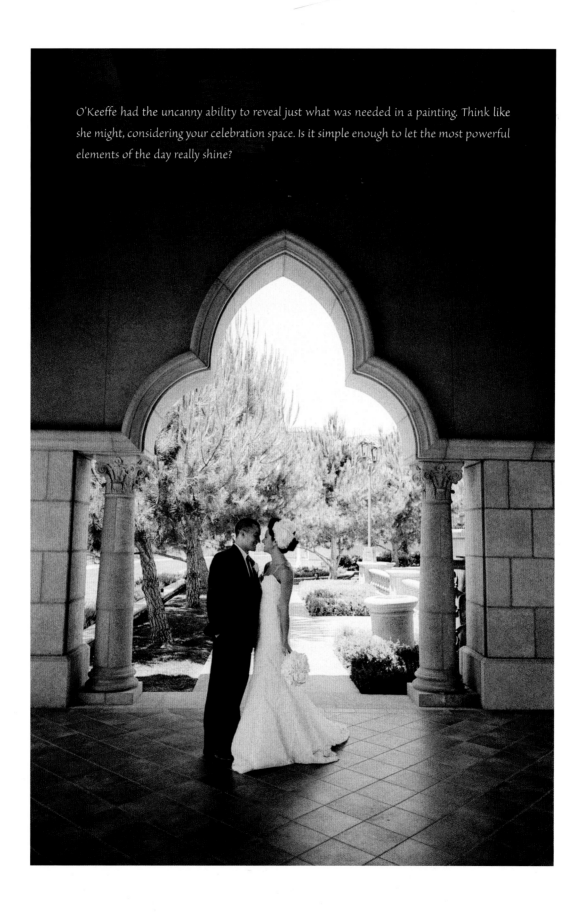

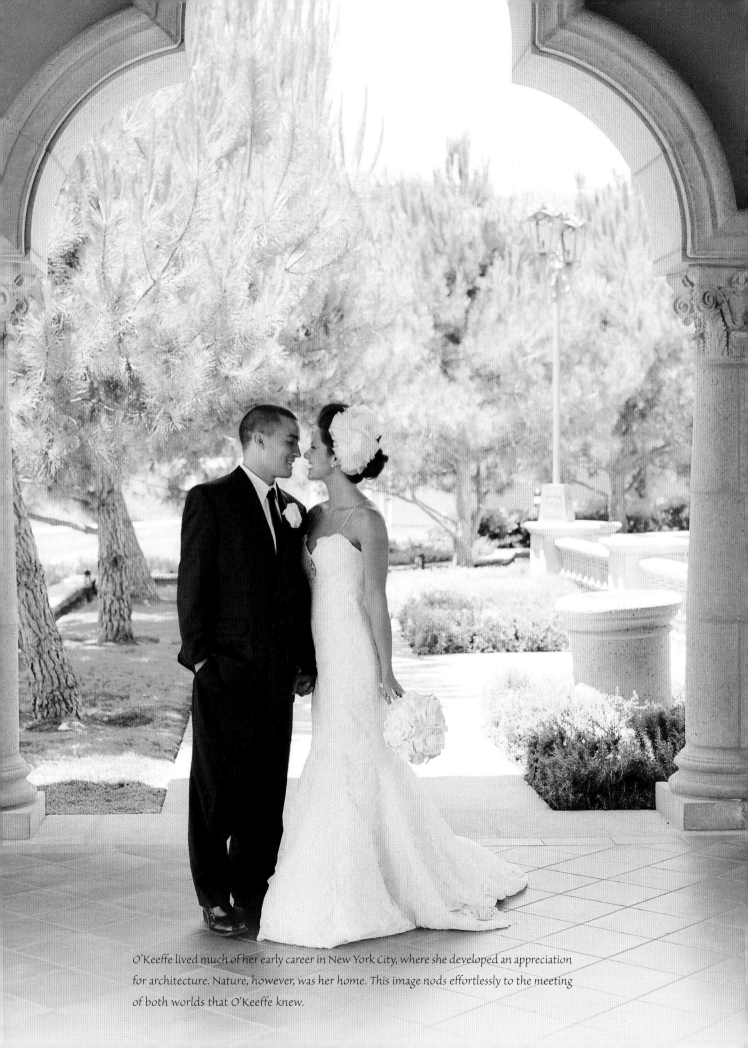

O'Keeffe lived much of her early career in New York City, where she developed an appreciation for architecture. Nature, however, was her home. This image nods effortlessly to the meeting of both worlds that O'Keeffe knew.

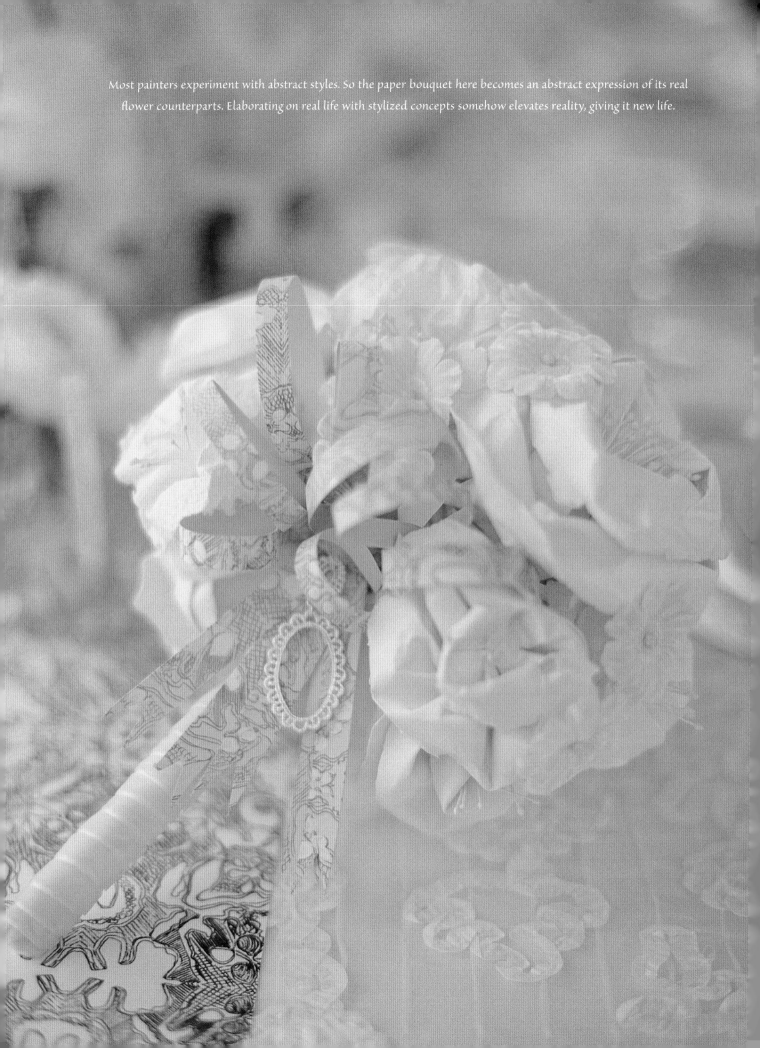

Most painters experiment with abstract styles. So the paper bouquet here becomes an abstract expression of its real flower counterparts. Elaborating on real life with stylized concepts somehow elevates reality, giving it new life.

Being inspired by a particular fine artist doesn't mean every last element must tie directly to the inspiration. Here, the invitation feels soft and white and feminine but no large flowers here. Overusing the artist's main theme can start to become predictable and dilute your vision.

Painters get personal, they imagine experiences that will surprise and delight. Shades of white communicate serenity and simplicity. Here, each guest is gifted with notes from the couple secured with patterned paper ribbon binding.

Here, our photo-
grapher captured a few
fine art images designed to
mimic some of O'Keeffe's
floral paintings.

Please join us
for a dinner celebration
Immediately following the ceremony
Capella Courtyard
The Grand del Mar
San Diego, California

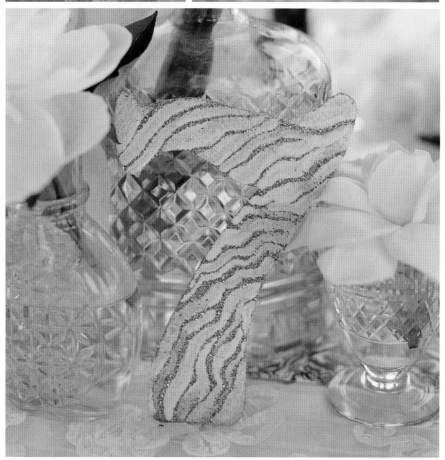

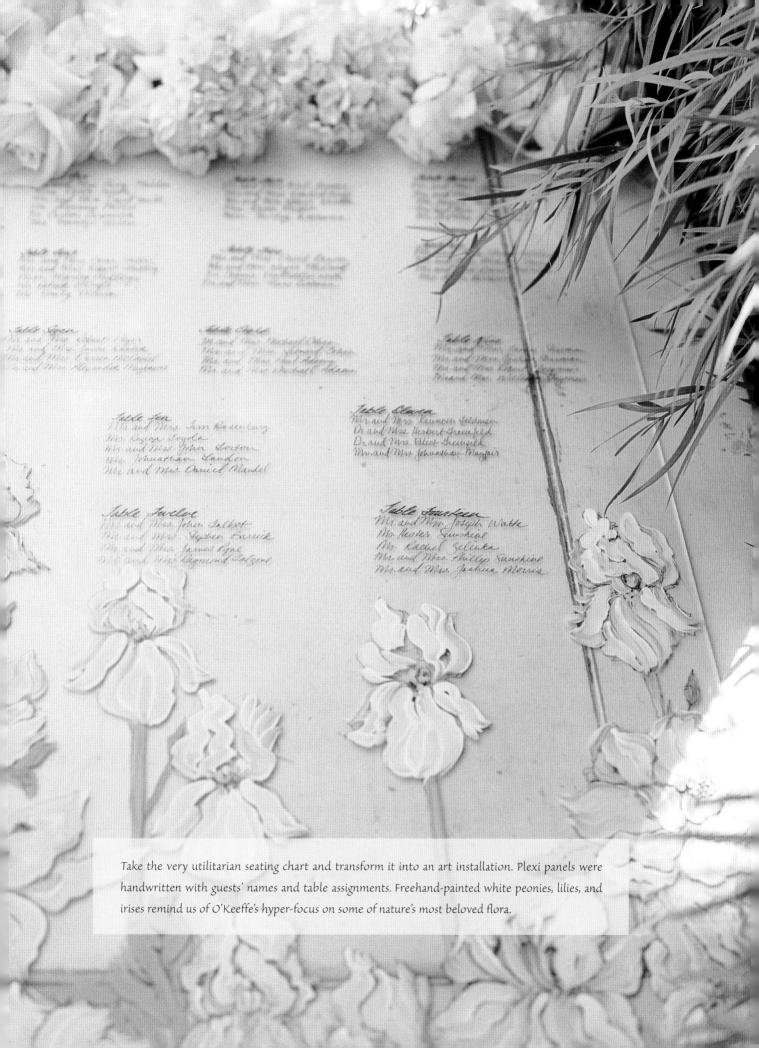

Take the very utilitarian seating chart and transform it into an art installation. Plexi panels were handwritten with guests' names and table assignments. Freehand-painted white peonies, lilies, and irises remind us of O'Keeffe's hyper-focus on some of nature's most beloved flora.

THINK LIKE A PAINTER

YOUR CELEBRATION TABLES ARE A COMPOSITION

PAINTERS EDIT IDEAS DOWN TO ONLY THE ELEMENTS THAT WILL BEST COMMUNICATE THEIR VISION.

Georgia O'Keeffe's CONCEPT DEFINITION

Georgia O'Keeffe was a twentieth-century American artist best known for her overscaled flower portraits. Many of her flower compositions featured white blooms like the iris, calla lily, and trumpet flower. O'Keeffe's painting style simplified the real life details of a flower and focused more on the graceful form of the bloom overall. Georgia O'Keeffe painted flowers so we, the viewers, would really take notice of their beauty.

TANGIBLE DESIGN IDEAS INSPIRED BY THE DEFINITION

Only white blooms, very little greenery, stems only. Cut glass mingled with plexi. All white linens and cake, so soft terracotta tones of Grand del Mar pop. Touches of black, white, and gray in stationery to reference O'Keeffe's grayscale paintings.

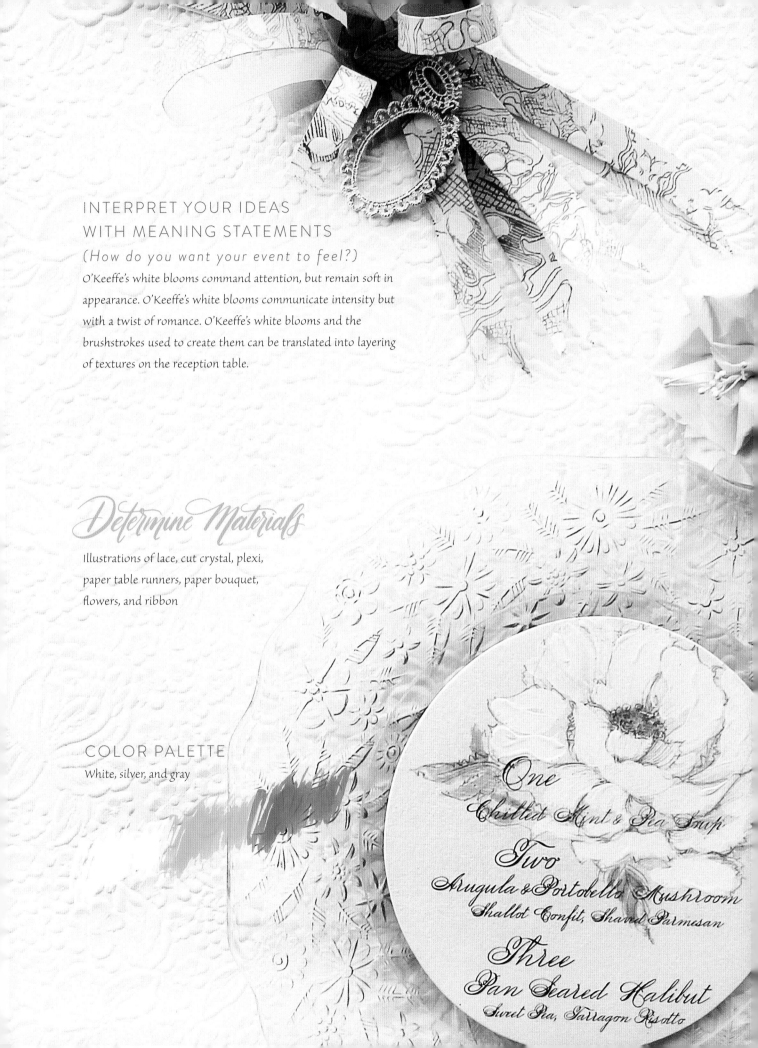

INTERPRET YOUR IDEAS
WITH MEANING STATEMENTS

(How do you want your event to feel?)

O'Keeffe's white blooms command attention, but remain soft in appearance. O'Keeffe's white blooms communicate intensity but with a twist of romance. O'Keeffe's white blooms and the brushstrokes used to create them can be translated into layering of textures on the reception table.

Determine Materials

Illustrations of lace, cut crystal, plexi, paper table runners, paper bouquet, flowers, and ribbon

COLOR PALETTE

White, silver, and gray

One
Chilled Mint & Pea Soup

Two
Arugula & Portobello Mushroom
Shallot Confit, Shaved Parmesan

Three
Pan Seared Halibut
Sweet Pea, Tarragon Risotto

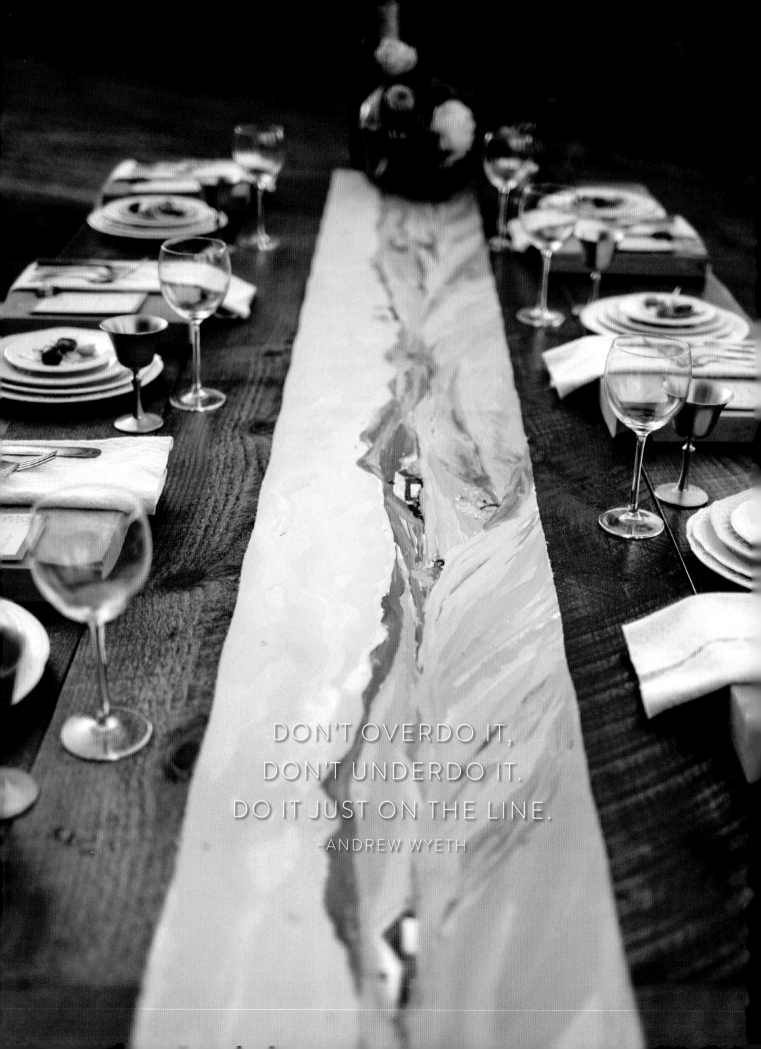

DON'T OVERDO IT,
DON'T UNDERDO IT.
DO IT JUST ON THE LINE.
—ANDREW WYETH

Andrew Wyeth's

PAINTERLY PASTORAL

Hillside Farms, Dallas, Pennsylvania

Andrew Wyeth (1917–2009) was in many ways a legend in his own time.

He painted his life, the people, and scenes around him that meant most. His style, more realist than abstract, captured simple moments of everyday life but pulsed with a quiet, emotional current that for so many seems irresistible to this day. Mr. Wyeth resisted the traditional oil medium used by so many fine artists of his time, as well as the popular urge to explore abstract subject matter. He mastered watercolor and egg tempera mediums in a time when both seemed permeable and fleeting, all the while developing a hyperrealistic style that seemed to honor the subject matter he painted. He consistently found a tentative balance between the grace of watercolor and the heaviness of a cold winter scene or dreariness of an abandoned barn. He made his own way, unapologetically, but did so with a soft voice, muted color palette, and quiet, unassuming subject matter.

So what could a painter with a subtle but laser-focused style have to teach us about wedding design? Well, just imagine your reception—outside perhaps, amidst the flora and fauna surrounding a 1900's cottage. Mr. Wyeth would encourage us to see our surroundings, he would ask us to love the place we chose for our ceremony and celebration, and to express that love with every last visual detail, no matter how subtle or small.

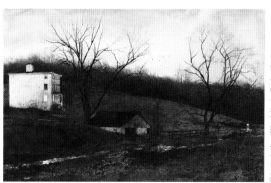

Evening at Kuerners, Andrew Wyeth

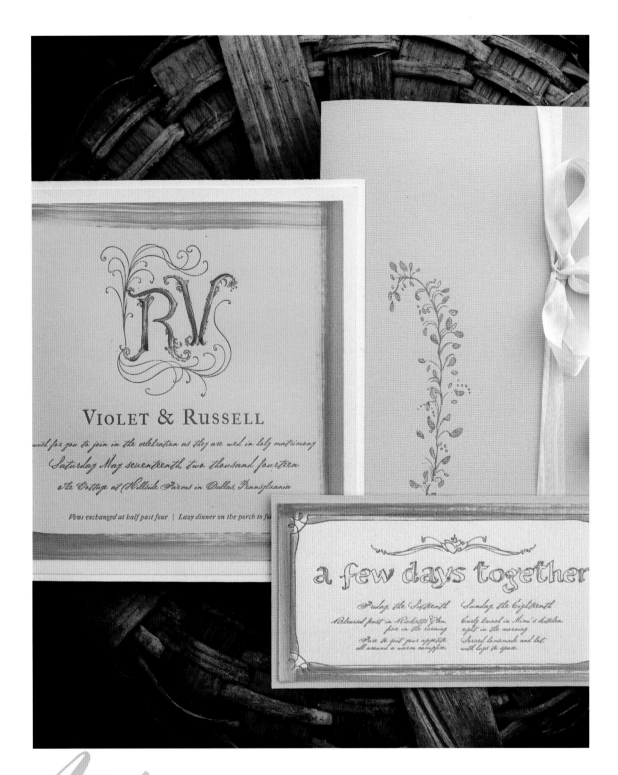

RV

VIOLET & RUSSELL

wish for you to join in the celebration as they are wed in holy matrimony

Saturday May seventeenth, two thousand fourteen

The Cottage at Hillside Farms in Dallas, Pennsylvania

Vows exchanged at half past four | Lazy dinner on the porch to fo

a few days together

Friday, the Sixteenth	*Sunday, the Eighteenth*

Art comes in many forms. Wyeth painted in a way that seemed to honor his subject matter. Even the most dilapidated or seemingly obscure structure became food for thought. Invitations are often sacrificed to ever-changing budgets or tech savvy whims, but look what can happen when they're treated as an art piece.

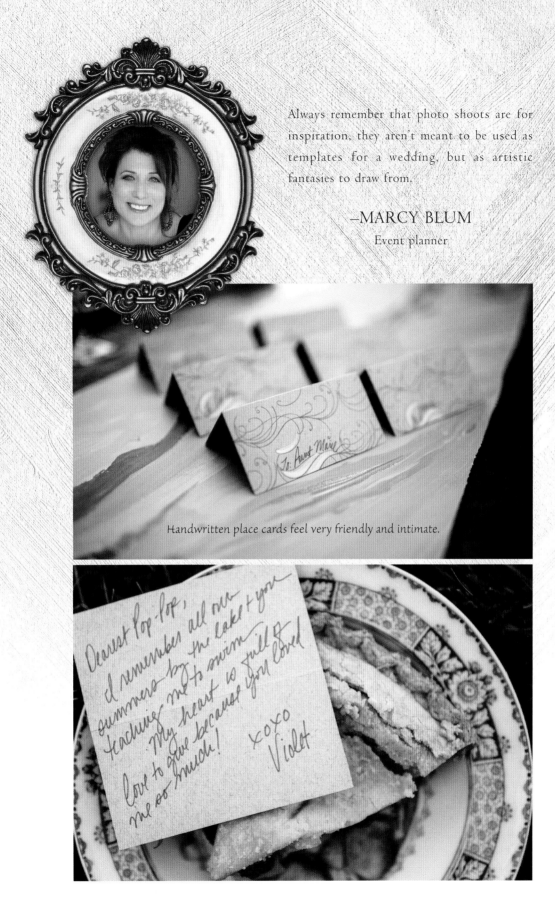

Always remember that photo shoots are for inspiration, they aren't meant to be used as templates for a wedding, but as artistic fantasies to draw from.

—MARCY BLUM
Event planner

Handwritten place cards feel very friendly and intimate.

Dearest Pop-Pop,
I'd remember all our summers by the lake & you teaching me to swim. My heart is full & love to give because you loved me so much!
xoxo
Violet

Inside each place card is a personally written note to each guest. Get lost imagining Mr. Wyeth himself writing these sweet little notes.

THE WORD PAINTERLY

Look closely at a painting on canvas . . . notice the buildup of paint and the lavish touch of a loaded paintbrush—this is a painterly look. Texture is at the heart of a painterly brushstroke. If you have the chance to view your inspiration artist's work up close and in person, don't pass it up.

Victorian embroidery alphabets

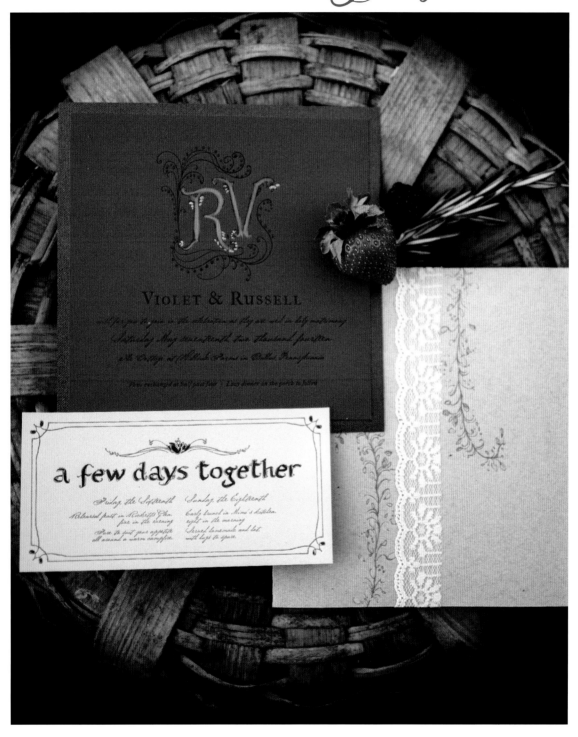

Victorian embroidery alphabets, or samplers, inspired the invitation's design here. Every element of wedding design has the opportunity to say something. Ask questions like what might the model in Wyeth's painting have been working on just before posing? Here, we answered, "embroidery hoop and needle."

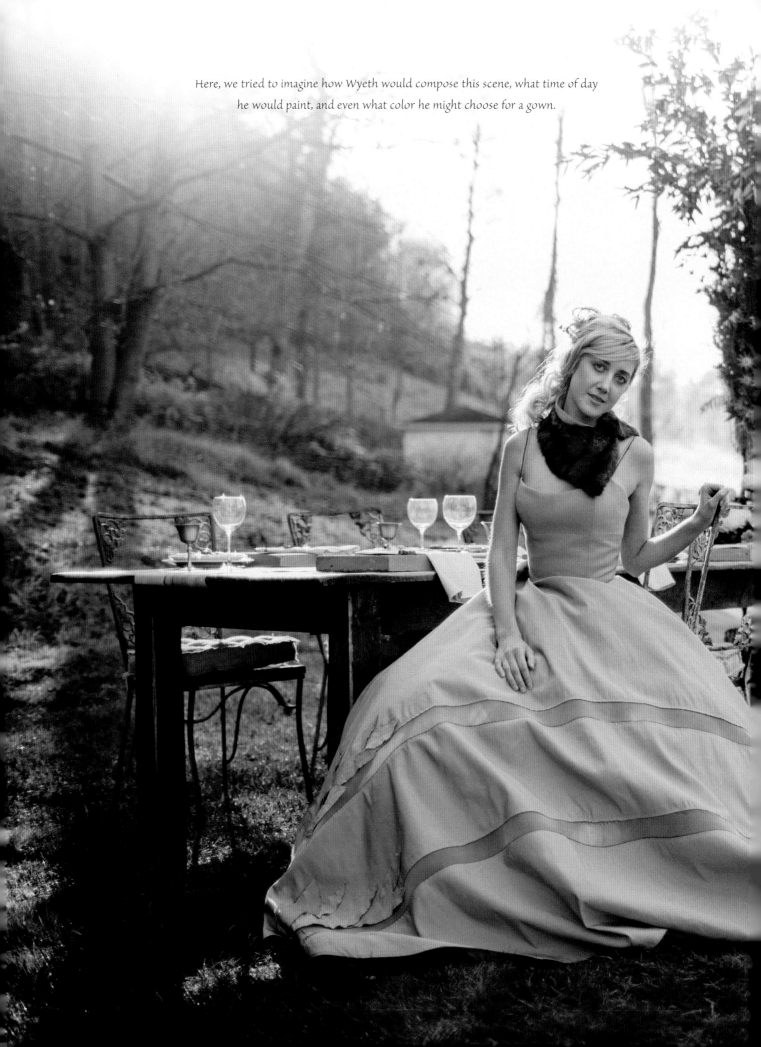

Here, we tried to imagine how Wyeth would compose this scene, what time of day he would paint, and even what color he might choose for a gown.

Let the artist's inspiration pour from your photography

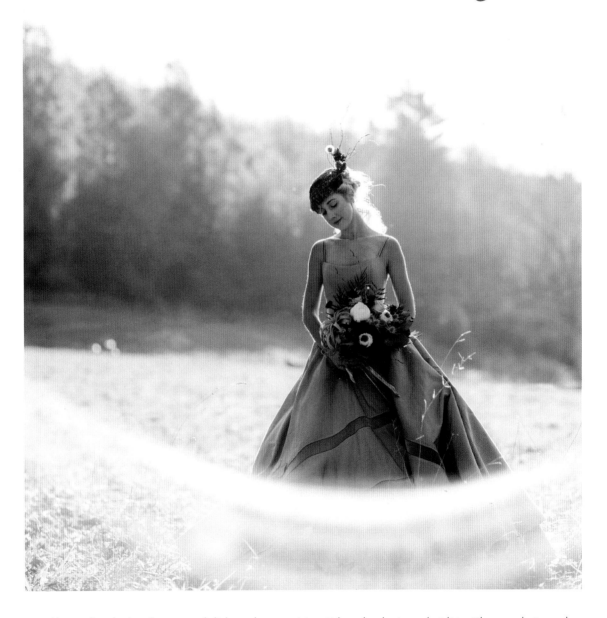

Wyeth's paintbrush plated magic with light and composition. When developing a shot list with your photographer, why not take a few cues from a painter's portfolio?

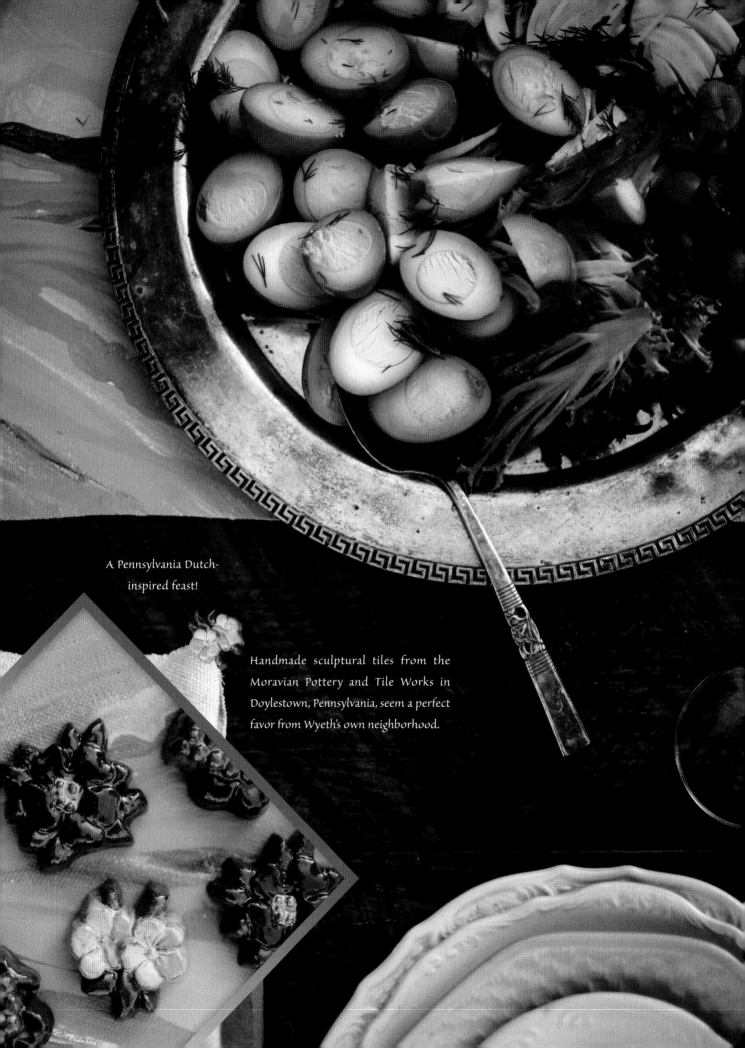

A Pennsylvania Dutch-
inspired feast!

Handmade sculptural tiles from the
Moravian Pottery and Tile Works in
Doylestown, Pennsylvania, seem a perfect
favor from Wyeth's own neighborhood.

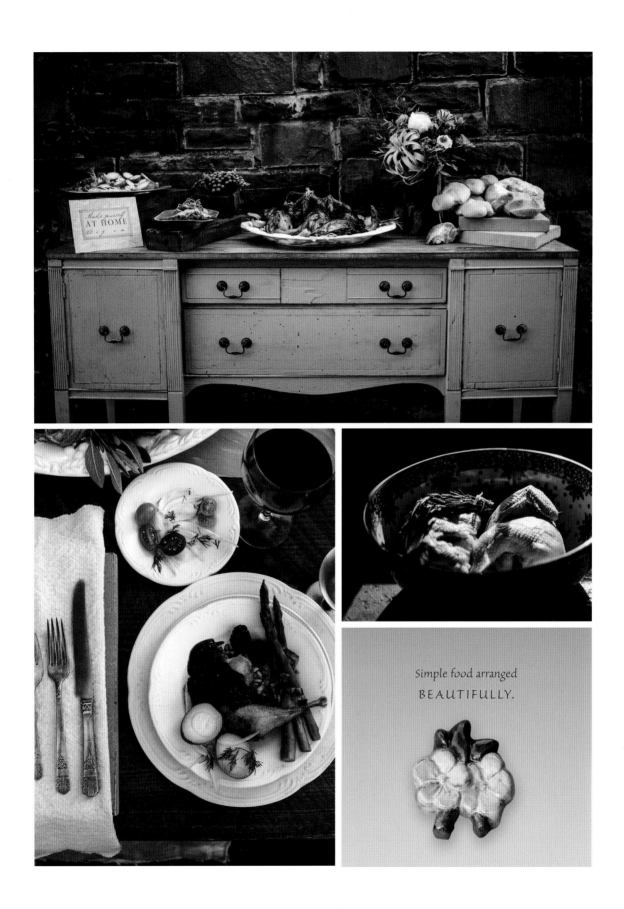

Simple food arranged
BEAUTIFULLY.

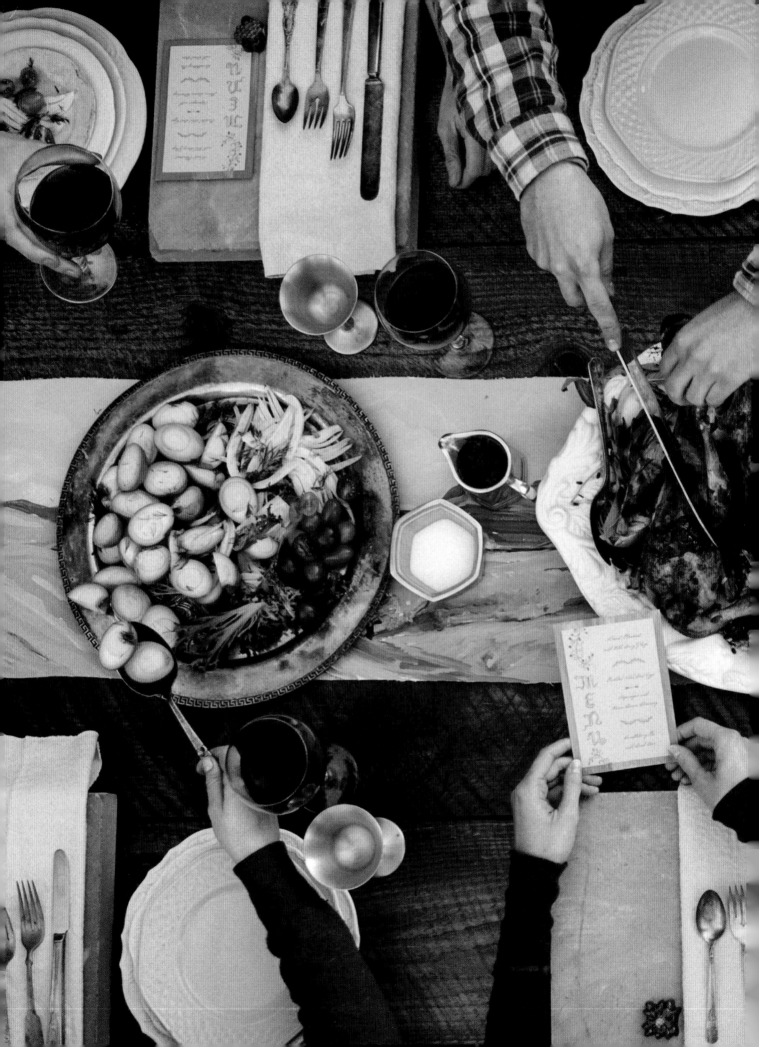

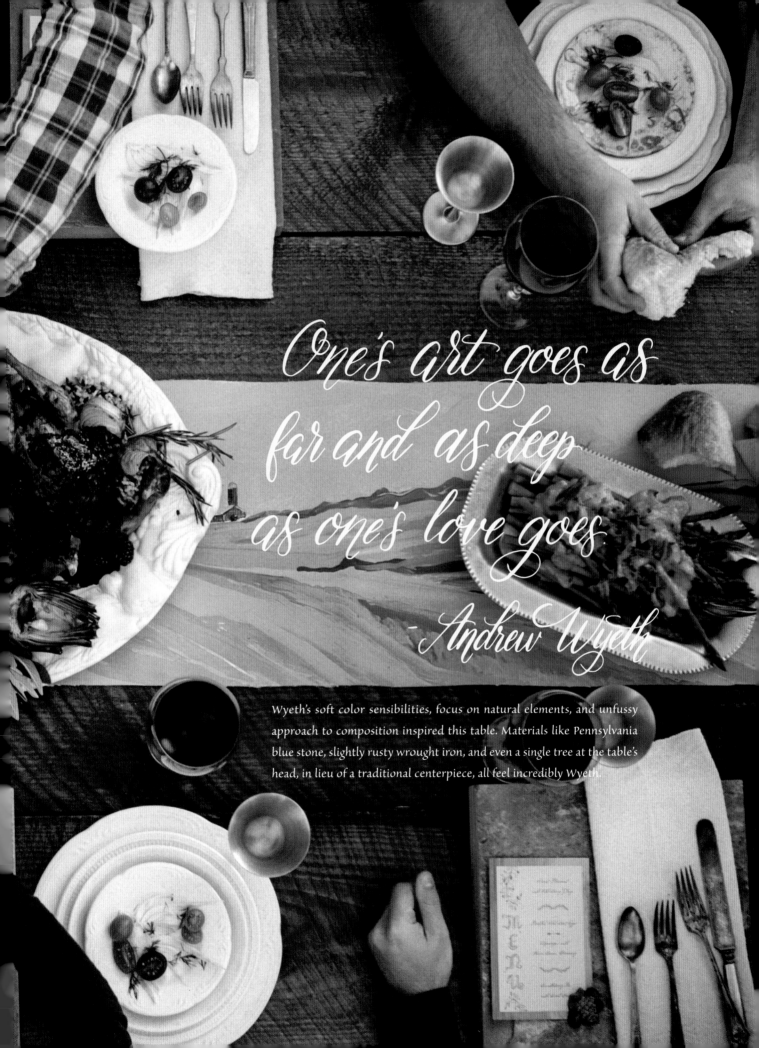

One's art goes as
far and as deep
as one's love goes.

- Andrew Wyeth

Wyeth's soft color sensibilities, focus on natural elements, and unfussy approach to composition inspired this table. Materials like Pennsylvania blue stone, slightly rusty wrought iron, and even a single tree at the table's head, in lieu of a traditional centerpiece, all feel incredibly Wyeth.

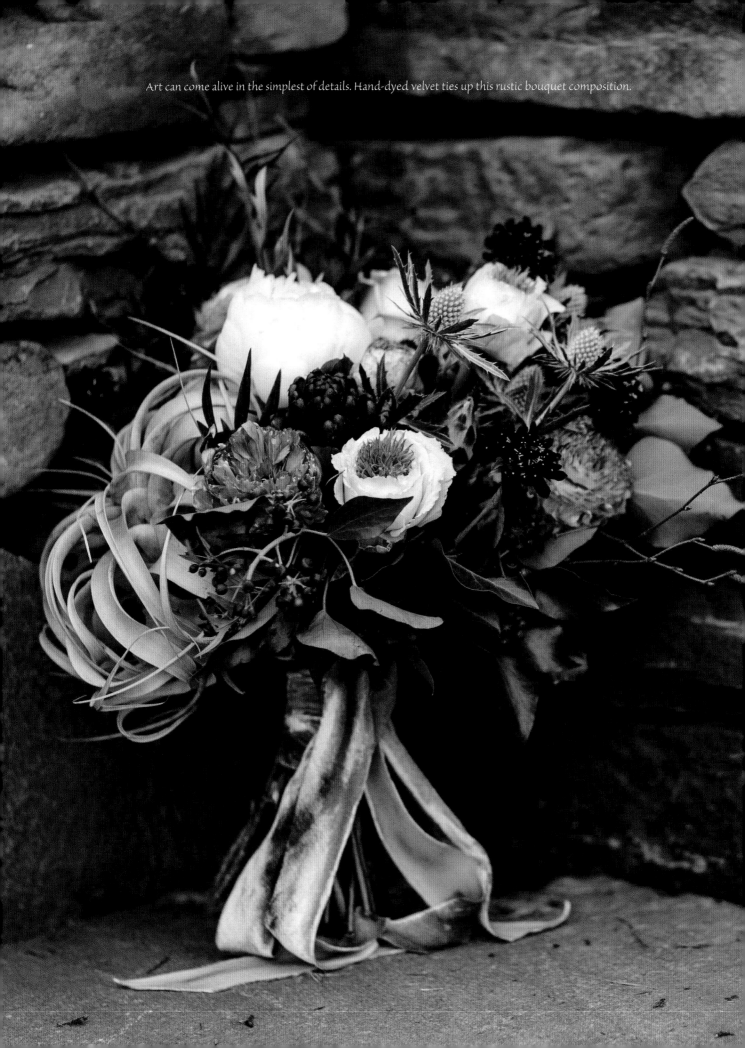

Art can come alive in the simplest of details. Hand-dyed velvet ties up this rustic bouquet composition.

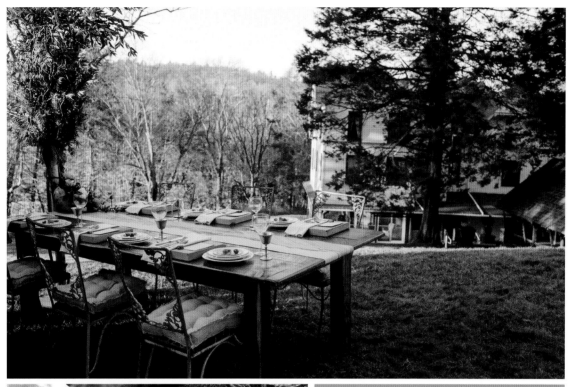

Couples can easily forget the importance of images that capture the journey in their wedding day. Of course, shots with the wedding party and Grandma are paramount, but add a few artsy shots like these to capture the small, quiet, but incredibly beautiful moments through-out the day. Andrew Wyeth's still lives often featured dramatic natural light like seen here.

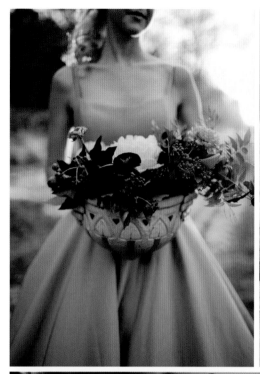
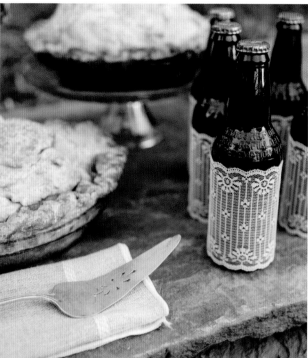
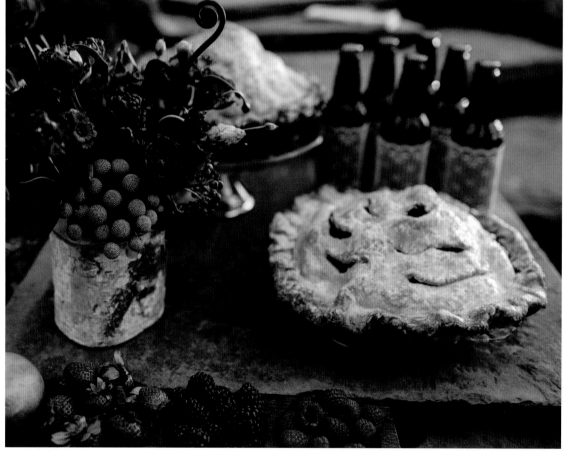

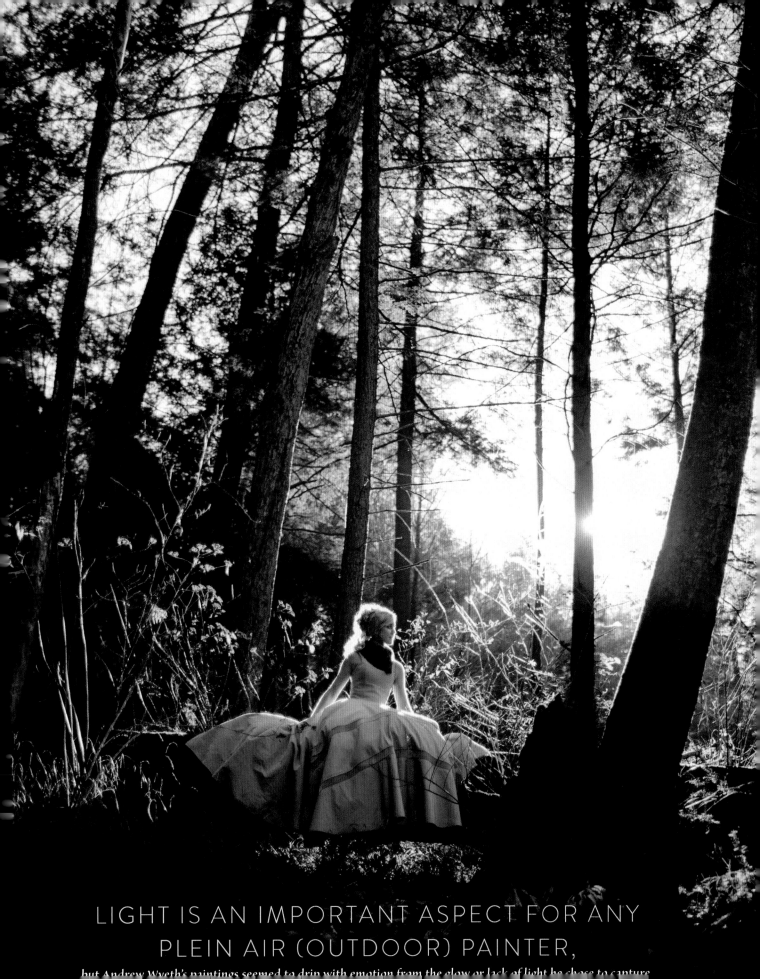

LIGHT IS AN IMPORTANT ASPECT FOR ANY
PLEIN AIR (OUTDOOR) PAINTER,
but Andrew Wyeth's paintings seemed to drip with emotion from the glow or lack of light he chose to capture.

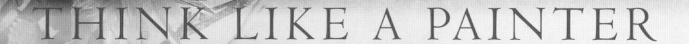

THINK LIKE A PAINTER

LEAVE NO DETAIL UNTOUCHED BUT REMEMBER A SUBTLE APPROACH

Painters transform the everyday ordinary into the coveted extraordinary.

Andrew Wyeth's

CONCEPT DEFINITION

Andrew Wyeth's work includes a laser-sharp focus on detail, but with a subtle color palette. His paintings feature subtle colors, as if all the paint he used was mixed with a bit of gray. Wyeth's work captures simple living in often humble surroundings, allowing the natural environment to shine.

TANGIBLE DESIGN IDEAS INSPIRED BY THE DEFINITION

Slate textures combined with painted canvas accents. Centerpieces at the end of a table as to not interfere with clean table design. Small pottery sculpture accents. Morning light photography. Wedding gown in a color other than white. Some rusted textures.

INTERPRET YOUR IDEAS WITH MEANING
STATEMENTS *(How do you want your event to feel?)*
Wyeth paintings conjure a feeling of comfort. Wyeth paintings honor place and
time. Wyeth paintings seem to glisten somehow. Wyeth paintings pay homage to
nature. Wyeth paintings possess a slightly mysterious mood.

Determine Materials

Slate slabs, hand-sewn details, feathers, pottery, vines,
ranunculus, peonies

COLOR PALETTE

Dusty blue, sage green, hints of blush, tan

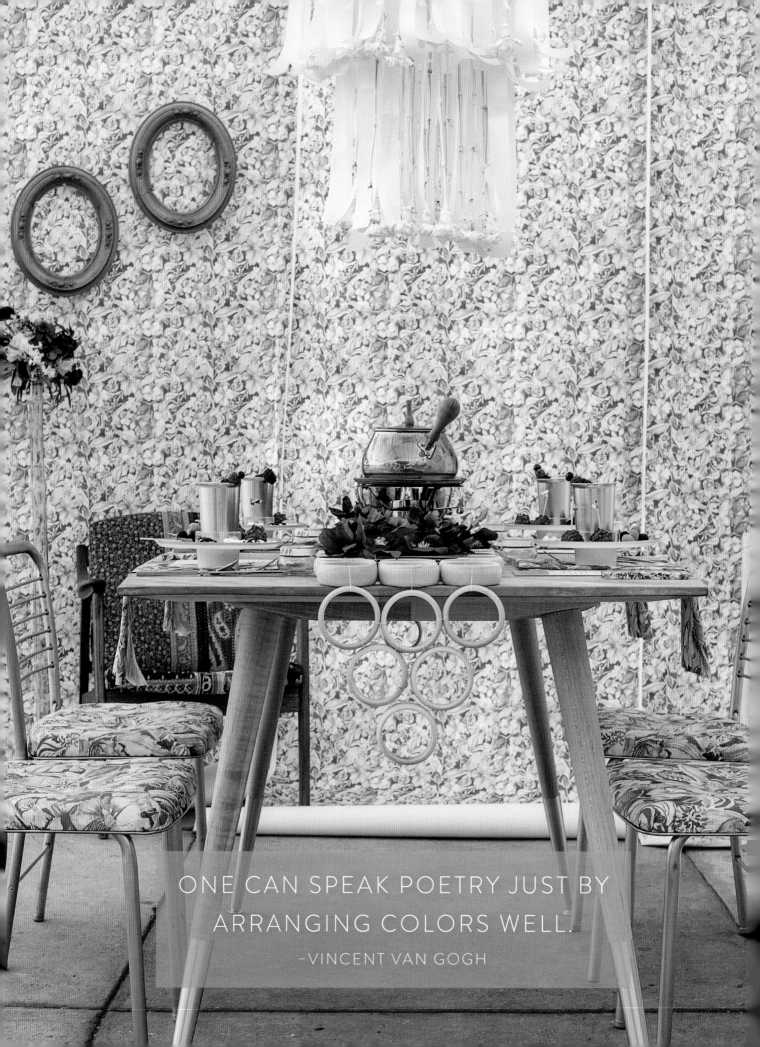

ONE CAN SPEAK POETRY JUST BY
ARRANGING COLORS WELL.

-VINCENT VAN GOGH

PANTONE'S RADIANT ORCHID

with Mucha

Horticulture Center, Philadelphia, Pennsylvania

Alphonse Mucha's (1860–1939) work has become incredibly recognizable in representing the Art Nouveau movement.

His flower-festooned, angel-esque subjects beam with femininity on a strong jewel-toned color palette. Here, we spun the look of Mucha's beautiful ladies into a fresh-faced take on pretty portraits during a cheerful brides-maid's luncheon.

Mucha approached color with-out reserve—he simply didn't hold back. What is your color palette? This is the quintessential question every couple is asked soon after the wedding date announcement, usually only preceded by did you pick your date? This question can wreak havoc on the wedding planning mind like little else. Choosing a color or small variety of hues that will forever feel deserving of the title favorite, selecting a palette that flows effortlessly with your

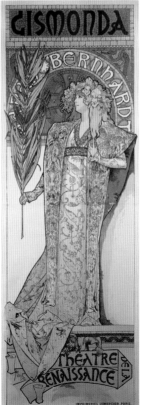

Sarah Bernhardt (1844–1923) as Gismonda at the Theatre de la Renaissance, color litho, 1894, Alphonse Marie Mucha

wedding property, and zeroing in on a few colors that will stare back at you from wedding albums for years to come is scary, right? Not really. Take a breath . . . I know you're panicking.

You see, color can be timeless when it is approached with con-sistency, variety, and confidence. Color can be sophisticated even at its boldest. Mucha had a knack for instinct and once he made a decision he stuck to it and went all the way. Here lies the secret to loving a color and surrendering to its beauty until death do you part, so to speak. Go with your gut, listen to your heart, block out all those voices that are not your own when choosing your palette, and then run with it. Commit whole-heartedly and never look back.

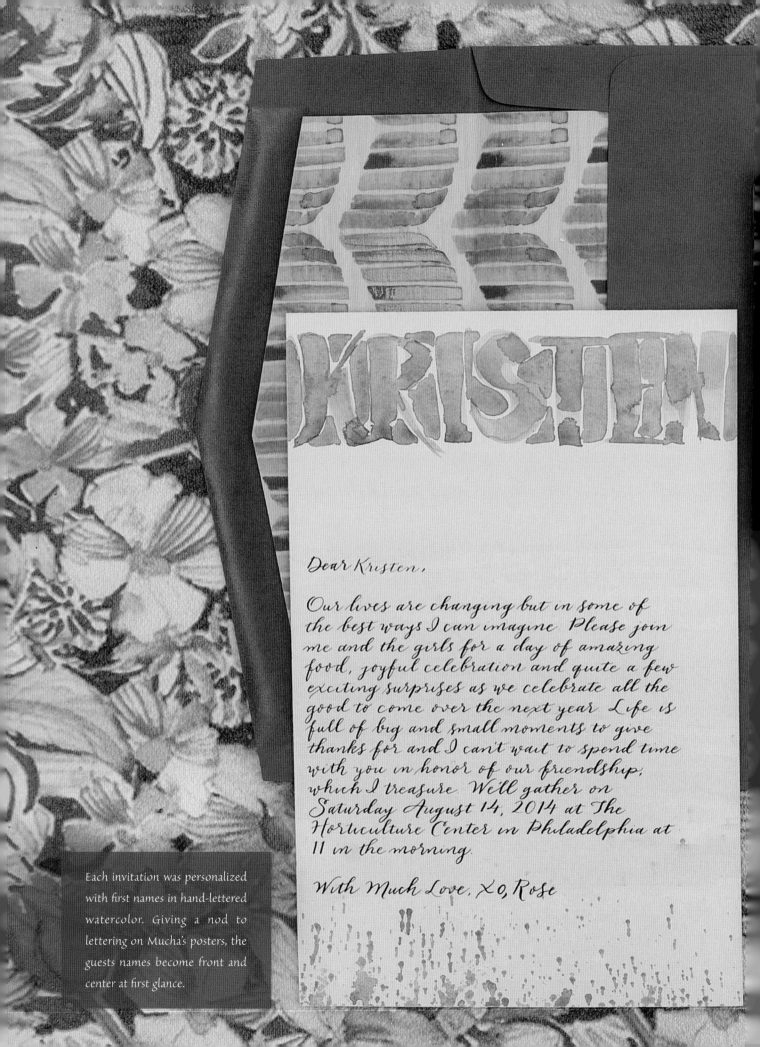

KRISTEN

Dear Kristen,

Our lives are changing but in some of the best ways I can imagine. Please join me and the girls for a day of amazing food, joyful celebration and quite a few exciting surprises as we celebrate all the good to come over the next year. Life is full of big and small moments to give thanks for and I can't wait to spend time with you in honor of our friendship, which I treasure. We'll gather on Saturday August 14, 2014 at The Horticulture Center in Philadelphia at 11 in the morning.

With Much Love, XO, Rose

Each invitation was personalized with first names in hand-lettered watercolor. Giving a nod to lettering on Mucha's posters, the guests names become front and center at first glance.

MENU

Eat Up, Friends!

Old-Fashioned
Browned Beef Stew
with red wine,
rutabaga, parsnips
and pearl onions

Corn Fritters
with maple syrup

Fried Silver Smelts
with homemade
spicy remoulade

Tossed Green Salad
with sour cream
dill dressing

Cherry Layer Cake

Make it personal

Welcome the chance

to wear a flower crown.

Mucha's nymph-like models are traded here for bold women, all with a powerful presence but not without the timeless enchantment of a flower crown.

All my life I've been drawn to art. As a child my real life pinboard was covered in magazine tear-outs and heart-fluttering print pieces, postcards, and illustrations. It was part highly visual artwork and part luxurious tangible aesthetic that inspired a path towards fine art photography and now print.

Art is very much a muse that helps inspire new forms of art. Be it a color palette, a particular flourish, texture, or a general aesthetic—we're always pulling together bits and pieces of influence from various artists to create the grand editorial ideas we share with you. It's easy for you to do the same for your wedding!

For example, take the Czech artist Mucha. His decorative art is inspiration for any boho chic bride. From glowing shades of summer solstice to floral halos, flowing gowns, organically tousled hairstyles, and botanical backdrops, all the details of your day can spawn from this artist's archive of inspiration.

So how do you create a cohesive wedding day look from a piece of art? Create a board. Whether real life or virtual, you need a place to hold your muse (i.e., the artwork) and build forward. From there start adding complementary details that set your heart aflutter: flowers, dresses, stationery, etc. Give yourself time to build and reflect on your board. It's a beautiful and sometimes emotional process as you add and remove pieces. Slowly but surely you'll create a harmony of thoughtful details for your dream day.

–KIM WISELEY
Founder of *Flutter* Magazine

Mucha's more decorative style is mirrored here with the touch-of-neon accessories and floral background.

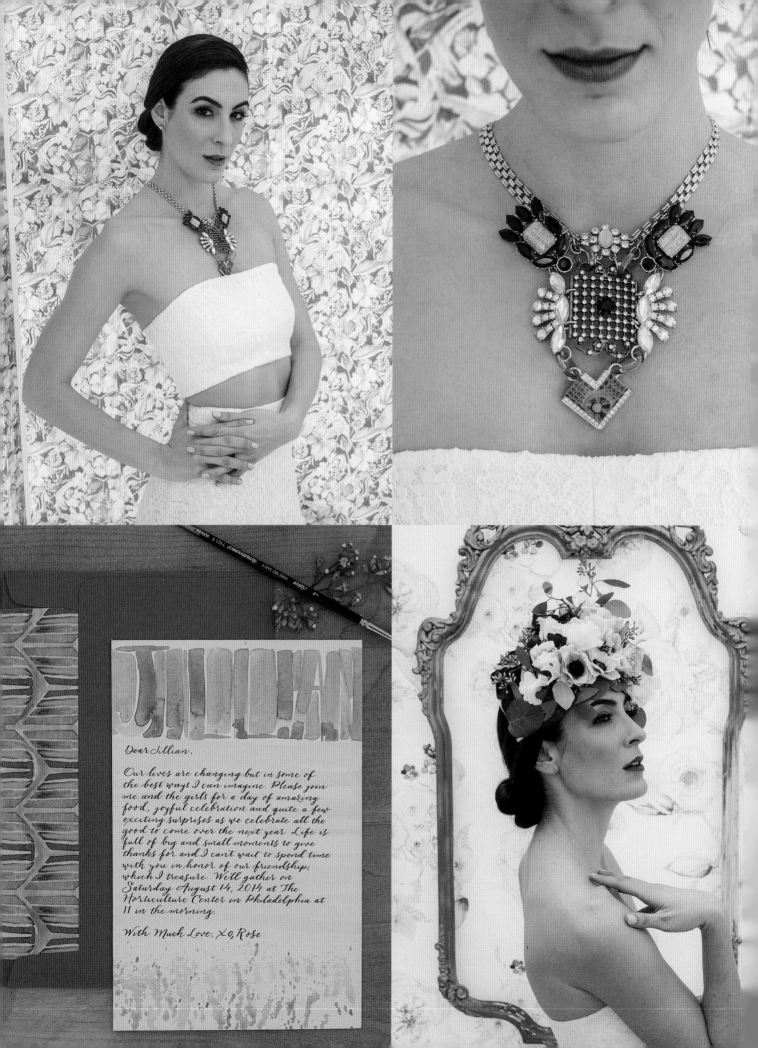

Dear Jillian,

Our lives are changing but in some of the best ways I can imagine. Please join me and the girls for a day of amazing food, joyful celebration and quite a few exciting surprises as we celebrate all the good to come over the next year. Life is full of big and small moments to give thanks for and I can't wait to spend time with you in honor of our friendship, which I treasure. We'll gather on Saturday August 14, 2014 at The Horticulture Center in Philadelphia at 11 in the morning.

With Much Love, XO, Rose

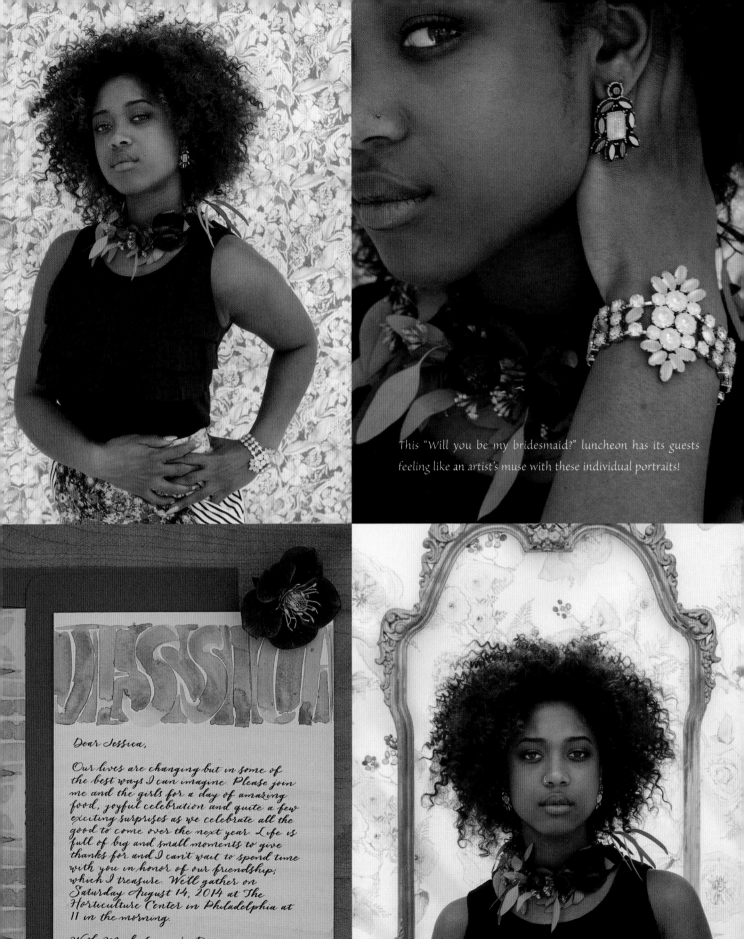

This "Will you be my bridesmaid?" luncheon has its guests feeling like an artist's muse with these individual portraits!

Dear Jessica,

Our lives are changing but in some of the best ways I can imagine. Please join me and the girls for a day of amazing food, joyful celebration and quite a few exciting surprises as we celebrate all the good to come over the next year. Life is full of big and small moments to give thanks for and I can't wait to spend time with you in honor of our friendship, which I treasure. We'll gather on Saturday August 14, 2014 at The Horticulture Center in Philadelphia at 11 in the morning.

With Much Love, XO, Rose

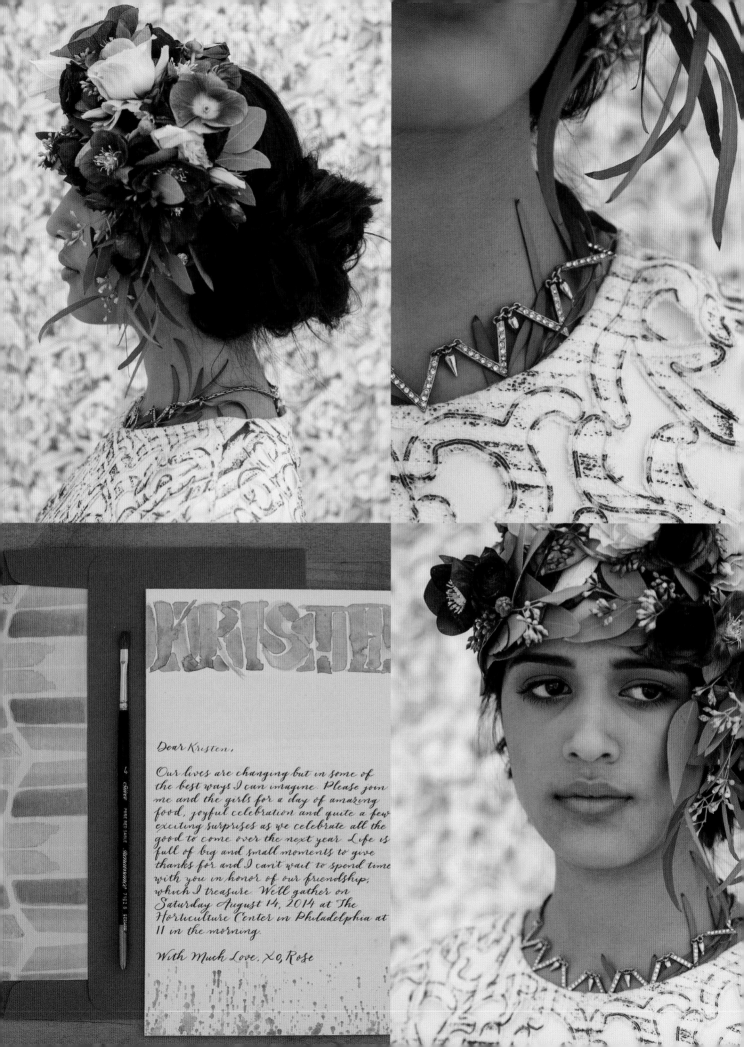

Dear Kristen,

Our lives are changing but in some of the best ways I can imagine. Please join me and the girls for a day of amazing food, joyful celebration and quite a few exciting surprises as we celebrate all the good to come over the next year. Life is full of big and small moments to give thanks for and I can't wait to spend time with you in honor of our friendship, which I treasure. We'll gather on Saturday August 14, 2014 at The Horticulture Center in Philadelphia at 11 in the morning.

With Much Love, XO, Rose

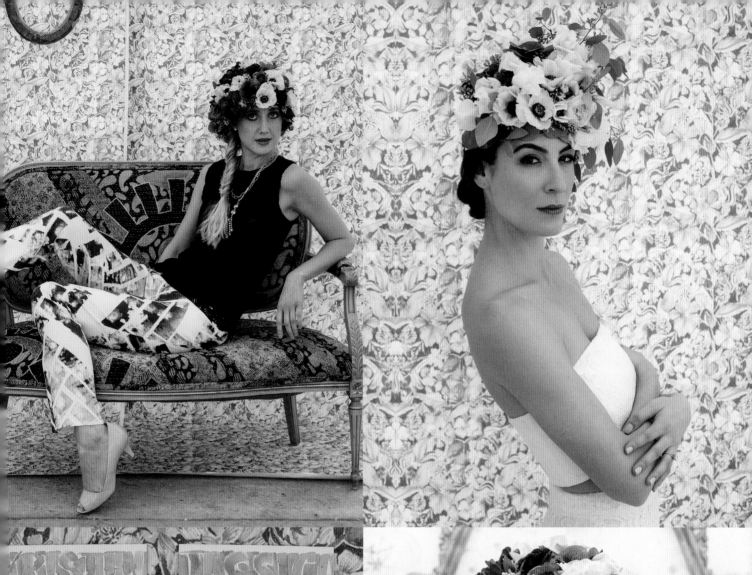

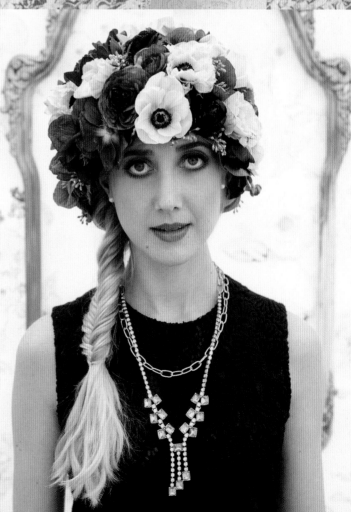

KRISTEN

JESSSICA

Dear Kristen,

Dear Jessica,

Our lives are changing but in some of the best ways I can imagine. Please join me and the girls for a day of amazing food, joyful celebration and quite a few exciting surprises as we celebrate all the good to come over the next year. Life is full of big and small moments to give thanks for and I can't wait to spend time with you in honor of our friendship, which I treasure. We'll gather on Saturday August 14, 2014 at The Horticulture Center in Philadelphia at 11 in the morning.

With Much Love, XO, Rose

LILLIAN

HOLLY

Dear Lillian,

Dear Holly,

Our lives are changing but in some of the best ways I can imagine. Please join me and the girls for a day of amazing food, joyful celebration and quite a few exciting surprises as we celebrate all the good to come over the next year. Life is full of big and small moments to give thanks for and I can't wait to spend time with you in honor of our friendship, which I treasure. We'll gather on Saturday August 14, 2014 at The Horticulture Center in Philadelphia at 11 in the morning.

With Much Love, XO, Rose

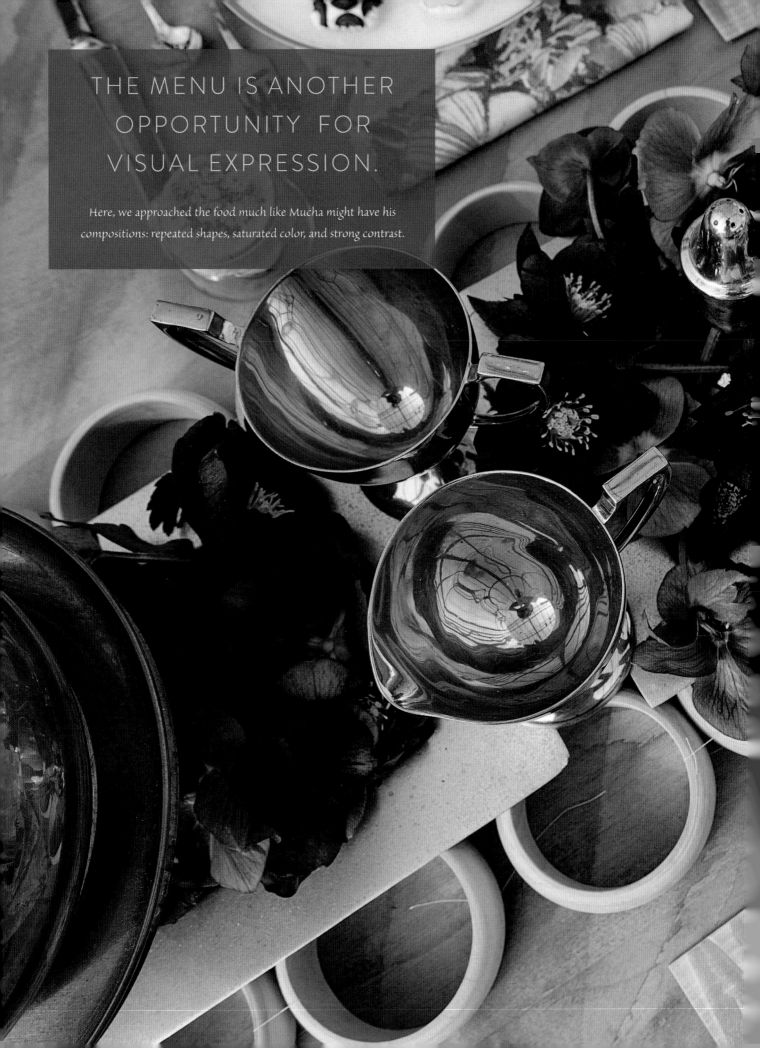

THE MENU IS ANOTHER OPPORTUNITY FOR VISUAL EXPRESSION.

Here, we approached the food much like Mucha might have his compositions: repeated shapes, saturated color, and strong contrast.

Mucha's famous Art Nouveau posters featured repeated elements, including flowers, swirls, circles, and leaves.

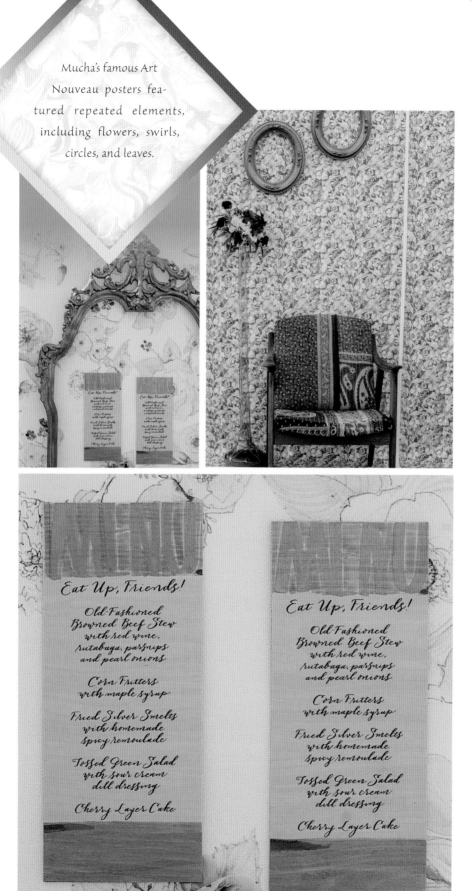

Eat Up, Friends!

Old-Fashioned Browned Beef Stew with red wine, rutabaga, parsnips and pearl onions

Corn Fritters with maple syrup

Fried Silver Smelts with homemade spicy remoulade

Tossed Green Salad with sour cream dill dressing

Cherry Layer Cake

Eat Up, Friends!

Old-Fashioned Browned Beef Stew with red wine, rutabaga, parsnips and pearl onions

Corn Fritters with maple syrup

Fried Silver Smelts with homemade spicy remoulade

Tossed Green Salad with sour cream dill dressing

Cherry Layer Cake

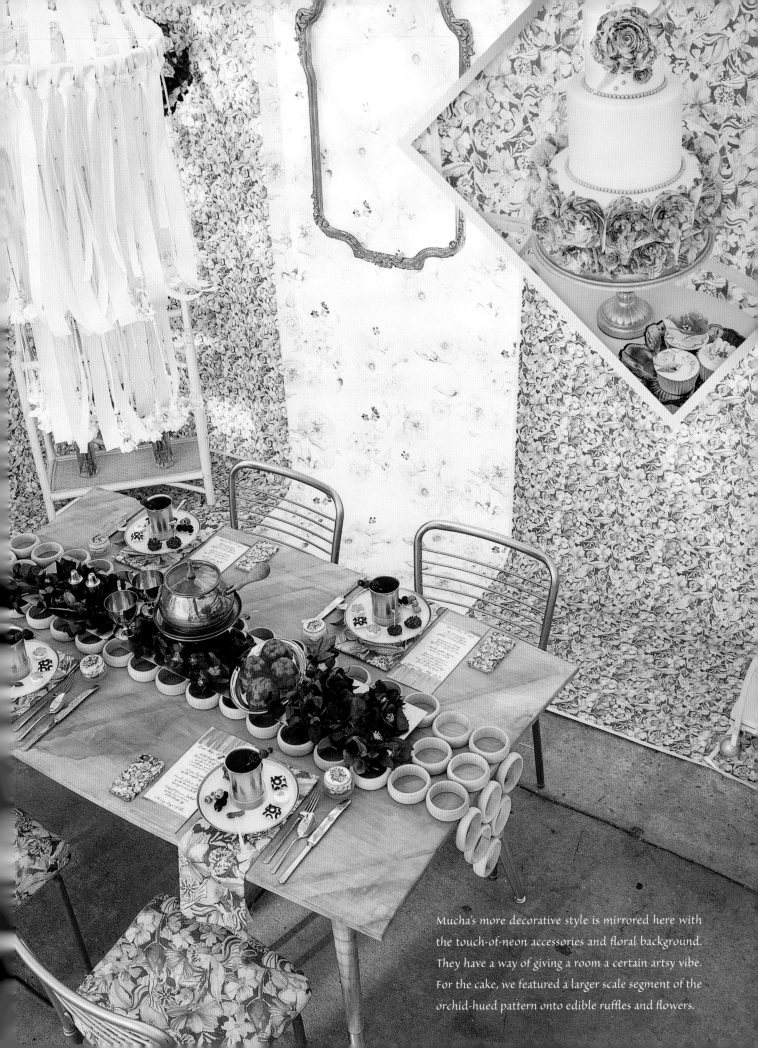

Mucha's more decorative style is mirrored here with the touch-of-neon accessories and floral background. They have a way of giving a room a certain artsy vibe. For the cake, we featured a larger scale segment of the orchid-hued pattern onto edible ruffles and flowers.

THINK LIKE A PAINTER

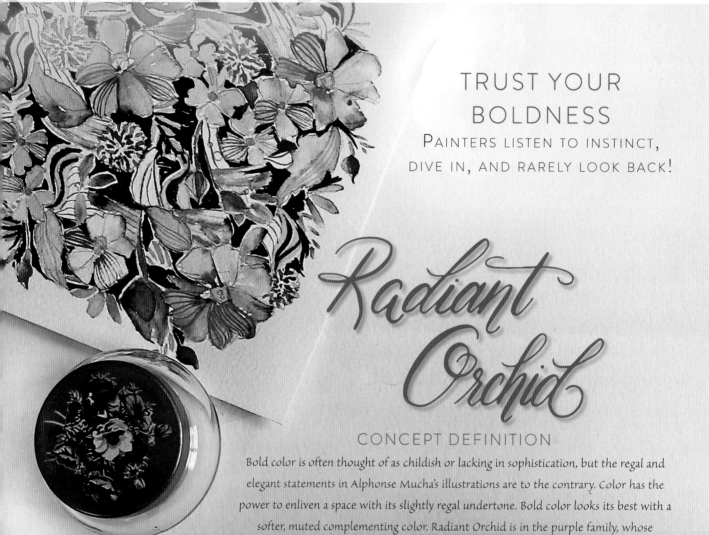

TRUST YOUR BOLDNESS
PAINTERS LISTEN TO INSTINCT, DIVE IN, AND RARELY LOOK BACK!

Radiant Orchid

CONCEPT DEFINITION

Bold color is often thought of as childish or lacking in sophistication, but the regal and elegant statements in Alphonse Mucha's illustrations are to the contrary. Color has the power to enliven a space with its slightly regal undertone. Bold color looks its best with a softer, muted complementing color. Radiant Orchid is in the purple family, whose opposite on the color wheel is yellow.

TANGIBLE DESIGN IDEAS INSPIRED BY THE DEFINITION

Lots of flowers in shades of raspberry, purple, and violet, with some greens. Small accents of soft pink, sage green, and splashes of yellow. Mix and match patterns. Bring black and white into attire. Accents of neon for contrast. Mid-twentieth-century accents of copper. Clean lines so Radiant Orchid doesn't look too sweet.

INTERPRET YOUR
IDEAS WITH MEANING
STATEMENTS (*How do
you want your event to feel?*)
Radiant Orchid is fun and youthful.
Radiant Orchid is sophisticated and
energizes. Radiant Orchid feels modern,
but still feminine. Radiant Orchid is like
a sweet wind on a warm day. Radiant
Orchid feels fancy and fun.

Determine Materials

Throwback snack trays, fondue pot, custom table linen,
copper, watercolored wood, and vintage gilded frames

COLOR PALETTE
Raspberry, violet, orchid, accents of sage
green, yellow, and gold

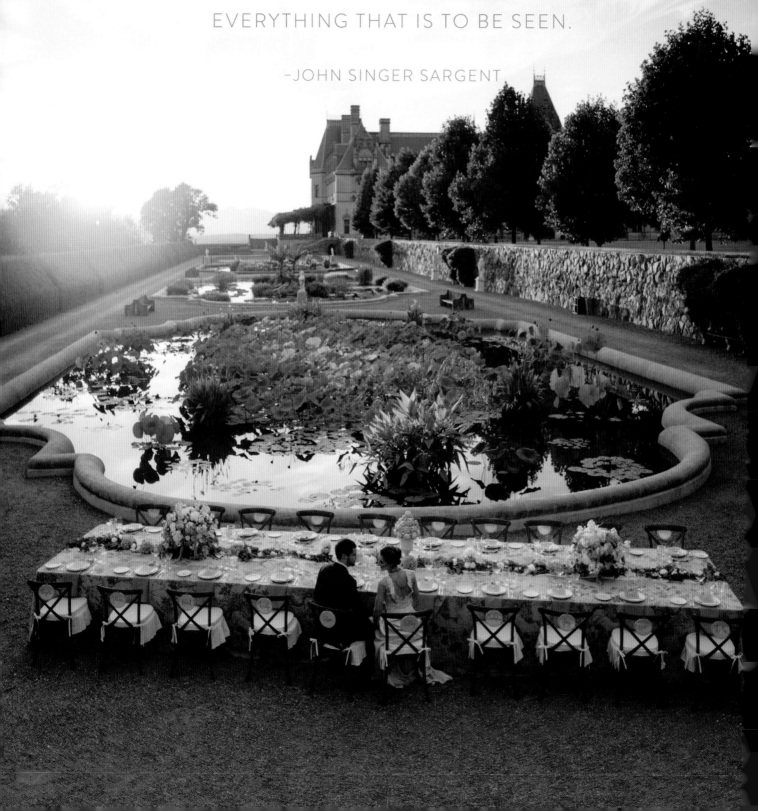

CULTIVATE AN EVER CONTINUOUS POWER OF
OBSERVATION . . . STORE UP IN THE MIND . . .
A CONTINUOUS STREAM OF OBSERVATIONS FROM
WHICH TO MAKE SELECTIONS LATER. ABOVE ALL
THINGS, GET ABROAD, SEE THE SUNLIGHT AND
EVERYTHING THAT IS TO BE SEEN.

–JOHN SINGER SARGENT

John Singer Sargent

AT BILTMORE ESTATE

Asheville, North Carolina

Biltmore Estate (constructed between 1889–1895) was envisioned
and built by artists of countless genres.

Architects, illustrators, painters, and craftsmen were brought together in large and small efforts to build a home of epic endeavor. Each artist was inspired first by their surroundings, becoming keenly aware of the opportunities that their daily visual life afforded the process. Artists through the ages are consistently hired for a vision and unique perspective that breathes life into their work. George Vanderbilt was a significant patron of John Singer Sargent, whose velvety portraits feature the curious grins of members of the Vanderbilt family and even their friends. Sargent's pieces can be seen throughout the walls of Biltmore Estate.

Frederick Law Olmsted, oil on canvas, 254 x 139.7 cm (100 x 55 in.), John Singer Sargent

Image courtesy of Biltmore Estate

As your planning adventure embarks, this chapter is designed to catapult your thinking to notice everything. You'll learn to develop your own visual perspective. Imagine noticing the way a stone carving looks against a cloudy sky, the color palette naturally occurring in a city park flooded with sunlight, or moments of architecture in a church whose majesty and romance could inspire a ceremony backdrop. Your curiosity can offer endless design opportunities, even if you'd never dare to call yourself "artistic." Curiosity doesn't need expertise to flourish, it only needs opportunity.

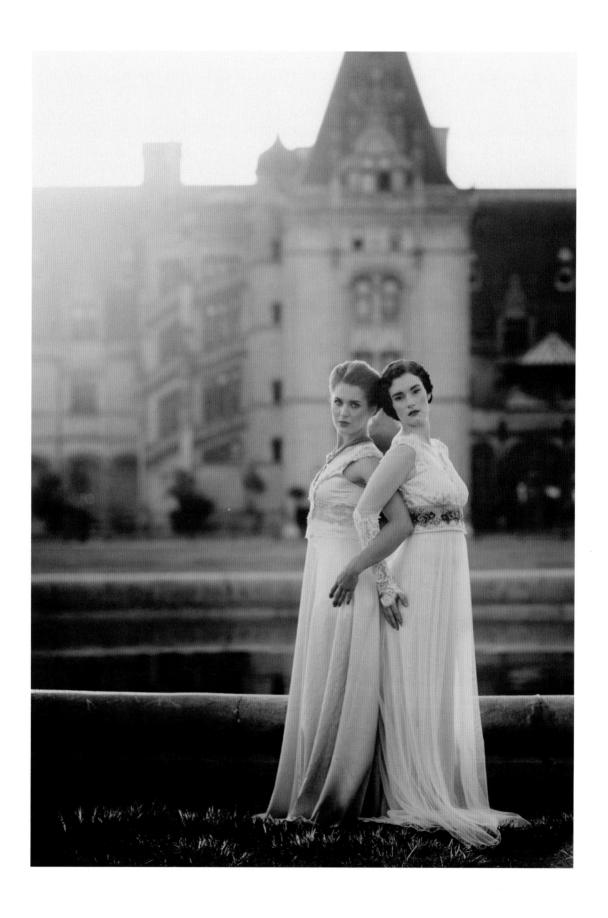

Individuality is an essential component to any artist's perspective. A wedding is a chance to embrace the originality of your interests and passions as a couple, as well as each of you separately. Take inspiration from things you love together. Perhaps it's the smell of lilacs, a sun setting over the horizon, or your mutual love of delicious food—use these elements to create your dream wedding day. As Kristy says, "your curiosity can offer endless design opportunities" so find out what it is you are passionate about together and incorporate that into your event. Part of the reason you've fallen in love is because you're each unique. Celebrate that as well and include elements you enjoy independently.

–JENNIFER STEIN

Editor in chief, *Destination I Do*

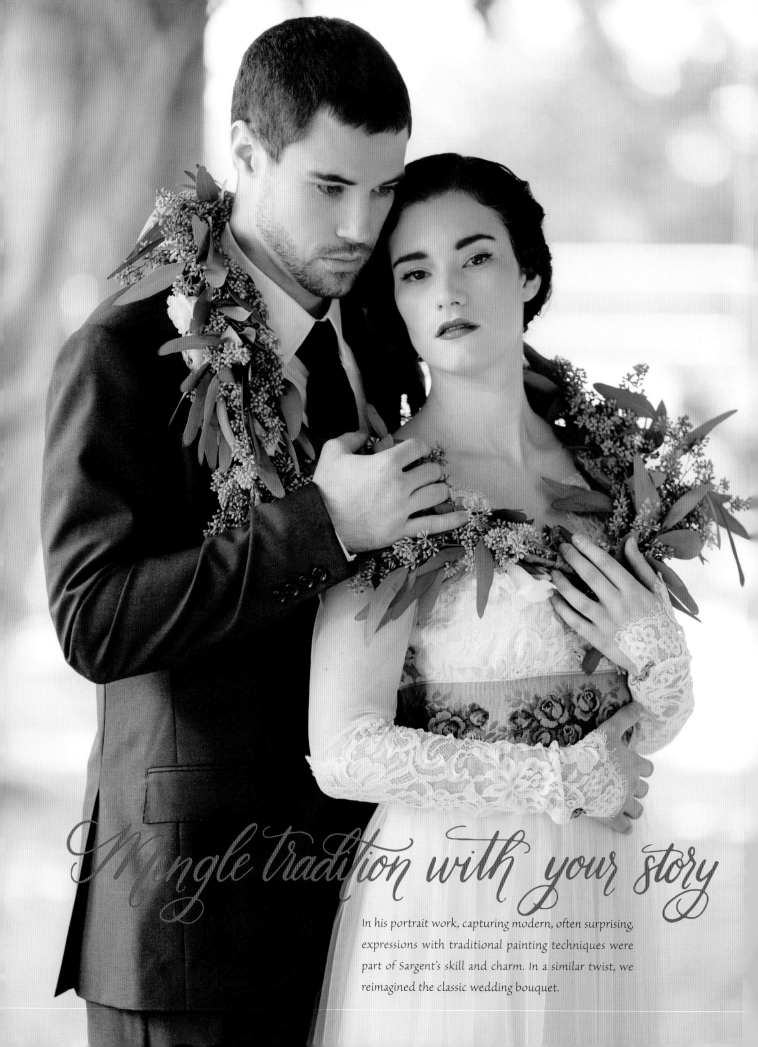

Mingle tradition with your story

In his portrait work, capturing modern, often surprising, expressions with traditional painting techniques were part of Sargent's skill and charm. In a similar twist, we reimagined the classic wedding bouquet.

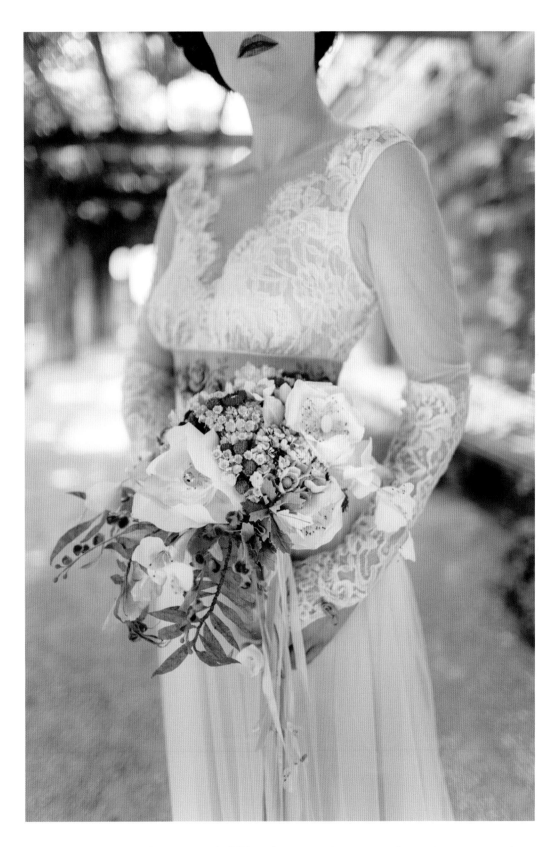

A portrait reminiscent of Sargent's early full-length portraits, but again with a modern spin on a classic bouquet where we traded fresh petals for paper and vintage millinery.

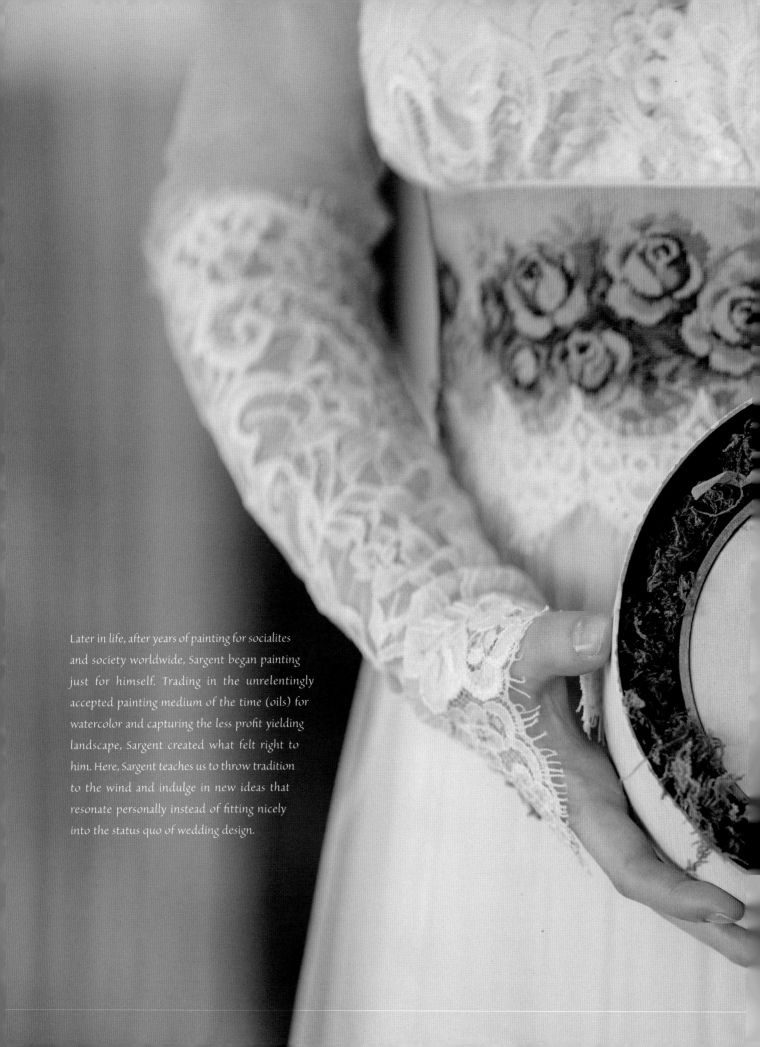

Later in life, after years of painting for socialites and society worldwide, Sargent began painting just for himself. Trading in the unrelentingly accepted painting medium of the time (oils) for watercolor and capturing the less profit yielding landscape, Sargent created what felt right to him. Here, Sargent teaches us to throw tradition to the wind and indulge in new ideas that resonate personally instead of fitting nicely into the status quo of wedding design.

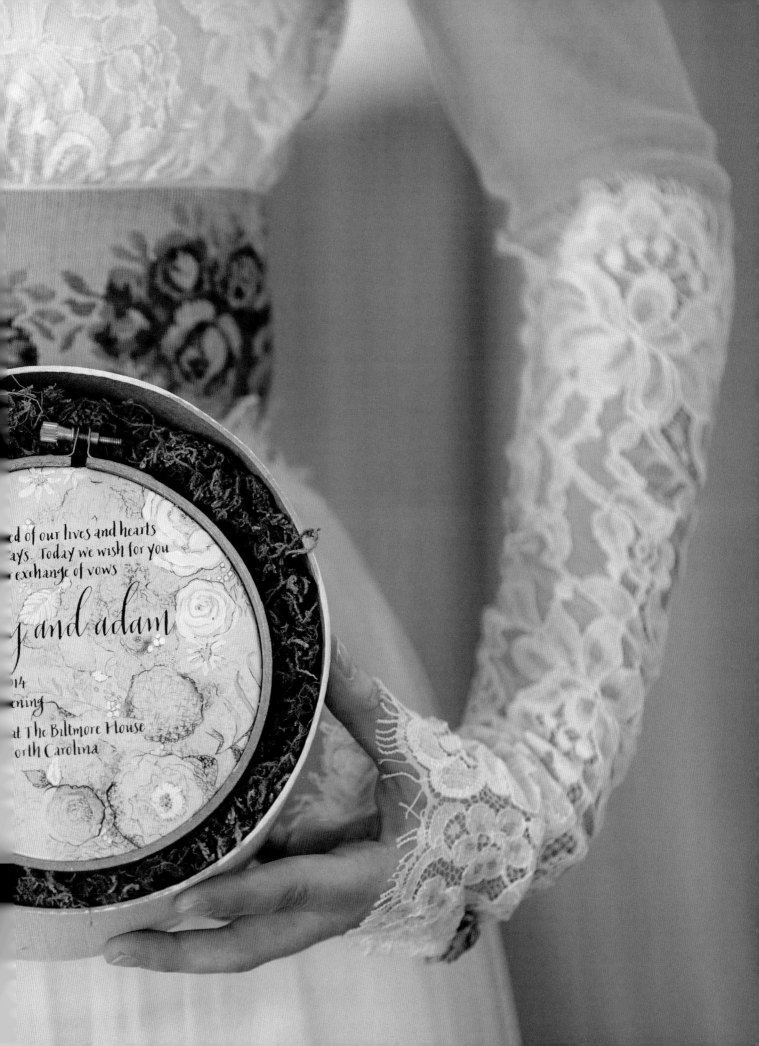

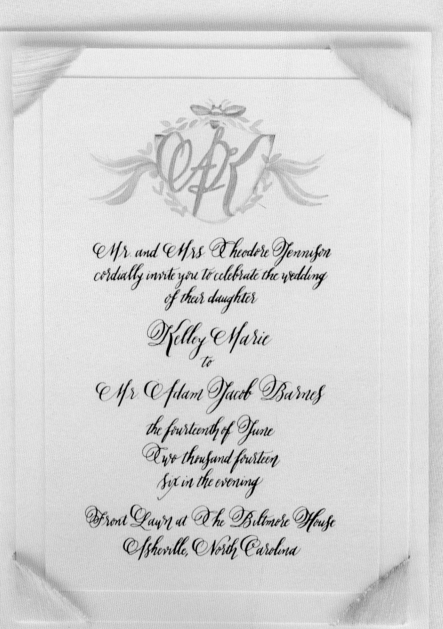

Mr. and Mrs. Theodore Jennison
cordially invite you to celebrate the wedding
of their daughter

Kelley Marie

to

Mr. Adam Jacob Barnes

the fourteenth of June
Two thousand fourteen
Six in the evening

Front Lawn at The Biltmore House
Asheville, North Carolina

Chi
Sweet
Cucumber, Bas

Baby Lett
Marcona
and W

Petite Beef
with Dijon
and

Cocktails ana
at half past se
South

The B

John Singer Sargent, like so many artists, possessed the gift of seeing opportunity everywhere. When viewing his paintings you get the distinct sense that every inch of the canvas, every brushstroke, has a purpose to communicate some secret moment shared between artist and subject.

14th June 2014

PAINTERS
SEE OPPORTUNITY...
EVERYWHERE...

The invitation mirrors the importance of carefully selected brushstrokes meant to take the viewer on a short visual journey. Each piece is carefully considered, avoids too much repetition of imagery, and speaks of simple harmony of color, shape, and subject matter.

We captured our couple on a terrace overlooking the gardens, where we imagine Sargent lingering while on the Biltmore property for a commissioned work.

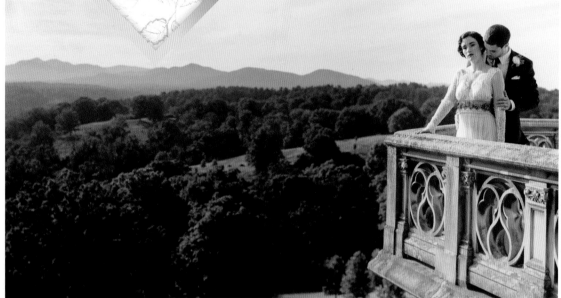

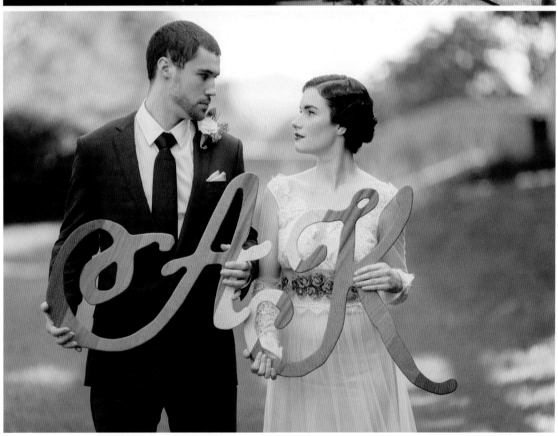

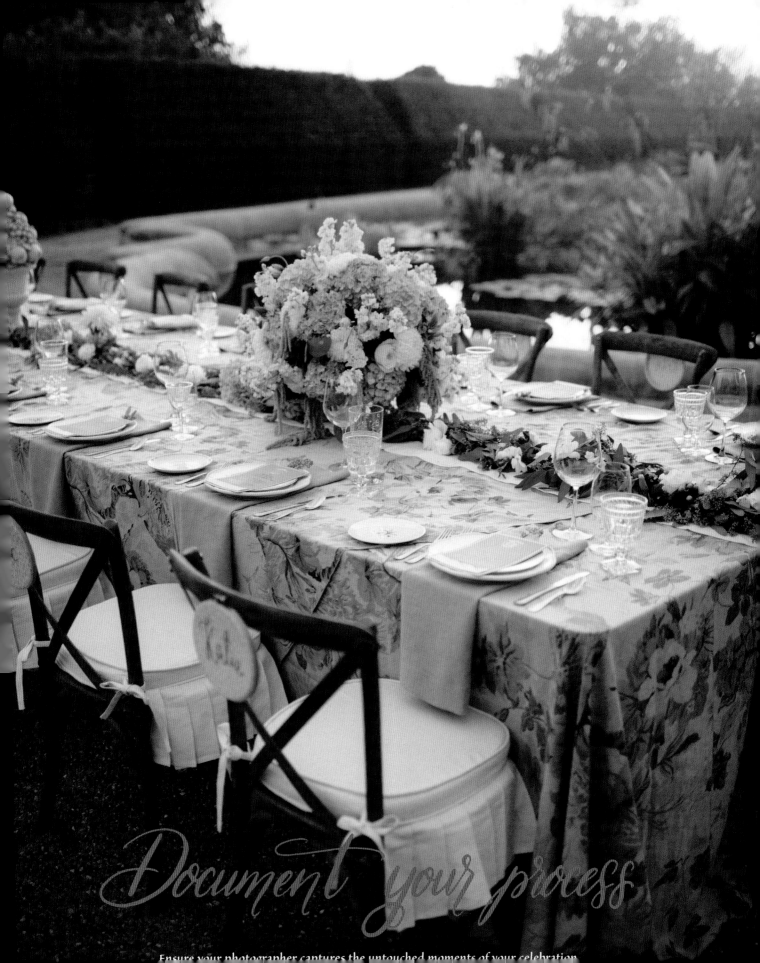

Document your process

Ensure your photographer captures the untouched moments of your celebration.

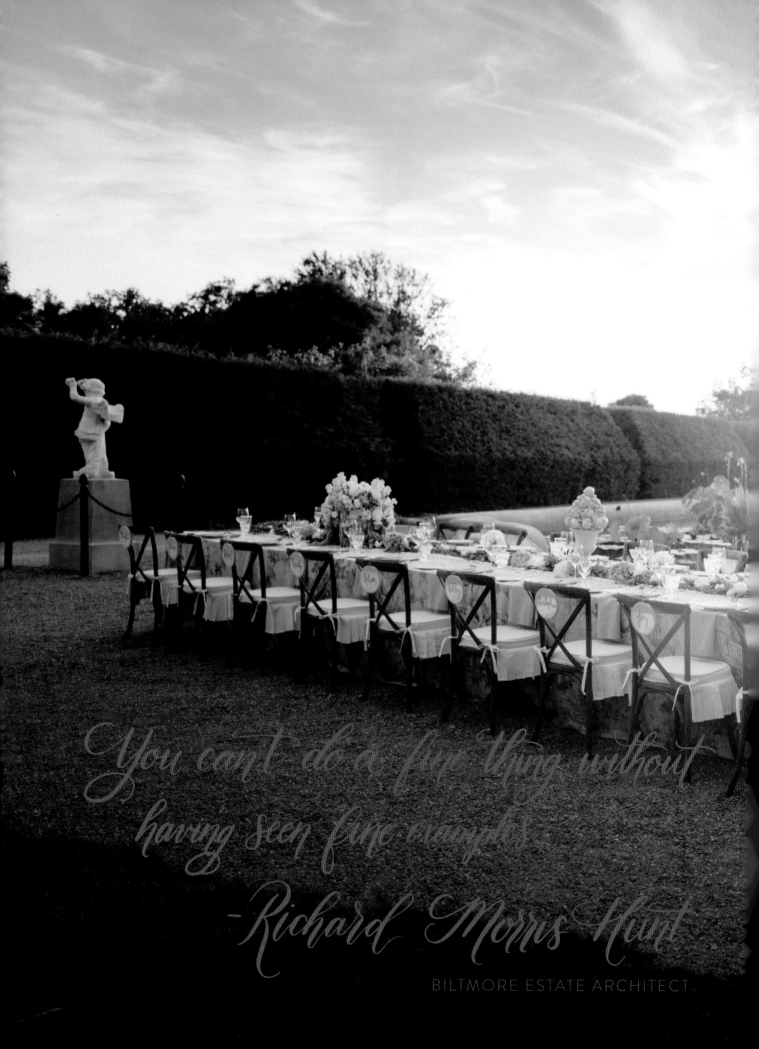

You can't do a fine thing without having seen fine examples.

Richard Morris Hunt

BILTMORE ESTATE ARCHITECT

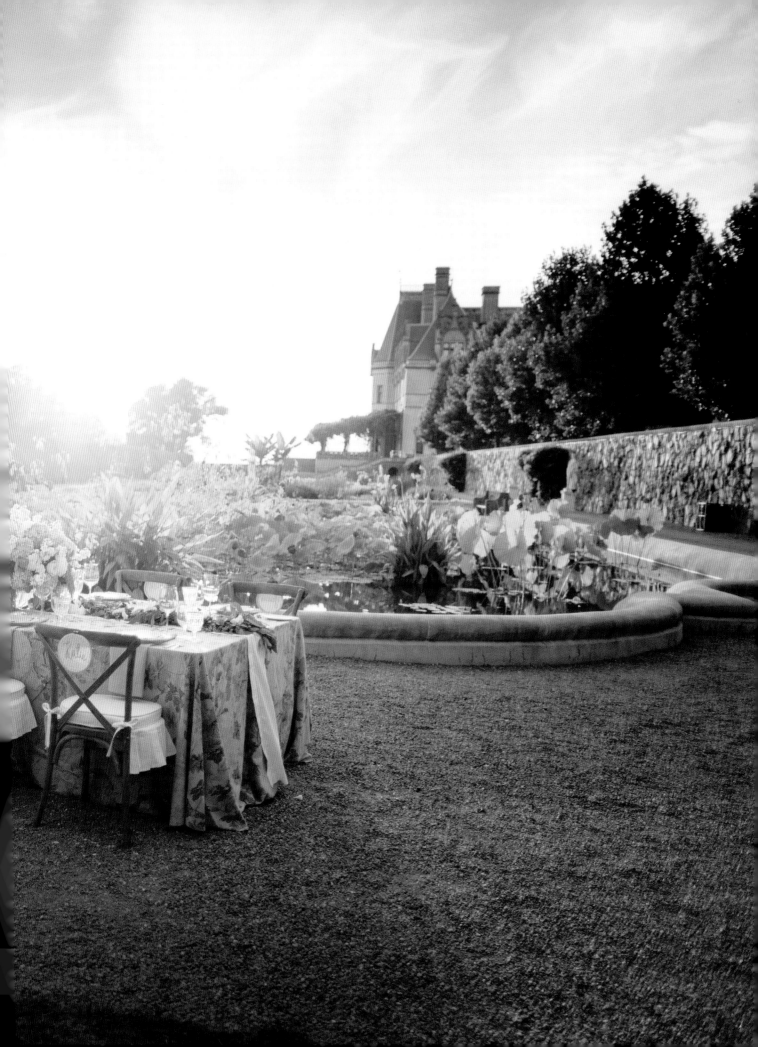

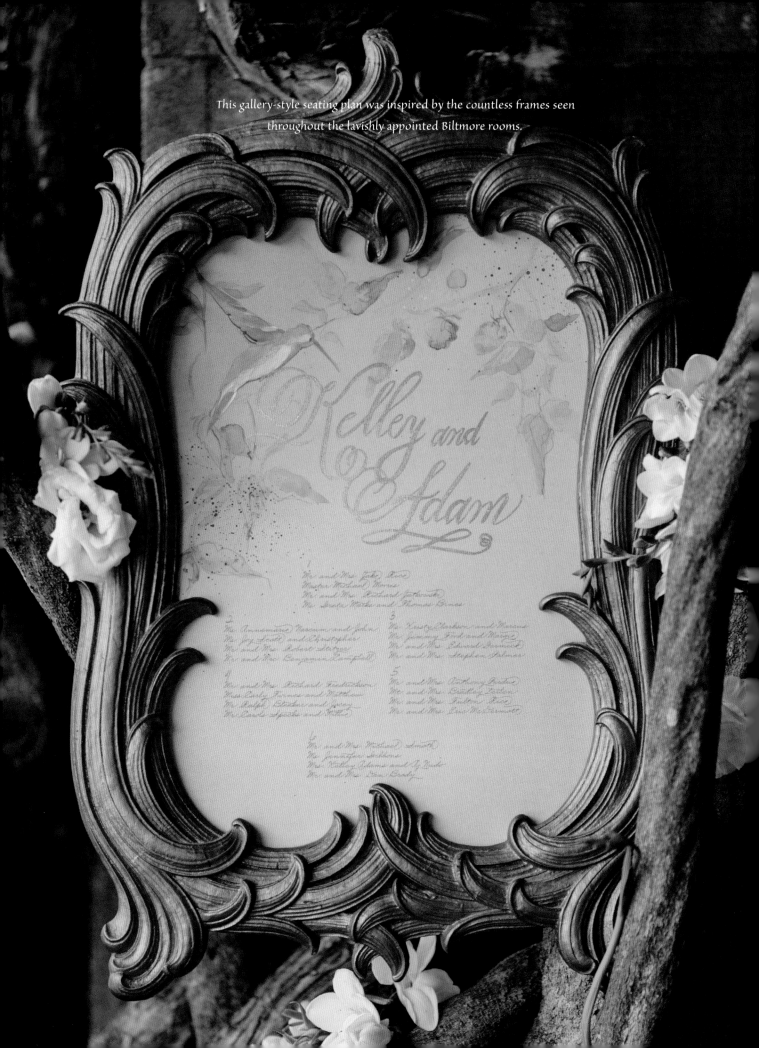

This gallery-style seating plan was inspired by the countless frames seen throughout the lavishly appointed Biltmore rooms.

Embroidery

Embroidery and cross-stitch can be seen throughout Biltmore Estate and even in a few Sargent paintings. Taking this classic element and modernizing it became an easy way to infuse artistry of a bygone era into a modern love story.

Painters see opportunity...

A painter's body of work holds so much inspiration for us—in the way they use color or how they capture light or a consistent use of a certain vantage point. Extract the smallest moment of enlightenment to infuse into your decor and design for powerful and meaningful results.

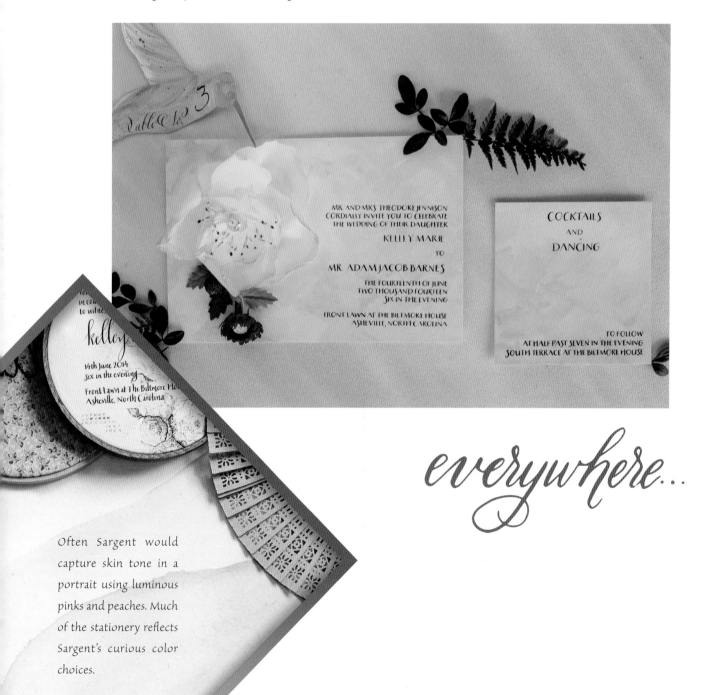

MR AND MRS THEODORE JENNISON
CORDIALLY INVITE YOU TO CELEBRATE
THE WEDDING OF THEIR DAUGHTER

KELLEY MARIE

TO

MR. ADAM JACOB BARNES

THE FOURTEENTH OF JUNE
TWO THOUSAND AND FOURTEEN
SIX IN THE EVENING

FRONT LAWN AT THE BILTMORE HOUSE
ASHEVILLE, NORTH CAROLINA

COCKTAILS
AND
DANCING

TO FOLLOW
AT HALF PAST SEVEN IN THE EVENING
SOUTH TERRACE AT THE BILTMORE HOUSE

everywhere...

Often Sargent would capture skin tone in a portrait using luminous pinks and peaches. Much of the stationery reflects Sargent's curious color choices.

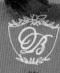

THINK LIKE A PAINTER

DEVELOP A DECOR PERSPECTIVE

PAINTERS CARRY NOTE-BOOKS, THEY RECORD MEMORIES, THEY LIVE TO EXPLORE.

your happiness is my happiness ××

Artful Reverie

CONCEPT DEFINITION

The construction of Biltmore was guided by the visionary perspective of its owner, George Vanderbilt. The result is a property with literally endless moments of thought-provoking vision. From room upon room of handcrafted furniture, a massive art collection (including Renoir), and expansive verandas carved with curious gargoyles to a personal library larger than many homes and extensive landscaped grounds, Biltmore Estate begs its guests to savor every glance. The portrait masterpieces of John Singer Sargent add an unmistakable painter's touch to the Biltmore walls.

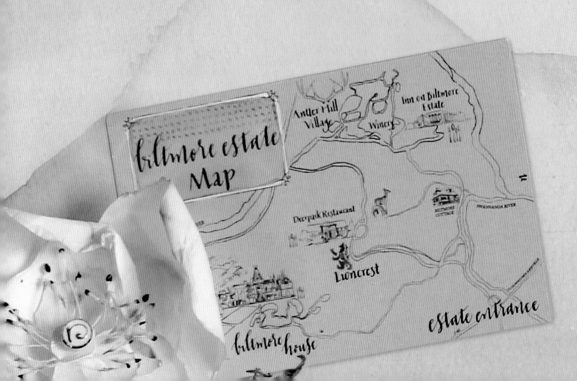

biltmore estate Map

Antler Hill Village

Inn on Biltmore Estate

Winery

SWANNANOA RIVER

BILTMORE COTTAGE

Deerpark Restaurant

Lioncrest

estate entrance

biltmore house

TANGIBLE DESIGN IDEAS INSPIRED BY THE DEFINITION

Classic monogram with a modern spin. Bold colors, complimented by soft green neutrals. Embroidery inspired artwork. Hand-gilded moments. Lush, traditional floral arrangements including amaranthus, dahlias, and hydrangea. Hand-dyed silk accents on stationery.

INTERPRET YOUR IDEAS WITH MEANING STATEMENTS
(How do you want your event to feel?)

Biltmore feels like a living museum. Biltmore is warm and somehow loving despite its size. Biltmore is full of rich colors. Biltmore's grounds seem to be blooming with life. Biltmore rooms are filled with richly woven fabric and embroidery.

Determine Materials

Eucalyptus, embroidery, moss, painted silk, smooth wood, hoop art, floral linens

COLOR PALETTE

Bright pink, white, gold, celery green, and taupe

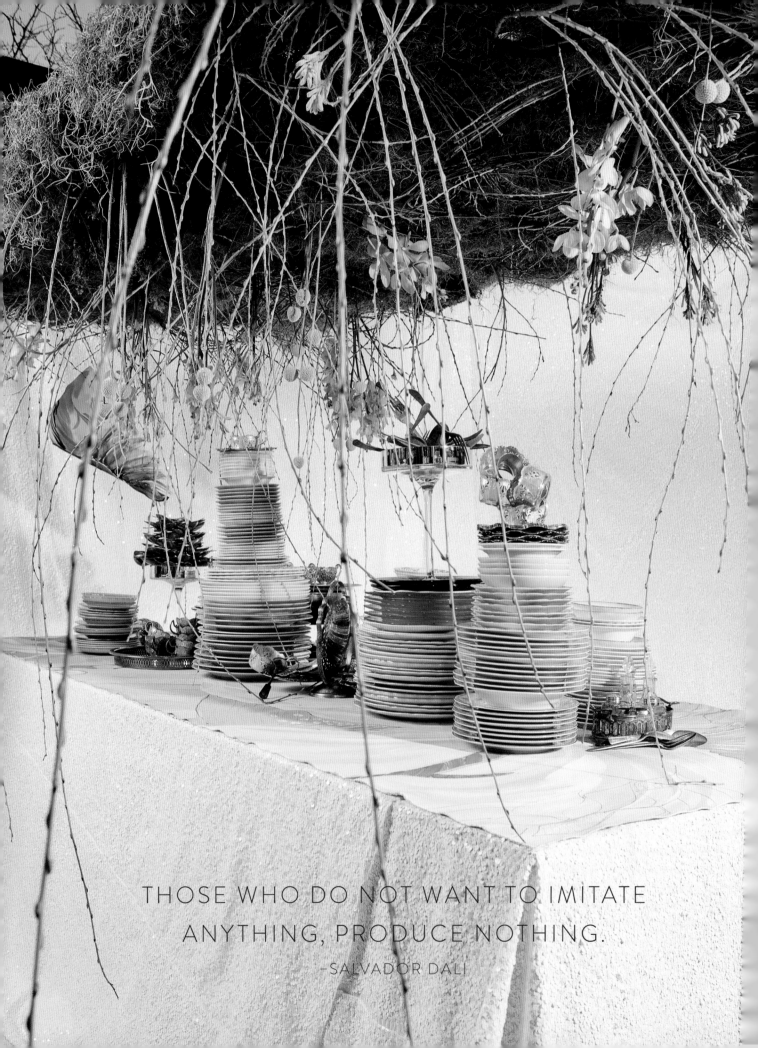

THOSE WHO DO NOT WANT TO IMITATE
ANYTHING, PRODUCE NOTHING.
–SALVADOR DALI

OUR MUSE

Mr. Salvador Dali

Lavish Body and Home, Scranton, Pennsylvania

Salvador Dali (1904–1989) was a character—one of his own imagining.

He was classified as a surrealist painter, a style that captures nonsensical and dream-like elements on canvas. Every day was a stage call and every step he took, I imagine, he perceived as a performance. Imagine a life where your wardrobe, walk, and pet choice were all part of a larger show you were attempting to produce, where literally every move you made had a theatrical backbone. This was Mr. Dali. Even his eccentric handlebar mustache was performance art.

Now, will this chapter suggest you follow Dali's lead and don a mustache or lobster-printed gown? Indeed no. However, I suggest you look deeper into the concept of how we view original ideas in weddings. Every couple desires their wedding to be personalized, "ours," one of a kind. Yes, of course, but these snowflake ideas don't always come from snowflake thinking. Dali urges us to step out and mirror his boldness, he invites us to find small moments of the completely unexpected

to call our own, just as he did. He desires us to juxtapose our ideas of a pretty, personalized wedding with the avant-garde or the slightly subversive. So let's be bold and a bit wild like Mr. Dali. Imitation is flattering as the old adage suggests, but imitation is also a catalyst to discover your own voice.

Details from Dali's Museum in Figueras, Catalunya, Spain. The museum, opened on September 28, 1974, houses the largest collection of works by Dali.

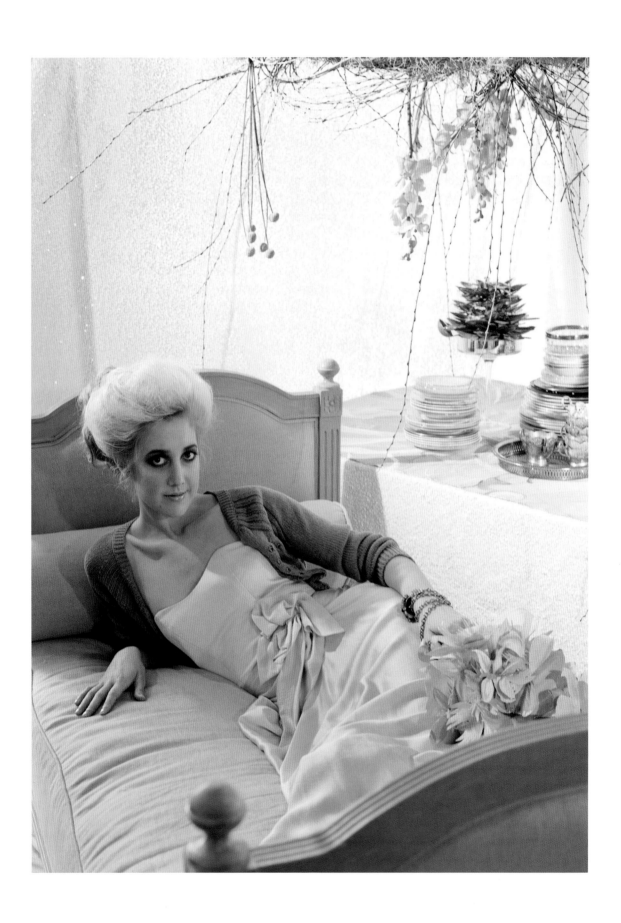

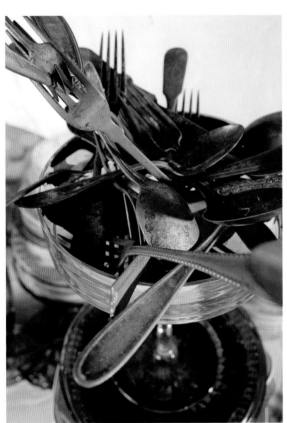

When it comes to current wedding design, the more eclectic and unique the environment is, the more memorable your wedding becomes. Thus, one method used to achieve your distinctive look is to mix traditional and nontraditional materials.

Flowers are no longer the only option for wedding décor, anything aesthetic is "allowed" into play. In this new era, we are finding that couples are willing to go that extra mile to create an elevated environment for their guests. Through the five senses the guests are left with an impressionable memory, not just a moment they enjoyed because it evoked an emotional response.

For every four design rules you follow, you should always break one to give that unexpected WOW! factor and to keep your creative juices flowing as a true artist and as an artist who is true to him or herself.

–JES GORDON
Owner & creative director, jesGORDON/properFUN

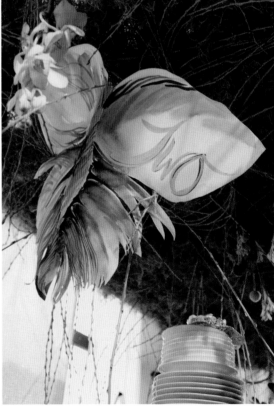

Spoons irreverently displayed in a heap, a floating butterfly table number dropped from a centerpiece hung from the ceiling, and a sumptuous chaise (opposite) pulled up to the dining table all speak to a very Dali wedding.

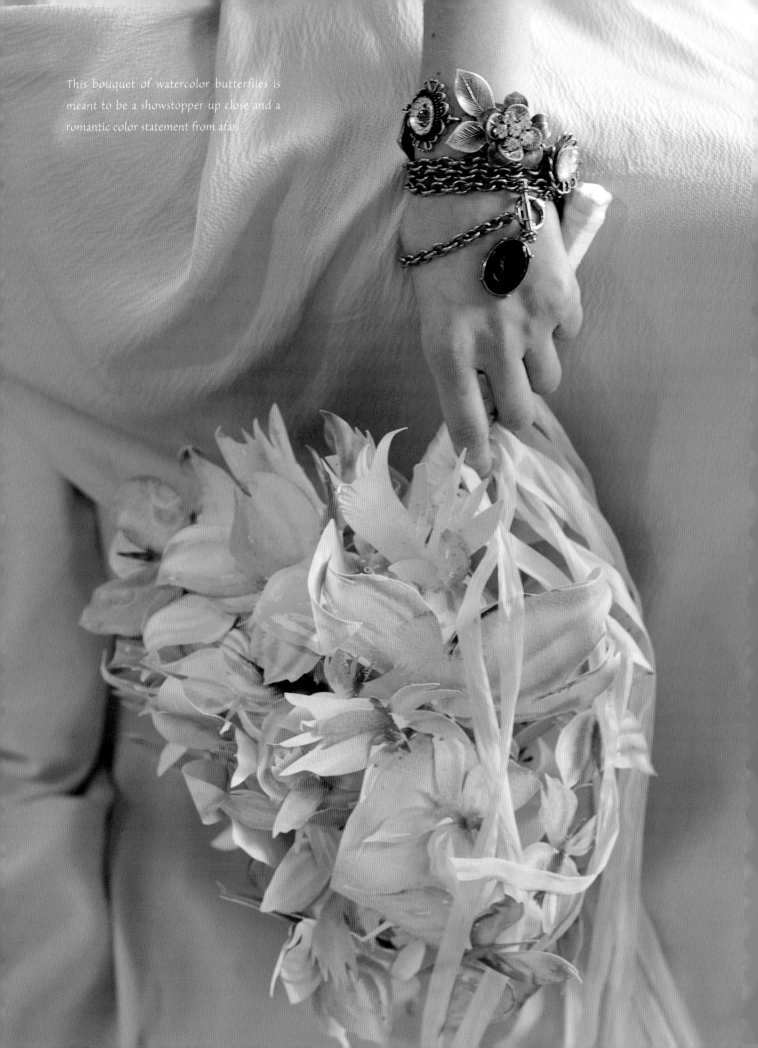

This bouquet of watercolor butterflies is meant to be a showstopper up close and a romantic color statement from afar.

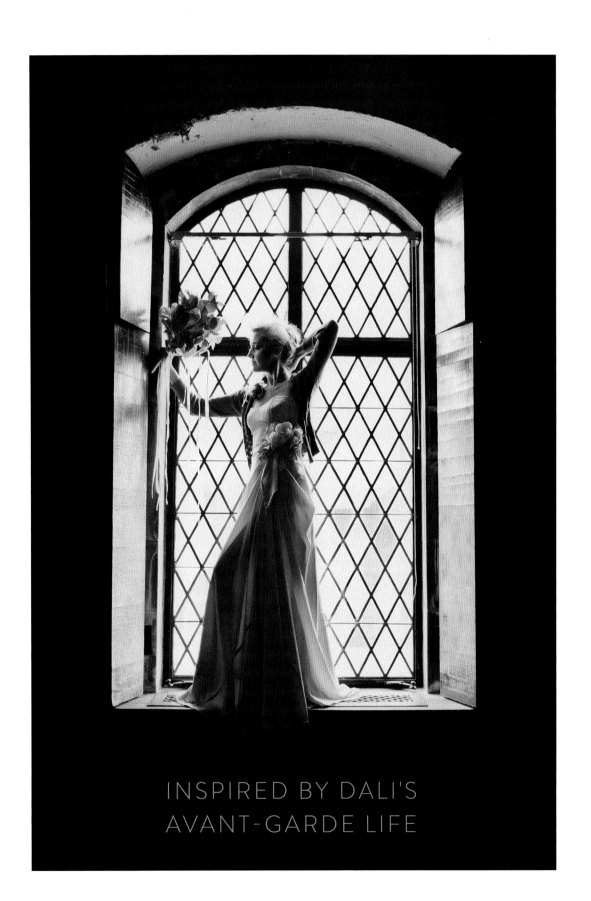

INSPIRED BY DALI'S
AVANT-GARDE LIFE

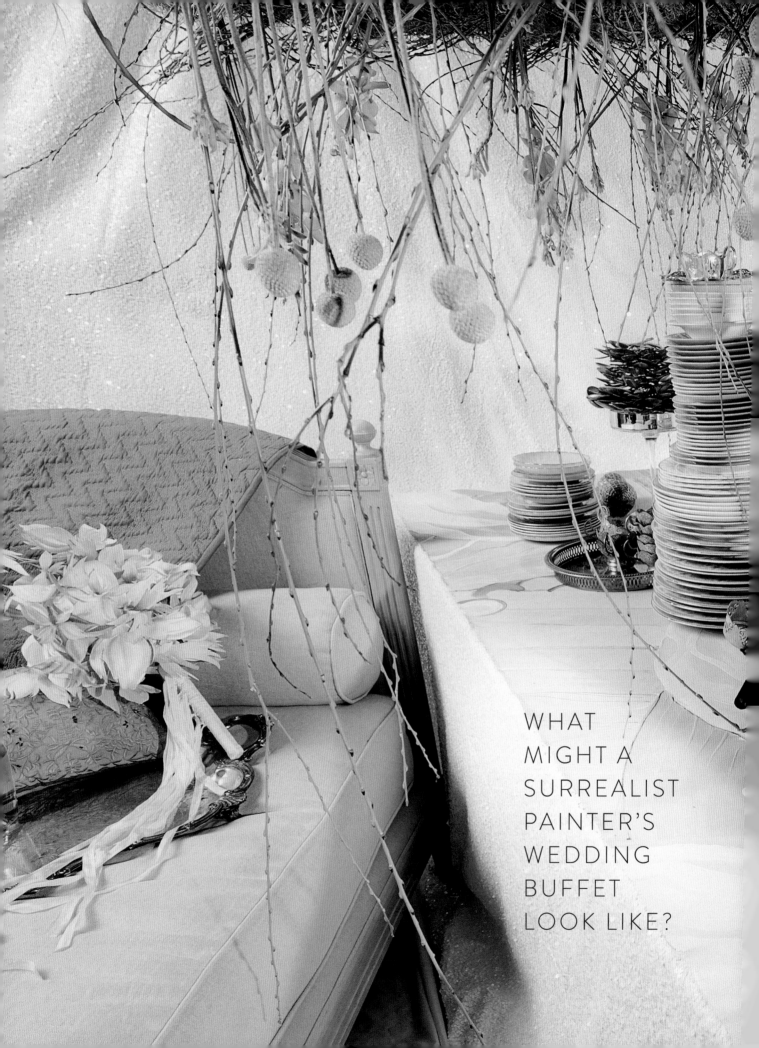

WHAT
MIGHT A
SURREALIST
PAINTER'S
WEDDING
BUFFET
LOOK LIKE?

Surrealism is destructive, but it destroys only what it considers to be shackles limiting our vision.

– Salvador Dali

Here, dessert was served on low tables for guests to sit and gather around. No stuffy, traditional sweets table here.

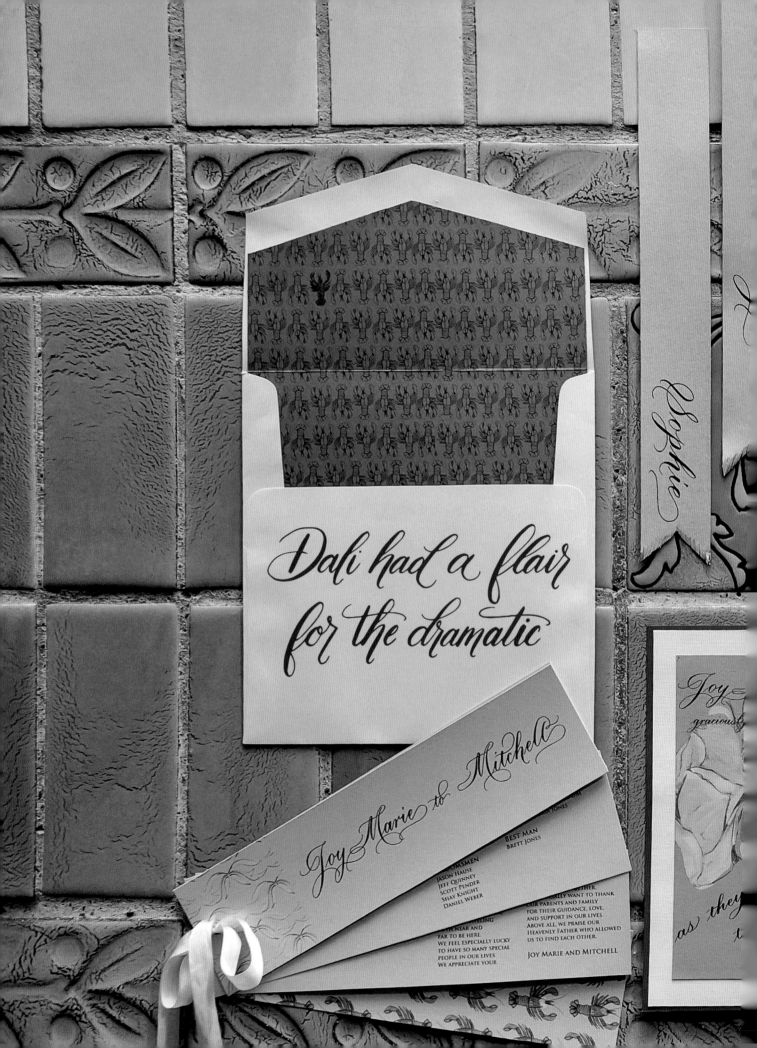

Dali had a flair
for the dramatic

Sophie

Joy Marie to Mitchell

GROOMSMEN
Jason Hause
Jeff Quinney
Scott Pender
Shay Knight
Daniel Weber

BEST MAN
Brett Jones

TRAVELING
FAR NEAR AND
FAR TO BE HERE.
WE FEEL ESPECIALLY LUCKY
TO HAVE SO MANY SPECIAL
PEOPLE IN OUR LIVES.
WE APPRECIATE YOUR

TOGETHER.
OUR PARENTS AND FAMILY
FOR THEIR GUIDANCE, LOVE,
AND SUPPORT IN OUR LIVES.
ABOVE ALL WE PRAISE OUR
HEAVENLY FATHER WHO ALLOWED
US TO FIND EACH OTHER.

JOY MARIE AND MITCHELL

Joy
graciously

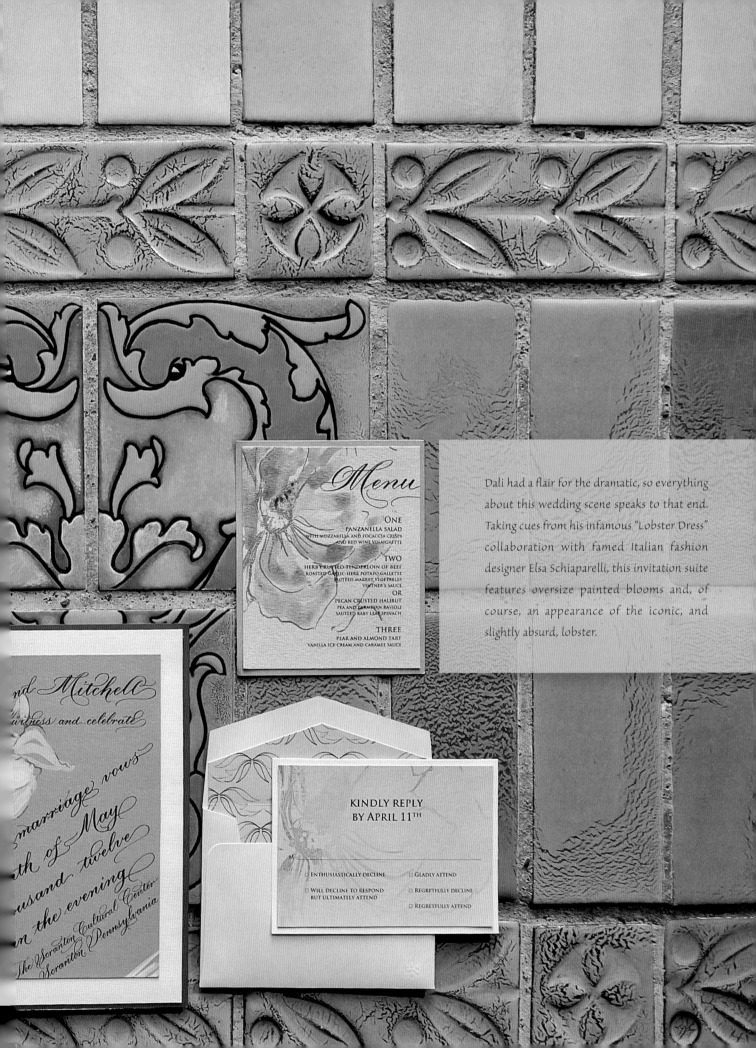

Menu

ONE
PANZANELLA SALAD
WITH MOZZARELLA AND FOCACCIA CRISPS
AND RED WINE VINAIGRETTE

TWO
HERB CRUSTED TENDERLOIN OF BEEF
ROASTED GARLIC HERB POTATO GALLETTE
SAUTÉED MARKET VEGETABLES
VINTNER'S SAUCE
OR
PECAN CRUSTED HALIBUT
PEA AND PARMESAN RAVIOLI
SAUTÉED BABY LEAF SPINACH

THREE
PEAR AND ALMOND TART
VANILLA ICE CREAM AND CARAMEL SAUCE

Dali had a flair for the dramatic, so everything about this wedding scene speaks to that end. Taking cues from his infamous "Lobster Dress" collaboration with famed Italian fashion designer Elsa Schiaparelli, this invitation suite features oversize painted blooms and, of course, an appearance of the iconic, and slightly absurd, lobster.

Mitchell

...witness and celebrate

...marriage vows

...th of May

...usand twelve

...n the evening

The Scranton Cultural Center
Scranton, Pennsylvania

**KINDLY REPLY
BY APRIL 11TH**

☐ ENTHUSIASTICALLY DECLINE ☐ GLADLY ATTEND

☐ WILL DECLINE TO RESPOND ☐ REGRETFULLY DECLINE
 BUT ULTIMATELY ATTEND
 ☐ REGRETFULLY ATTEND

This invitation measured about eighteen inches in diameter and was made of layer upon layer of shimmering cardstock painted with patterns.

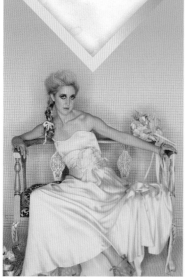

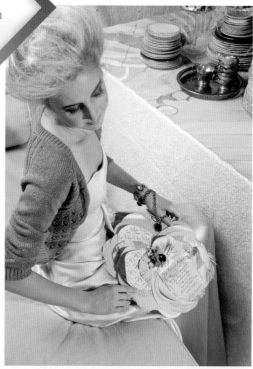

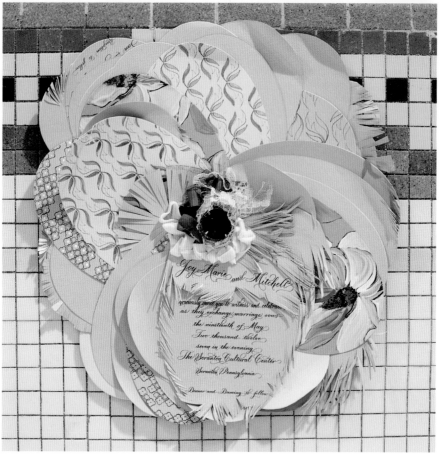

Cut fringe and a large gem added loads of texture. I call this a surrealist experiment in invitation design!

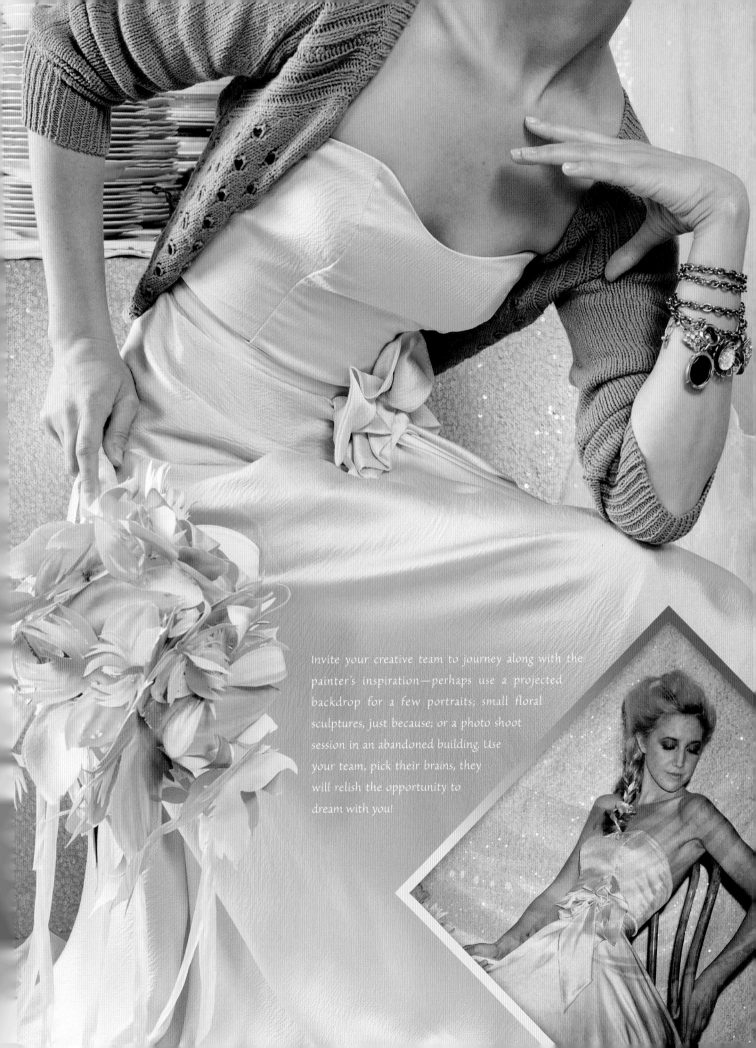

Invite your creative team to journey along with the painter's inspiration—perhaps use a projected backdrop for a few portraits; small floral sculptures, just because; or a photo shoot session in an abandoned building. Use your team, pick their brains, they will relish the opportunity to dream with you!

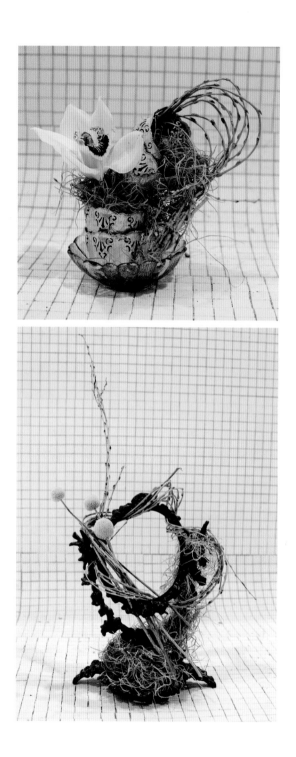

Painters are daring and rarely do what is expected. We shot the bride in an empty pool. She is both edgy and feminine amidst the sea of tile. While Dali may not be your style, he can teach the art of making bold choices confidently.

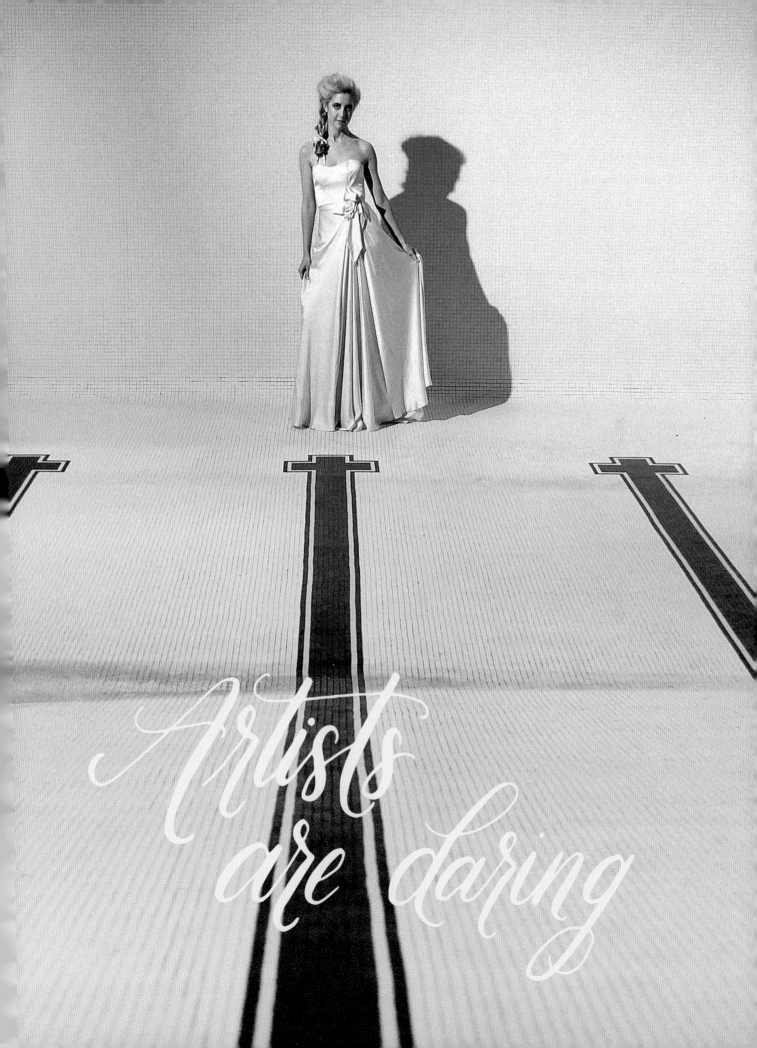

Artists are daring

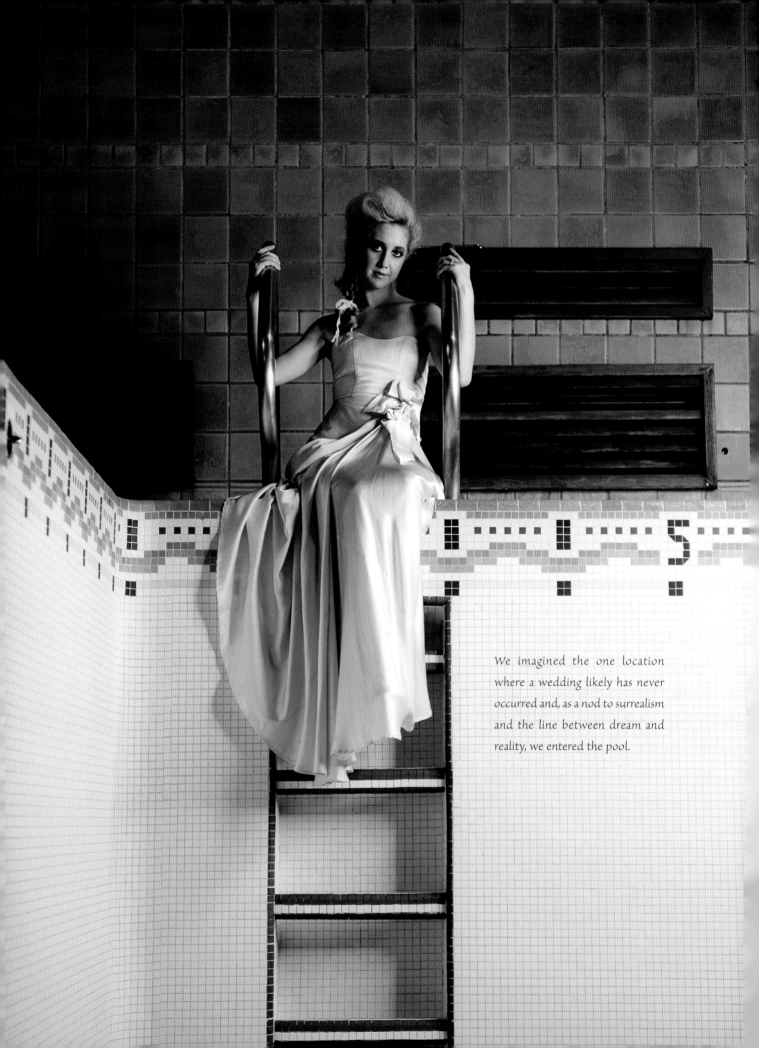

We imagined the one location where a wedding likely has never occurred and, as a nod to surrealism and the line between dream and reality, we entered the pool.

To be enlightened by Dali's artistry
IS TO THINK OUTSIDE THE BOX.

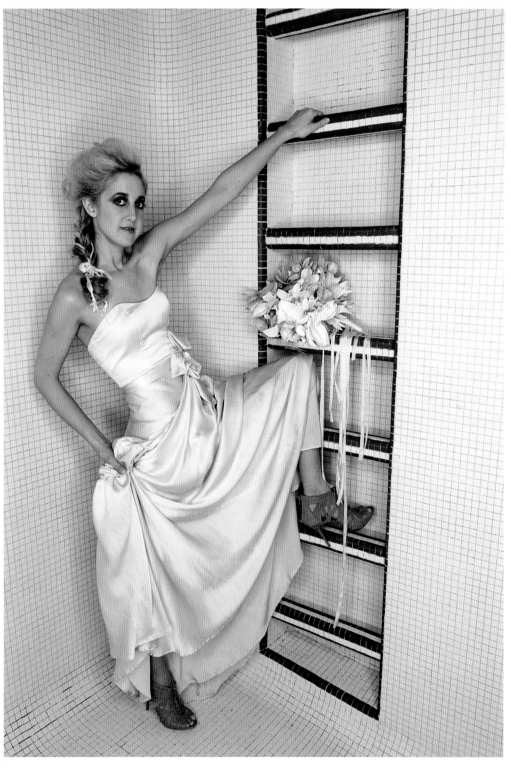

Actually, it is to jump outside the box and paint it red.

Freedom lies in being bold.

-Robert Frost

This canvas backdrop made an appearance in various places. Consider hiring a painter to create a masterful backdrop to make an appearance throughout the day.

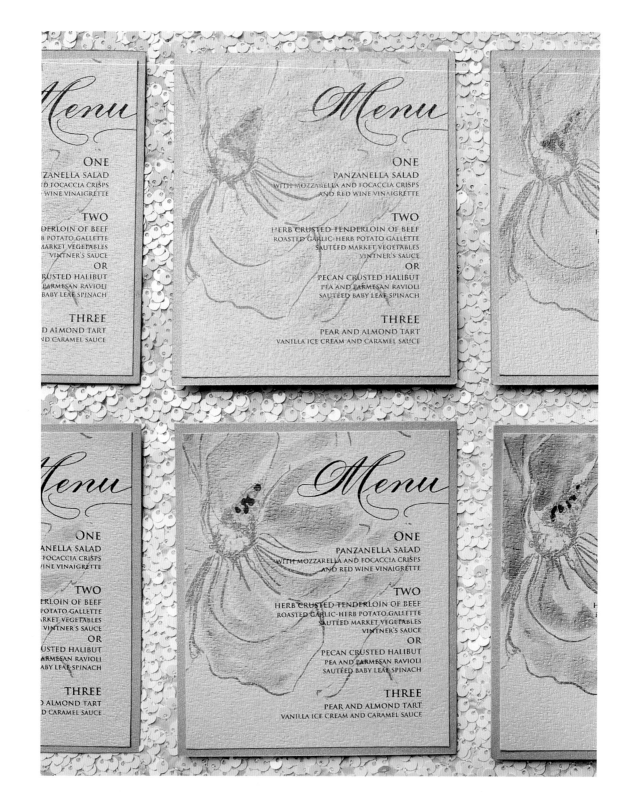

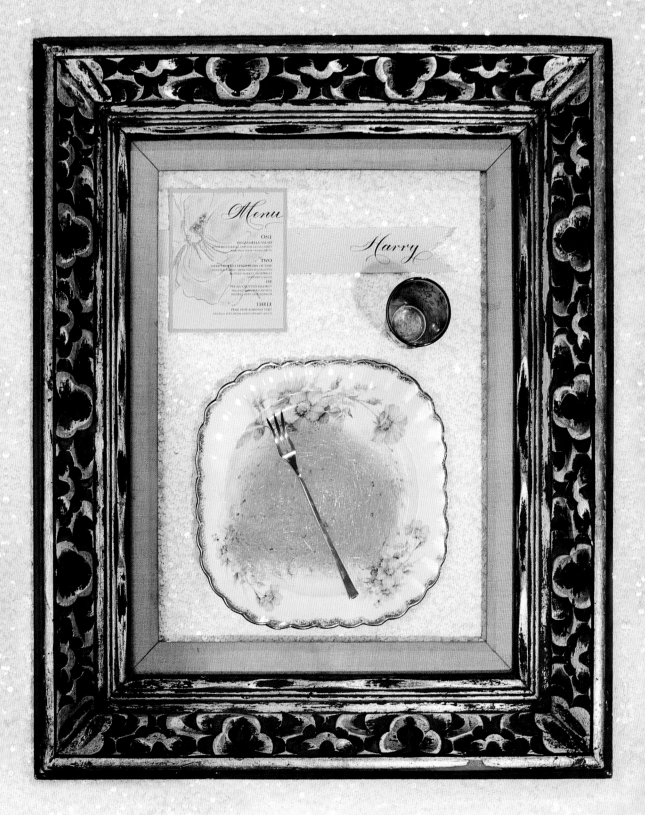

Here, we framed a sample place setting and snapped a shot atop white sequin fabric. Don't forget to capture the wit and charm of your very carefully curated design elements.

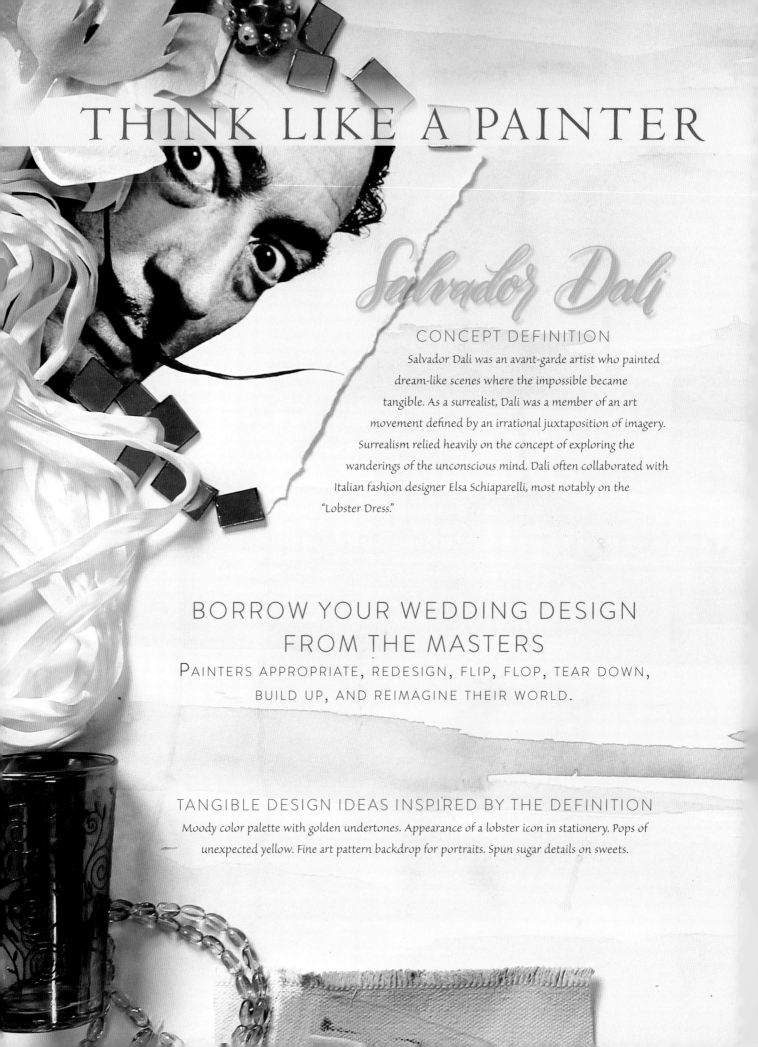

THINK LIKE A PAINTER

Salvador Dali

CONCEPT DEFINITION

Salvador Dali was an avant-garde artist who painted dream-like scenes where the impossible became tangible. As a surrealist, Dali was a member of an art movement defined by an irrational juxtaposition of imagery. Surrealism relied heavily on the concept of exploring the wanderings of the unconscious mind. Dali often collaborated with Italian fashion designer Elsa Schiaparelli, most notably on the "Lobster Dress."

BORROW YOUR WEDDING DESIGN FROM THE MASTERS

PAINTERS APPROPRIATE, REDESIGN, FLIP, FLOP, TEAR DOWN, BUILD UP, AND REIMAGINE THEIR WORLD.

TANGIBLE DESIGN IDEAS INSPIRED BY THE DEFINITION

Moody color palette with golden undertones. Appearance of a lobster icon in stationery. Pops of unexpected yellow. Fine art pattern backdrop for portraits. Spun sugar details on sweets.

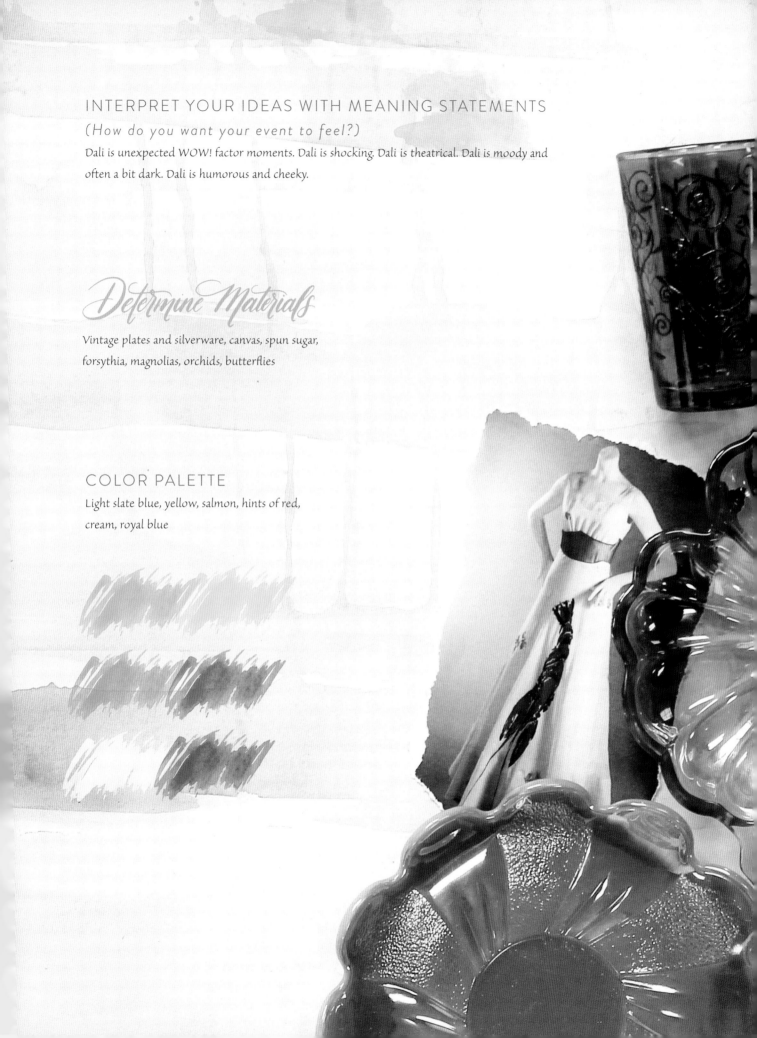

INTERPRET YOUR IDEAS WITH MEANING STATEMENTS
(How do you want your event to feel?)

Dali is unexpected WOW! factor moments. Dali is shocking. Dali is theatrical. Dali is moody and often a bit dark. Dali is humorous and cheeky.

Determine Materials

Vintage plates and silverware, canvas, spun sugar, forsythia, magnolias, orchids, butterflies

COLOR PALETTE

Light slate blue, yellow, salmon, hints of red, cream, royal blue

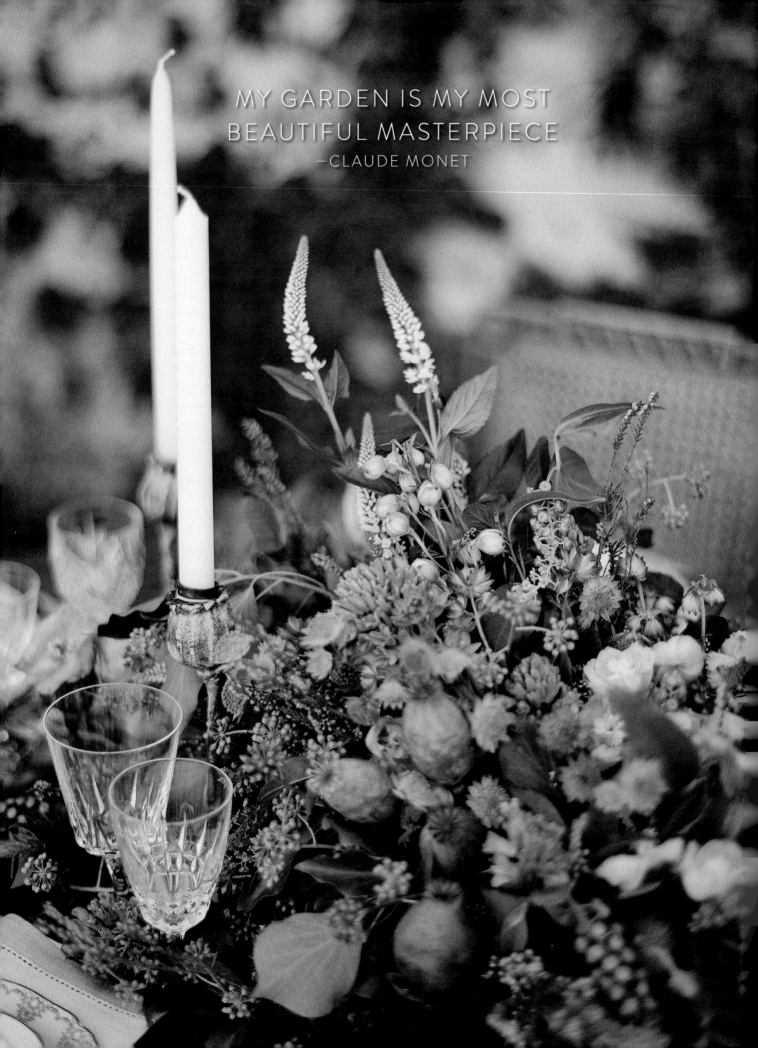

MY GARDEN IS MY MOST
BEAUTIFUL MASTERPIECE
—CLAUDE MONET

Monet's

WATERCOLOR GARDEN

Domaine des Iris, La Chapelle-Fortin, France

Claude Monet (1840–1926) did not just paint one way.

Sure, he was a painter and spent decades of his life composing with a brush and paint, but Monet also had a passion for gardening, a passion so strong it deeply informed his paintings. Your wedding can be informed too, far beyond what is expected of your planning journey. If you adore flowers, try growing a small garden and watching for surprise moments of enlightenment. Maybe you adore the winter season—step away from that addicting idea site and take a trip, get your feet in some snow! We curate and collect ideas best when given the chance to live in them, not only research them.

Wedding planning conjures images of couples sitting at a table, landlocked by their surroundings, poring over laptop screens filled with pages of wow-worthy ideas. You get lost in the sea of sameness, eventually feeling numb to all the options that feel original and done before, all at the same time. Wedding planning doesn't necessarily happen one way—in front of a computer screen or beside stacks of magazines.

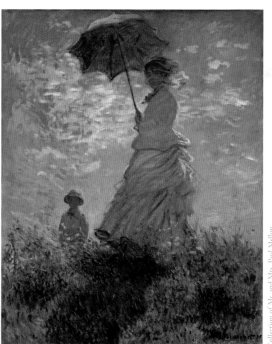

Woman with a Parasol - Madame Monet and Her Son, painting, 1875, Claude Monet

Collection of Mr. and Mrs. Paul Mellon

Impressionist painters like Monet were often called "painters of light." Small, layered brushstrokes would blend together to ultimately create a recognizable, yet soft, scene. Our invitation here features a collection of impressionistic brushstrokes individually hand painted on each card in shades of gold, white, shimmery ivory, and blush.

Alice & Theo

Together with our families

we invite you to join us

as we exchange our wedding vows

Twenty First of October

Two thousand seventeen

six in the evening with

celebratory dinner to follow

Domaine des Bois

Seeing new sites, different architecture and design, and experiencing smells and tastes all can open your eyes to new ways of doing things that can then be reinterpreted into your event.

For destination weddings it is also nice to incorporate local cultural traditions. With our weddings in France, this can be anything from using Paris as the theme of the day, incorporating an artisanal cheese course, or using a famous piece of French art as the decor inspiration.

—ANNE MULVIHILL
Fête in France

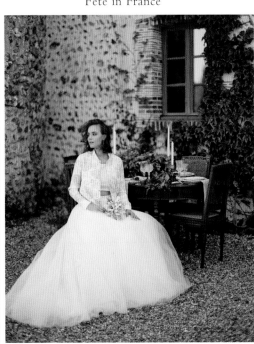

Monet painted his subjects again and again, time after time, to whittle down the scene to its most basic and beautiful.

Painter's edit No extra fuss is needed when your wedding property is this stunning.

Every day I discover even more beautiful things

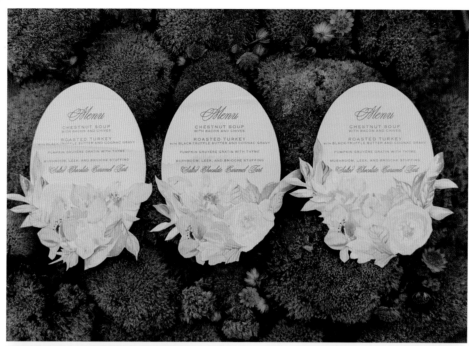

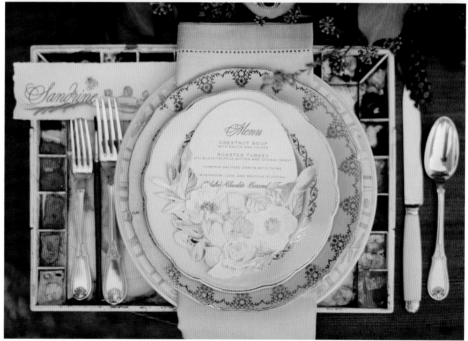

IT IS INTOXICATING ME, AND I WANT TO
PAINT IT ALL, MY HEAD IS BURSTING . . .

–CLAUDE MONET

Menu

CHESTNUT SOUP
WITH BACON AND CHIVES

ROASTED TURKEY
WITH BLACK-TRUFFLE BUTTER AND COGNAC GRAVY

PUMPKIN GRUYÈRE GRATIN WITH THYME

MUSHROOM, LEEK, AND BRIOCHE STUFFING

Salted Chocolate Caramel Tart

Much of the color palette, and especially the place cards, were inspired by Monet's waterlilies series, which he painted late in life when he was nearly blind.

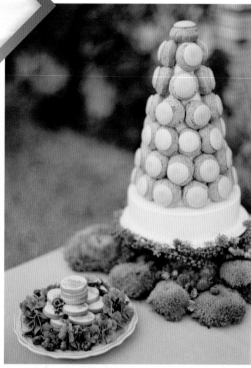

The massive canvases of Monet's waterlilies envelop you with shades of purple, violet, and blue.

GIVE YOURSELF PERMISSION TO EXPLORE.

Explore a place, a biography, a painting style...

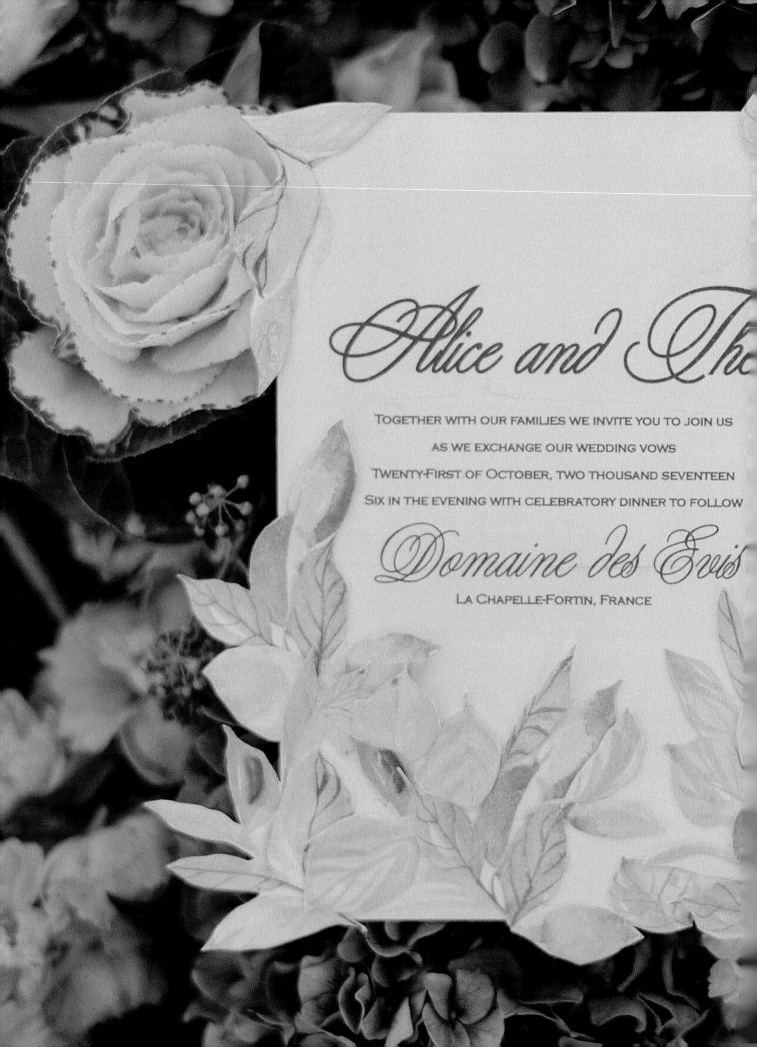

Alice and The...

TOGETHER WITH OUR FAMILIES WE INVITE YOU TO JOIN US

AS WE EXCHANGE OUR WEDDING VOWS

TWENTY-FIRST OF OCTOBER, TWO THOUSAND SEVENTEEN

SIX IN THE EVENING WITH CELEBRATORY DINNER TO FOLLOW

Domaine des Evis

LA CHAPELLE-FORTIN, FRANCE

JOIN US FOR A

Rehearsal Dinner

ON THE TWENTIETH OF OCTOBER

AT HALF PAST SEVEN

Le Jardin des Plumes

1 RUE DU MILIEU, GIVERNY

Here, simple hand-cut leaves rest atop rich, cottony cardstock, all brushed with the slightest touch of sheer shimmer inks. They are meant to be reminiscent of Monet's brushstrokes on canvas capturing the light floating atop fields of blooms.

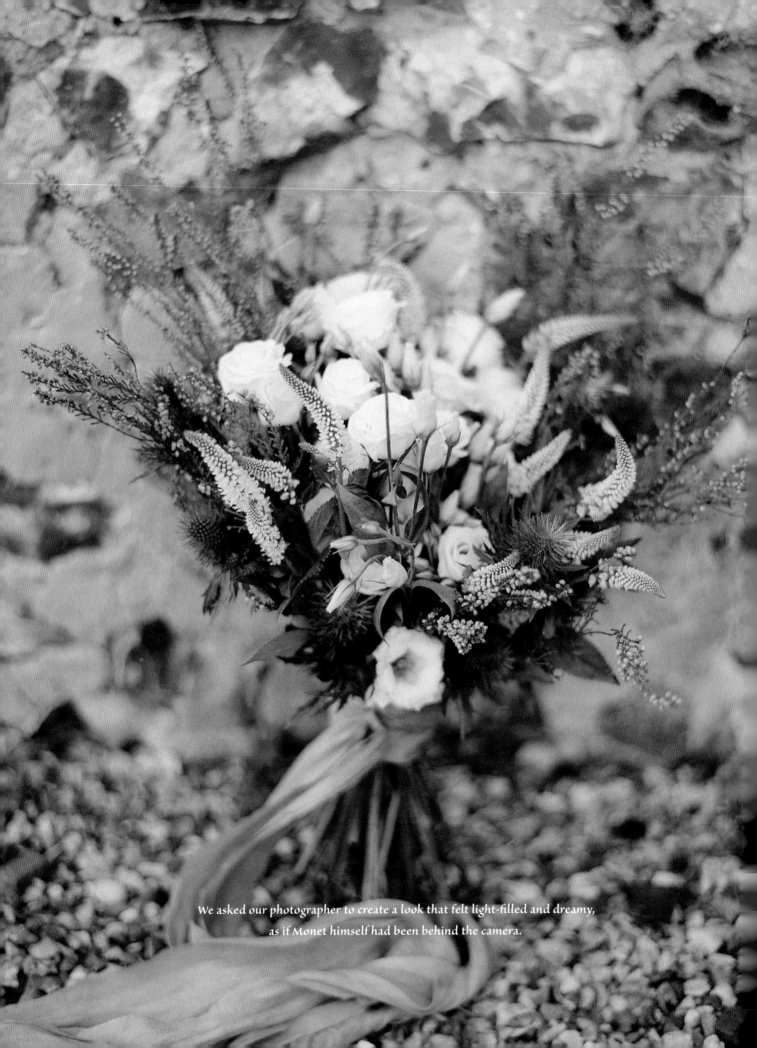

We asked our photographer to create a look that felt light-filled and dreamy,
as if Monet himself had been behind the camera.

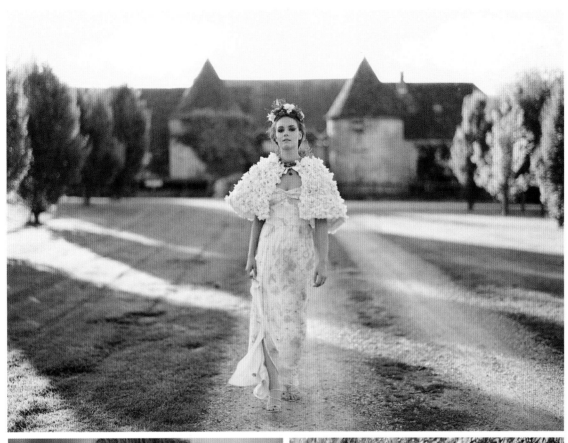

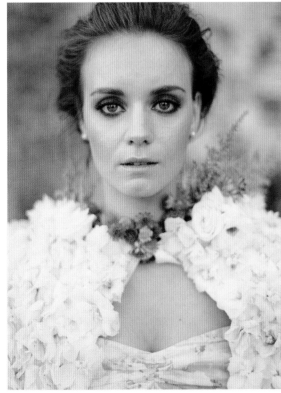

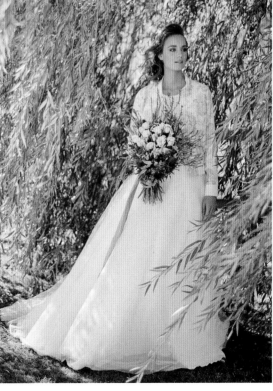

You can design a
wedding based on a
single painter's body of work, a
single painting, or even their general
style, but first commit to reading his
or her biography.

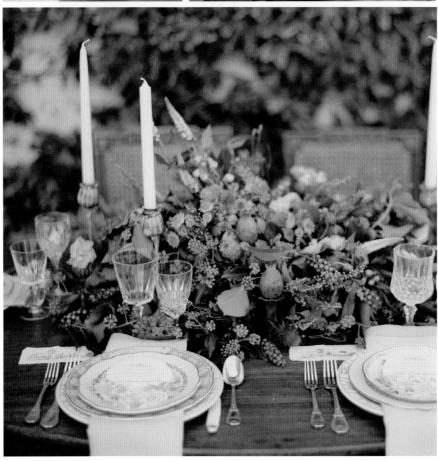

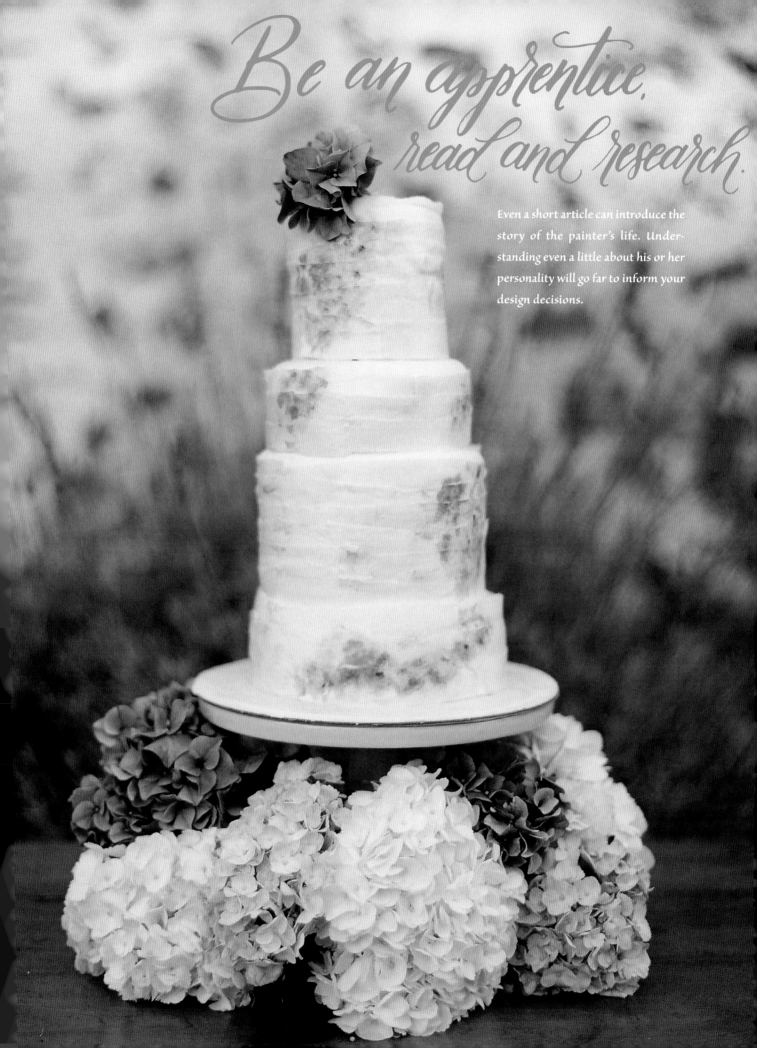

Be an apprentice, read and research.

Even a short article can introduce the story of the painter's life. Understanding even a little about his or her personality will go far to inform your design decisions.

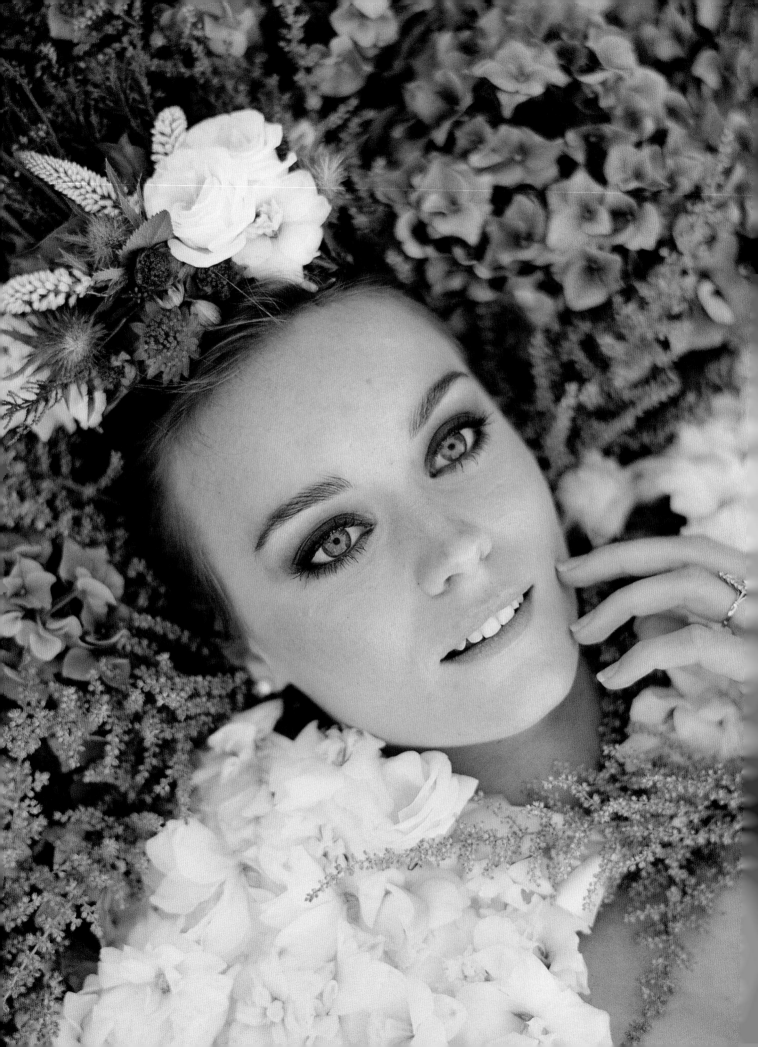

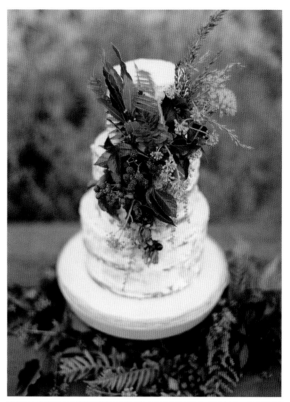

Learn when to yell and when to

whisper.

THINK LIKE A PAINTER

YOUR CELEBRATION IS
A BELOVED GARDEN
PAINTERS HAVE A KNACK FOR ALLOWING THEIR PASSIONS
TO INFORM THEIR ARTWORKS.

Monet's

CONCEPT DEFINITION

Monet painted light with thousands of tiny, well
thought out brushstrokes. His artwork was considered at
the core of impressionism and it is thought that one of
his paintings was the movement's namesake. Soft color
palettes, with a low contrast between colors, epitomize
this prolific artist's aesthetic.

TANGIBLE DESIGN IDEAS
INSPIRED BY THE DEFINITION

Dense but textural blooms resemble brushstrokes when seen from afar.
Impressionist style, pastel patterns on gowns. Painterly stationery to
mimic a painted canvas's texture. Weeping willows.

INTERPRET YOUR IDEAS WITH MEANING STATEMENTS

(How do you want your event to feel?)

Impressionism is calming. Impressionism feels soft and friendly. Impressionism reminds one of heavily petaled blooms. Impressionism is friends gathered around a candlelit table.

COLOR PALETTE

Lavender, cornflower blue, muted rose, accents of red, fuchsia, soft gold, white, cream

Determine Materials

Mint colored china, figs, berries and thistle, taper candles, astilbe, silk

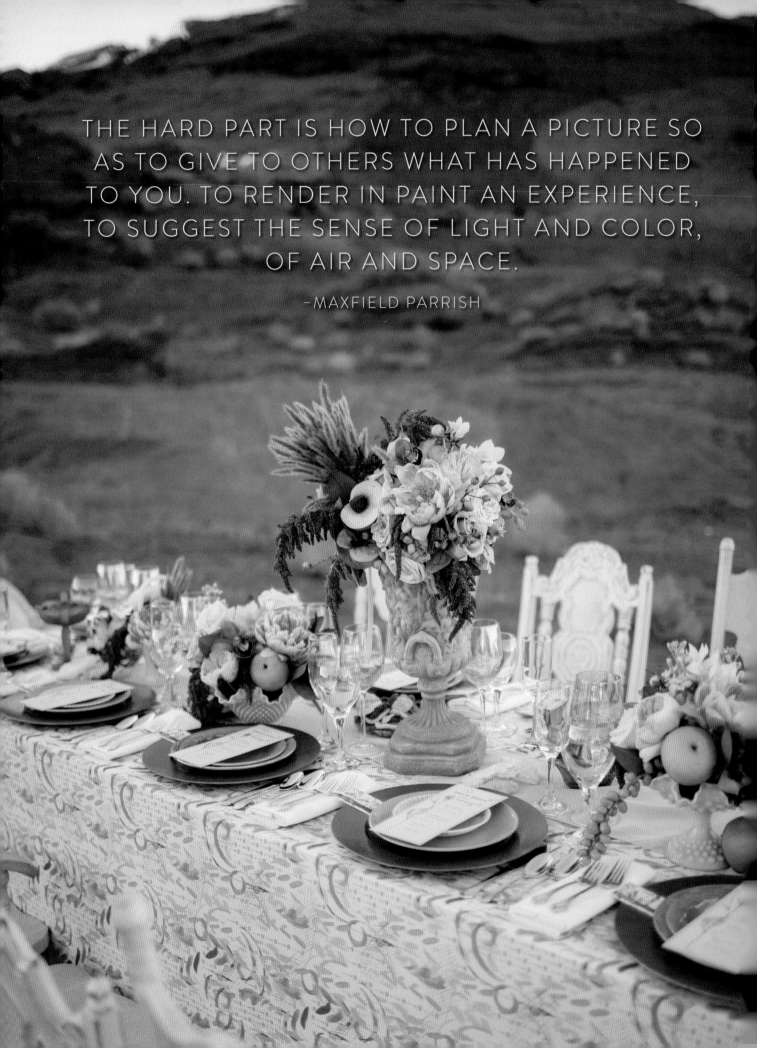

THE HARD PART IS HOW TO PLAN A PICTURE SO
AS TO GIVE TO OTHERS WHAT HAS HAPPENED
TO YOU. TO RENDER IN PAINT AN EXPERIENCE,
TO SUGGEST THE SENSE OF LIGHT AND COLOR,
OF AIR AND SPACE.

–MAXFIELD PARRISH

Maxfield Parrish

IN RED ROCK COUNTRY

Southern Utah

Maxfield Parrish (1870–1966) was a famed American illustrator
known for creating distinctive saturated hues.

In 1902, famed American illustrator Maxfield Parrish traveled to Arizona, which resulted in the creation of a desert series that was in many ways a deviation from his popular style. Parrish's sense of color is astounding and immediately recognizable to this day. He captured color like no one else of his time, using startling texture and dimension. The desert series traded his signature "Parrish Blue" for shades of terracotta, gold, rust, and all that you might imagine a desert landscape to possess. Taking the well-known photography filter sepia, which reminds us of the light and color Parrish captured in the desert, we've transformed a seemingly mundane concept—a color filter—into a magical scene

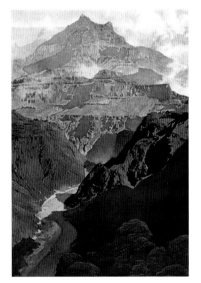

Grand Canyon, 1902, Maxfield Parrish

reminiscent of Maxfield Parrish's enchanting work.

Mundane items can be infused with new life by the grace of a curious thought and a well-intentioned act of making. We all have this power, to see the world for what it isn't supposed to be and use that gift to our advantage. In weddings, the mundane becomes magical with the free gift of artistic thinking. Think of some classically creative ideas we've all seen, scrap wood used as whimsical table numbers, save the dates silkscreened on handkerchiefs, and berries placed in bowls as centerpieces. These ideas all began as creative sparks inspired to turn something old into something new—to reinvent, if you will.

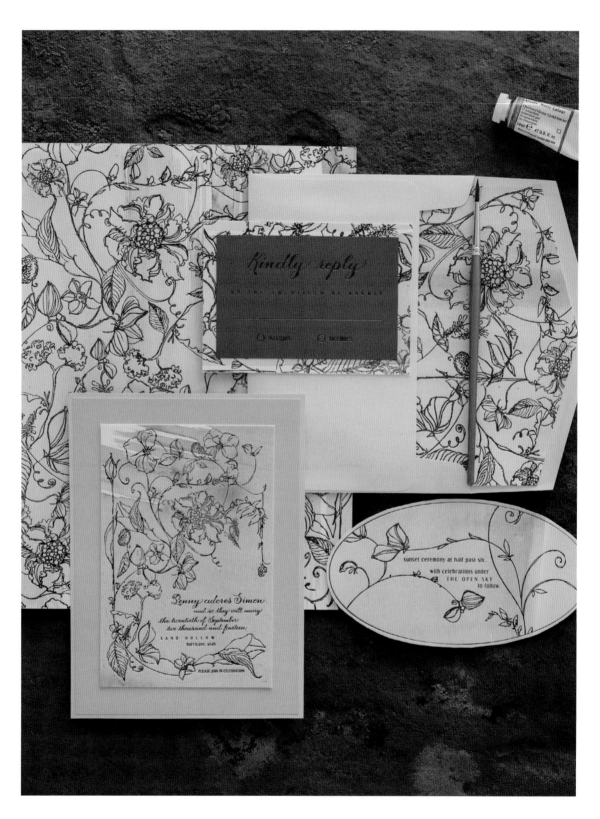

Parrish repeatedly featured organic elements in his works. Leaves, blooms, trees, and moss, to name a few, directly inspired the composition of the invitation. Shimmering rose gold foil nods to Parrish's luminescent use of light and color.

When planning your wedding, costs can add up quickly! Brand new items from stores or online are not necessary. I always love the idea of reinventing items you already have on hand or creating new ones on your own! Look around your home or ask your family and friends for unique items. Thrift stores, flea markets, or garage sales are always a great resource for everything from furniture pieces to smaller decor items. It is amazing what you can reuse and repurpose for your wedding decor. The very best benefit of these efforts is that if you use items that have not been seen before, your wedding will be unlike anyone else's.

–LAURA STAGG

Owner & lead designer, Forevermore Events

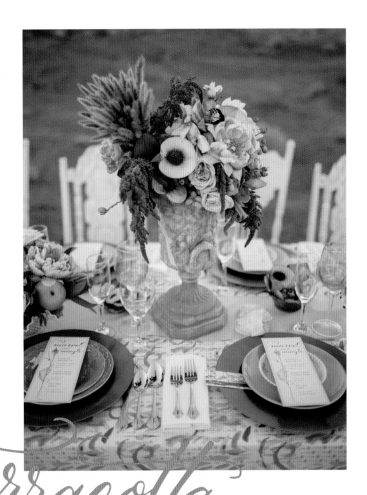

Terracotta

With Maxfield Parrish's work as our main inspiration, terracotta became the quintessential finish to reflect the coloring.

123

We don't see things as they are, we see them as we are.
-Anaïs Nin

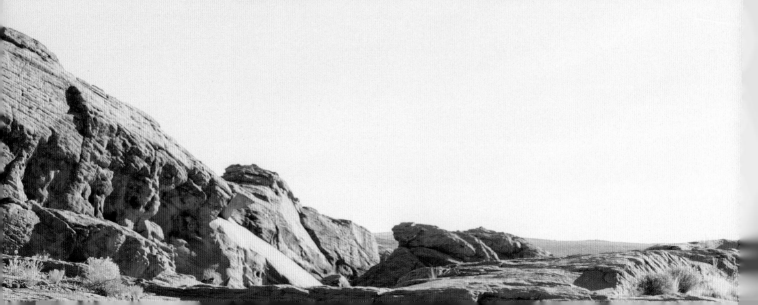

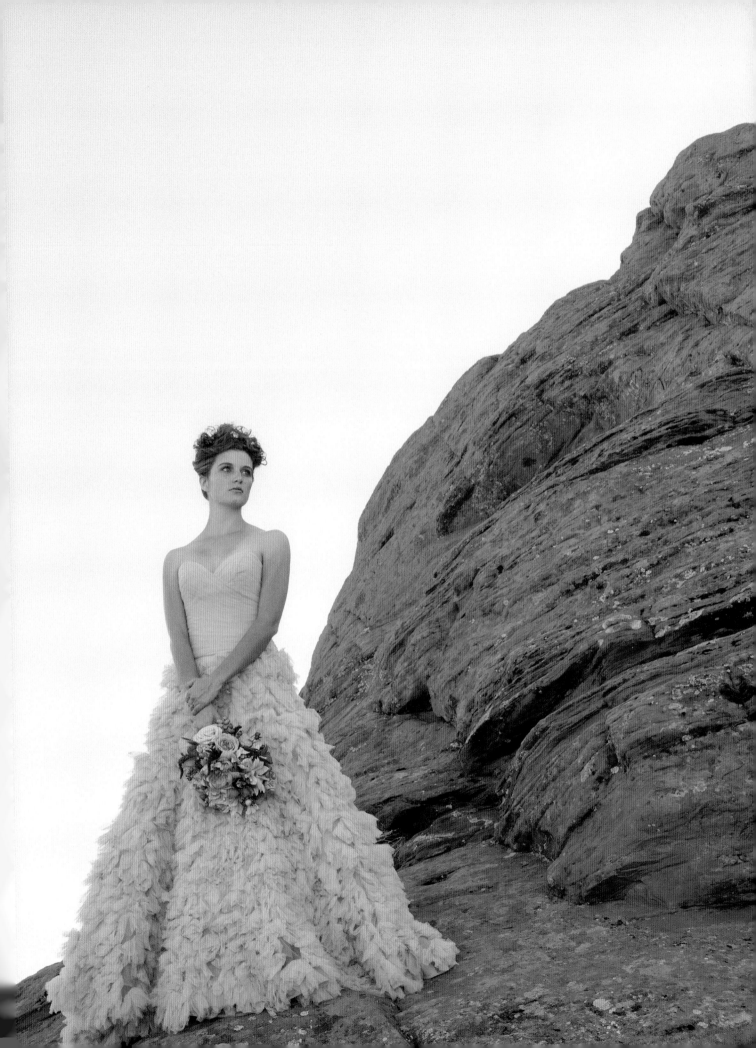

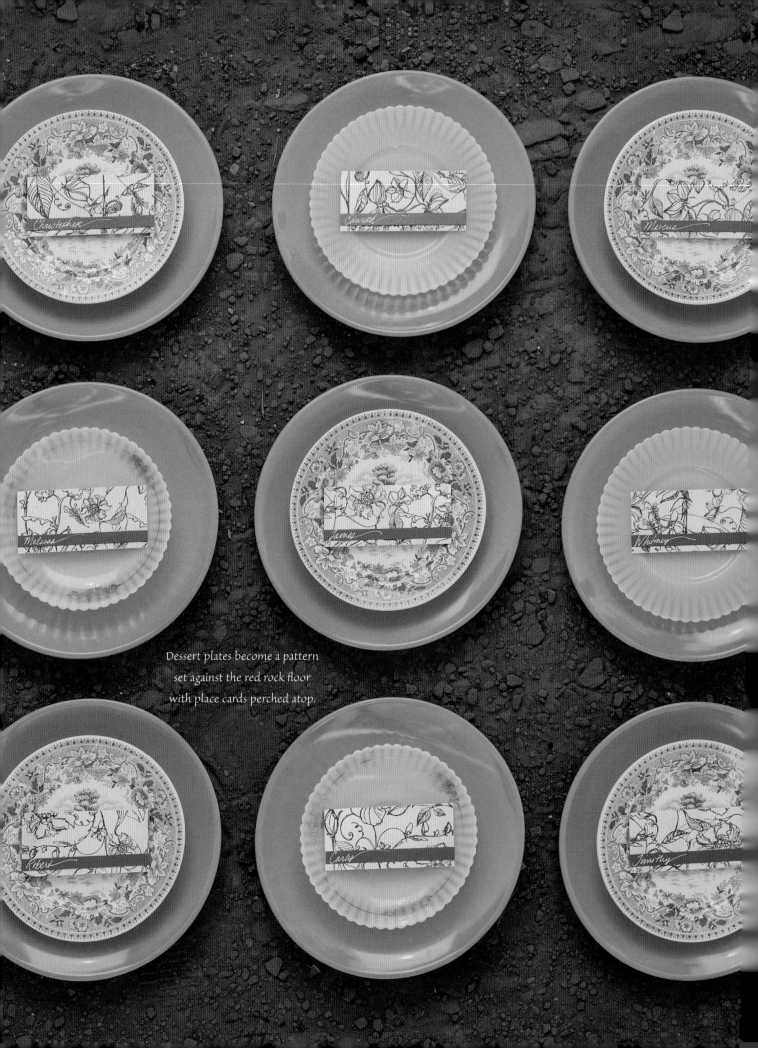

Dessert plates become a pattern
set against the red rock floor
with place cards perched atop.

sunset ceremony at half past six.

with celebrations under
THE OPEN SK
to fo

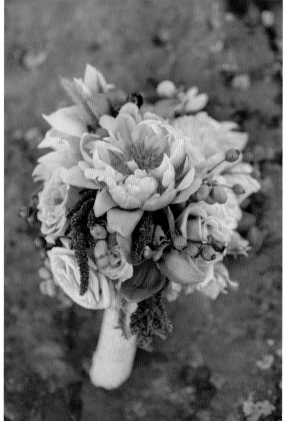

Like Parrish in the desert,
we chose a color palette
and strictly adhered to
our choice.

BLACK BEAN &
ROAST CORN CAKE

with whipped avocado
cream and candied
cilantro.

BUTTERNUT GNOCCHI
& SAUTÉED SCALLOPS

in sweet chili
lime butter.

SWEET APPLE
TAMALES

with sour cherry
and tamarind glaze.

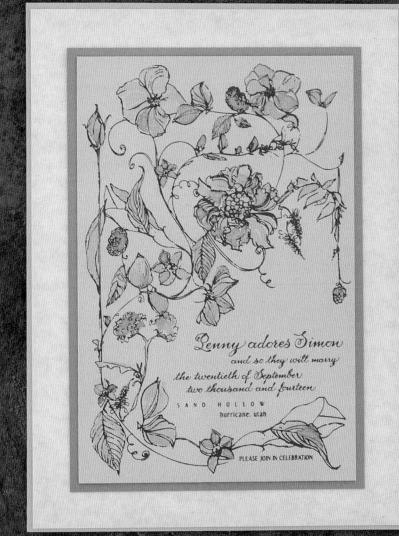

Penny adores Simon
and so they will marry
the twentieth of September
two thousand and fourteen

SAND HOLLOW
hurricane, utah

PLEASE JOIN IN CELEBRATION

touches and whispers of color

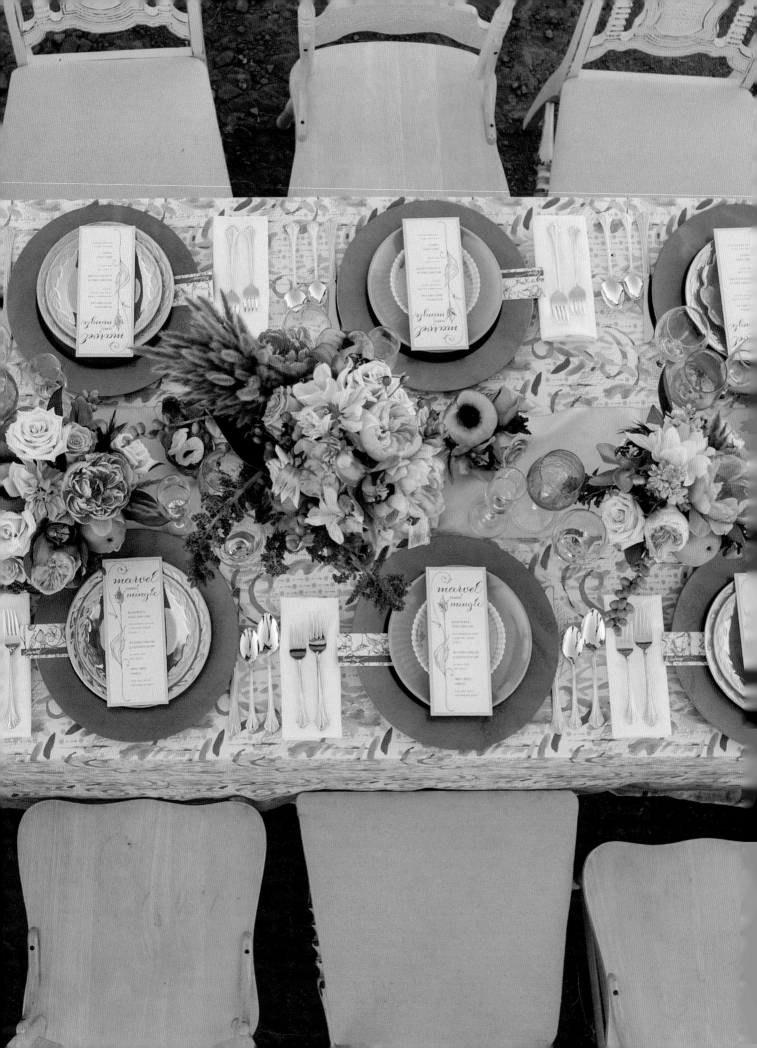

Reinvent, redefine, recreate

"It is generally admitted that the most beautiful qualities of a color are in its transparent state with the light shining through the color." –Maxfield Parrish

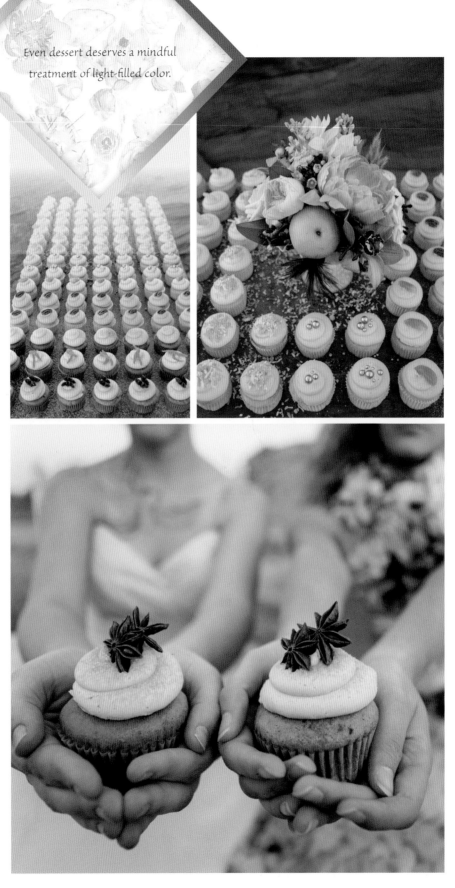

Even dessert deserves a mindful treatment of light-filled color.

Cupcakes were organized to present an ombré effect from soft yellow to pink. They were then festooned with shiny baubles, star anise, and even candied orange rind.

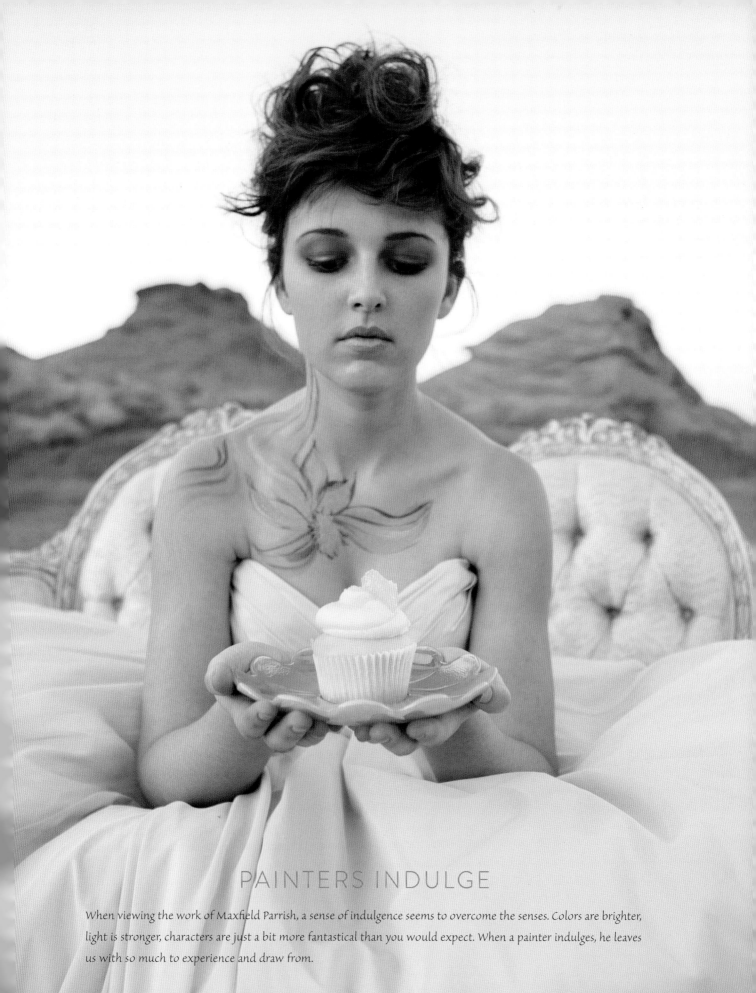

PAINTERS INDULGE

When viewing the work of Maxfield Parrish, a sense of indulgence seems to overcome the senses. Colors are brighter, light is stronger, characters are just a bit more fantastical than you would expect. When a painter indulges, he leaves us with so much to experience and draw from.

THINK LIKE A PAINTER

EXAMINE THE CONCEPT
ARTISTS DIVE IN, BREAK IDEAS INTO SMALLER PARTS, AND INTERPRET WHAT THEY SEE.

CONCEPT DEFINITION
Our inspiration painting features a sepia-like color palette, which refers to a reddish-brown pigment used by artists since the nineteenth century. Also a term used to describe a photography tone seen in vintage images, where hues of reddish-brown manifest instead of hues of gray as in a traditional black and white photo.

TANGIBLE DESIGN IDEAS INSPIRED BY THE DEFINITION
Low contrast color (minimal difference between light and dark),
tonal color, grainy/vintage, textures, shimmery finishes

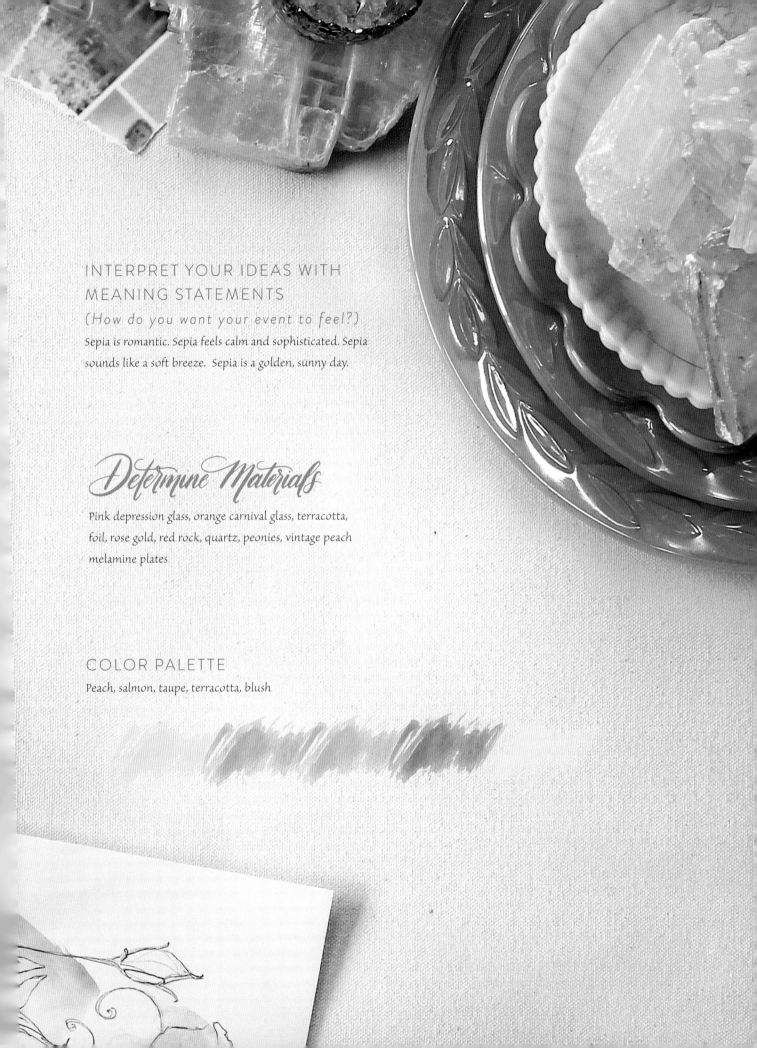

INTERPRET YOUR IDEAS WITH MEANING STATEMENTS

(How do you want your event to feel?)

Sepia is romantic. Sepia feels calm and sophisticated. Sepia sounds like a soft breeze. Sepia is a golden, sunny day.

Determine Materials

Pink depression glass, orange carnival glass, terracotta, foil, rose gold, red rock, quartz, peonies, vintage peach melamine plates

COLOR PALETTE

Peach, salmon, taupe, terracotta, blush

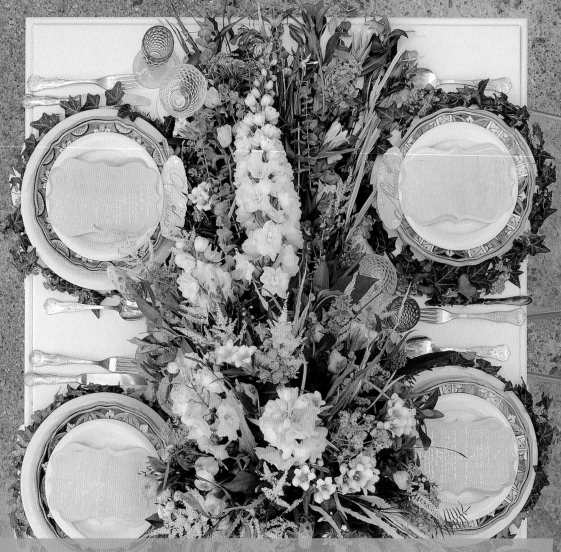

HISTORY . . . CAN GIVE US A FULLER
UNDERSTANDING OF OURSELVES, AND
OF OUR COMMON HUMANITY . . .

–ROBERT PENN WARREN

THIRTEENTH CENTURY-INSPIRED

with Giotto

Grand Hotel Convento di Amalfi, Italy

Giotto di Bondone (1266–1337) was an Italian painter from
Florence and considered by many to be the first in line of the great painters
who contributed to the Renaissance.

Giotto began drawing from life to capture a more realistic version of his subjects, a technique not often practiced in his time. Natural colors, smooth skin tones, and a sense for the viewer that he or she is part of the scene are hallmarks of Giotto's style.

The Cappuccini Monastery, now known as the Grand Hotel Convento di Amalfi, is one of the most important monuments on the Amalfi Coast. Celebrations here have the distinct honor of having an architectural backdrop dripping with centuries-old structures and artwork, including restored arches and a church from the thirteenth century. This is a humbling space where experiences cross paths with the ages. Imagine Giotto himself traveling here from Florence, armed with his materials and ready to paint!

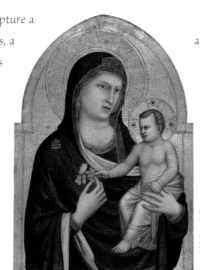

Madonna and Child, painting, c. 1320–1330, Giotto

Samuel H. Kess Collection

Given that weddings are literally an active process of making history, Giotto seemed a perfect inspiration point for a wedding set in a thirteenth-century monastery. Soon your images will be in frames on a mantel and quicker than you can dream, your tenth wedding anniversary festivities will be underway. When planning your celebration today, think about how this event will soon be part of your personal history. How are your decisions changed by realizing this? In the same way, your decisions might be influenced by a historical frieze at the entrance to your church or a restored archway near your head table, physical traces of our pasts enliven surroundings. However, remembering we are part of history can inspire more timeless, thoughtful choices.

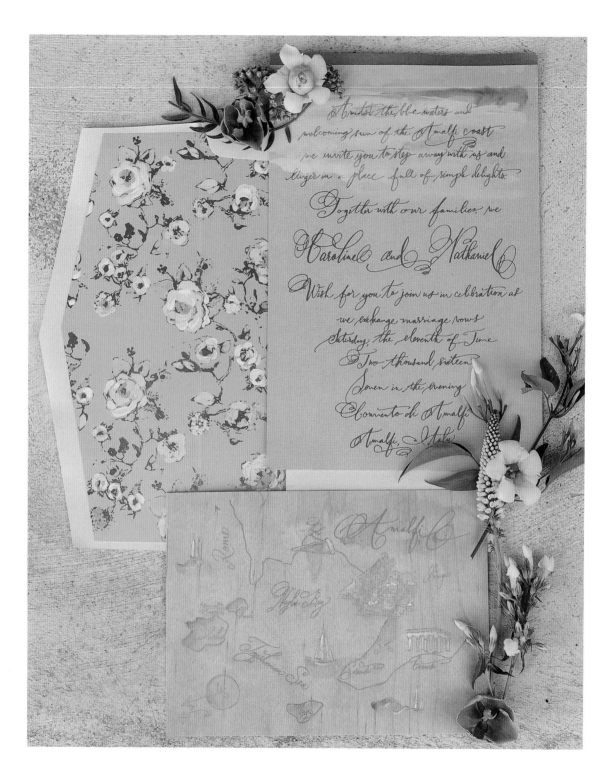

Gold was a prominent finish in much of Giotto's work. Gilding was a mainstay of so many fresco artists of the time. As such, the invitation boasts gold foil and gold watercolor brushstrokes.

The Friars of Cappuccini Monastery lived very simple and genuine lives and showed a deep love and respect for the land and what nature had to offer. They were artisans and produced everything they needed at the Convento. But the age-old tradition of using local suppliers and offering friendly hospitality is still alive in Italian culture today, especially in the south.

Our advice to couples is to adopt a similar mindset to the Friar artisans that once inhabited the Convento. Regardless of where in the world you host a celebration, I believe the keys to a successful event are to be authentic and use local artists and produce whenever possible.

—VALENTINA DI TINCO
Wedding planner at SposiamoVi

Works by thirteenth-century painters often possess a decorative vibe. Decorative artwork can be characterized by a stylized look where simplified shapes are favored for the more realistic and detailed. Taking our cues from a stylized aesthetic, this invitation is a paired down trail of vines, leaves, and blooms.

A paper flower crown
to keep forever.

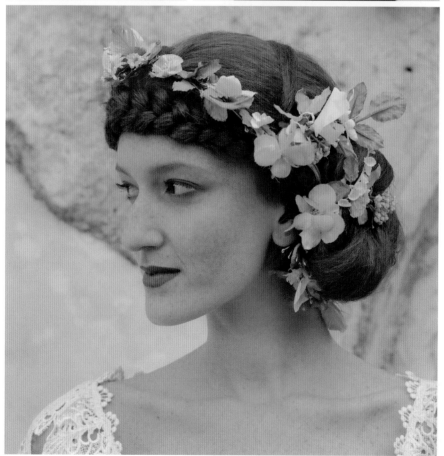

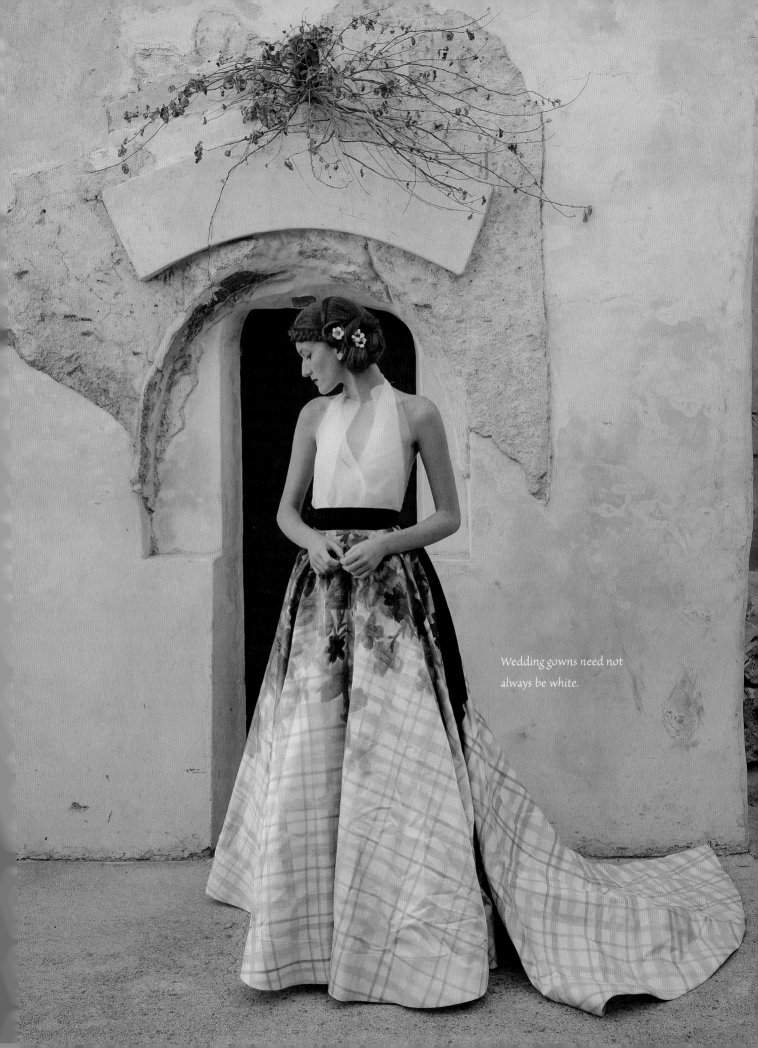

Wedding gowns need not
always be white.

Every painting is a voyage into a sacred harbour.

- Giotto di Bondone

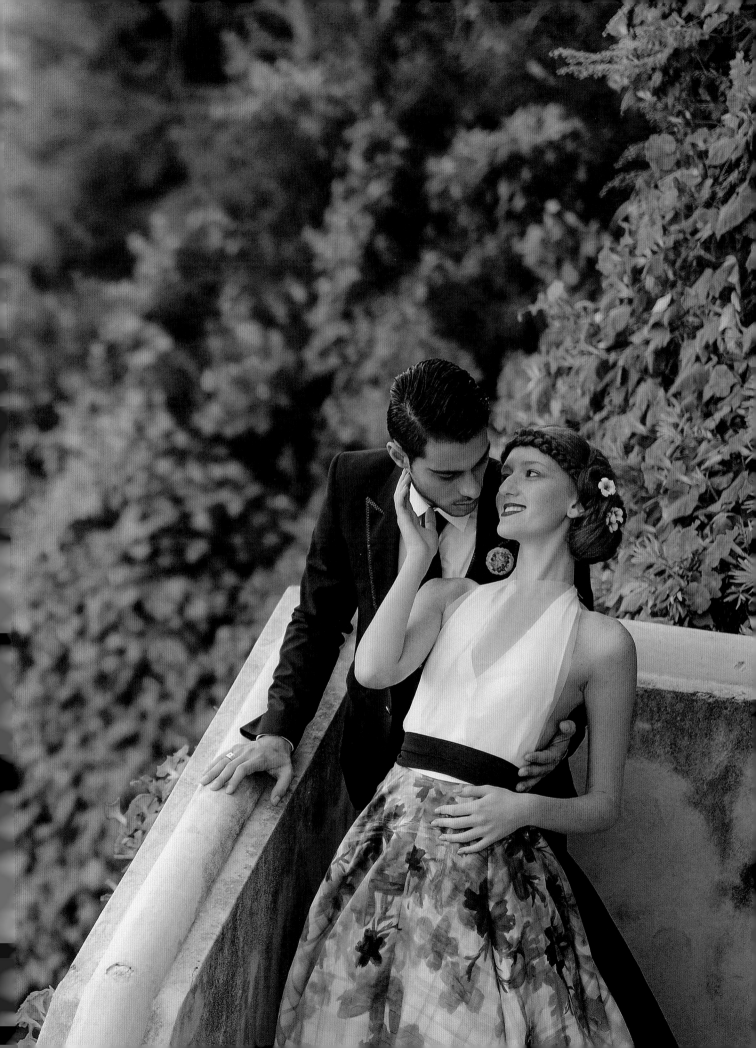

Together with our families,

Caroline and Nathaniel

Wish for you to join us in celebration as
we exchange marriage vows

Saturday, the eleventh of June
Two thousand sixteen

Seven in the evening
Convento di Amalfi

Amalfi, Italy

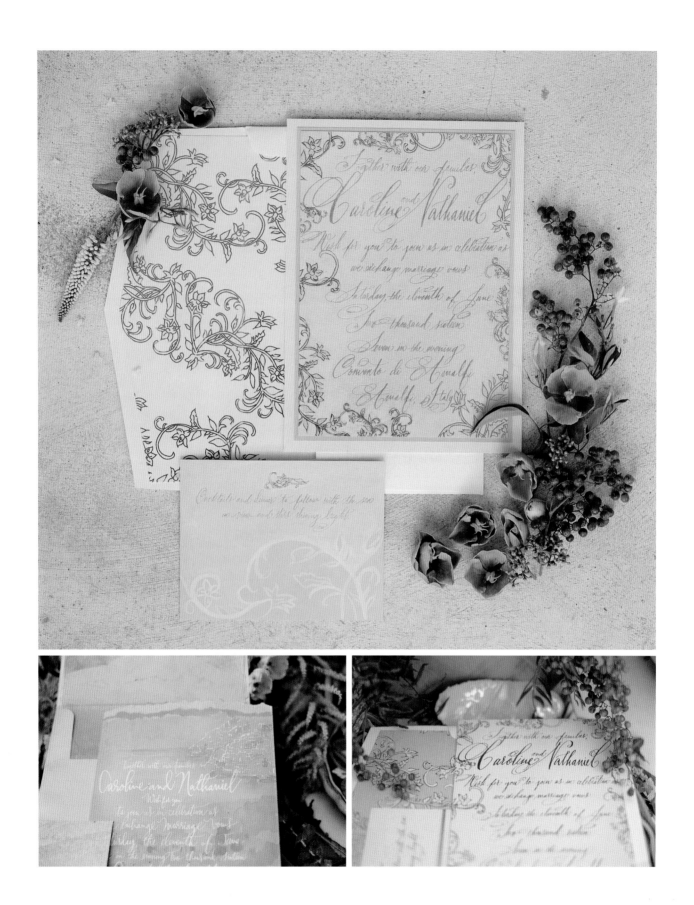

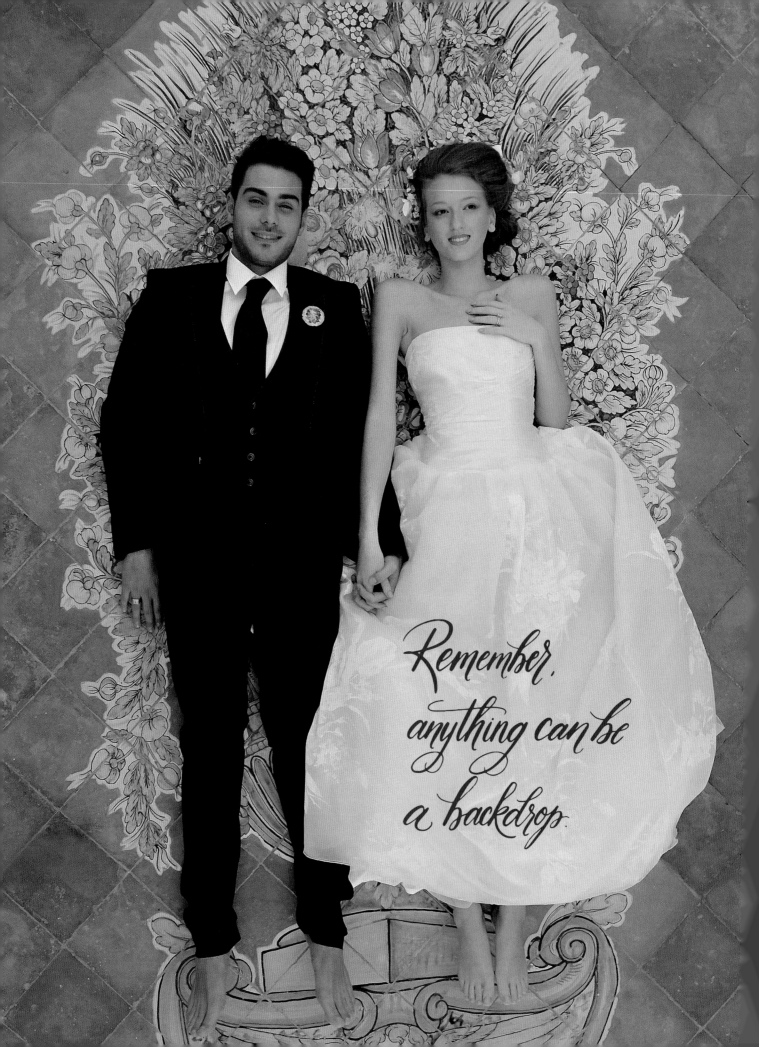

Remember, anything can be a backdrop.

Giotto, like so many Renaissance painters, found beauty in the everyday: a simple room, the mountainside, a public square. Here, we were lured by the floor of the Convento (opposite).

Hand-painted Italian artisan pins give guests a reason to remember a painter's touch long after the celebration.

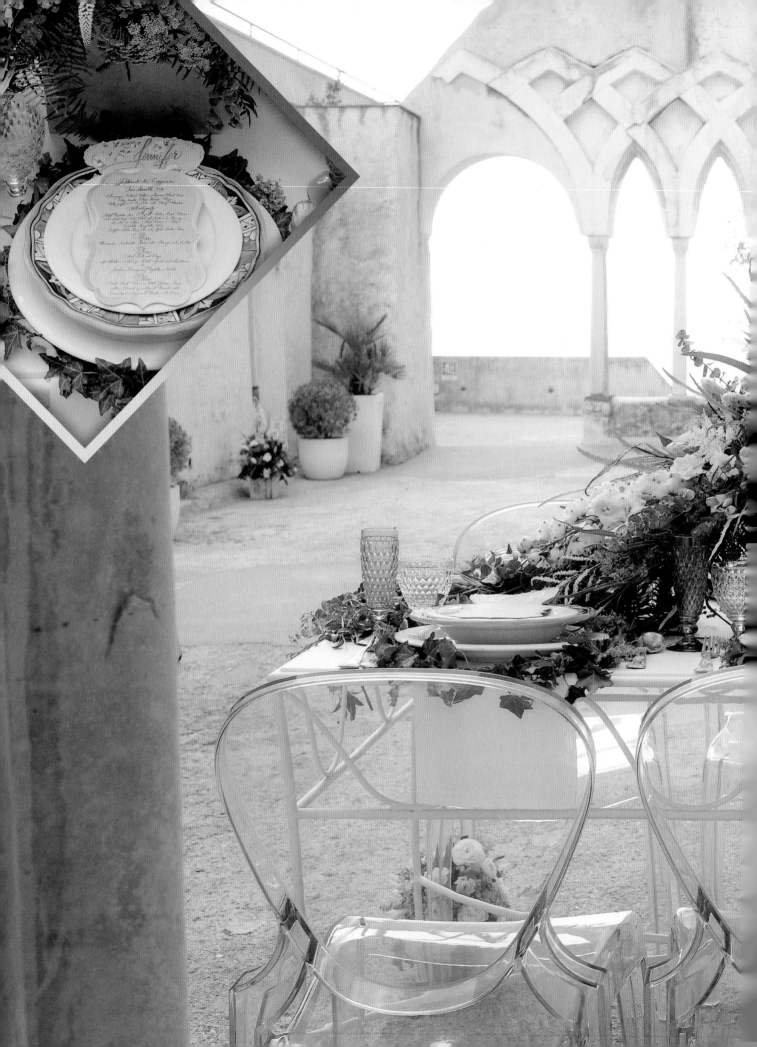

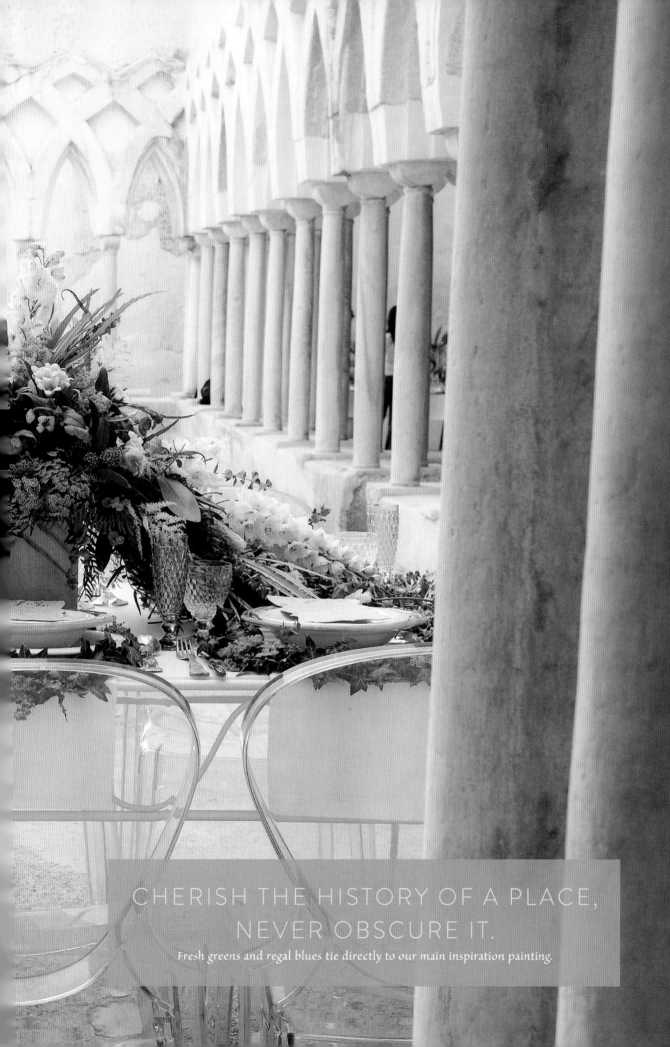

CHERISH THE HISTORY OF A PLACE,
NEVER OBSCURE IT.

Fresh greens and regal blues tie directly to our main inspiration painting.

Look for curious places to express your painter's inspiration.

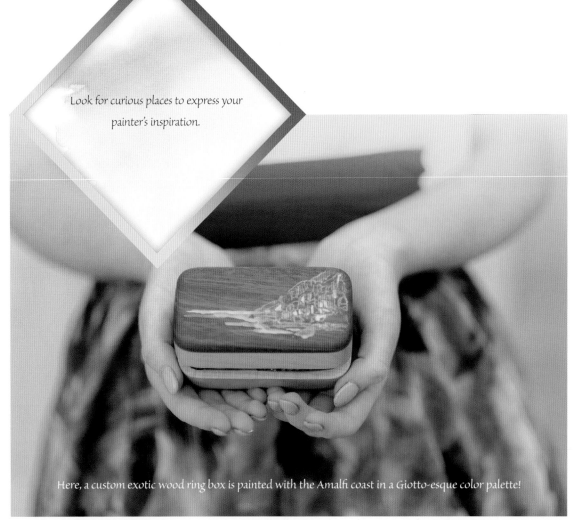

Here, a custom exotic wood ring box is painted with the Amalfi coast in a Giotto-esque color palette!

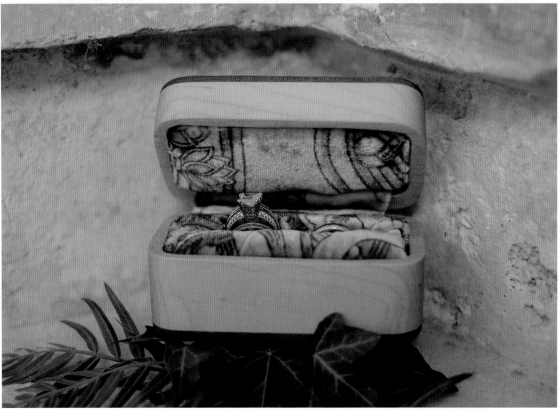

n°3 *Delizia al Cioccolato*
Mini cake with dark chocolate mousse
and a mandarin ... biscuit

...à alla Melannurca e Cannella
...ked sponge cake in apple liquor
...with a dusting of cinnamon

Our cake feels as if it could be right at home in a Giotto composition.

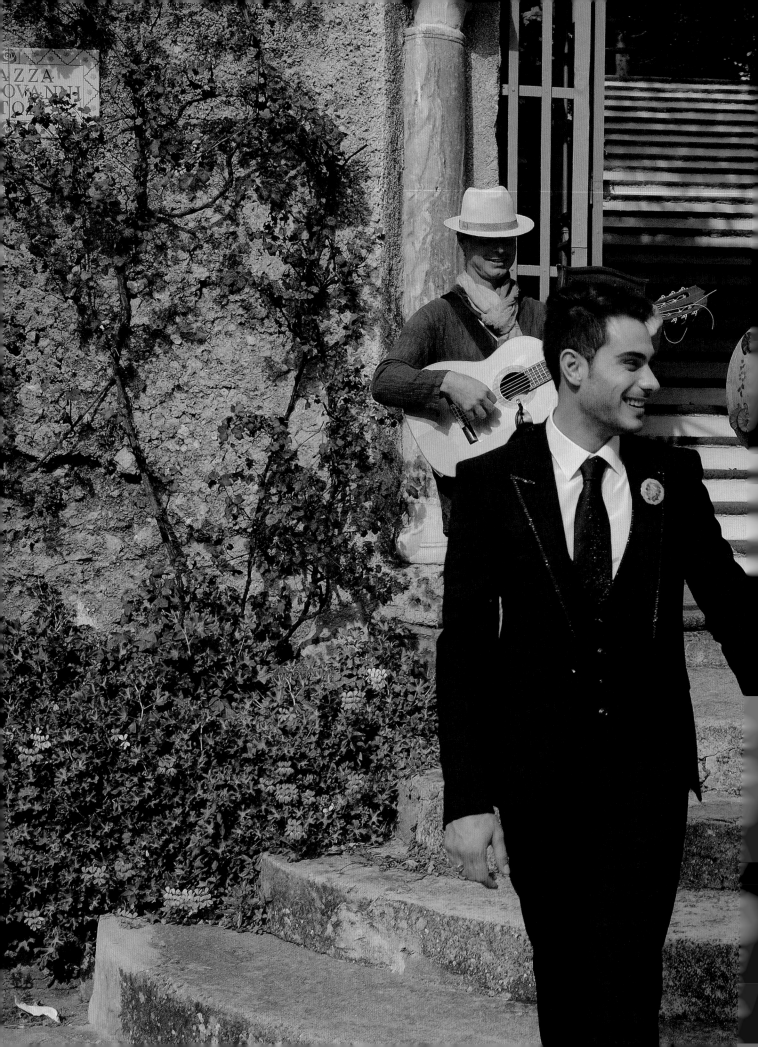

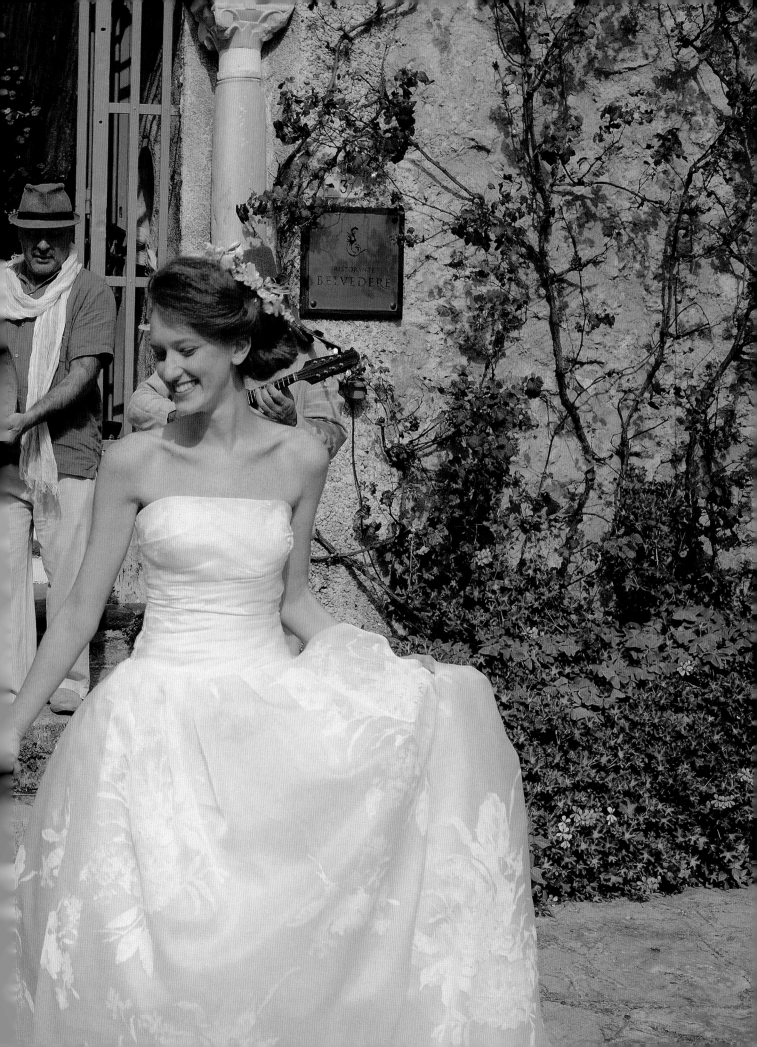

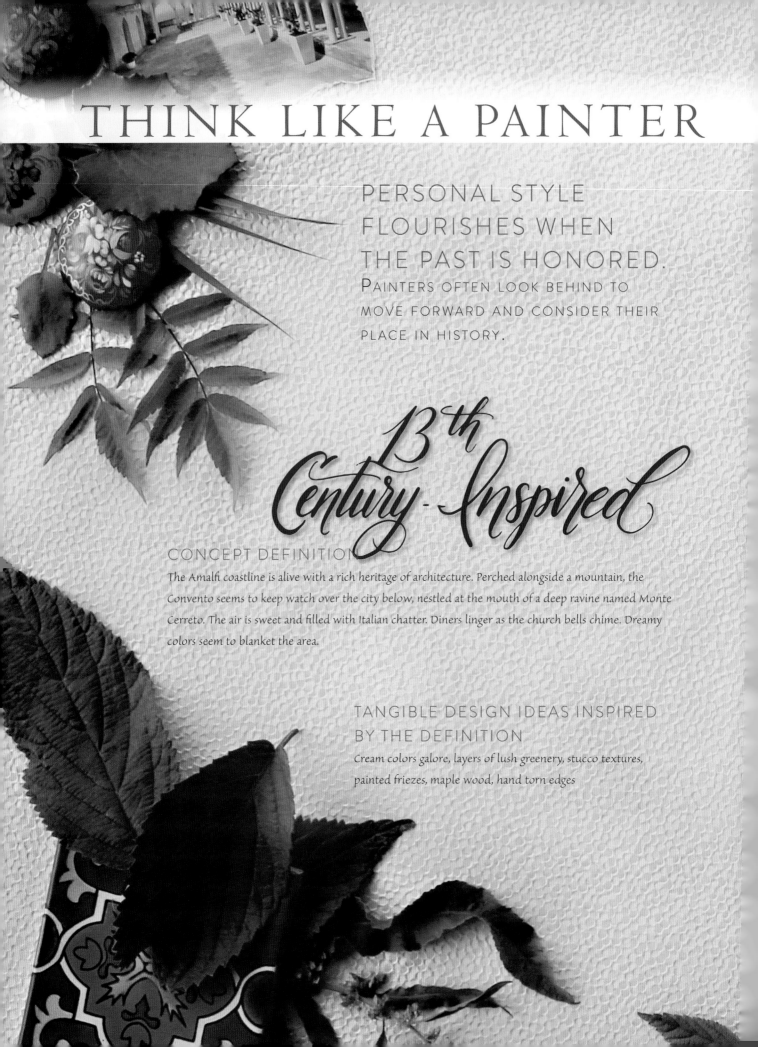

PERSONAL STYLE
FLOURISHES WHEN
THE PAST IS HONORED.
PAINTERS OFTEN LOOK BEHIND TO
MOVE FORWARD AND CONSIDER THEIR
PLACE IN HISTORY.

13th Century-Inspired

CONCEPT DEFINITION

The Amalfi coastline is alive with a rich heritage of architecture. Perched alongside a mountain, the Convento seems to keep watch over the city below, nestled at the mouth of a deep ravine named Monte Cerreto. The air is sweet and filled with Italian chatter. Diners linger as the church bells chime. Dreamy colors seem to blanket the area.

TANGIBLE DESIGN IDEAS INSPIRED BY THE DEFINITION

Cream colors galore, layers of lush greenery, stucco textures, painted friezes, maple wood, hand torn edges

INTERPRET YOUR IDEAS
WITH MEANING STATEMENTS
(How do you want your event to feel?)
Amalfi is breezy. Amalfi is sunwashed and pure. Amalfi is live
music in the middle of the day. Amalfi is hand-painted gowns.
Amalfi is blooming cliffsides.

Determine Materials
Italian Majolica pottery, red currants, regional Italian desserts, gold leaf
and foil, colored cut glass, watercolor wood

COLOR PALETTE
Cream, royal blue, sage green, yellow,
accents of blush

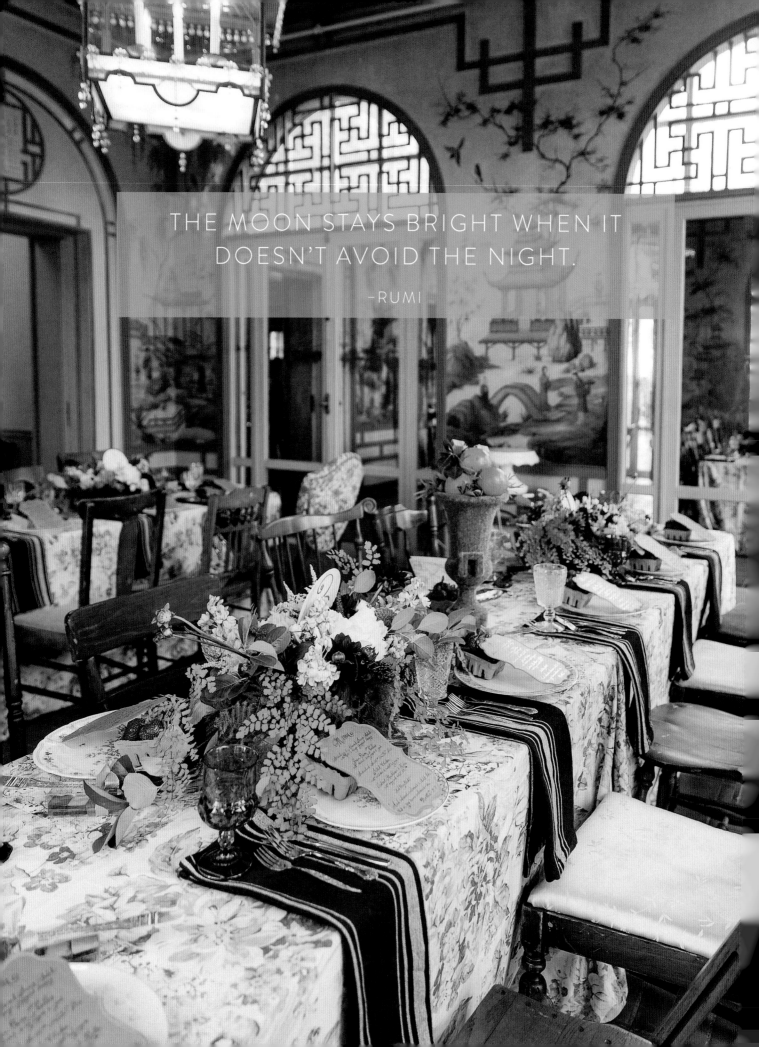

THE MOON STAYS BRIGHT WHEN IT
DOESN'T AVOID THE NIGHT.

–RUMI

Frida Kahlo

IN BLOOM

Hayfield House, Lehman, Pennsylvania

Frida Kahlo (1907–1954) lived a short but colorful life.

And in the process, imbued us with her wisdom through countless self portraits and richly emotional and personal landscapes. Frida was born in her parents' home aptly named La Casa Azul (The Blue House). Brave in expression both on and off the canvas, she charged through life, pained limbs be damned and excuses forgotten. Her vibrant personality and style abounded regardless of her circumstance.

Events are a celebration of families joining, lives beginning, and, of course, love. Love and all its joy, often along with chaos, hides within it powerful tales to be told. Can we step inside an artist's life for a moment to absorb their emotions only to later spill them out on our celebrations? Why not? An artist's composition, impact, and style isn't only communicated with a brush in hand but often in a life well lived. We can draw from that, let it fill us up with big ideas.

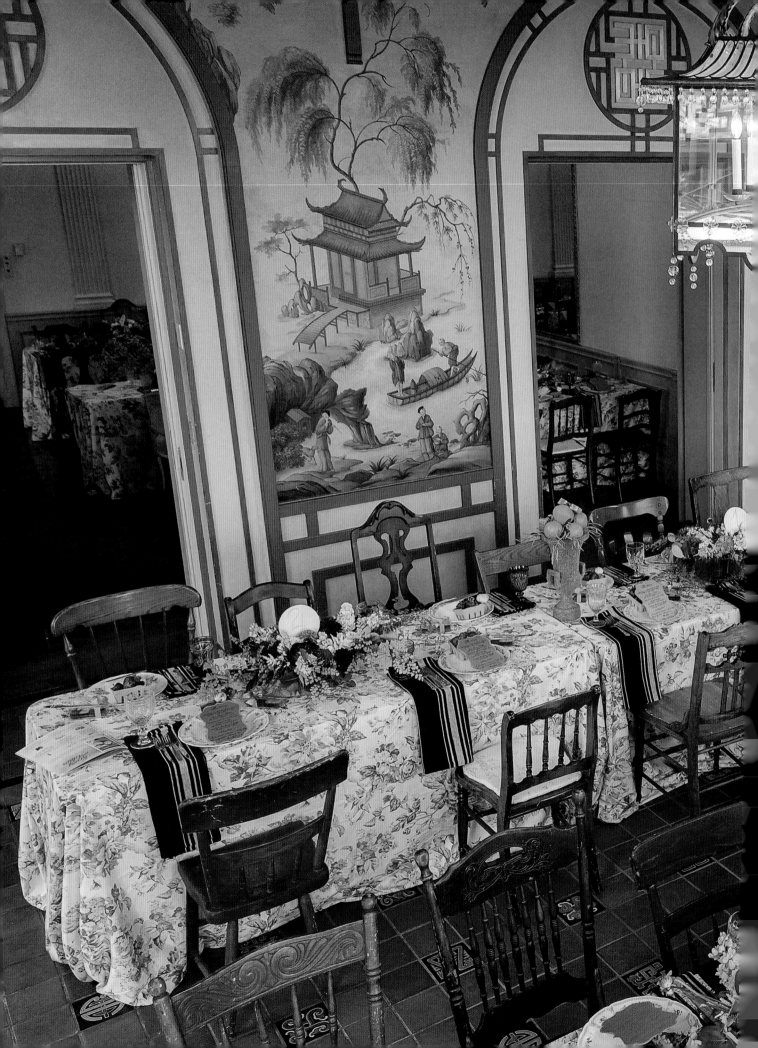

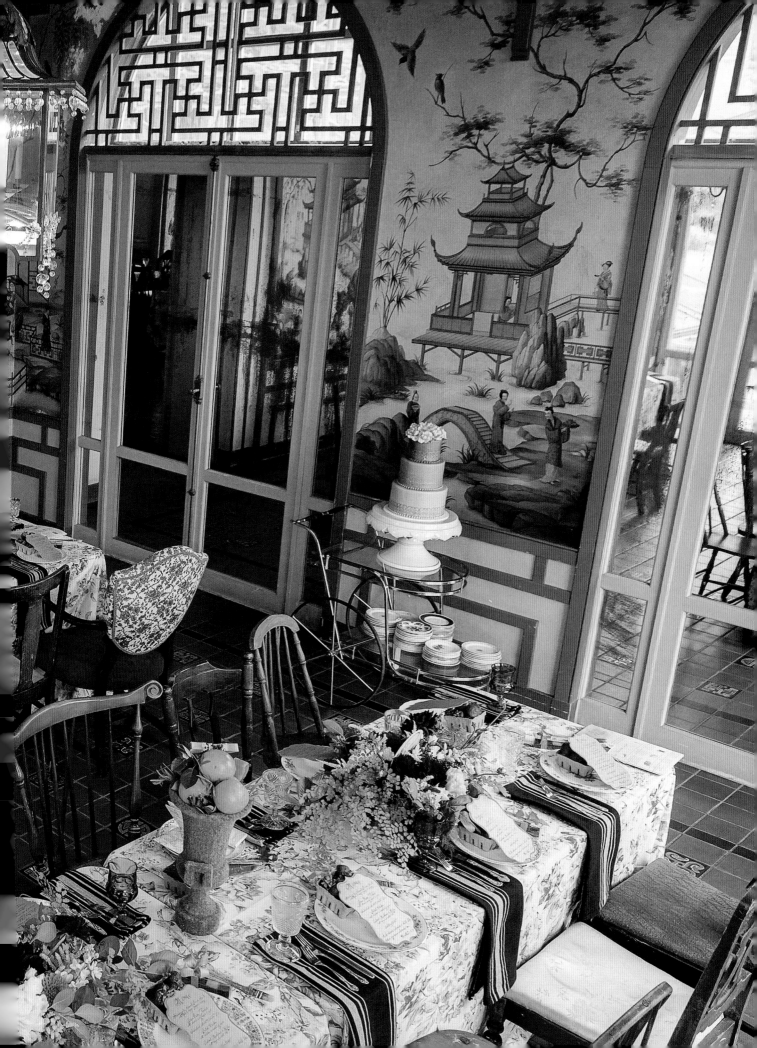

Danielle, Mika, & Celeste Sedivi
440 McKinley Street
Exeter, PT
1 8 6 4 3

Kristy & Adam
are adopting a baby!

The agency is picked, the Paperwork is in,
now the real fun is about to begin.
Please join us in helping them prepare for a bundle of joy
as they wait to be matched with a girl or a boy.
Sunday, June 28th 2015, from 12:30 to 4:00 in the afternoon
Hayfield House ~ Lehman, Pennsylvania
Given with love by Linda Rice
& Amy Palmer

Additional
Information

Composition is what I dream of every night; how the landscape and the light help make a strong image is always the challenge as a fine art wedding photographer. My eyes see the landscape first, then the light. Keeping a clean canvas is key to not compete with the gorgeous couple and details I'm documenting at a wedding. The emotional part of the image and learning to manage difficult lighting is what most photographers struggle with. The challenge is to maintain consistency throughout an event in one day that could have six different lighting situations. The lighting is the icing on the cake, the "voila" moment.

–JOSE VILLA
Fine art photographer

Invite your guests to be part of the decor

Frida was most often captured with some type of adornment in her hair. Wreaths, wraps, and single blooms turned the everyday Frida into an iconic face. We invited guests to be part of the decor with their very own Frida-inspired wreath.

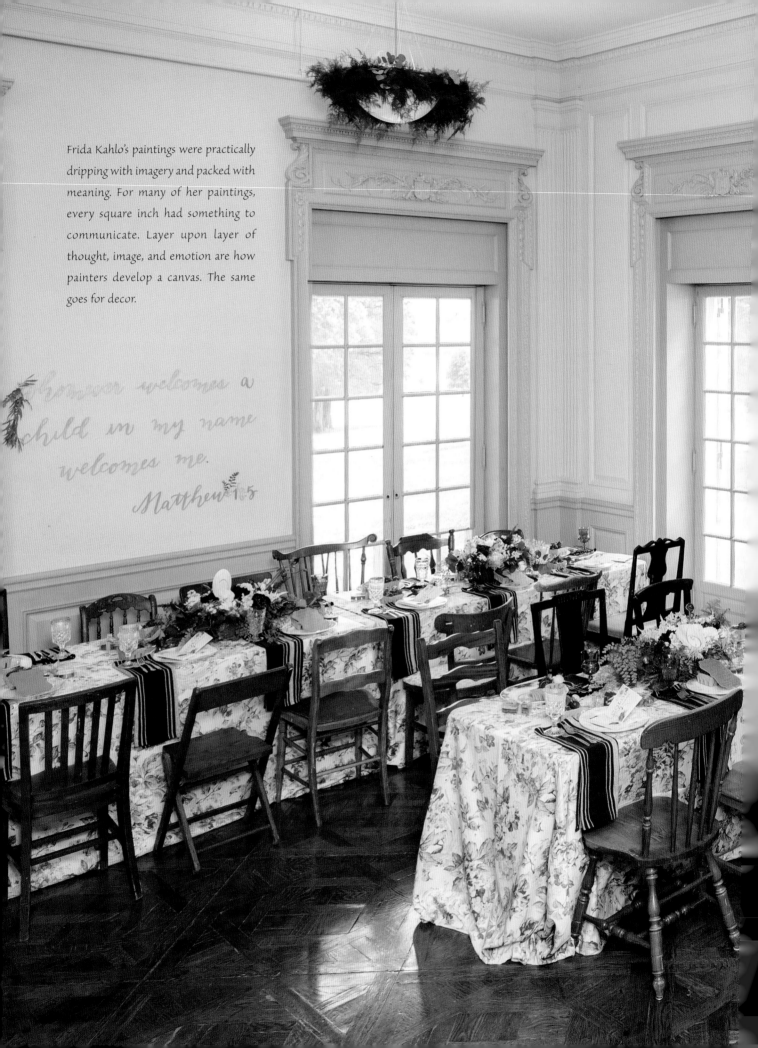

Frida Kahlo's paintings were practically dripping with imagery and packed with meaning. For many of her paintings, every square inch had something to communicate. Layer upon layer of thought, image, and emotion are how painters develop a canvas. The same goes for decor.

Whoever welcomes a child in my name welcomes me.
Matthew 18:5

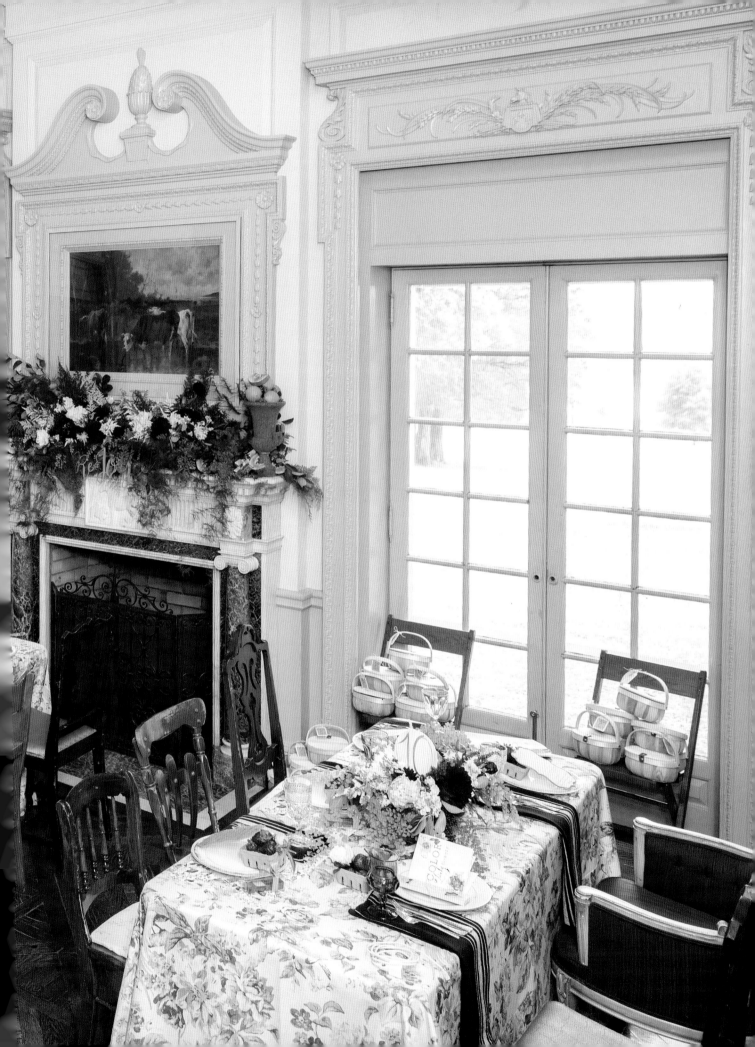

Individually illustrated seating cards displayed on a dip-dyed linen, paintbrush festooned artist palette truffles, and a meal as colorful as Frida's color choices.

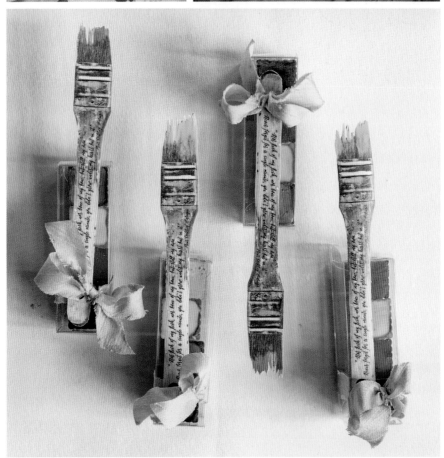

Layer upon layer...

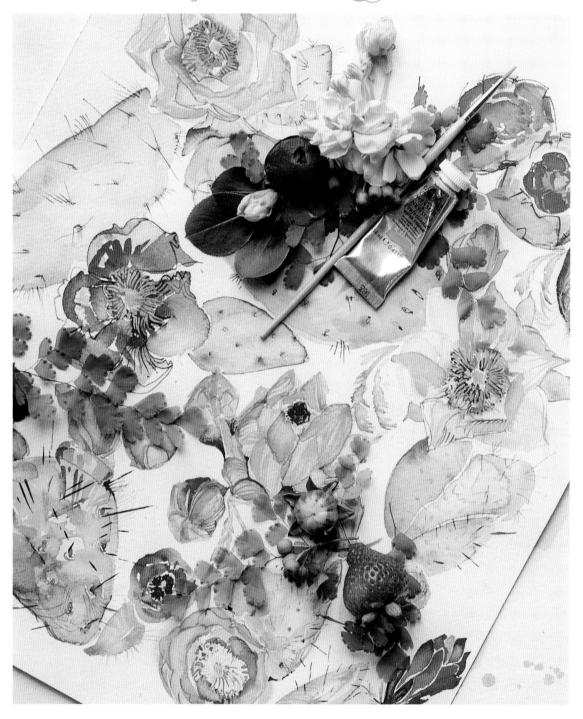

A look at the original watercolor artwork inspired by Frida's home gardens. Elements from this original are used throughout stationery, placemats, and even the cake!

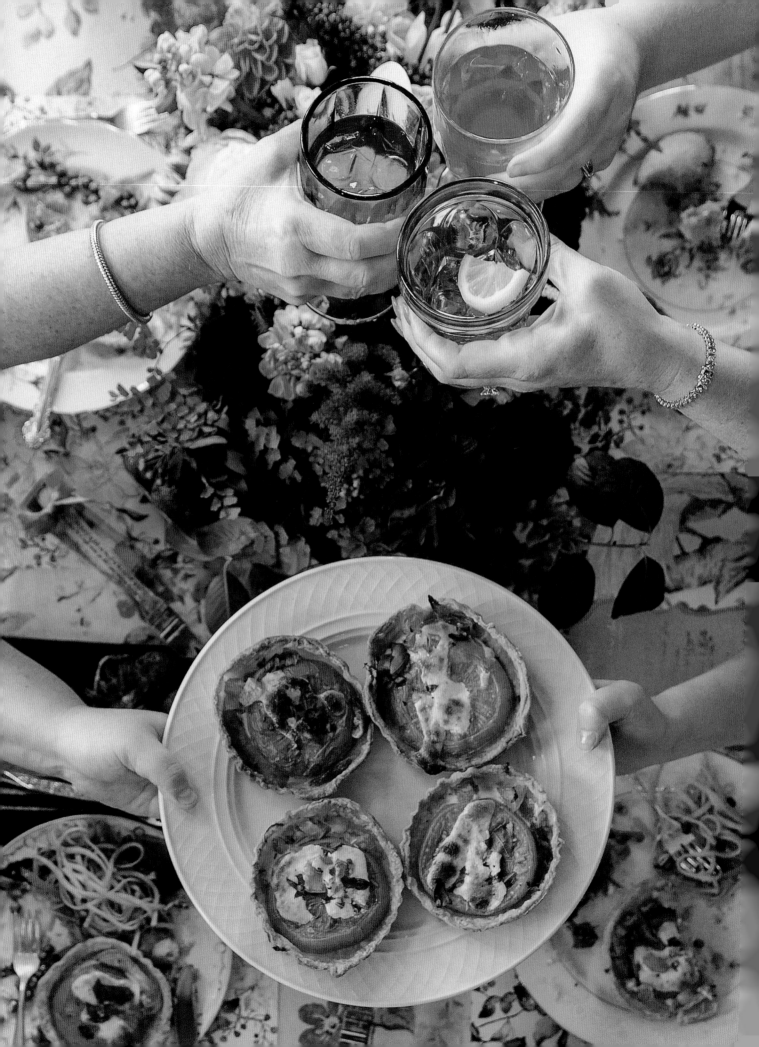

THERE IS NOTHING MORE PRECIOUS
THAN LAUGHTER.

—FRIDA KAHLO

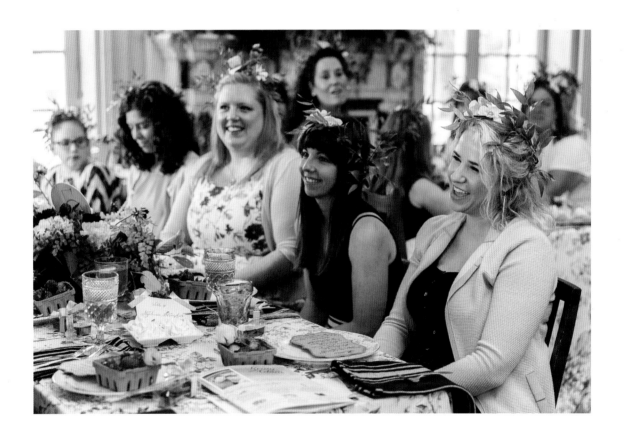

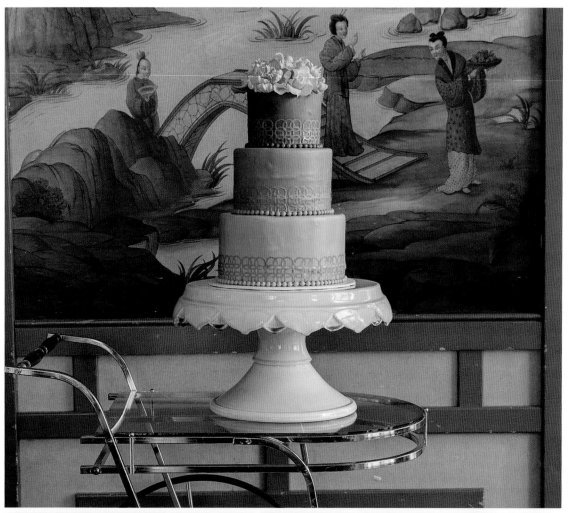

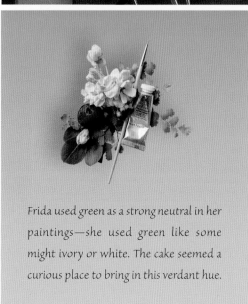

Frida used green as a strong neutral in her paintings—she used green like some might ivory or white. The cake seemed a curious place to bring in this verdant hue.

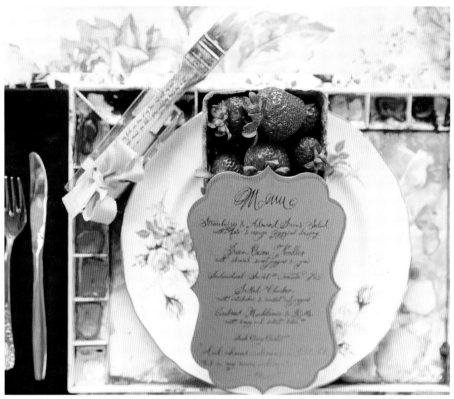

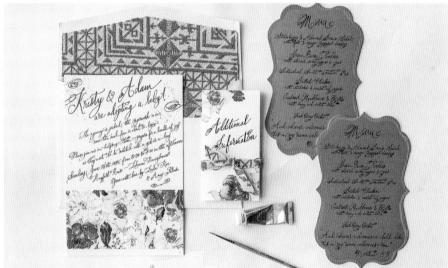

Think in textures

Invitations offer up nearly endless opportunities to express yourself. Choose eclectic artwork and a variety of design elements piece by piece to keep the look unpredictable.

Frida often com-
bined elements in her
paintings that simply didn't seem
to belong together. Here, pints of
strawberries each pop with an
unexpected young
peony bud.

LET THE LITTLE ONES
BE ARTISTS, TOO,

with a mini coloring book favor for the kiddos!

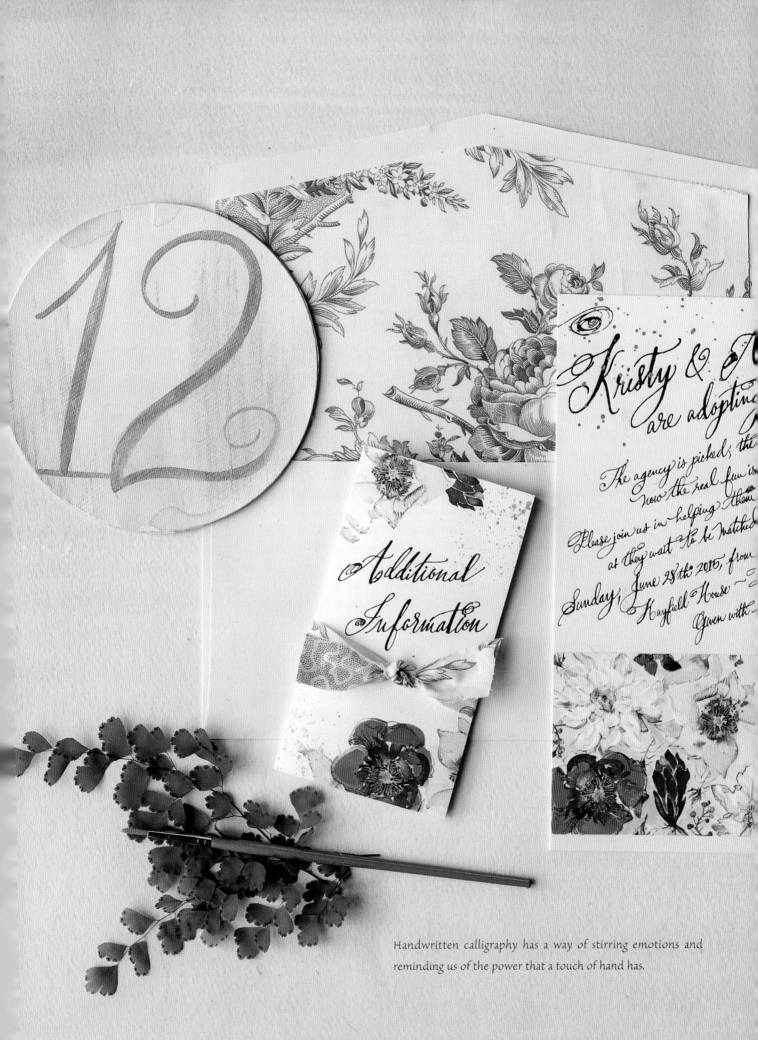

Handwritten calligraphy has a way of stirring emotions and reminding us of the power that a touch of hand has.

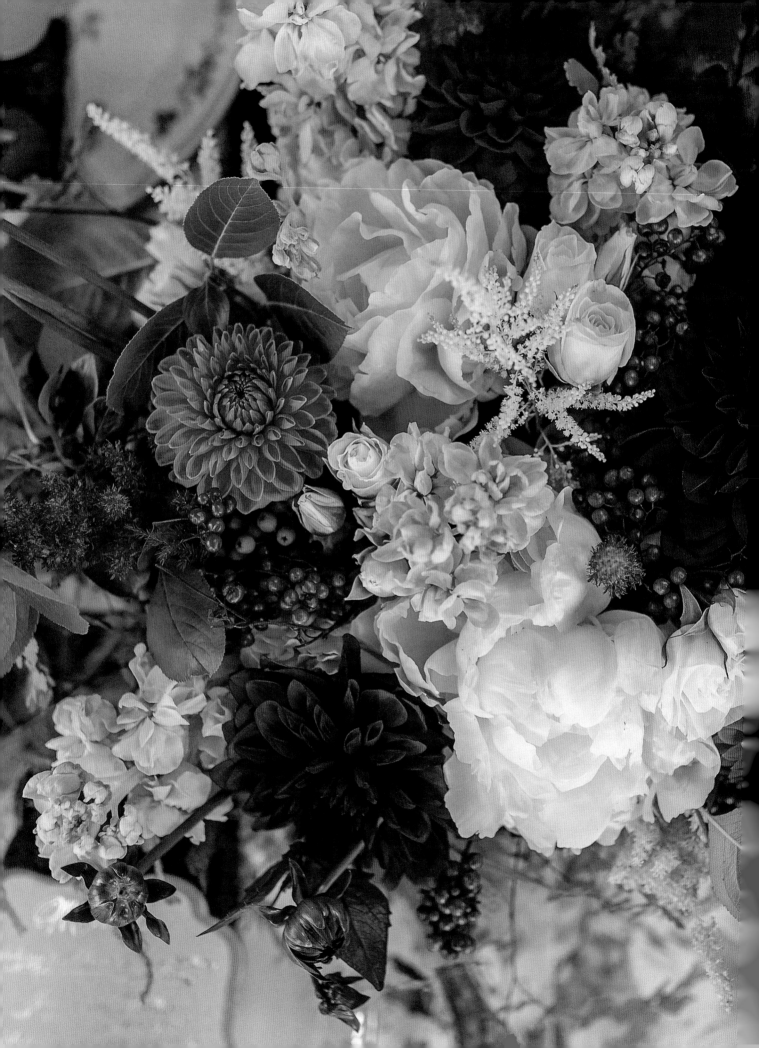

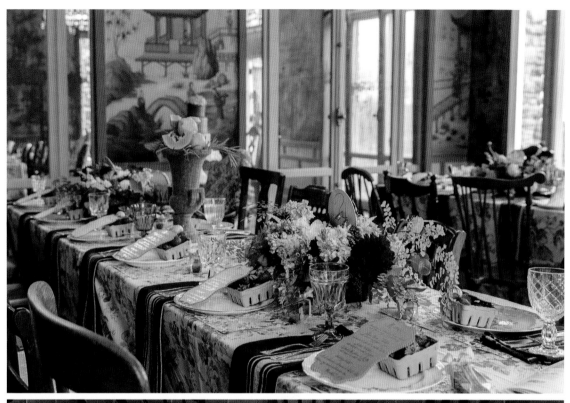

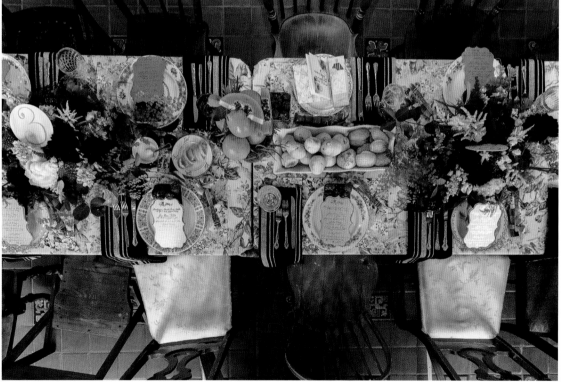

173

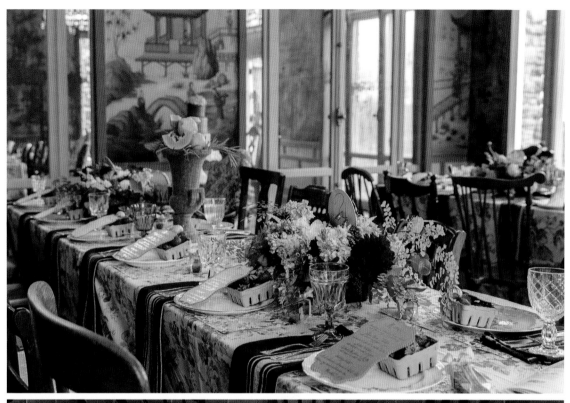

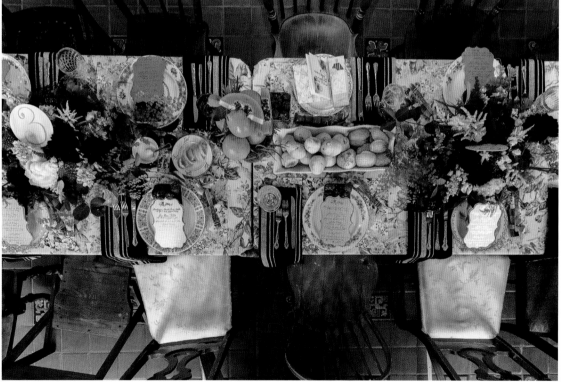

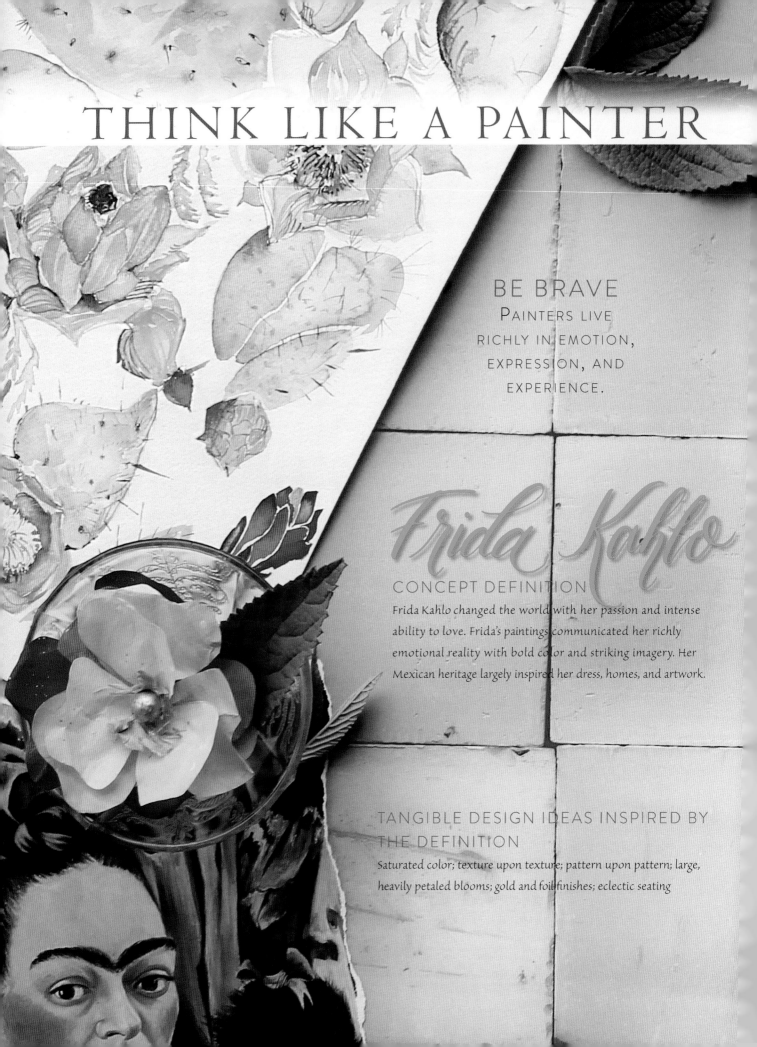

THINK LIKE A PAINTER

BE BRAVE
PAINTERS LIVE RICHLY IN EMOTION, EXPRESSION, AND EXPERIENCE.

Frida Kahlo

CONCEPT DEFINITION

Frida Kahlo changed the world with her passion and intense ability to love. Frida's paintings communicated her richly emotional reality with bold color and striking imagery. Her Mexican heritage largely inspired her dress, homes, and artwork.

TANGIBLE DESIGN IDEAS INSPIRED BY THE DEFINITION

Saturated color; texture upon texture; pattern upon pattern; large, heavily petaled blooms; gold and foil finishes; eclectic seating

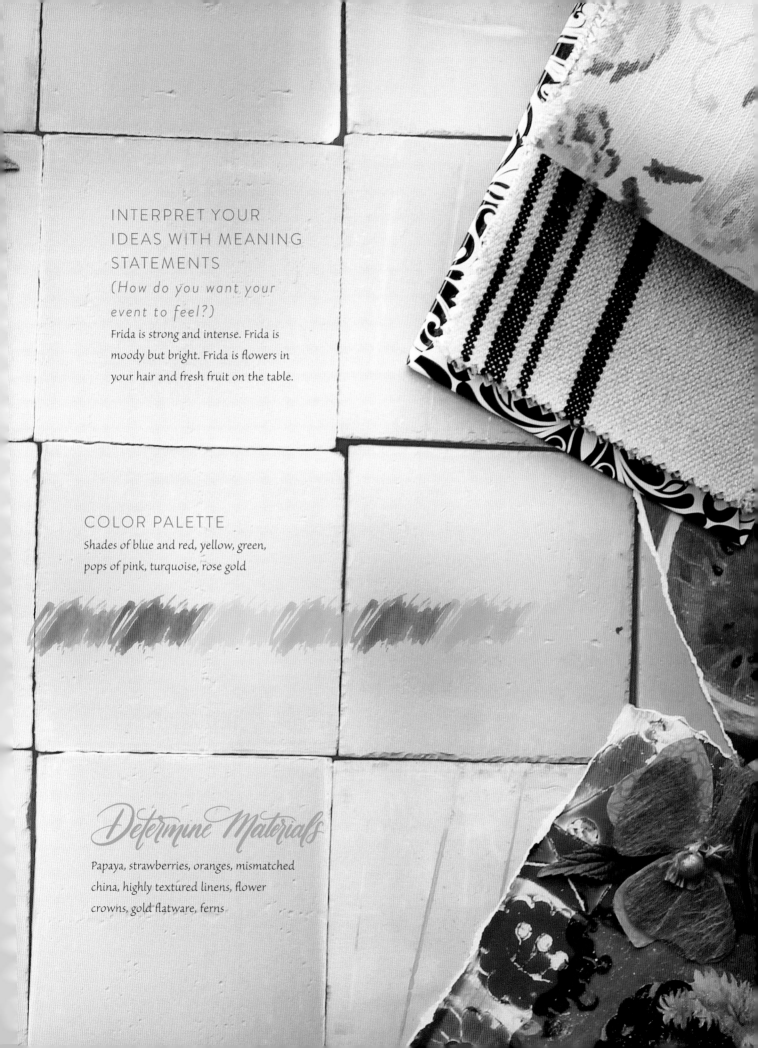

INTERPRET YOUR
IDEAS WITH MEANING
STATEMENTS
*(How do you want your
event to feel?)*
Frida is strong and intense. Frida is
moody but bright. Frida is flowers in
your hair and fresh fruit on the table.

COLOR PALETTE
Shades of blue and red, yellow, green,
pops of pink, turquoise, rose gold

Determine Materials

Papaya, strawberries, oranges, mismatched
china, highly textured linens, flower
crowns, gold flatware, ferns

AND NOW HERE IS MY SECRET, A VERY
SIMPLE SECRET: IT IS ONLY WITH THE HEART THAT
ONE CAN SEE RIGHTLY.

–ANTOINE DE SAINT-EXUPÉRY, *THE LITTLE PRINCE*

Edward Hopper

AT CONGRESS HALL

Cape May, New Jersey

Edward Hopper's (1882–1967) rise to notoriety and fame
was slow and, at times, agonizing.

Many of Hopper's colleagues' pasts included periods of obscurity, depression, and poverty, but Hopper's challenges went a bit deeper. He struggled to find his voice, his artistic style, and what is an artist without a recognizable style? Hopper was known to sit for days facing his easel in despair for what to paint. He even began illustrating for magazines, a skill easily mastered but one he hardly felt passion for.

So many couples struggle to find a clear voice in their wedding design. Being inundated with past editorial and "WOW" weddings plastering every square inch of social media offers up ideas, yes, but where in the world do you go from there? Researching the lives, times, and struggles of favorite artists can offer tangible insight into the creative process—how real artists think, feel, and function. It was only when Hopper dug deep into his own experience and found love in his life that

his passions and aesthetic were ignited. Read the magazines, skim the Instagram feeds, sure, but always look back to experience, and ultimately love, to fuel the big decisions.

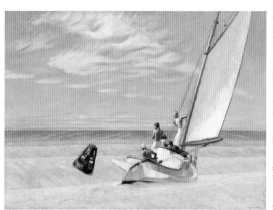

Ground Swell, oil on canvas, 1939, Edward Hopper

Corcoran Collection, Museum Purchase, William A. Clark Fund

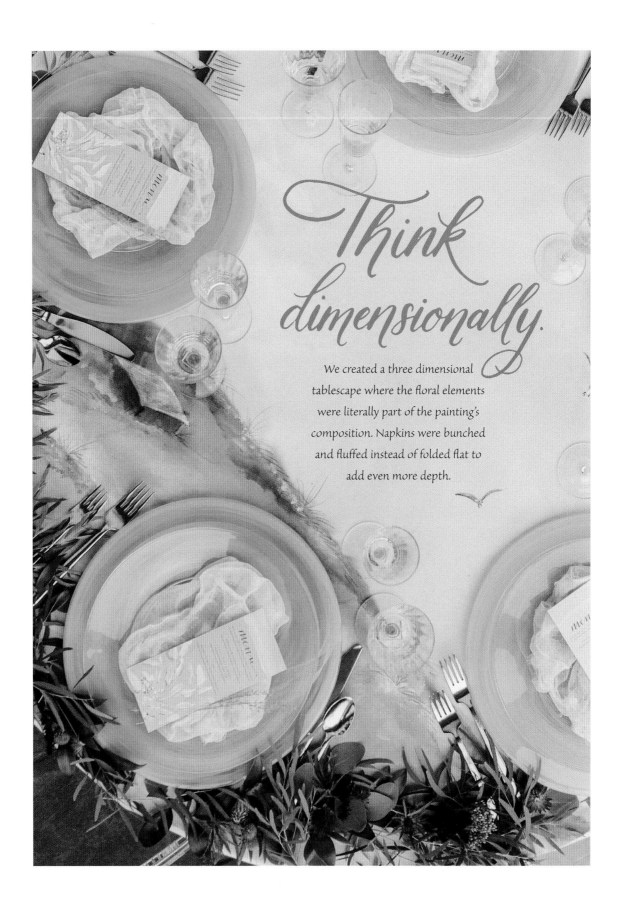

Think dimensionally.

We created a three dimensional
tablescape where the floral elements
were literally part of the painting's
composition. Napkins were bunched
and fluffed instead of folded flat to
add even more depth.

As a wedding designer, we are often tasked with bringing together ideas from all aspects: the bride, the bride's mother and friends, the venue's look and limitations, and so on. To create a gorgeous and, more importantly, cohesive affair, we must narrow our vision and ask our couples to do the same. Getting to the root of their relationship, to the very people they are inside . . . that's what inspires us and consequently, their wedding aesthetic. Crafting a wedding design based on a legendary American artist was second nature for us. We reached into his paintings to pull the colors, the feelings, the landscapes . . . and at the end of it, with Kristy's painterly touch, the design came together and evoked Edward Hopper's artistic intentions.

–SHANNON WELLINGTON
Shannon Wellington Weddings

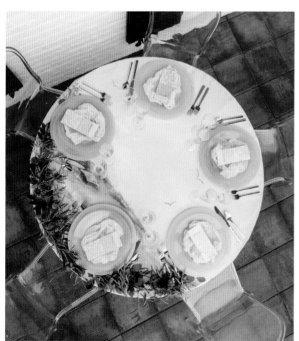

The tabletop and invitation became both a straightforward and more abstract homage to Edward Hopper's rich painting style. Each tabletop featured a painted canvas topper in the classic painterly style, while the invitations featured more abstract brushstrokes of the same style.

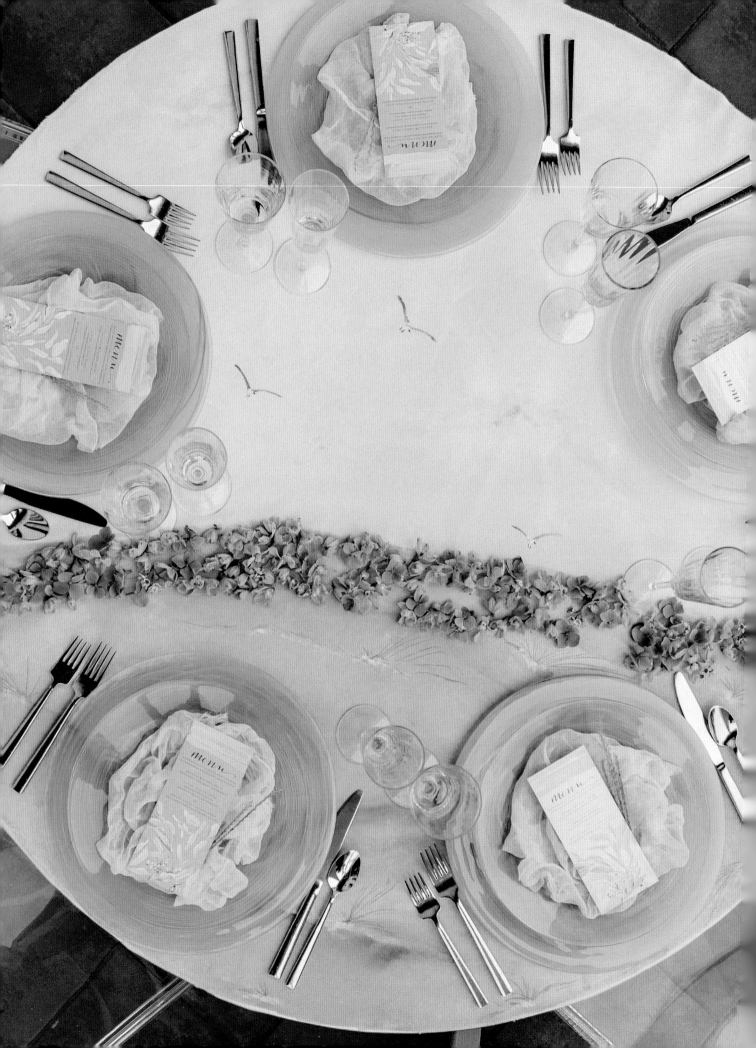

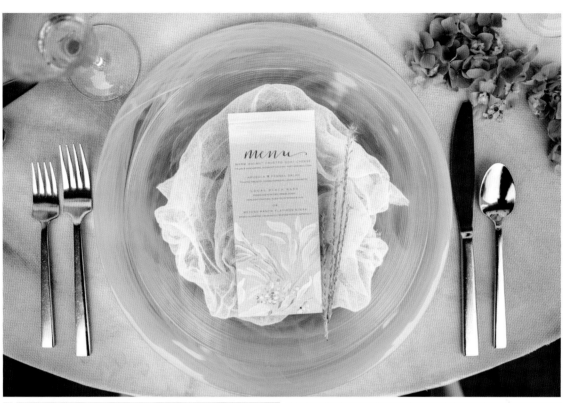

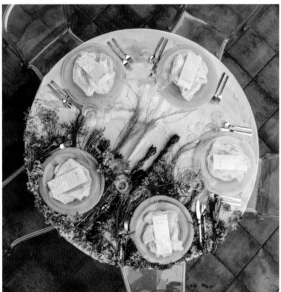

Each table featured a unique scene inspired by Hopper's seaside compositions. Dinner menus boasted individually hand-painted brushstrokes to represent the ocean and sky.

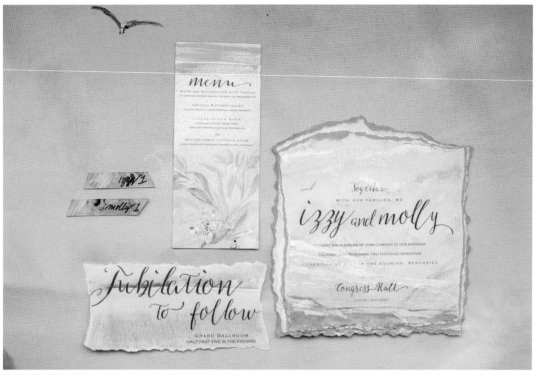

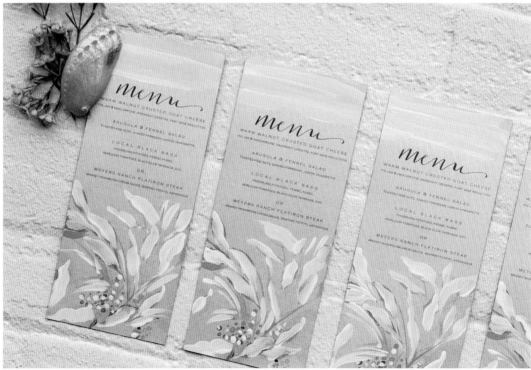

When using a painter as wedding design inspiration, a nearly endless stream of decor fodder awaits you. A painter's general style, color choices, personality, and even lifestyle can impact your choices. Look to the painter as a whole person to create an immersive design aesthetic.

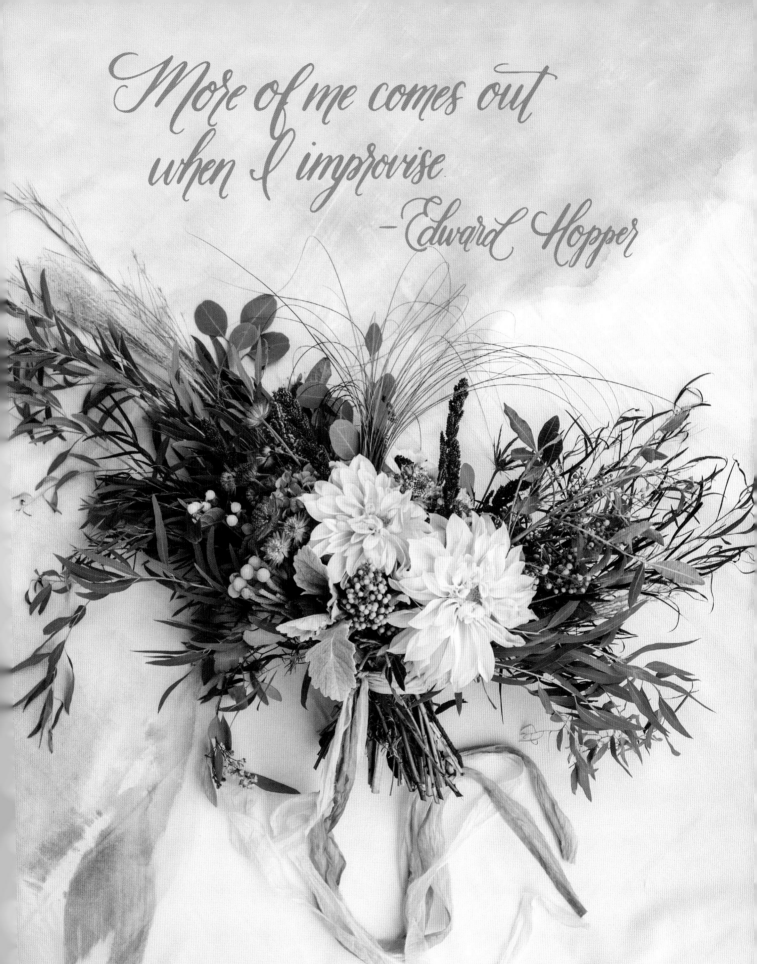

More of me comes out when I improvise.

—Edward Hopper

A shot list for your photographer is key, but give room for improvisation, for last minute experiments, and for additions to the shot list. Here, our bouquet was placed on a painted tabletop before all was set.

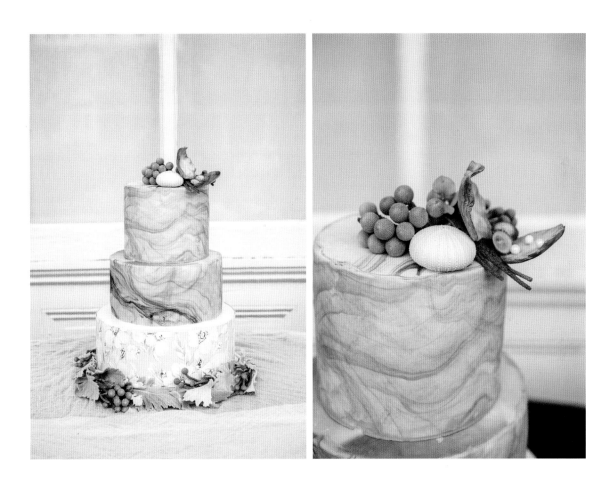

The cake offers endless opportunities to infuse mindful details and further express your design prowess. Here, we added a touch of the feminine with a heavily painted floral wrap around the cake's base layer along with a quirky oyster shell topper.

Use your instincts

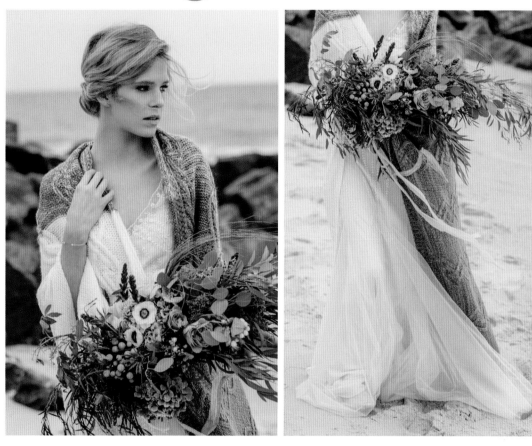

Our bride was cold as she posed with the wind whipping and waves crashing, so we wrapped her in a lofty throw. We felt as if Hopper himself could have been behind an easel instead of our photographer behind the camera.

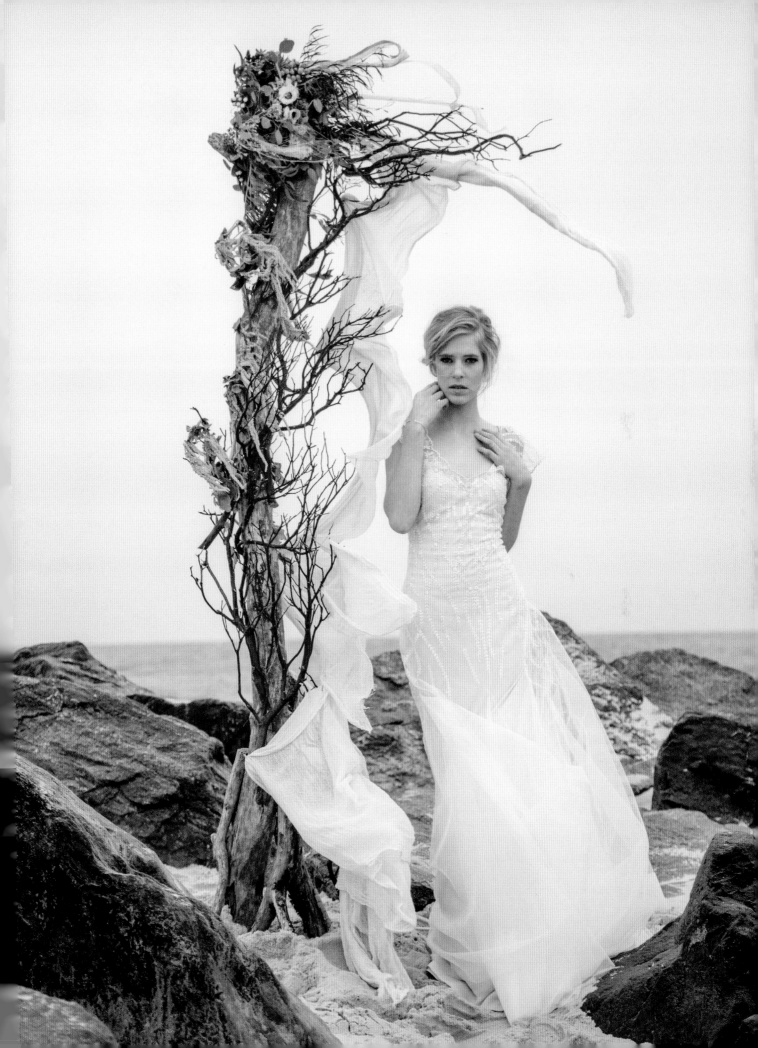

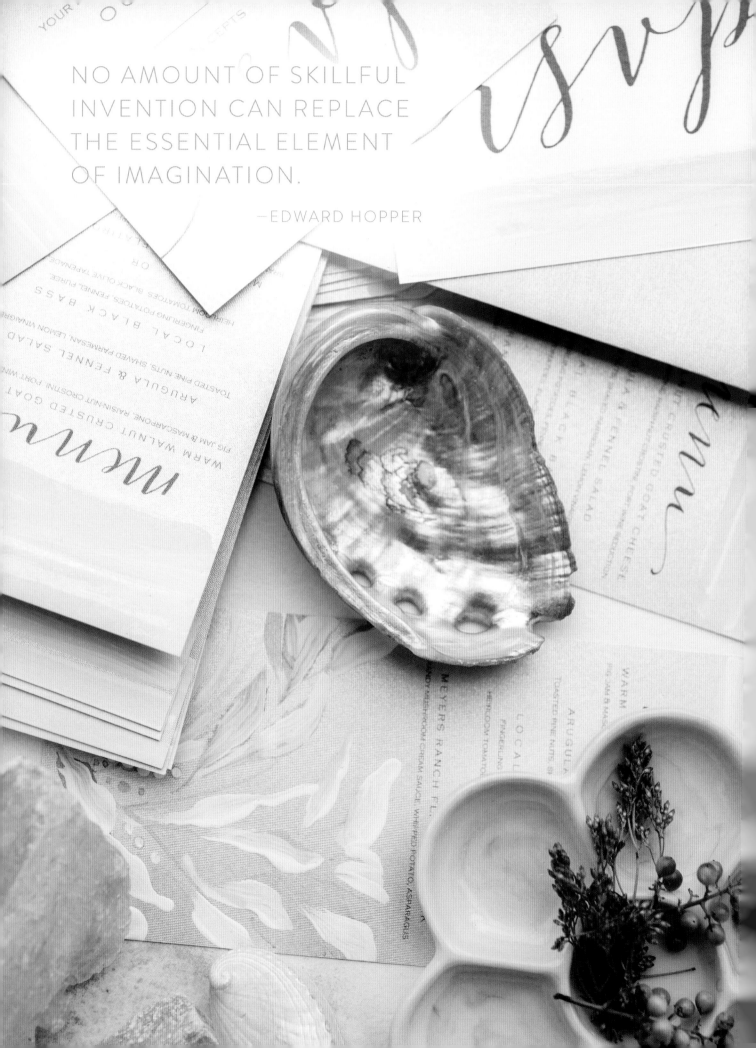

NO AMOUNT OF SKILLFUL
INVENTION CAN REPLACE
THE ESSENTIAL ELEMENT
OF IMAGINATION.

—EDWARD HOPPER

Color theory for color palettes

together
WITH OUR FAMILIES, WE

izzy and molly

Congress Hall

Complementary colors (opposite on the color wheel) do just that—they complement one another. For example, red/green, blue/orange, and purple/yellow; or better yet, pink/celery, slate/amber, and lavender/gold.

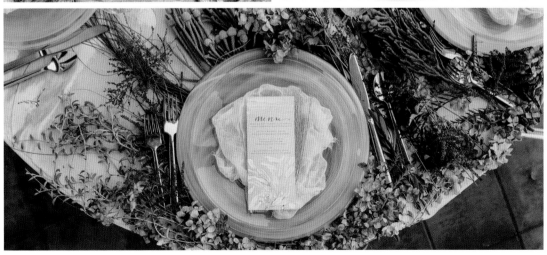

EACH SQUARE INCH OF AN ARTIST'S CANVAS IS AN OPPORTUNITY FOR INSPIRATION.

Here, we wanted to nod to the rich greens seen in so many of Hopper's seaside compositions. Our backdrop became a few simple leaves painted in the sand.

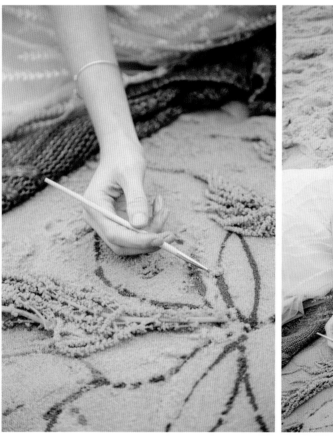 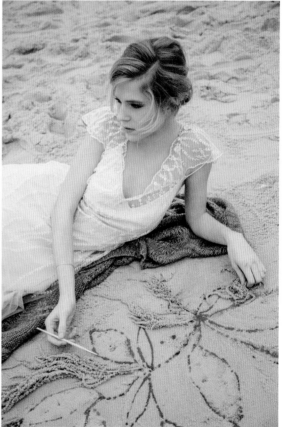

Often the most unexpected moments of a wedding day are those that juxtapose the mundane, like a sandy beach, with the remarkable painting in the sand. Our bride chose her moment and dove into it's possibilities. With her wrap laid down to protect the dress, she allowed herself a few minutes of wildness and abandon on a day filled with tradition and schedules. How will you make room for the unexpected on your day?

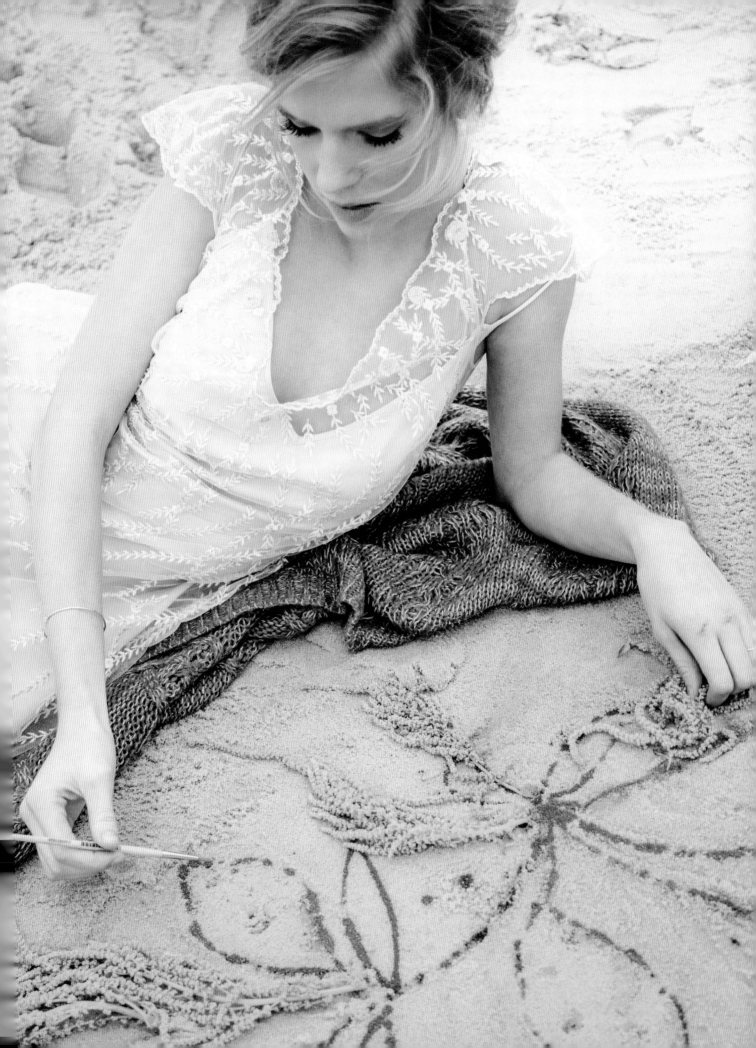

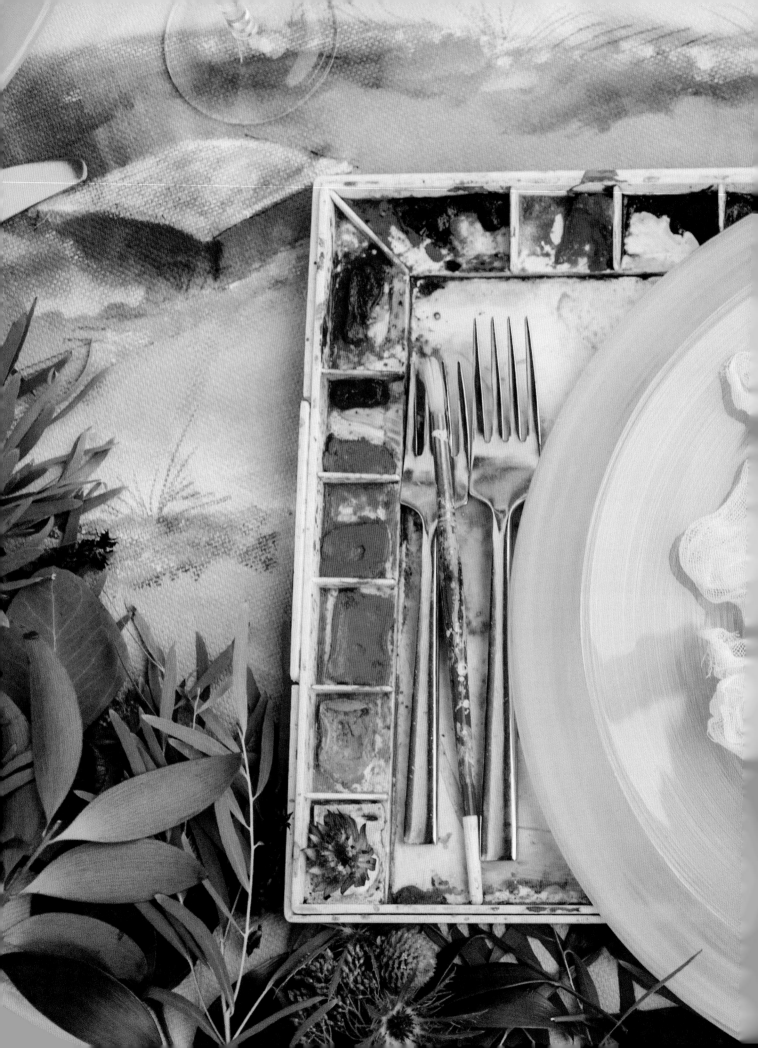

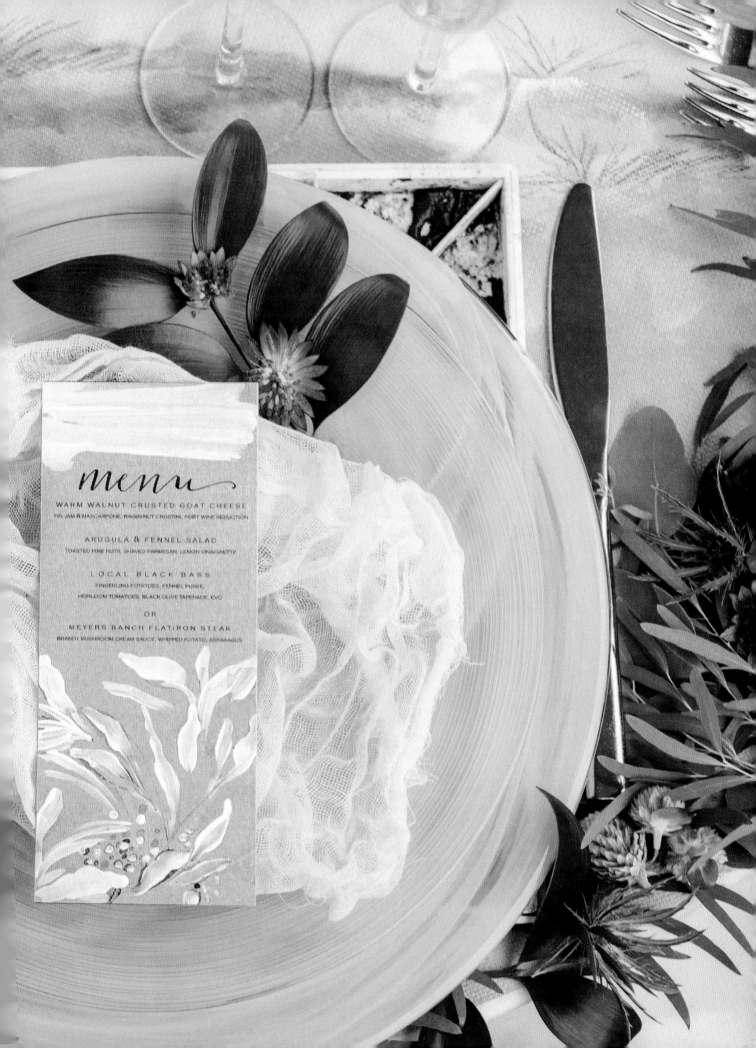

menu

WARM WALNUT CRUSTED GOAT CHEESE
FIG JAM & MASCARPONE, RAISIN NUT CROSTINI, PORT WINE REDUCTION

ARUGULA & FENNEL SALAD
TOASTED PINE NUTS, SHAVED PARMESAN, LEMON VINAIGRETTE

LOCAL BLACK BASS
FINGERLING POTATOES, FENNEL PUREE,
HEIRLOOM TOMATOES, BLACK OLIVE TAPENADE, EVO

OR

MEYERS RANCH FLATIRON STEAK
BRANDY MUSHROOM CREAM SAUCE, WHIPPED POTATO, ASPARAGUS

START WITH LOVE

PAINTERS REALIZE THE VALUE OF LOOKING
INWARD TO MOTIVATE THEIR CREATIVITY.

Edward Hopper

CONCEPT DEFINITION

Edward Hopper was an American painter who understood the power that love
holds to propel creative fervor. After years of searching for an artistic voice,
Hopper's creative vision was only ignited by the passions of finding his true
love. It was then that he sought after canvases filled with everyday scenes,
velvety in texture and rich in visual rhetoric. Filled with buttery color palettes
of blues, creams, and golden tones and just straddling the line between
saturated and not, Hopper's artwork made us feel at home and curious in the
same moment.

TANGIBLE DESIGN IDEAS INSPIRED BY THE DEFINITION

Matte finishes, seagrass textures, opalescent sheen, gauzy fabrics, soft
contrast color palette

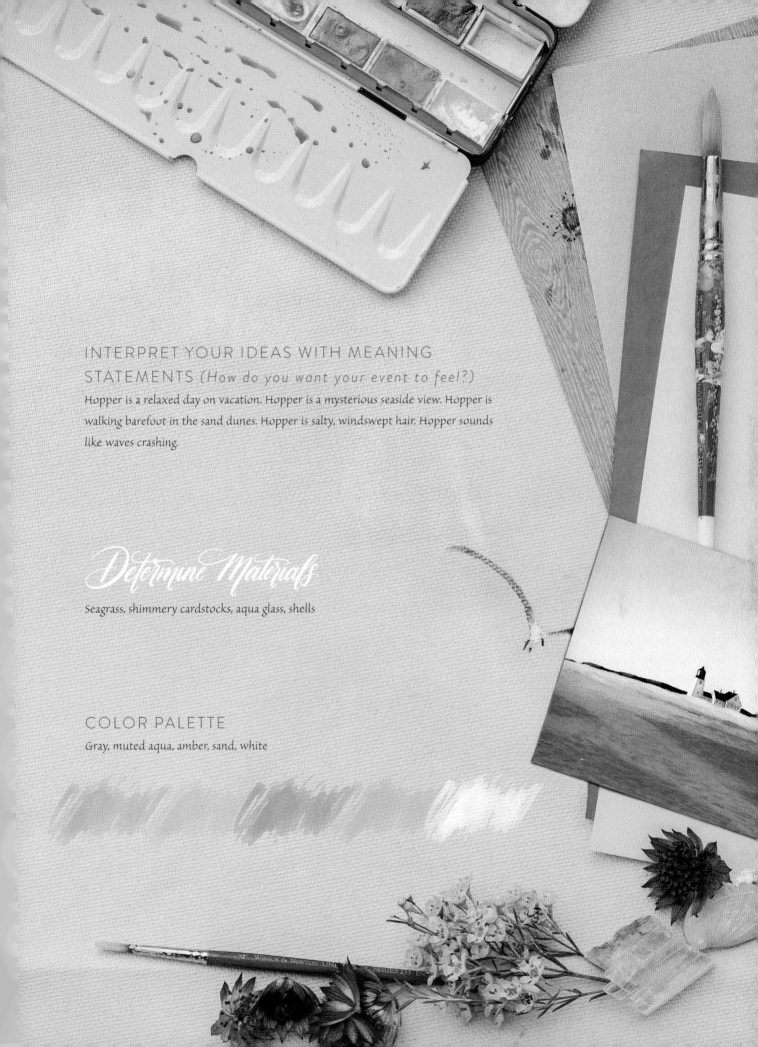

INTERPRET YOUR IDEAS WITH MEANING STATEMENTS *(How do you want your event to feel?)*

Hopper is a relaxed day on vacation. Hopper is a mysterious seaside view. Hopper is walking barefoot in the sand dunes. Hopper is salty, windswept hair. Hopper sounds like waves crashing.

Determine Materials

Seagrass, shimmery cardstocks, aqua glass, shells

COLOR PALETTE

Gray, muted aqua, amber, sand, white

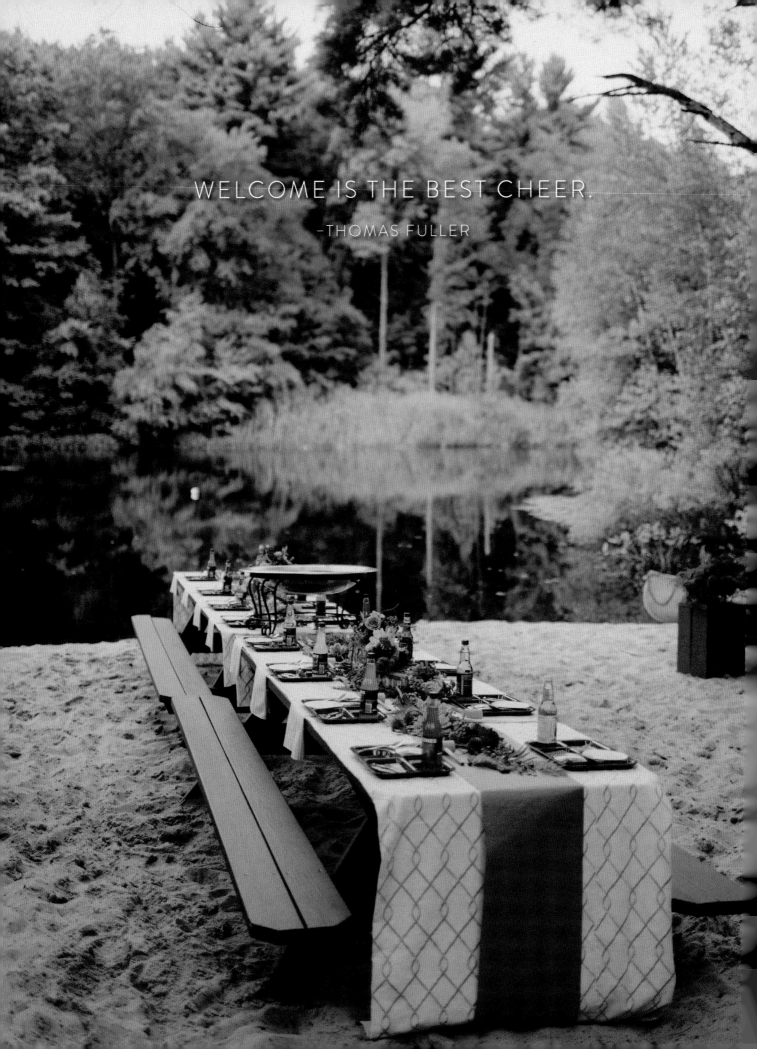

WELCOME IS THE BEST CHEER.

-THOMAS FULLER

A SPIROGRAPH LOBSTER BOIL WITH

Andy Warhol

Twin Ponds, Harding, Pennsylvania

Andy Warhol (1928–1987) could be described in countless ways—artist, illustrator, wild child, art innovator, and so on . . .

Mr. Warhol, though all these things, was first and foremost an instigator. He made things happen, forced us to think differently, and, above all, begged us to express ourselves thoughtfully. As a leader in the American pop art movement, where soup cans and other inanimate objects were elevated to high art, Warhol inspired a fascination with the magic and marvel of utilitarian objects that we all use regardless of status or income.

If you happen to be a child of the 80s, you might remember the original drawing toy, the Spirograph. Of course, the simple box full of curious plastic discs, colored pens, and paper have made a comeback, and regardless of your age, it's difficult to deny the fascination. Spirograph art seems to encapsulate a decade of fun . . . a time when simple pleasures gave way to the Wonder Bread and Slinky generation of consumerism. Events are supposed to be fun, it is a

celebration indeed, and remembering the fun, the imperfect joy that games and silly moments offer goes the distance in crafting an event that is both visually exciting and just a good time!

In this chapter, we begin with the Spirograph and the whimsical, festive art that results from the childish act of swirling your pen around a page. We recall the lessons Warhol taught in making something "wow!" out of seemingly uninspired objects. Learn from a festive celebration chock full of silly moments. There's something freeing about enjoying dessert served in your very own Wonder Woman lunch box or eating dinner on a plastic cafeteria tray, the likes of which you probably haven't seen since sixth grade. It's time to discover how these silly moments make guests feel loved and at home. We want guests to feel this way, even in a ballroom atmosphere, right?

Are you having fun yet?

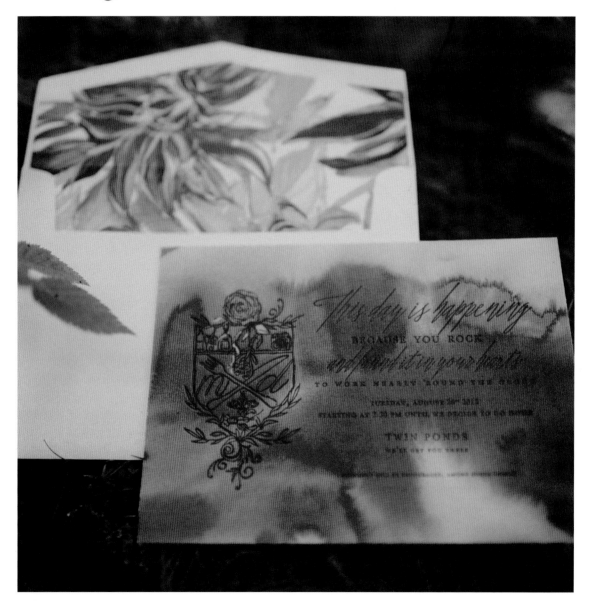

Don't take things too seriously, you'll have more fun that way. Pure and saturated color was a hallmark in much of Warhol's work. These bold, ink-splotched invitations are wonderfully Warhol.

Couples often come to me struggling with their wedding day color palette. They seem to have this preconceived notion that in order to achieve the perfect wedding day color palette, they have to match every single element, from the bridesmaid dresses to the linens and florals. My recommendation? Don't be afraid to color outside the lines a bit! Mix it up. Go with varying shades of one color or better yet, select an unexpected pairing of colors that will provide contrast and visual interest. Always remember that the goal shouldn't be to match every single detail. It's not a science. Rather, it's all about coordinating your colors, and finding a look that feels right.

–CHRISSY OTT

Editor/owner, *The Perfect Palette*

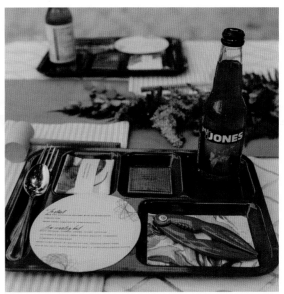

Here, a lobster bib becomes decor, a cafeteria tray transforms a traditional place setting, and a custom soda bottle takes the place of a more expected beverage, like wine or water.

ART IS WHAT YOU
CAN GET AWAY WITH.
Andy Warhol

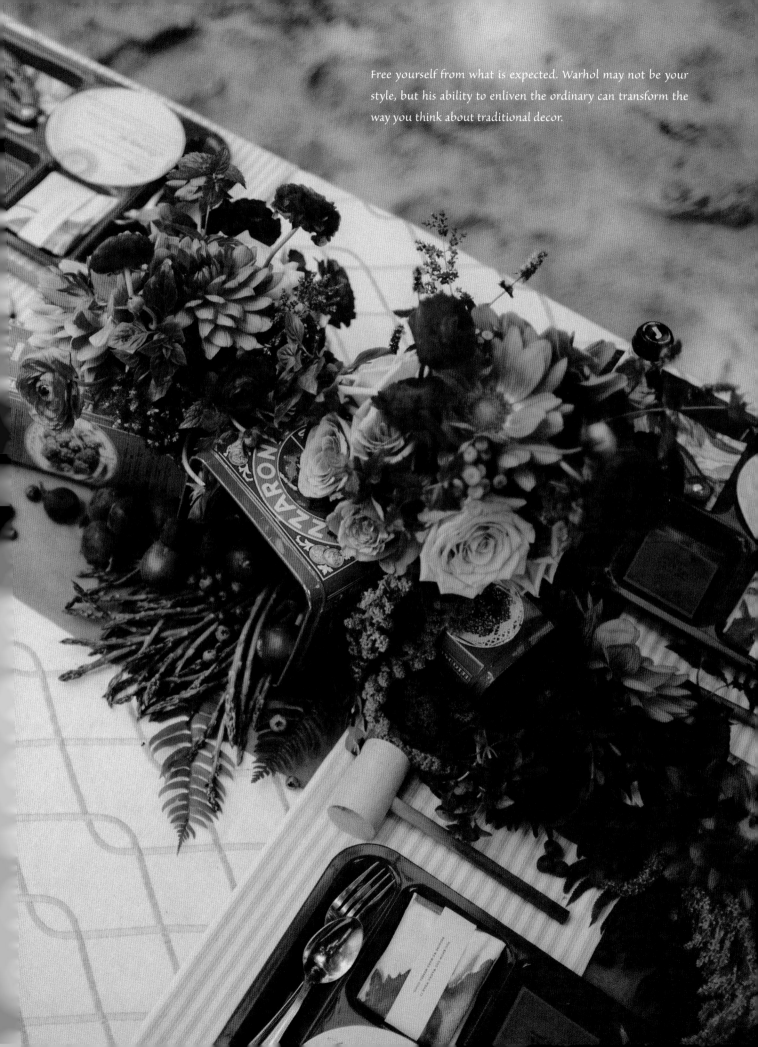

Free yourself from what is expected. Warhol may not be your style, but his ability to enliven the ordinary can transform the way you think about traditional decor.

Think in similarities not sameness.

Spirograph art only appeared once
in this event's decor, but similar qualities made an
appearance in the linens and invitations.

To start

CRAB AND ANDOUILLE FRITTERS WITH CILANTRO SAUCE

TOMATO PIES

FRIED GREEN TOMATOES W/ REMOULADE SAUCE

Low country boil

SPICY SAUSAGE, LOBSTER, SHRIMP, CLAMS, POTATOES

BUTTERMILK BISCUITS, SWEET POTATO BISCUITS, CORNBREAD

HOMEMADE HUSHPUPPIES

SWEET CORN BUFFET W/ MELTED BUTTER, CHOPPED FRESH HERBS,

BLACK SEA SALT, CAJUN SEASONING MIX + A GORGONZOLA/BACON BUTTER

SO, YOU LOVE PINK DAHLIAS?

This doesn't mean that pink dahlias need appear on every possible surface. What reminds you of pink dahlias? Their
petals and compact shape? A richly colored silk ribbon, perhaps, or a woven textile in the perfect shade of pink?

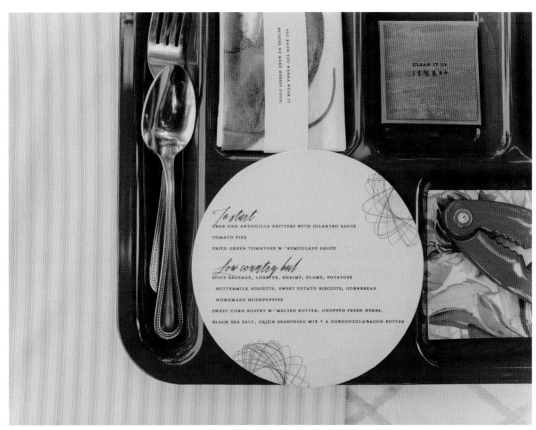

To start
CRAB AND ANDOUILLE FRITTERS WITH CILANTRO SAUCE

TOMATO PIES

FRIED GREEN TOMATOES W/ REMOULADE SAUCE

Low country boil
SPICY SAUSAGE, LOBSTER, SHRIMP, CLAMS, POTATOES

BUTTERMILK BISCUITS, SWEET POTATO BISCUITS, CORNBREAD

HOMEMADE HUSHPUPPIES

SWEET CORN BUFFET W/ MELTED BUTTER, CHOPPED FRESH HERBS,

BLACK SEA SALT, CAJUN SEASONING MIX + A GORGONZOLA/BACON BUTTER

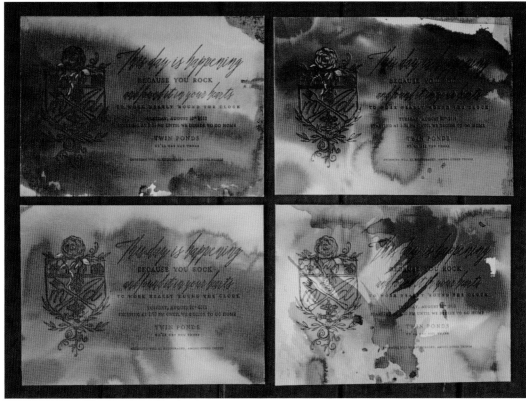

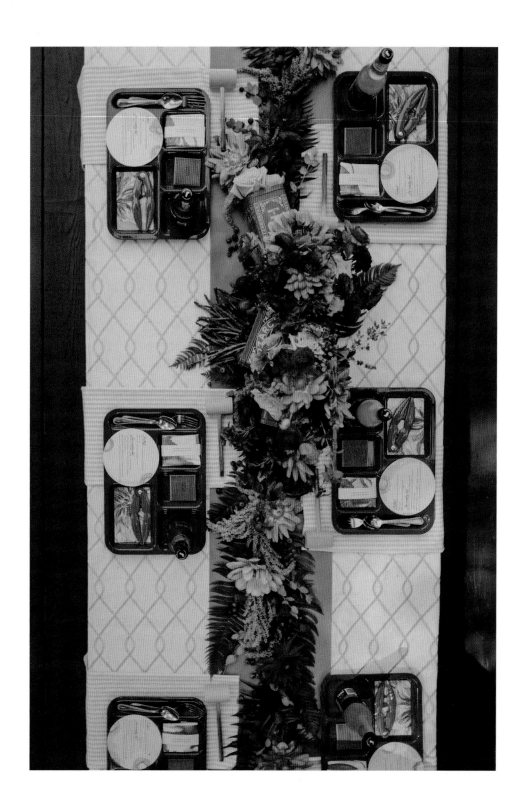

Pop art was a movement where beauty and fascination was found in everyday objects. Here, biscuit tins were used as vases, butcher paper became a table runner, asparagus was used as floral greens, and lobster mallets were watercolored in shades of bright pink.

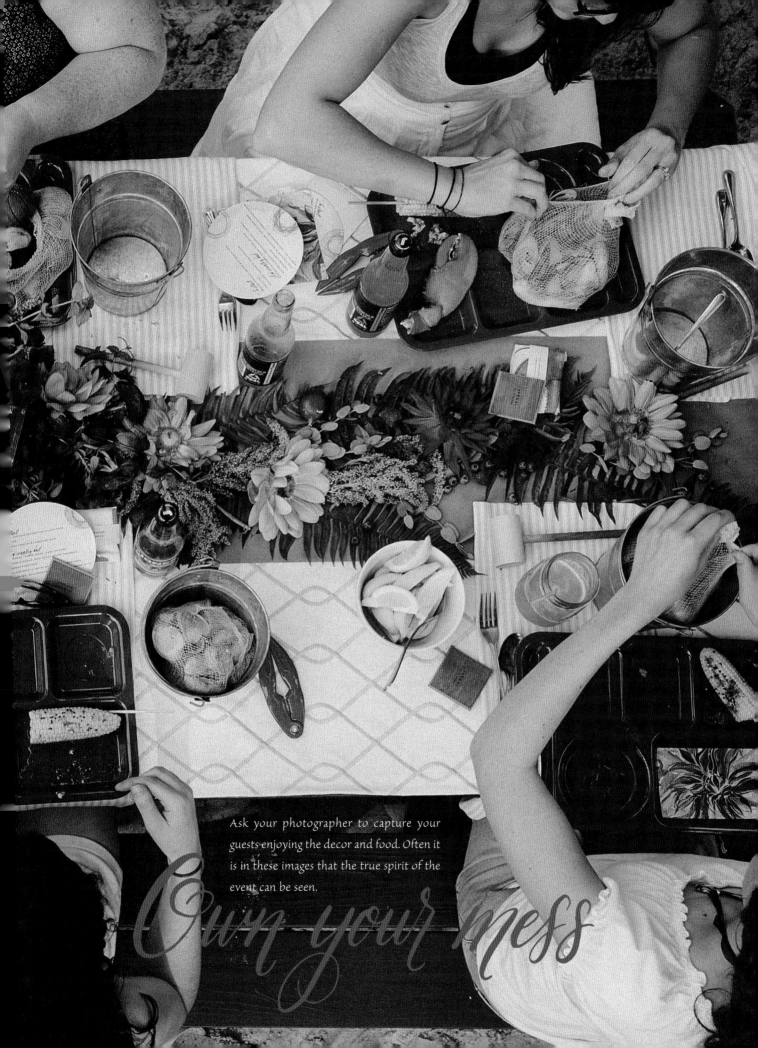

Ask your photographer to capture your guests enjoying the decor and food. Often it is in these images that the true spirit of the event can be seen.

Own your mess

In the 80s, it was incredibly popular to have your portrait stylized a la Warhol in nearly neon palettes repeated in various colors.

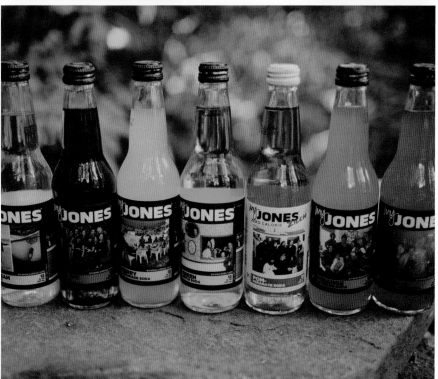

Marilyn Monroe's version of this look is probably the most recognizable example. So, as a spin on this concept, we used images of the guests on Jones soda bottle labels with brightly colored soda inside!

Savor
MANAGEABLE MOMENTS OF DIY

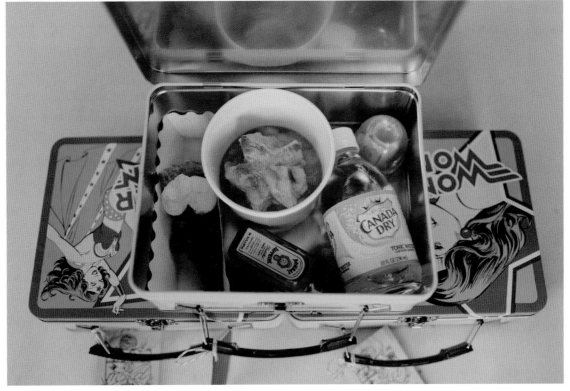

Too much DIY can ruin the fun! Here, we filled Wonder Woman lunch boxes with desserts galore. Simple, easily made favor tags were tied on with baker's twine.

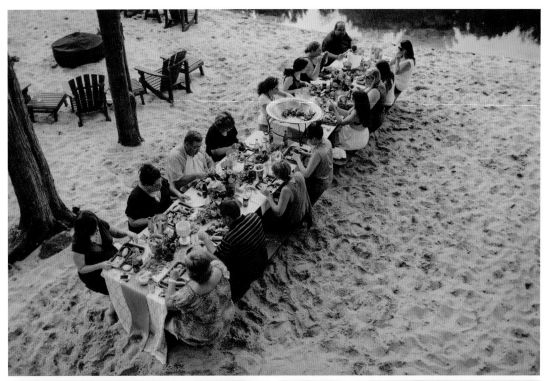

LIFE DOES NOT HAVE TO BE PERFECT
TO BE WONDERFUL.

–ANNETTE FUNICELLO

Believe me, my friend, there is nothing—absolutely nothing—half so much worth doing as simply messing about the boats

Kenneth Grahame

THE WIND IN THE WILLOWS

THINK LIKE A PAINTER

NEVER FORGET TO HAVE FUN
PAINTERS PLAY, THEY EXPERIMENT, THEY REVEL.

Andy Warhol

CONCEPT DEFINITION

When I think of how much fun making art can be, Andy Warhol comes to mind. His strong, colorful portrait canvases and painted homage to soup cans spoke of fun and a lighthearted approach to life if we examine them from a purely visual perspective. So what does it take to produce a fun event? Fun equals comfort food, surroundings, and warm memories. Comfortable guests are happy guests!

TANGIBLE DESIGN IDEAS INSPIRED BY THE DEFINITION

Bright bold colors contrasted by earthy neutrals, whimsical art details, ink-based watercolor artwork, kitschy place settings

INTERPRET YOUR IDEAS WITH
MEANING STATEMENTS
(How do you want your event to feel?)

Fun events are bustling. Fun events are delicious. Fun events make you feel at home. Fun events remind you of beloved shared memories. Fun events are full of surprises!

Determine Materials

Red melamine, dahlias, butcher paper, Spirograph art, vintage tins

COLOR PALETTE

Red, fuchsia, electric blue, grass green, white

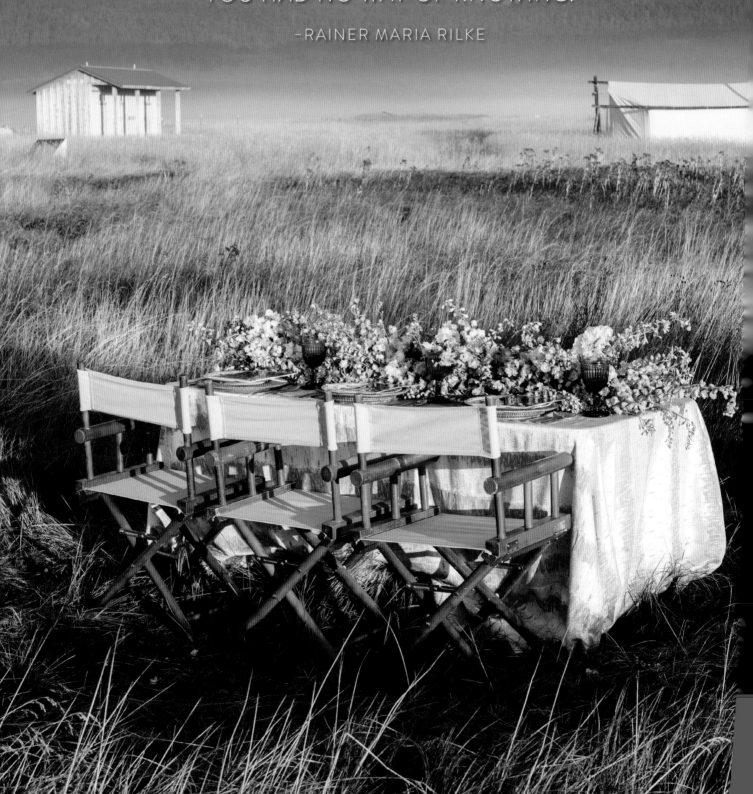

OH, THE JOYS OF TRAVEL! . . . TO FEEL THAT SOMETHING IN YOUR HEART, SOMEHOW INDIGENOUS TO THIS NEW LAND IS COMING TO LIFE FROM THE MOMENT OF YOUR ARRIVAL. YOU FEEL YOUR BLOOD INFUSED WITH SOME NEW INTELLIGENCE, WONDROUSLY NOURISHED BY THINGS YOU HAD NO WAY OF KNOWING.

–RAINER MARIA RILKE

Moran's

YELLOWSTONE

 ### West Yellowstone, Montana

Thomas Moran's (1837–1926) expedition sketches helped shape the Yellowstone National Park we know today.

His paintings uncovered the scope and sheer scale of lands that no oral description could ever accurately describe. Yellowstone was Moran's love, and to many he is considered the Father of Yellowstone National Park. Moran possessed the uncanny ability to capture color in ways that celebrated the colliding of subtlety and boldness, somehow always simultaneously in play around Yellowstone.

Artists are able to capture subtlety, to be aware of quiet moments surrounding them because time is taken, eyes are open, and their minds are willing. This chapter is designed to reveal how Thomas Moran's painting expeditions can inform our journey in wedding design. I'm sure we can agree that discovering a place in real time, versus through photos online, can be infinitely more enlightening. Wedding venues are chosen for myriad reasons, but destination couples seem to have a deeper connection to their choices. So put the time and effort in to become intimately acquainted with the lands and spirit of your venue.

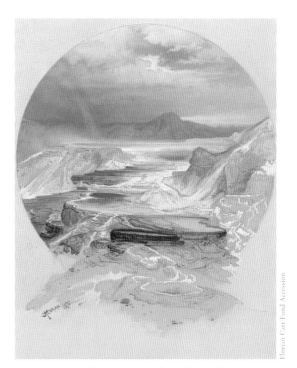

Minerva Terrace, Yellowstone, watercolor and gouache over graphite on blue, 1872, Thomas Moran

Florian Carr Fund Accession

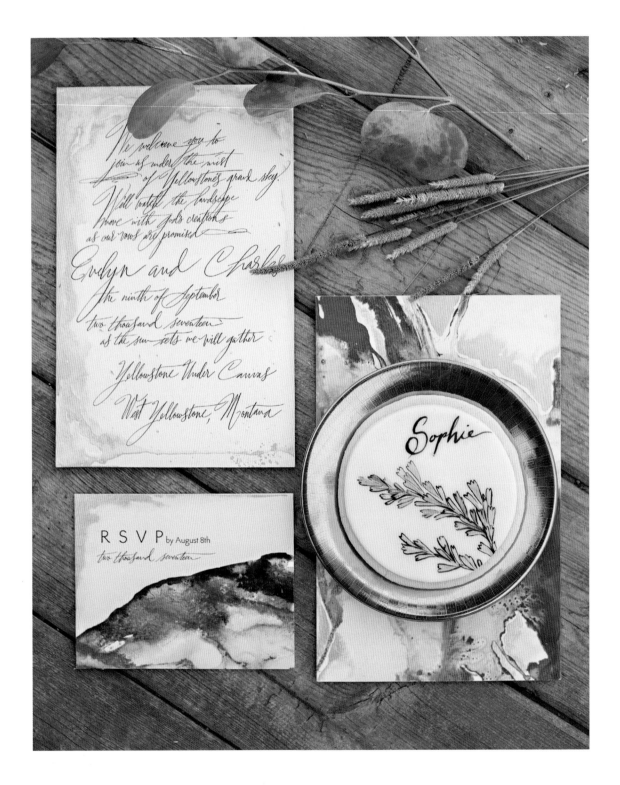

The geysers of Moran's Yellowstone are filled with unexpected color, especially on sunny days. Inspired by the mineral deposits that afford these colors amidst the quiet of nature, the invitation features more abstract artwork in textural bursts.

Venue choice influences the rest of the entire event experience. It influences how the guests will feel, how far they will travel, and the adventures that they will have in the surrounding area. What will the temperature be like? Will they bundle up with cozy wraps around a crackling fire in the mountains, or will they walk around in balmy breezes barefoot?

Venue choice is selecting the canvas for the entire celebration. The music, the decor, the design, the food are all layers and layers of artwork influenced by the event space. These elements bring the space to life, much like a canvas comes more and more alive with each brushstroke. A desert venue with vast open views washed in a palette of browns, terracottas, and rock striations will possibly lead one to design a soft neutral celebration influenced by these colors and textures. A beach venue set on a sandy shore with blue sparkling waters lapping at your toes will perhaps lead one to host an alfresco dinner party with tropical touches and a soft palette that blends into the sea. A loft event space set in the heart of a bustling city with a glittering skyline will influence a more formal affair with contemporary touches. Your event space is just that—a space to be filled up with personal touches.

–CORTNIE PURDY-FAUSNER
Founder of The Venue Report

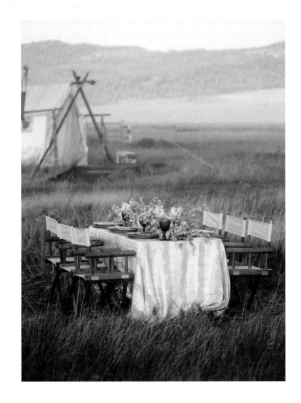

Get out there

Painters in national parks were hikers. They traveled for hours on foot, scouting the perfect spot before setting up their mobile studio. Get out on foot, explore your venue, smell the air, see what's blooming, what critters peek out from behind trees, how does the land elevate around you? It will be these discoveries that help you to express the venue's heart and soul in your decor.

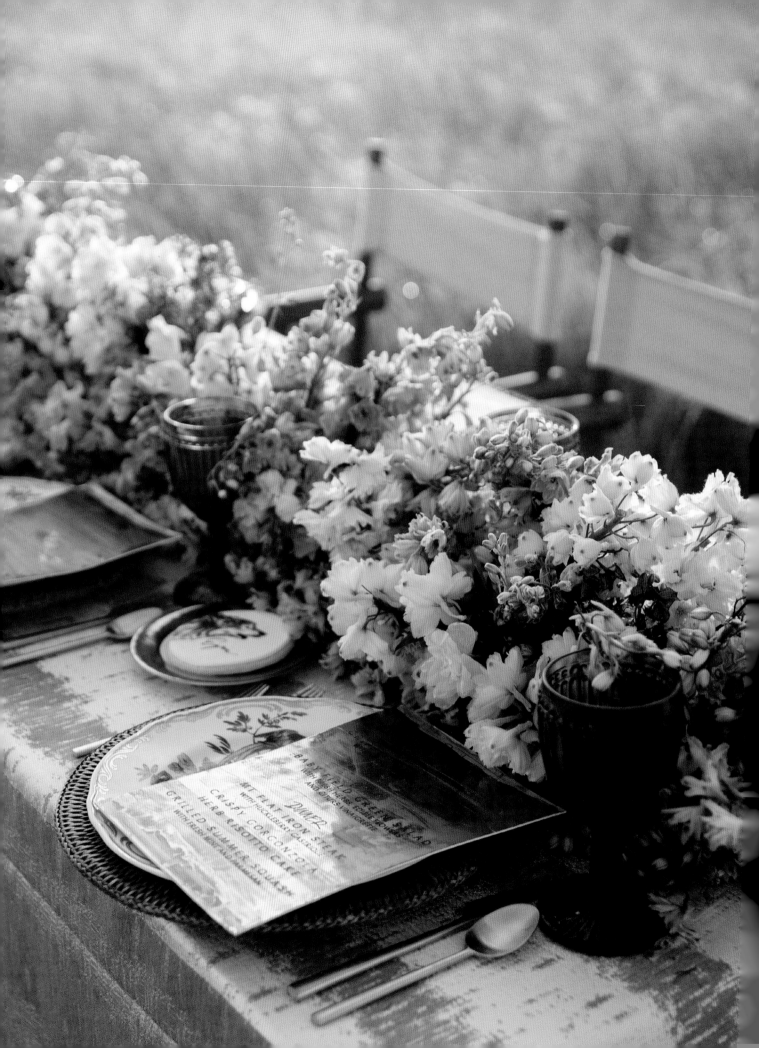

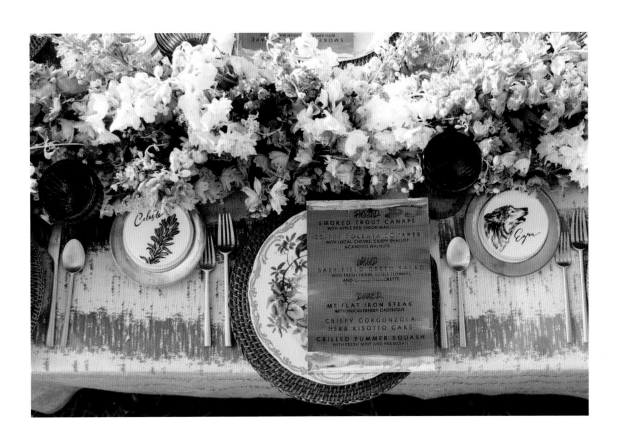

Lupine is an iconic flower indigenous to Yellowstone Valley, so the centerpieces here were crafted to resemble a field of these mountainous blooms.

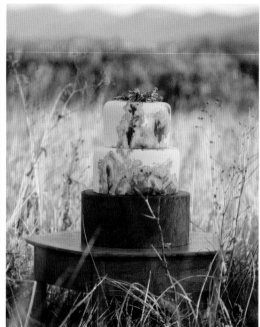

Imagining yourself as the painter's muse, or model shall we say, is a powerful way to spark creative ideas. How might Moran have dressed a bride in Yellowstone? What choices would he have made? Where in Yellowstone National Park would you photograph a cake painted by Moran? Would he choose linens that were solid, sparkling, or those that boasted a textural, velvety finish?

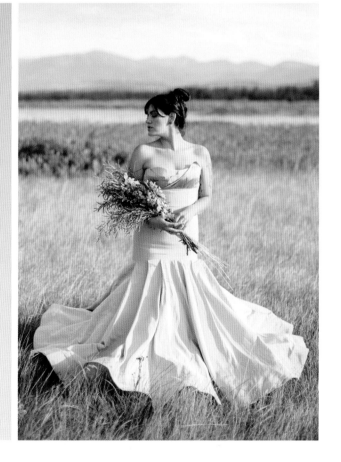

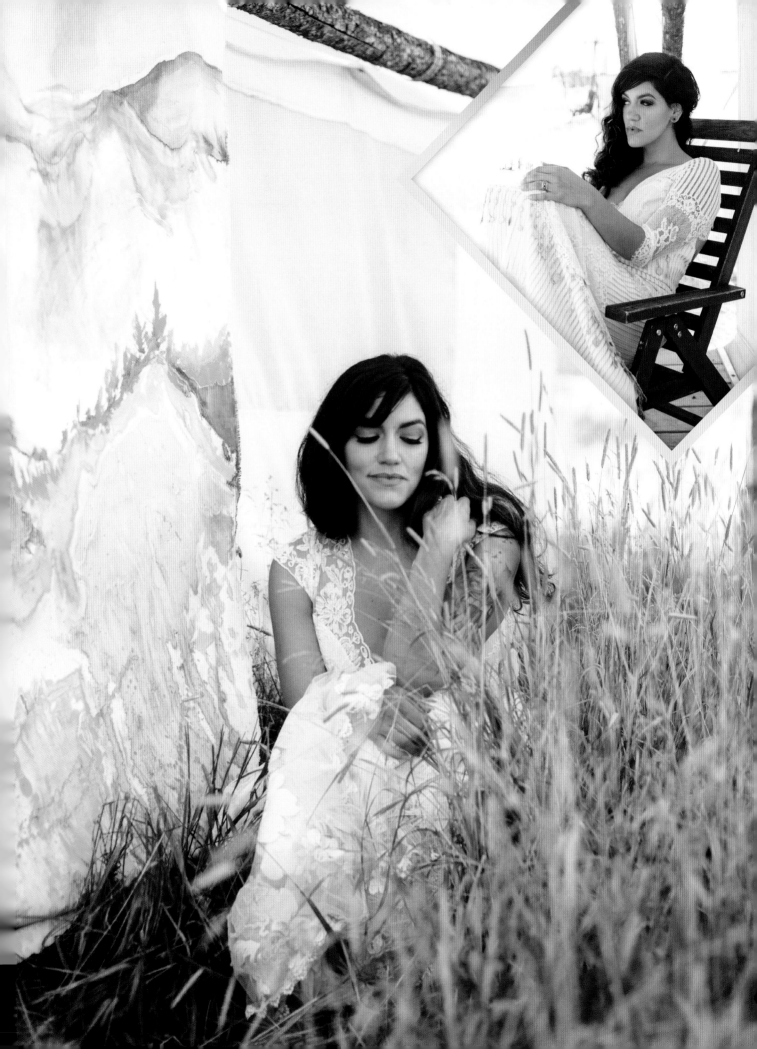

Using brushstrokes that mimicked some of Moran's more spirited canvases, we created a backdrop perfect for a ceremony or just a pretty portrait, like the one seen here.

YOU BELONG AMONG THE WILDFLOWERS . . . YOU BELONG SOMEWHERE YOU FEEL FREE.

–TOM PETTY

Painted cookies doubled as favors and place cards and, like the centerpieces, we again called on indigenous flora for subject matter.

In art... knowledge is power...

I MUST KNOW THE GEOLOGY.
I MUST KNOW THE TREES AND THE
ATMOSPHERE AND THE MOUNTAIN
TORRENTS AND THE BIRDS THAT FLY IN
THE BLUE ETHER ABOVE ME.

–THOMAS MORAN

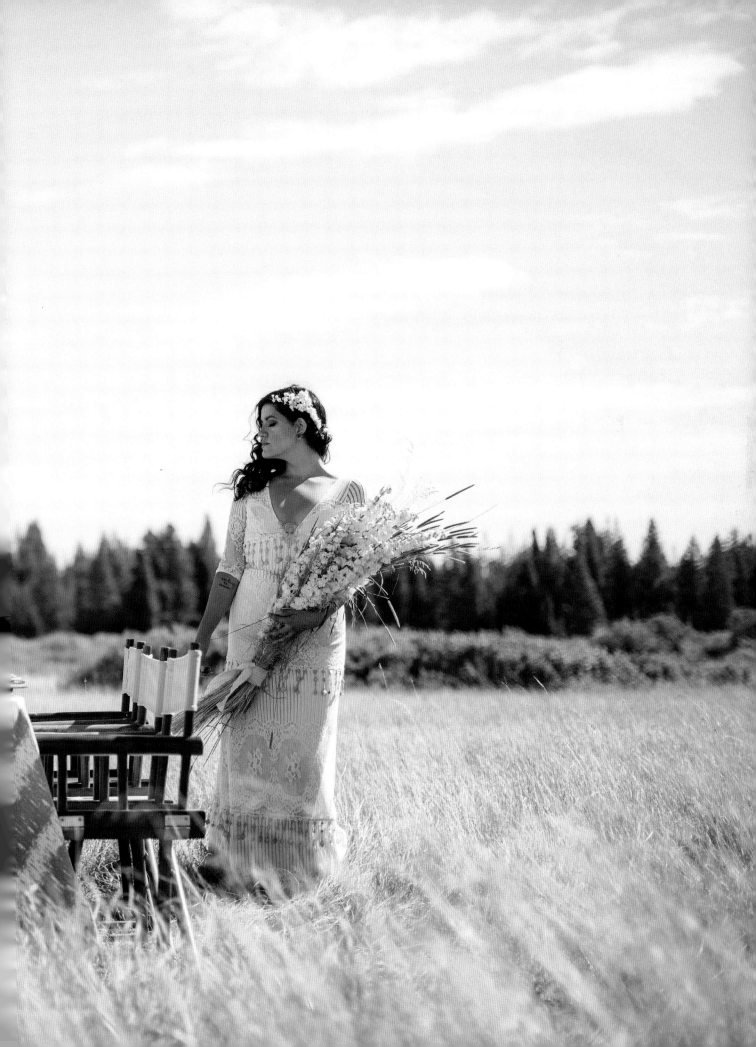

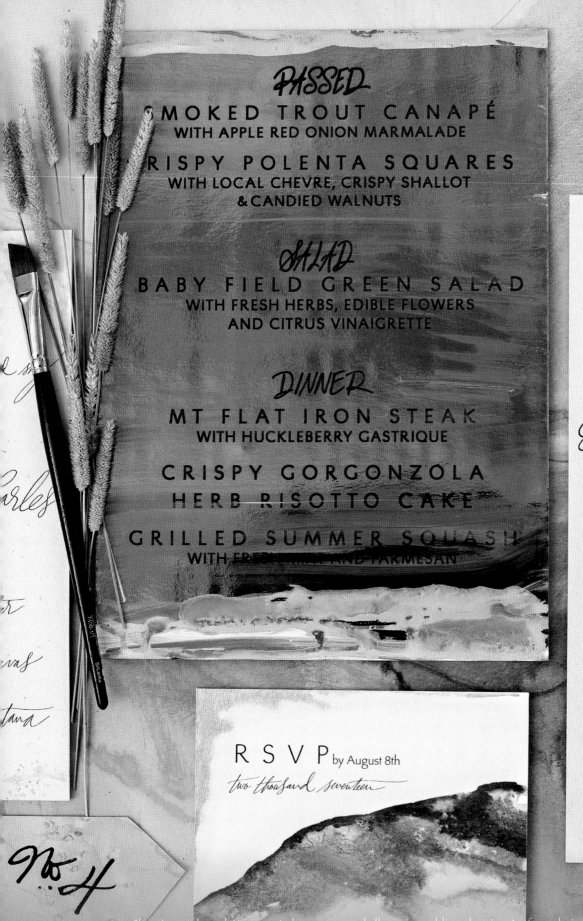

PASSED

SMOKED TROUT CANAPÉ
WITH APPLE RED ONION MARMALADE

CRISPY POLENTA SQUARES
WITH LOCAL CHEVRE, CRISPY SHALLOT
& CANDIED WALNUTS

SALAD

BABY FIELD GREEN SALAD
WITH FRESH HERBS, EDIBLE FLOWERS
AND CITRUS VINAIGRETTE

DINNER

MT FLAT IRON STEAK
WITH HUCKLEBERRY GASTRIQUE

CRISPY GORGONZOLA
HERB RISOTTO CAKE

GRILLED SUMMER SQUASH
WITH FRESH BASIL AND PARMESAN

09.09.17

Evelyn and C

PARENTS OF THE
BRIDE

Joseph Orrico
Amy Martelli

MAID OF HONOR

Alison Orrico

BRIDESMAIDS

Lisa Lagomarsino Torres
Jenny Boyc
Courtney Arki
Evana Pagano
Heather Viggiani

FLOWER GIRL

Meredith Jones

OFFICIANT

David Gerbitz

PARENTS
THE GR

Ronald &
Suzanne

BEST M

Chris &

GROOM

Joseph C
Jason Pa
Thomas
Brandon
Andy H

RING B

Graham
Brennan
Braden

TO OUR FAMILY AND FRIENDS, TH

It means the world to us to have yo
Thank you for being our support sy
Our encouragement. Our partners
For loving us through the ups and t
For being our mentors, teachers, a

RSVP by August 8th
two thousand seventeen

Choosing a color palette seems to be a common challenge in wedding planning. As if our choices lock us into a few hued options, any deviation starts to feel wrong. Thinking like a painter when it comes to color gives you the freedom to work within shades of color to arrive at a more natural palette that feels slightly eclectic but effortless just the same.

See in shades of a color.

Andrea	No. 4	Barbara	No. 6
Leonard	No. 6	Samuel	No. 1
Ralph	No. 5	Mariel	No. 5
Charles	No. 1	Fiona	No. 3
Alexandra	No. 4	Eleanor	No. 5

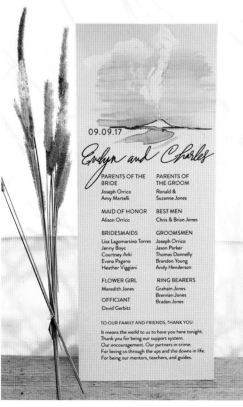

09.09.17

Evelyn and Charles

PARENTS OF THE BRIDE	PARENTS OF THE GROOM
Joseph Orrico	Ronald &
Amy Martelli	Suzanne Jones
MAID OF HONOR	**BEST MEN**
Alison Orrico	Chris & Brian Jones
BRIDESMAIDS	**GROOMSMEN**
Lisa Lagomarsino Torres	Joseph Orrico
Jenny Boyc	Jason Parker
Courtney Arki	Thomas Donnelly
Evana Pagano	Brandon Young
Heather Viggiani	Andy Henderson
FLOWER GIRL	**RING BEARERS**
Meredith Jones	Graham Jones
	Brennan Jones
OFFICIANT	Braden Jones
David Gerbitz	

TO OUR FAMILY AND FRIENDS, THANK YOU.

It means the world to us to have you here tonight.
Thank you for being our support system.
Our encouragement. Our partners in crime.
For loving us through the ups and the downs in life.
For being our mentors, teachers, and guides.

Calling on Moran's love of the natural, seating cards were printed on curly maple wood veneer and dip dyed to create a mountainous silhouette. Handwritten calligraphy on each lends the impression that Moran could have penned these himself.

A simple program featuring hand-painted artwork of Old Faithful, Yellowstone's most popular geyser. Just a hint of the invitation's bold reds and blues are evident.

Outdoor painters learned weather patterns along with sunrise and sunset times so to have optimal conditions for their painting sessions.

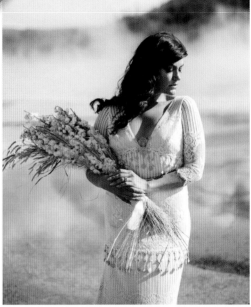

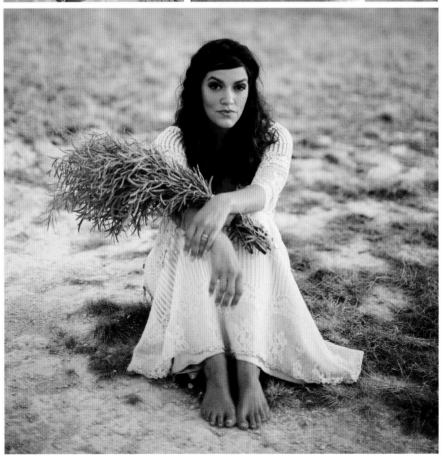

Remember the light Collaborate with your photographer to determine the best light for portraits.

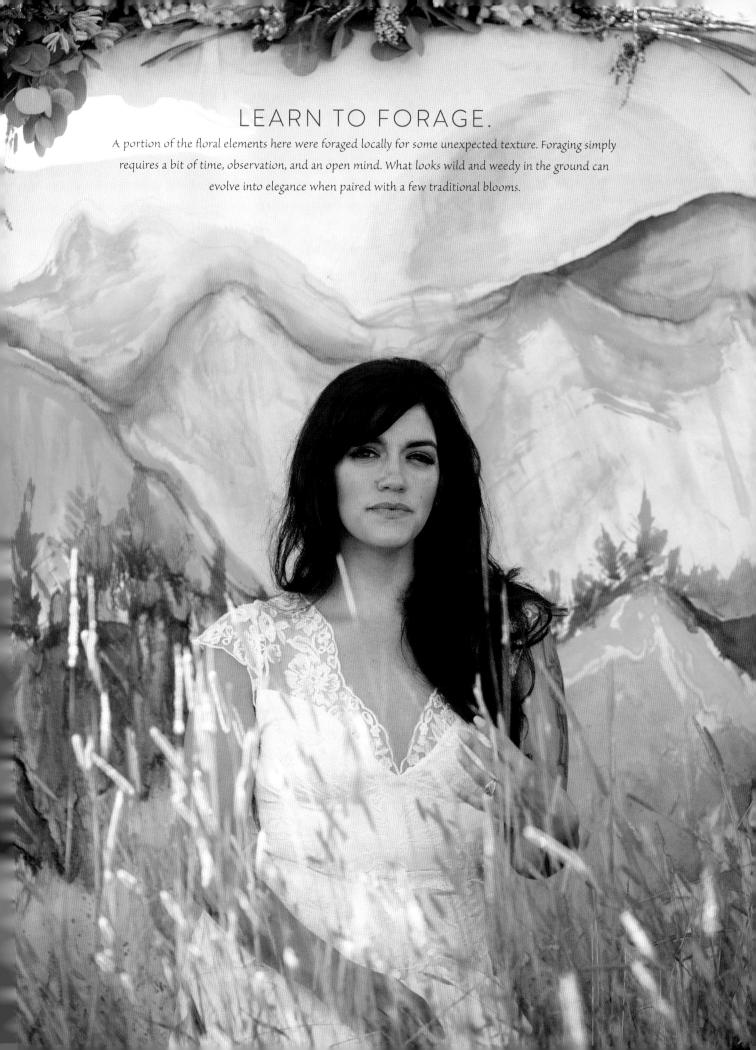

LEARN TO FORAGE.

A portion of the floral elements here were foraged locally for some unexpected texture. Foraging simply requires a bit of time, observation, and an open mind. What looks wild and weedy in the ground can evolve into elegance when paired with a few traditional blooms.

Think in the abstract

Thomas Moran painted the trees, terraces, and geysers of Yellowstone, but to be inspired by his works doesn't require you to use trees, terraces, and geysers as specific imagery in your decor. Terrace inspiration could lead to a unique bar display, geyser inspiration to an unexpected wedding cake design, and tree inspiration could transform into a portrait location choice.

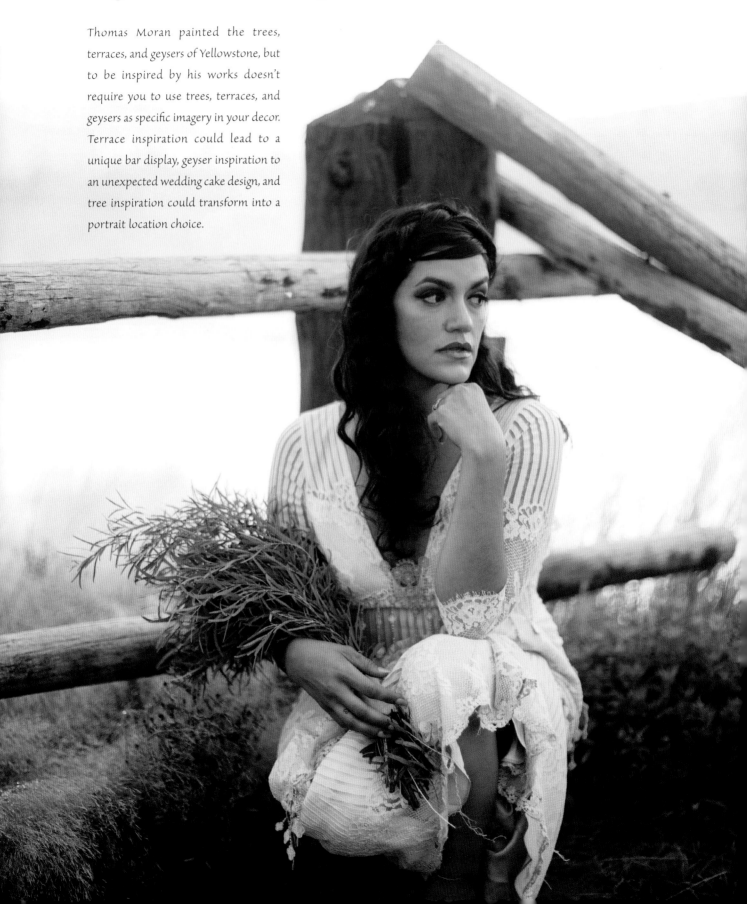

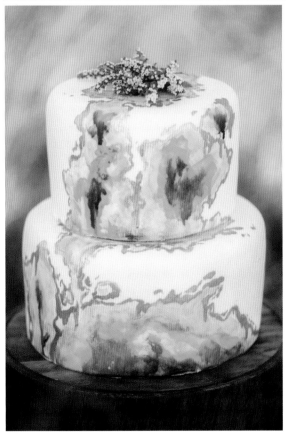

THINK LIKE A PAINTER

STEP AWAY FROM THE SCREEN
Painters launch expeditions, so can you.

Moran's Yellowstone
CONCEPT DEFINITION

Thomas Moran was more than a painter. He was part of many expeditions in and around Yellowstone meant to traverse the land, documenting his findings through careful journeys and consistent journaling. In essence, Thomas Moran was called upon for his ability to be perceptive. He discovered endless crags and crevices, where blue sky met with the rainbow of colors present in a treasure trove of natural geysers.

TANGIBLE DESIGN IDEAS INSPIRED BY THE DEFINITION

Rocky-like textures, rugged wood, reflective and slightly shimmery finishes, explosive watercolor textures

INTERPRET YOUR IDEAS WITH MEANING STATEMENTS (How do you want your event to feel?)

Yellowstone is expansive. Yellowstone is bright. Yellowstone is full of natural energy. Yellowstone is a glowing sunrise each morning. Yellowstone feels majestic and otherworldly.

Determine Materials

Cottony papers, rattan, canvas, neutral sequins, curly maple wood

COLOR PALETTE

Golden wheat, orange, yellow, sky blue,
accents of purple

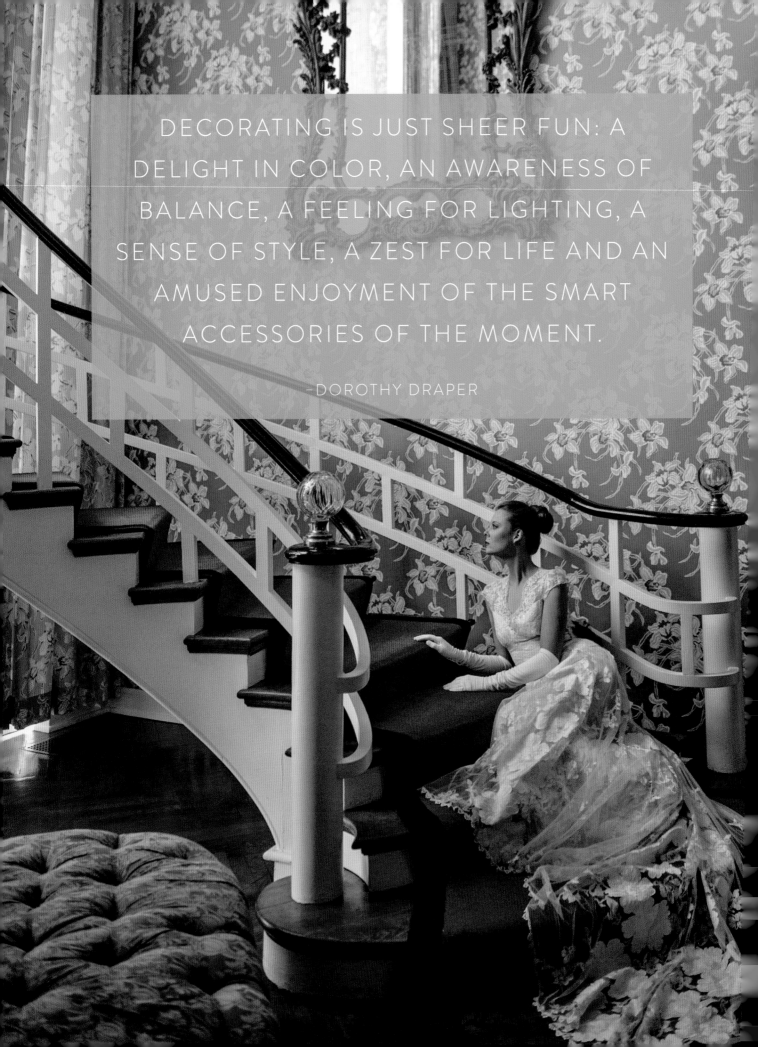

DECORATING IS JUST SHEER FUN: A DELIGHT IN COLOR, AN AWARENESS OF BALANCE, A FEELING FOR LIGHTING, A SENSE OF STYLE, A ZEST FOR LIFE AND AN AMUSED ENJOYMENT OF THE SMART ACCESSORIES OF THE MOMENT.

–DOROTHY DRAPER

Dorothy Draper's

GREENBRIER

White Sulpher Springs, West Virginia

Dorothy Draper (1889–1969), it seems, never worried much.

She resisted concepts held in high esteem by mainstream designers of her time. She pushed back on the traditional and ideas of "doing things correctly." Draper honored instinct, intuition, rule breaking, and boldness in an age where everyday conformists were at home in their drab surroundings. Ms. Draper, just like any painter, began conceptualizing with pen, paper, and brush. The difference? Her sketches came to life quite literally in her interior design.

When commissioned by properties, she took charge without apology and let her vision permeate every aspect of design—from architecture and furniture design to menu layout and dinnerware patterns. She was the art director of her projects before the position

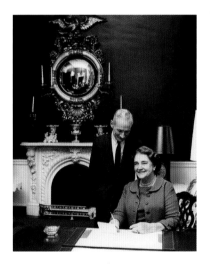

Courtesy of The Greenbrier

was completely understood and widely used.

Draper invites us to art direct our wedding design and decor. Draper would encourage you to go all the way with an idea—infusing its life into countless aspects of decor. Leave no stone unturned, no path untraveled when making decisions and ordering priorities. In this chapter, we explore a historical property touched in endless ways by the masterful hand of Dorothy Draper. Rooms at this property need little or no embellishment, according to most, but in our wedding imaginations, The Greenbrier became our composition to build upon. Covering a good thing just doesn't make good sense, but elevating and embellishing a good thing, well that is a whole other beautiful story.

235

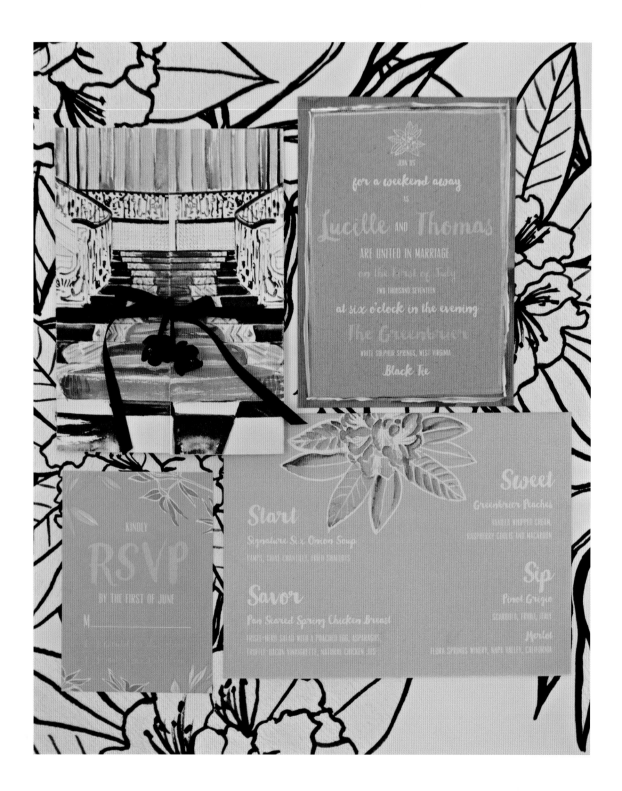

Two strong visuals at The Greenbrier are the main staircase and the love of West Virginia's state flower, the rhododendron. The invitation design honored both in subtle and obvious ways.

Honoring instinct and infusing your own sense of style is essential to personalization—without either, personalization can feel less authentic. I am most creative and satisfied with my work when I am the most "me." When designing for myself, I evaluate what I need to add or subtract from the design to make it more "me." When designing for a client, I ask: "What will refine this concept to most accurately represent them?" The answers to this simple question instantly elevates the design.

–STEFANIE MILES
Stefanie Miles Events

HAVE YOU EVER CONSIDERED HOW MUCH PURE STUFF AND NONSENSE SURROUNDS THIS SUBJECT OF INTERIOR DECORATION? PROBABLY NOT. ALMOST EVERYONE BELIEVES THAT THERE IS SOMETHING DEEP AND MYSTERIOUS ABOUT IT OR THAT YOU HAVE TO KNOW ALL SORTS OF COMPLICATED DETAILS ABOUT PERIODS BEFORE YOU CAN LIFT A FINGER. WELL, YOU DON'T.

–DOROTHY DRAPER

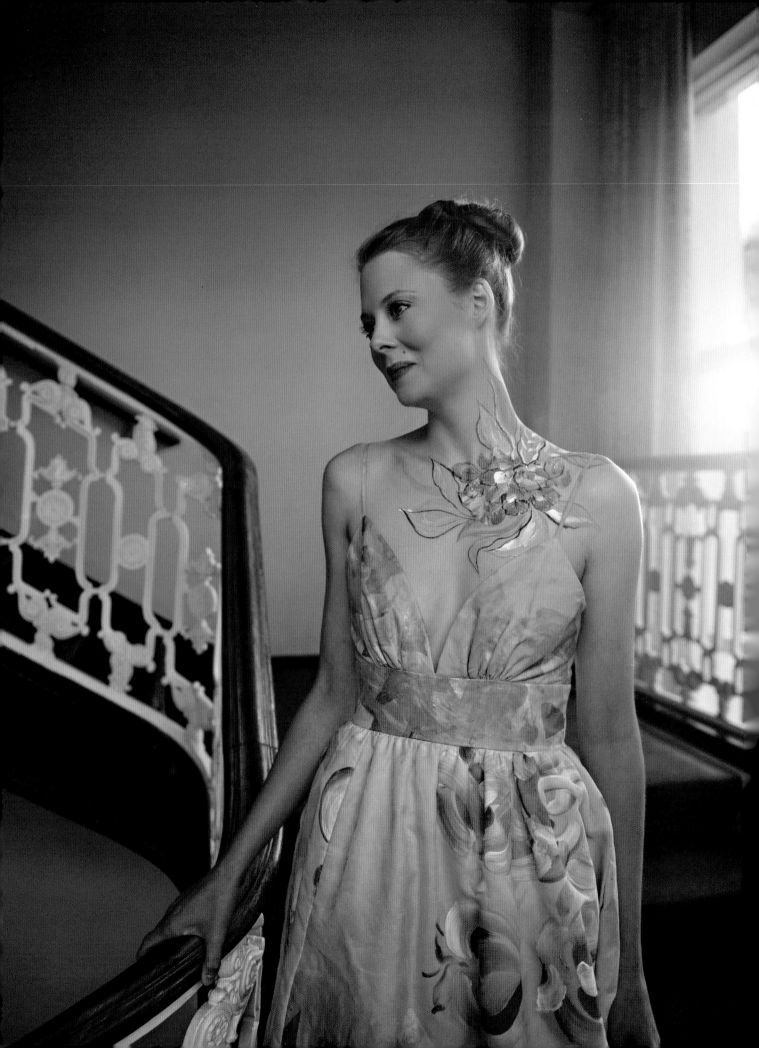

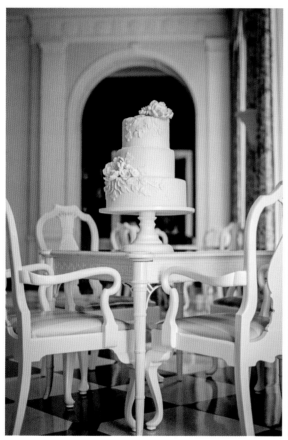
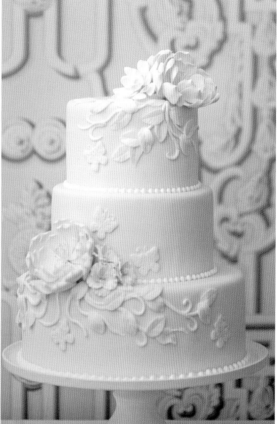

Draper was known for overscaled plaster architectural ornamentation in her interior designs. Our cake called on this approach specifically with an all-white palette and sculpted flowers made to appear cast in plaster. Indulging in visual rest with the white of the cake allows the colorful surroundings and attire to not overwhelm. When making decisions that involve color, remember to allow for understatement here and there as to not have one particular element dominate.

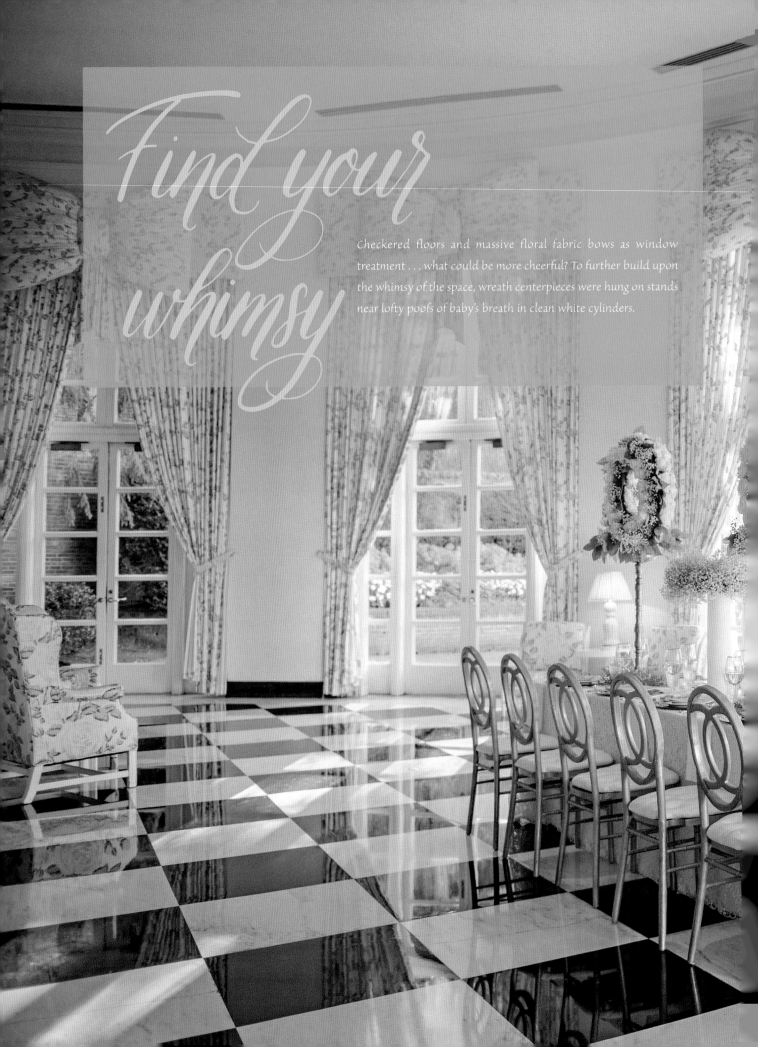

Find your whimsy

Checkered floors and massive floral fabric bows as window treatment . . . what could be more cheerful? To further build upon the whimsy of the space, wreath centerpieces were hung on stands near lofty poofs of baby's breath in clean white cylinders.

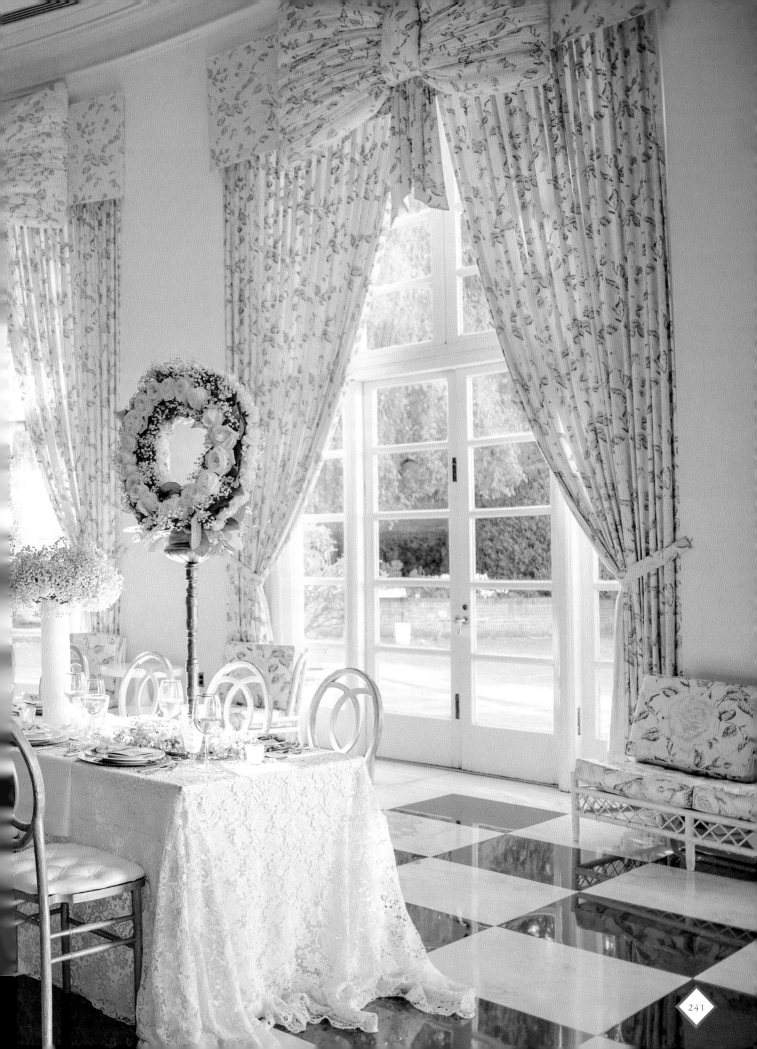

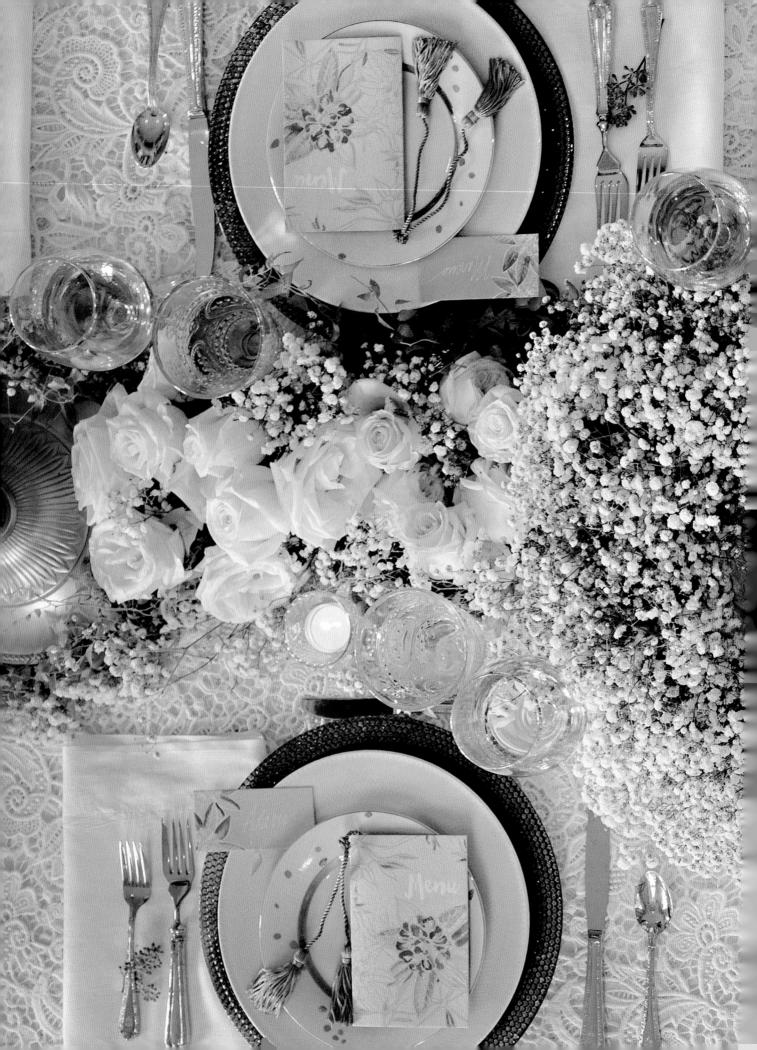

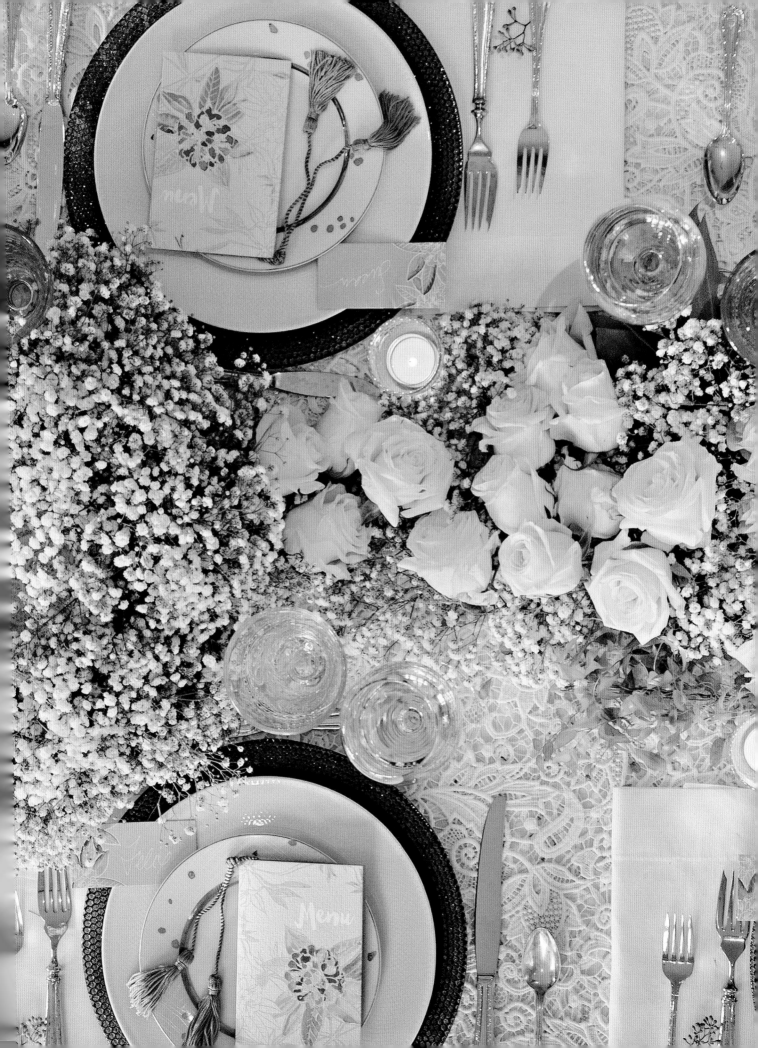

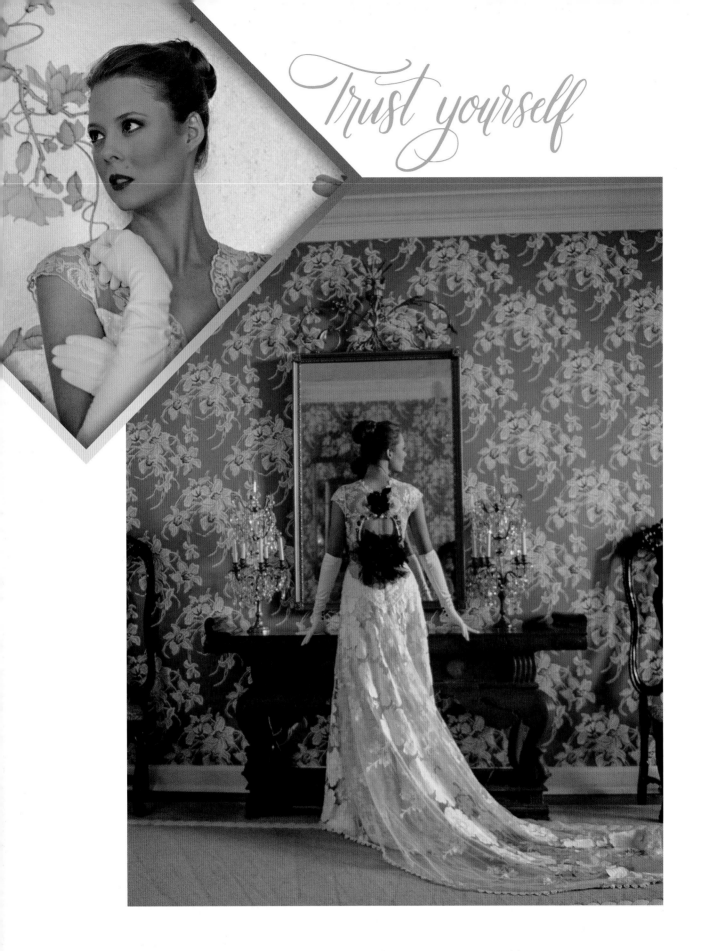

Trust yourself

Trust yourself, your vision, your perspective. If Ms. Draper could, so can you.

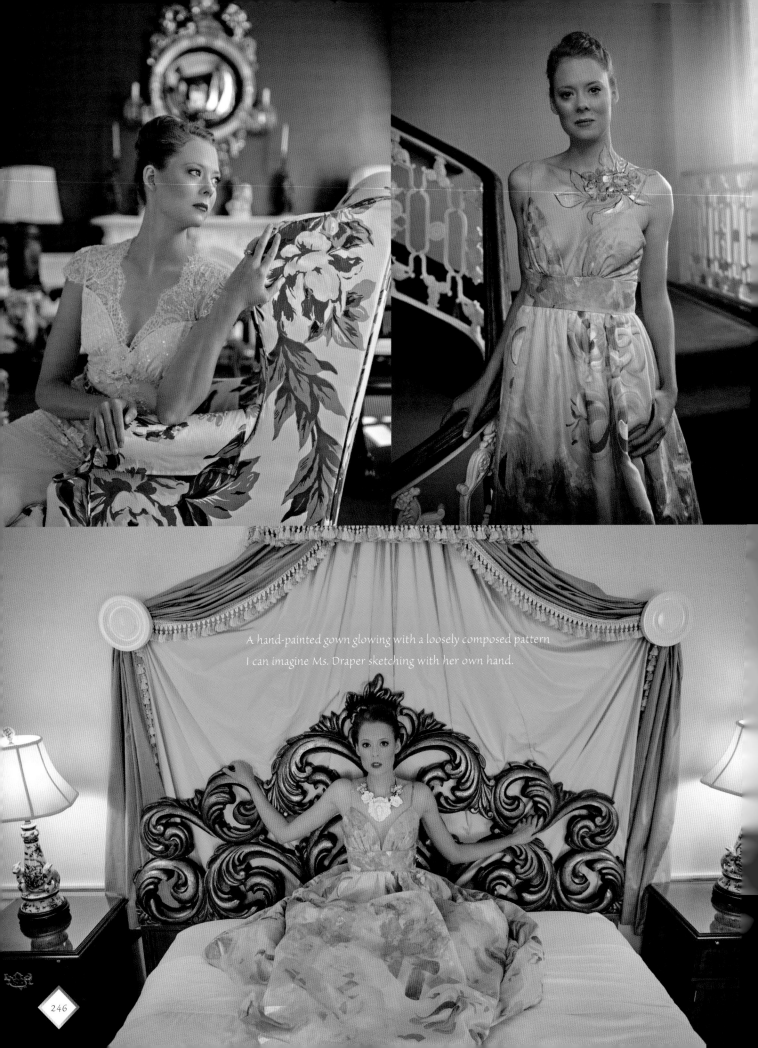

A hand-painted gown glowing with a loosely composed pattern
I can imagine Ms. Draper sketching with her own hand.

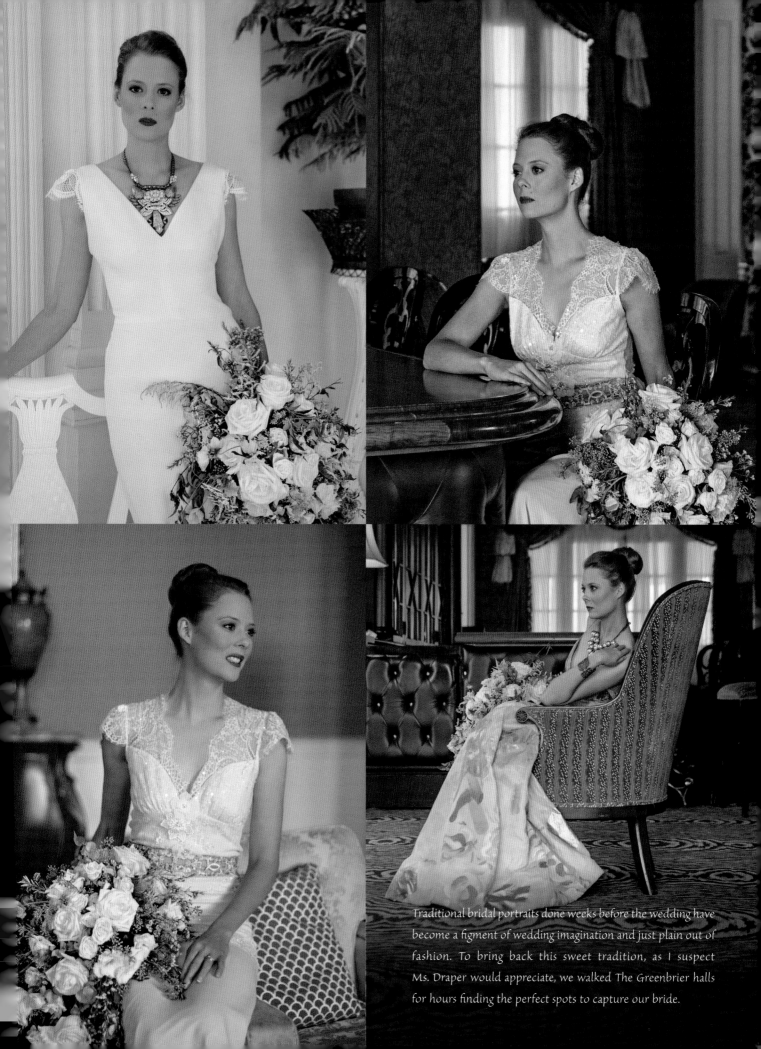

Traditional bridal portraits done weeks before the wedding have become a figment of wedding imagination and just plain out of fashion. To bring back this sweet tradition, as I suspect Ms. Draper would appreciate, we walked The Greenbrier halls for hours finding the perfect spots to capture our bride.

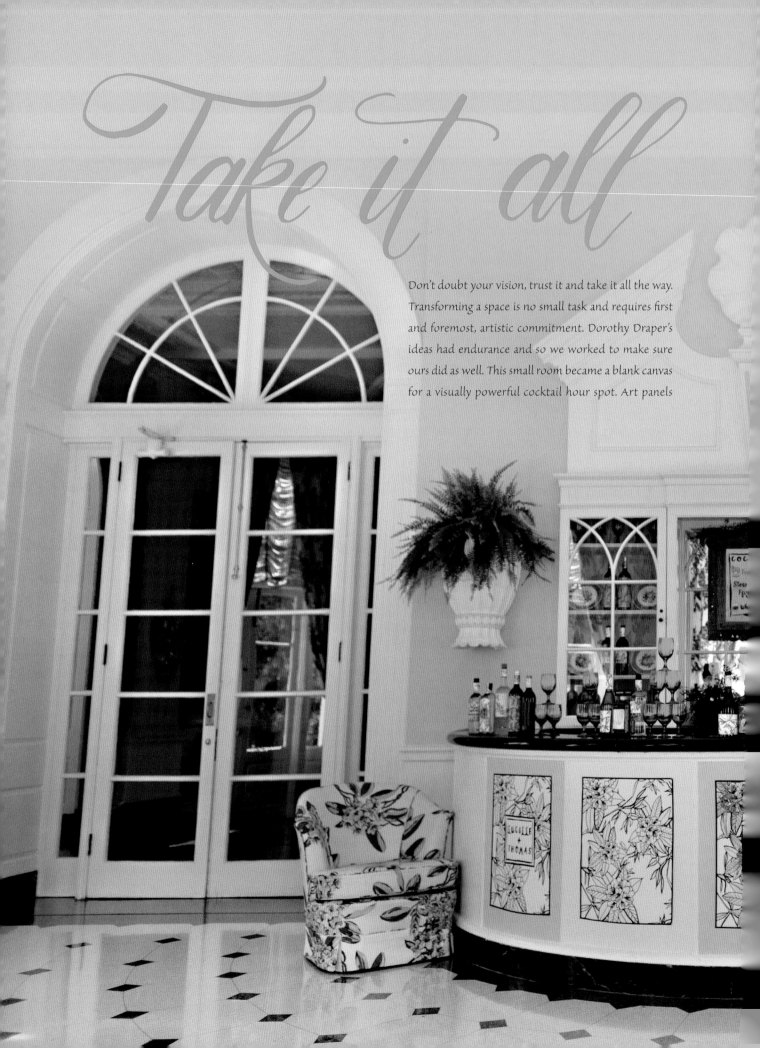

Take it all

Don't doubt your vision, trust it and take it all the way. Transforming a space is no small task and requires first and foremost, artistic commitment. Dorothy Draper's ideas had endurance and so we worked to make sure ours did as well. This small room became a blank canvas for a visually powerful cocktail hour spot. Art panels

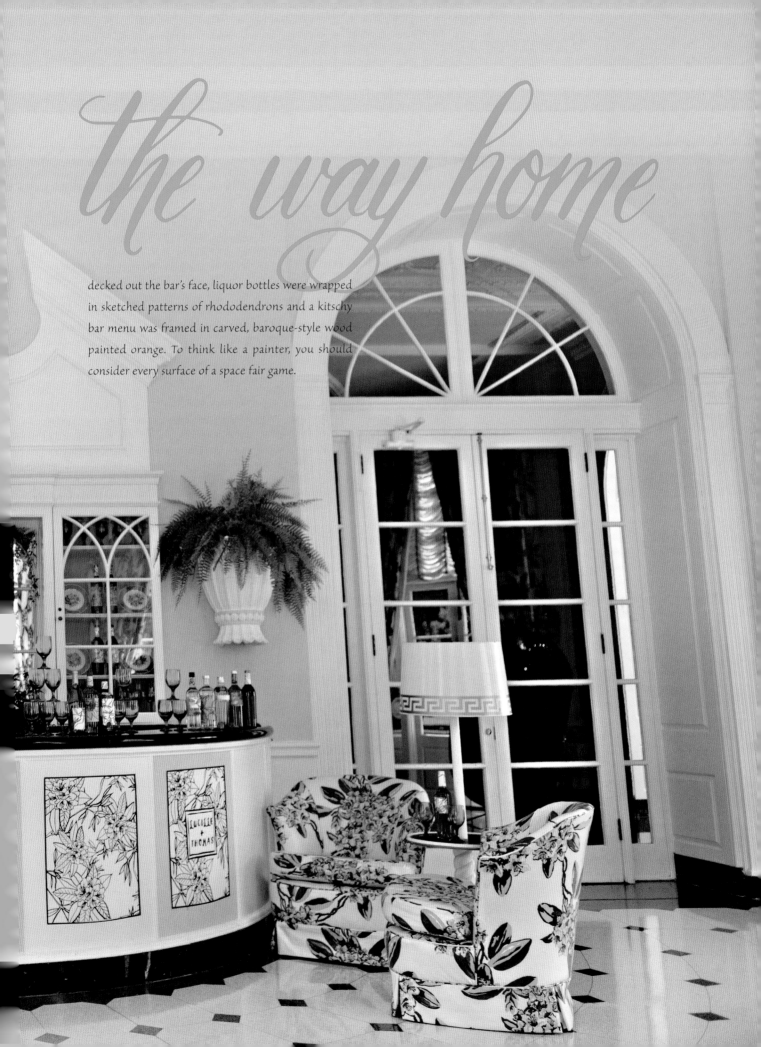

the way home

decked out the bar's face, liquor bottles were wrapped in sketched patterns of rhododendrons and a kitschy bar menu was framed in carved, baroque-style wood painted orange. To think like a painter, you should consider every surface of a space fair game.

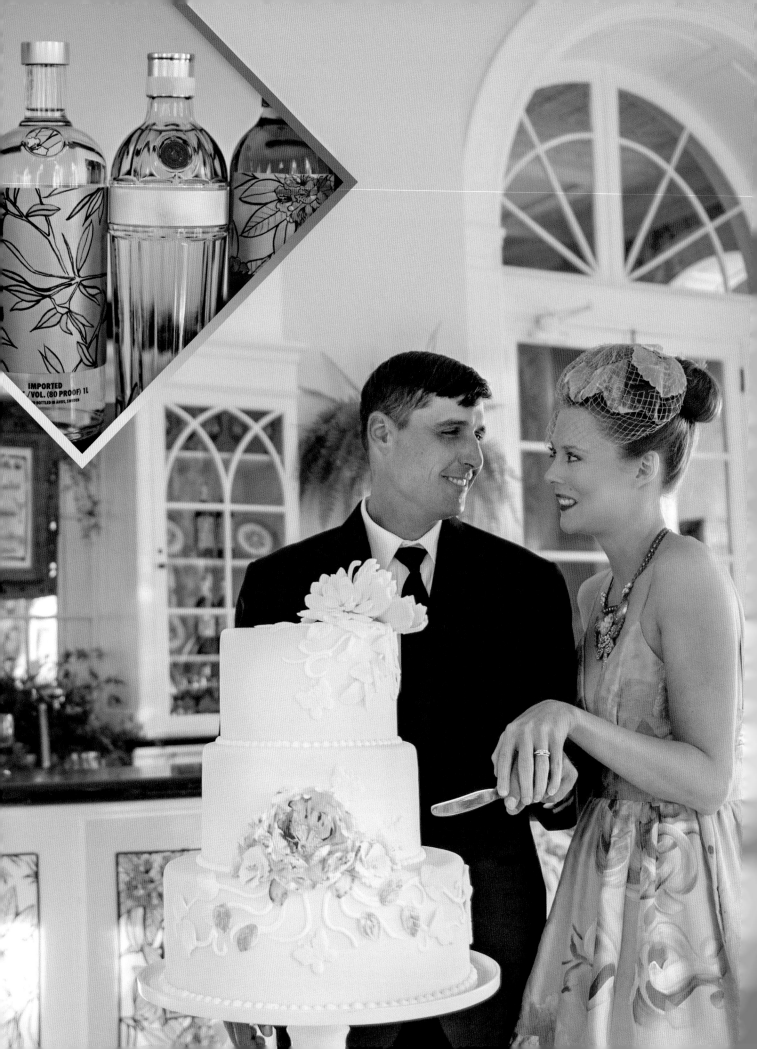

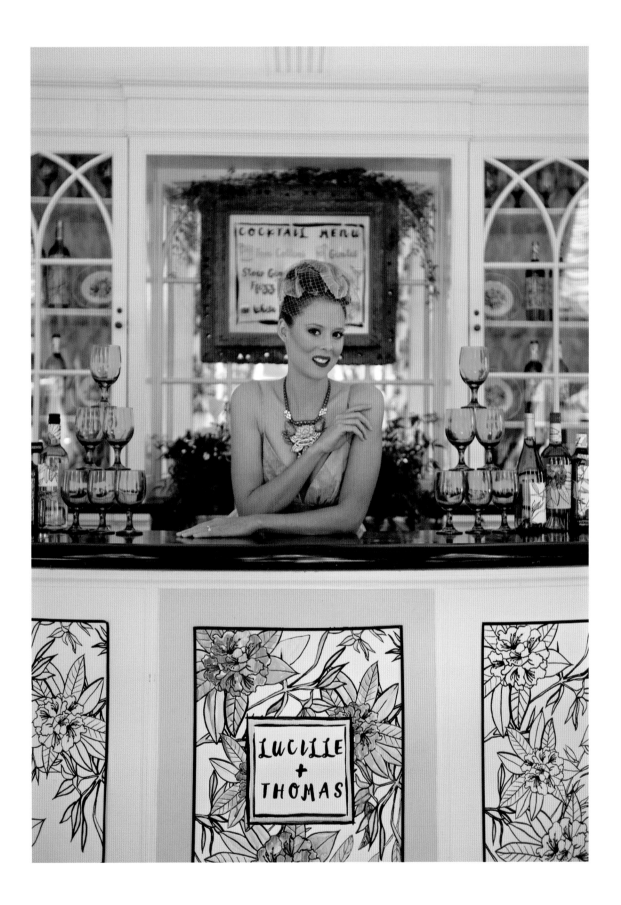

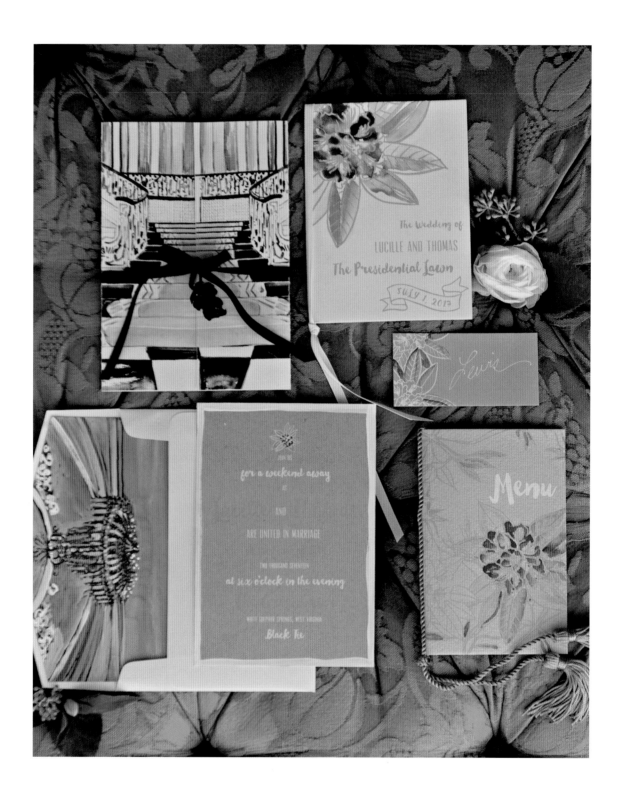

Silkscreened stationery is reminiscent of the countless wallpaper patterns and fixtures seen throughout The Greenbrier property.

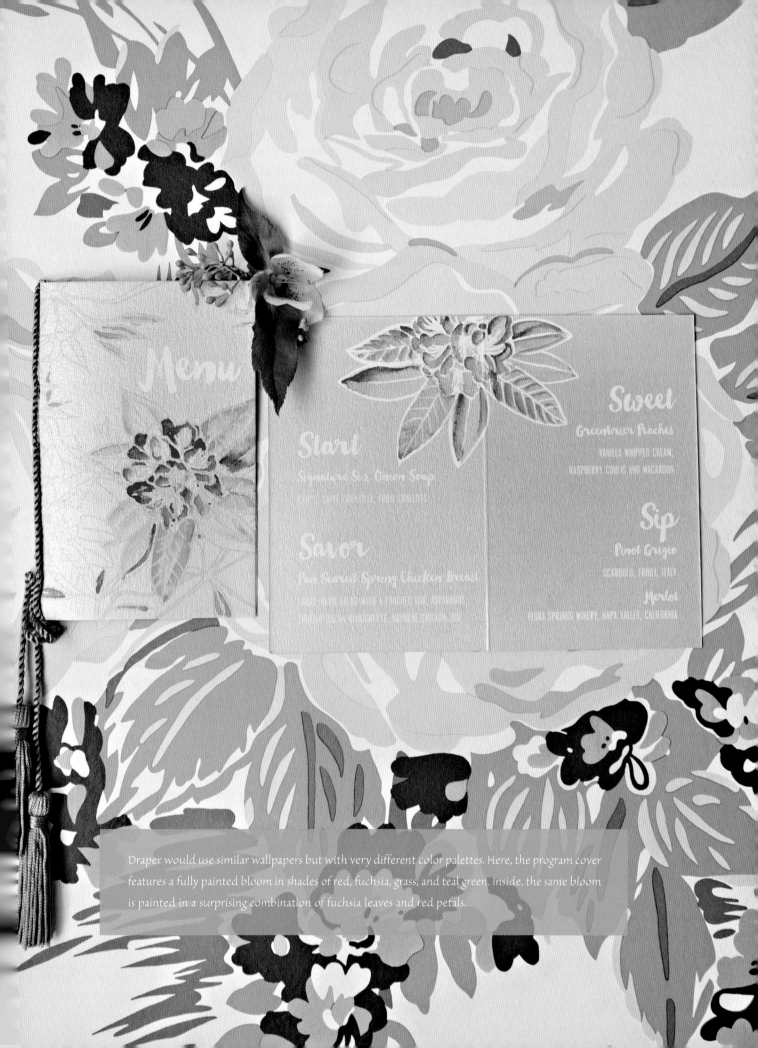

Menu

Start
Signature Six Onion Soup
RAMPS, CHIVE CHANTILLY, FRIED SHALLOTS

Savor
Pan Seared Spring Chicken Breast
SPRING ONION SALAD WITH A POACHED EGG, ASPARAGUS,
BUTTERMILK-BACON VINAIGRETTE, NATURAL CHICKEN JUS

Sweet
Greenbrier Peaches
VANILLA WHIPPED CREAM,
RASPBERRY COULIS AND MACAROON

Sip
Pinot Grigio
SCARBOLO, FRANCE, ITALY

Merlot
FLORA SPRINGS WINERY, NAPA VALLEY, CALIFORNIA

Draper would use similar wallpapers but with very different color palettes. Here, the program cover features a fully painted bloom in shades of red, fuchsia, grass, and teal green. Inside, the same bloom is painted in a surprising combination of fuchsia leaves and red petals.

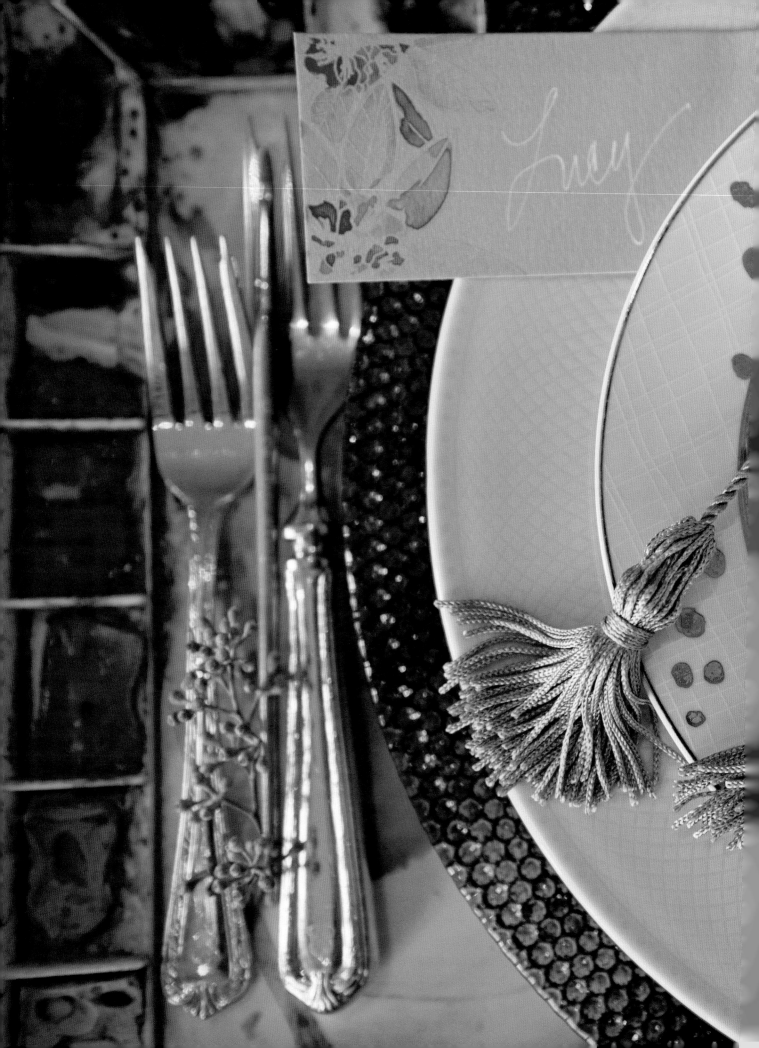

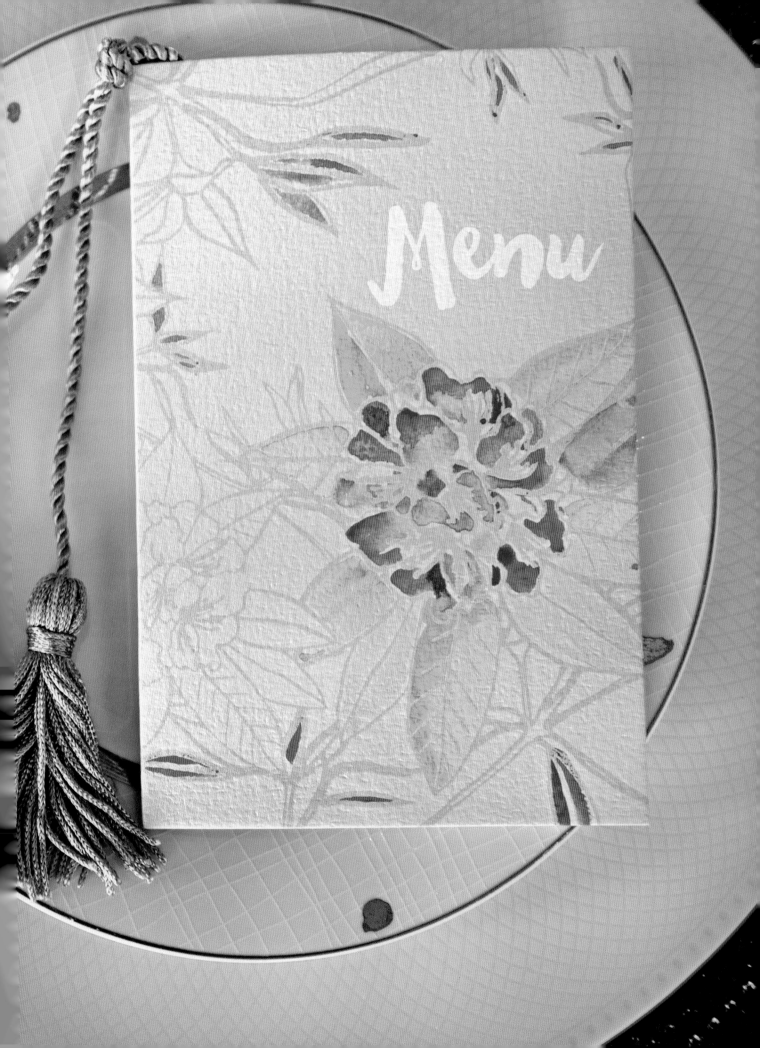

Another favorite design element of Draper's were tassels, which were woven amidst the place cards.

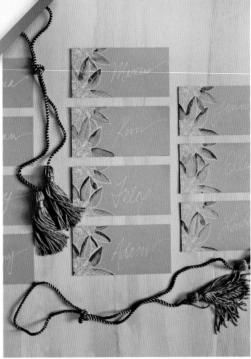

To honor Draper's love of black and white, programs featured sheer black watercolor rhododendrons. Certainly not an obvious color choice for a typically rougey-hued flower, but it just worked.

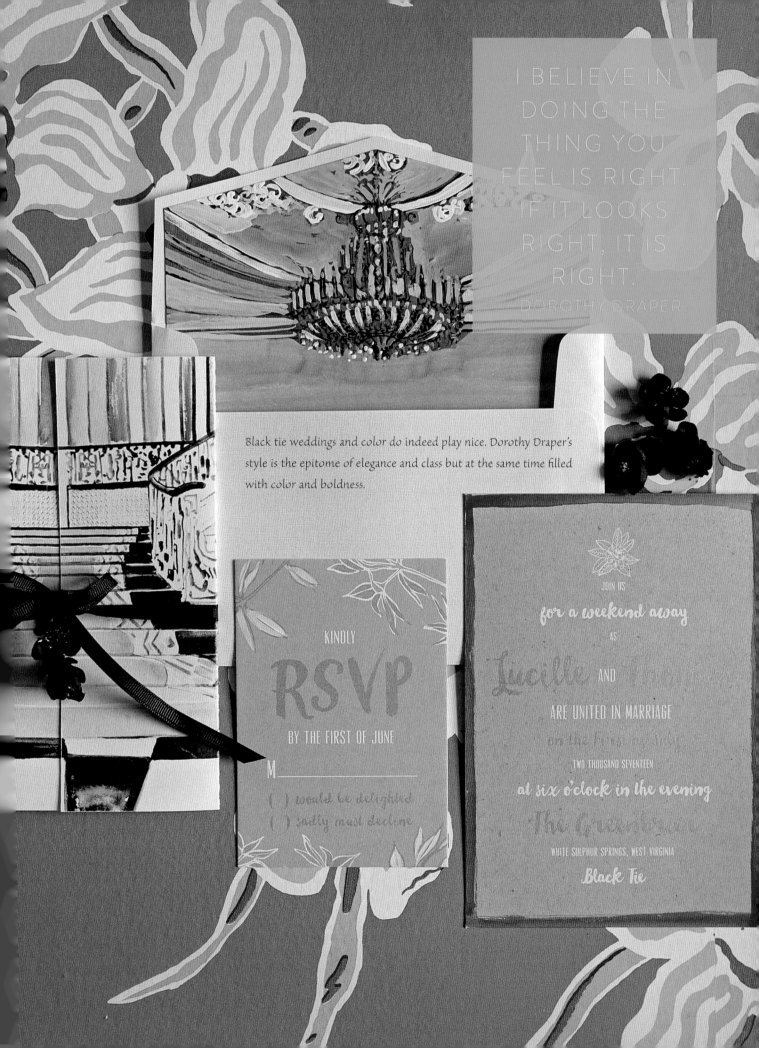

I BELIEVE IN DOING THE THING YOU FEEL IS RIGHT. IF IT LOOKS RIGHT, IT IS RIGHT.
— DOROTHY DRAPER

Black tie weddings and color do indeed play nice. Dorothy Draper's style is the epitome of elegance and class but at the same time filled with color and boldness.

KINDLY

RSVP

BY THE FIRST OF JUNE

M _____

() would be delighted
() sadly must decline

JOIN US

for a weekend away

as

Lucille AND Thomas

ARE UNITED IN MARRIAGE

on the First of July

TWO THOUSAND SEVENTEEN

at six o'clock in the evening

The Greenbrier

WHITE SULPHUR SPRINGS, WEST VIRGINIA

Black Tie

THINK LIKE A PAINTER

BE YOUR OWN ART DIRECTOR

Painters see the whole picture through all the tiny details.

Dorothy Draper's

CONCEPT DEFINITION

The Greenbrier is a property whose visual personality was defined by one iconic visionary. Dorothy Draper's bravery for color and expression inspired a generation and reached millions through her *Good Housekeeping* column, "Decorating Is Fun." She begged us to be bold, leaving all that was drab behind. Draper's work today at The Greenbrier feels much like a very chic Candyland for adults, where color is king and fear of boldness has no place.

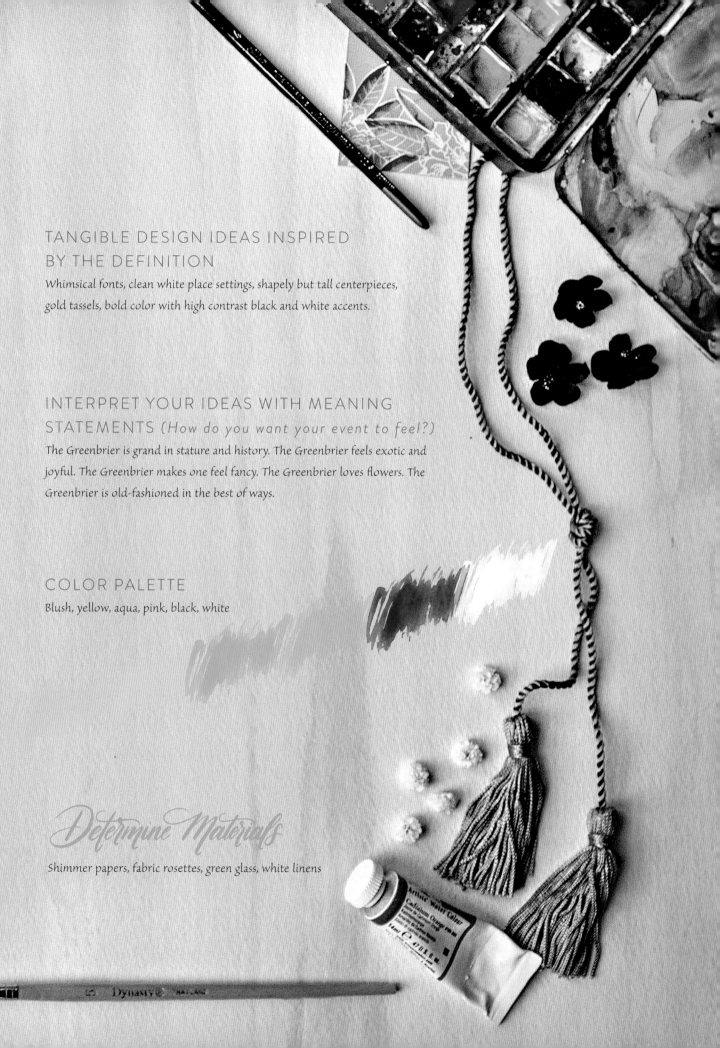

TANGIBLE DESIGN IDEAS INSPIRED BY THE DEFINITION

Whimsical fonts, clean white place settings, shapely but tall centerpieces, gold tassels, bold color with high contrast black and white accents.

INTERPRET YOUR IDEAS WITH MEANING STATEMENTS *(How do you want your event to feel?)*

The Greenbrier is grand in stature and history. The Greenbrier feels exotic and joyful. The Greenbrier makes one feel fancy. The Greenbrier loves flowers. The Greenbrier is old-fashioned in the best of ways.

COLOR PALETTE

Blush, yellow, aqua, pink, black, white

Determine Materials

Shimmer papers, fabric rosettes, green glass, white linens

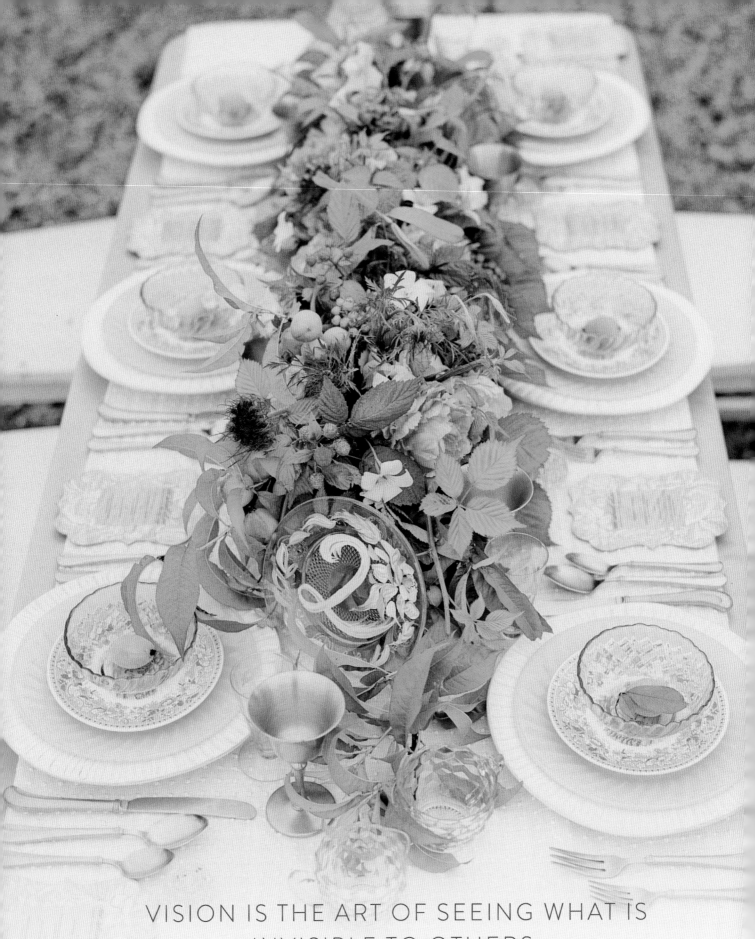

VISION IS THE ART OF SEEING WHAT IS
INVISIBLE TO OTHERS.

– JONATHAN SWIFT

Soft Botanicals

WITH THE BAUER BROTHERS

Botanical artists through the ages have been charged with the task of replicating nature leaf by leaf, where every bump, bloom, piece, and pod becomes a chance to magnify the realities of nature.

Traditionally, botanical illustrators are realists, meaning they attempt to record in pencil, ink, or paint the true scale, form, and structure of a plant, animal, fruit, or flower. Their illustrations rarely simplify, but almost always magnify, the level of detail our naked eye can perceive.

In this chapter, the idea of botanical art is given a twist. Instead of magnifying the details of the blooms seen on the pages to follow, we aimed to elevate their beauty through painterly expression, all the while attempting to capture the soul of a flower, its graceful beauty, and gentle personality. Become the artist in your wedding planning by taking a time-honored art style and giving it your own interpretation. In this train of thought, Monet's thousands of tiny brushstrokes could become a pastel, confetti-themed soiree. Van Gogh's *Starry Night* could translate into a colorful firefly filled scene on an invitation. Don't be afraid to show guests the flipside of a favorite painter's style.

Wedding decor based on ideas deeply rooted in original, or even unexpected, thinking will go a long way in making a powerful impression at your event.

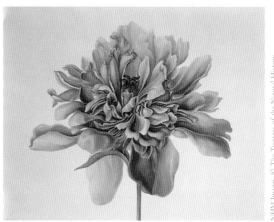

Paeonia sp., *Peony*
Plate 1 From Drawings of Kew Plants by Franz Bauer (1758-1840). Detailed close-up of flower head. Held in the Botany Library at the Natural History Museum, London.

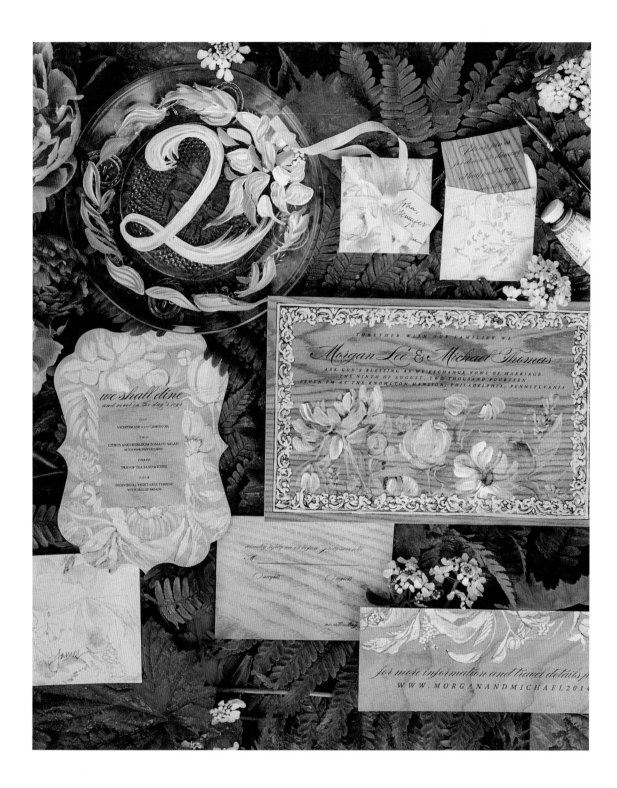

Meaningful wedding design inspired by a favorite artist is meant to be liberating . . . giving you a bounty of ideas, not restricting you to exact copies of a particular work. My take on a botanical artist's style is much more loose and lavish than a traditional and more exacting botanical illustration would be. Instead, I looked to the way botanical painters examine a single type of flower or species from a variety of perspectives.

To truly create art, what you create needs to resonate with your soul. If what you're creating leans more in the direction of something you think others will like versus what is truly you, there will be a piece of satisfaction missing. In putting together an event or wedding, collaborate and hire people who embody your taste and vision, point them in a direction, and let them create. If you love an artist and hire them because of that—let them spread their wings, and magic will happen.

—BRAEDON FLYNN

Photographer and founder of The Artist Report

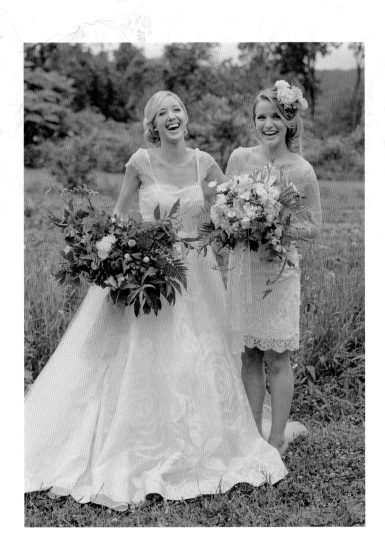

The setting, a farmer florist's field, offered endless opportunities to pluck the perfect specimens for each bouquet. Sweeping blooms covered this custom gown's skirt in the softest shades of pink.

A classic characteristic of botanical painters are compositions where vines, tendrils, and leaves creep and crawl over the page.

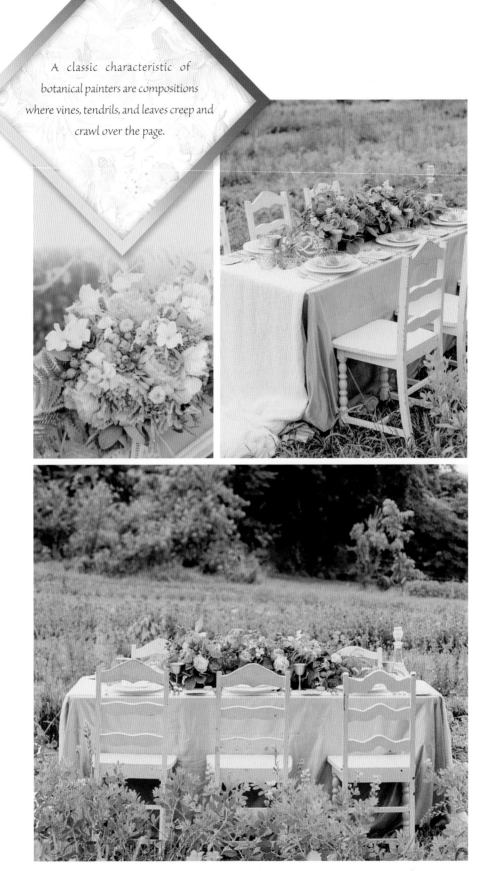

Botanical painters find delight in highlighting even the smallest details of a plant's anatomy. Here, the table features vines creeping from the centerpiece onto and around china and glassware.

What views of a single flower might a botanical painter capture? Side, top down, bud with leaf, fully open bloom revealing the center. All of these views were integrated in the menu cards painted on ash wood veneer.

we shall dine
and revel in the day's joys

ONE
VICHYSSOISE WITH LEMON OIL

TWO
CITRUS AND HEIRLOOM TOMATO SALAD
WITH PINK PEPPERCORNS

THREE
TRIO OF TEA SANDWICHES

FOUR
INDIVIDUAL VEGETABLE TERRINE
WITH GRILLED BREADS

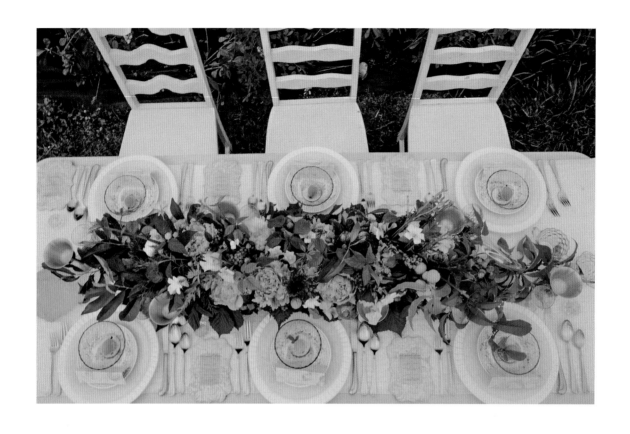

I found I could say things with
color and shapes that I couldn't
say any other way—things
I had no words for.
 —Georgia O'Keeffe

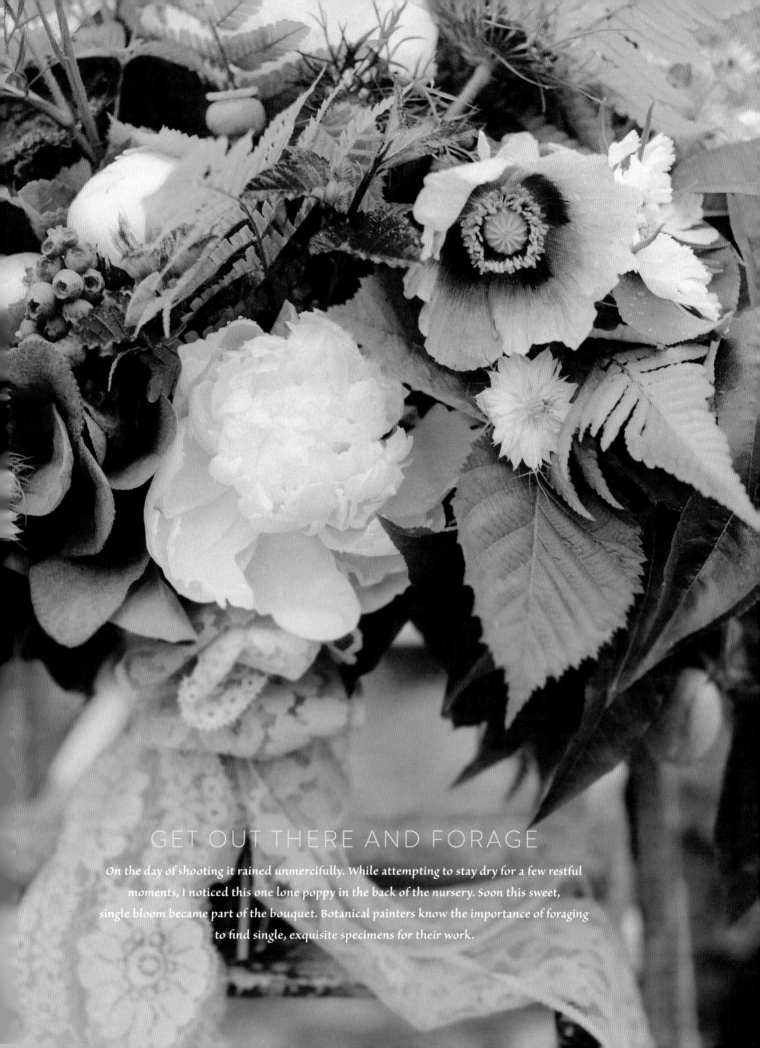

GET OUT THERE AND FORAGE

On the day of shooting it rained unmercifully. While attempting to stay dry for a few restful
moments, I noticed this one lone poppy in the back of the nursery. Soon this sweet,
single bloom became part of the bouquet. Botanical painters know the importance of foraging
to find single, exquisite specimens for their work.

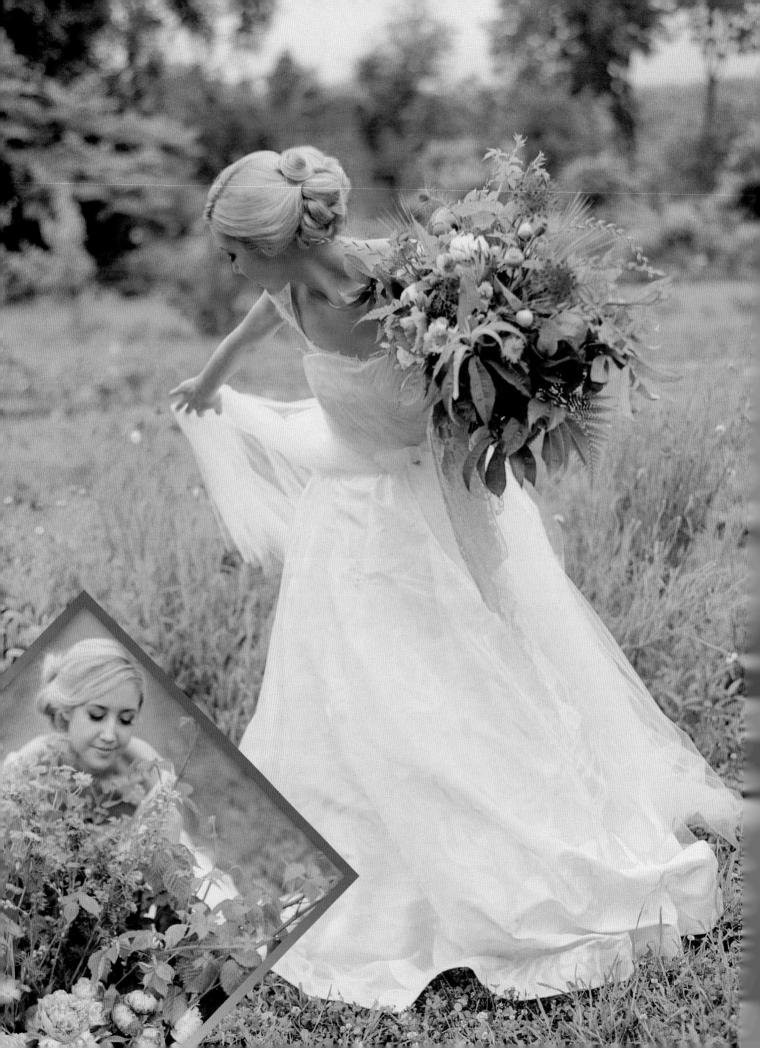

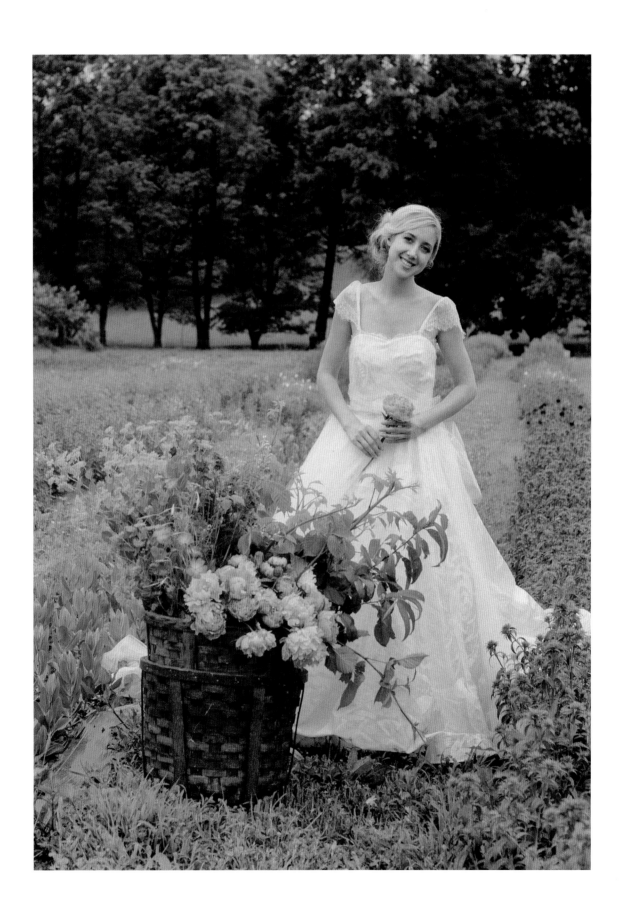

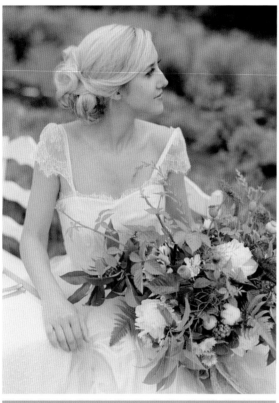

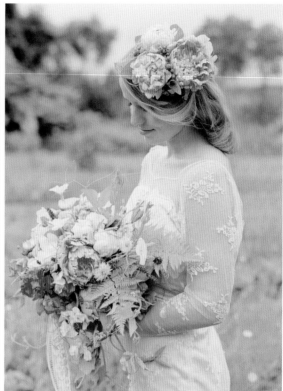

Look closely at a botanical illustration. Then look again. On second glance, you'll likely find an element you didn't see initially. Use this practice in your invitation suite design. What small element can be included, but perhaps not noticed at first look?

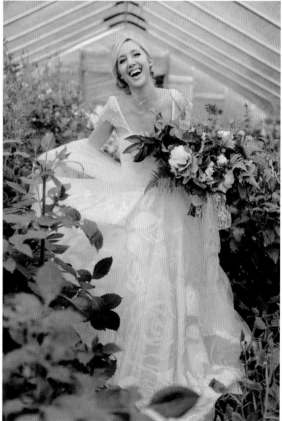

Adore options ...

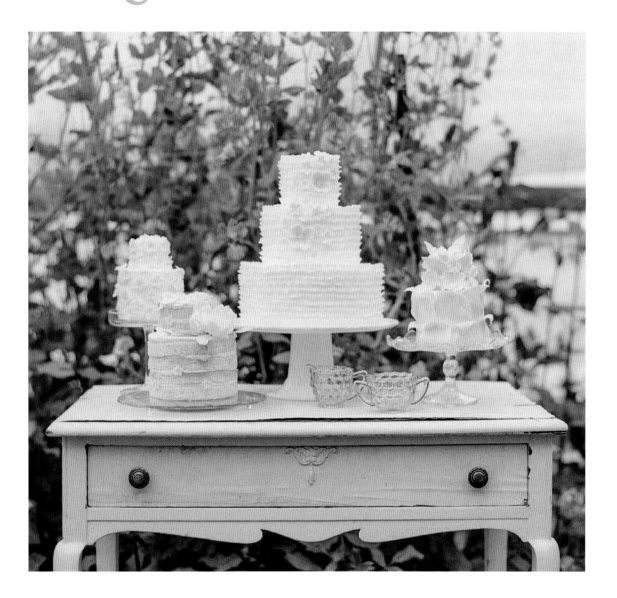

A variety of cake designs paid homage to a botanical painter's way of examining a single specimen's parts. Each cake features different parts of the same plant —large leaves; whimsical tendrils; tiny open blooms; and full, ruffly flowers.

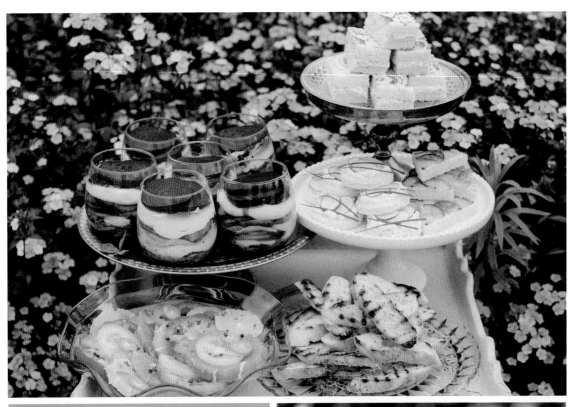

Using a painter as wedding inspiration will focus your efforts, as each decision can always go back to a simple question: "What would the painter do?"

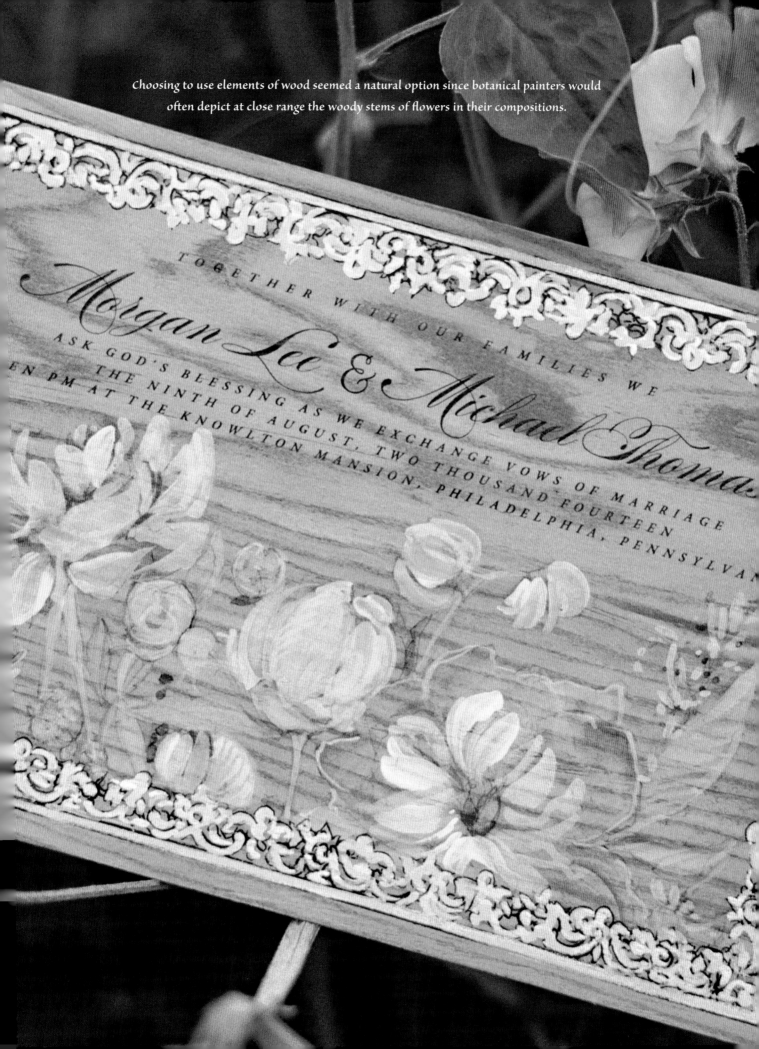

Choosing to use elements of wood seemed a natural option since botanical painters would often depict at close range the woody stems of flowers in their compositions.

TOGETHER WITH OUR FAMILIES WE

Morgan Lee & Michael Thomas

ASK GOD'S BLESSING AS WE EXCHANGE VOWS OF MARRIAGE

THE NINTH OF AUGUST, TWO THOUSAND FOURTEEN

EN PM AT THE KNOWLTON MANSION, PHILADELPHIA, PENNSYLVA

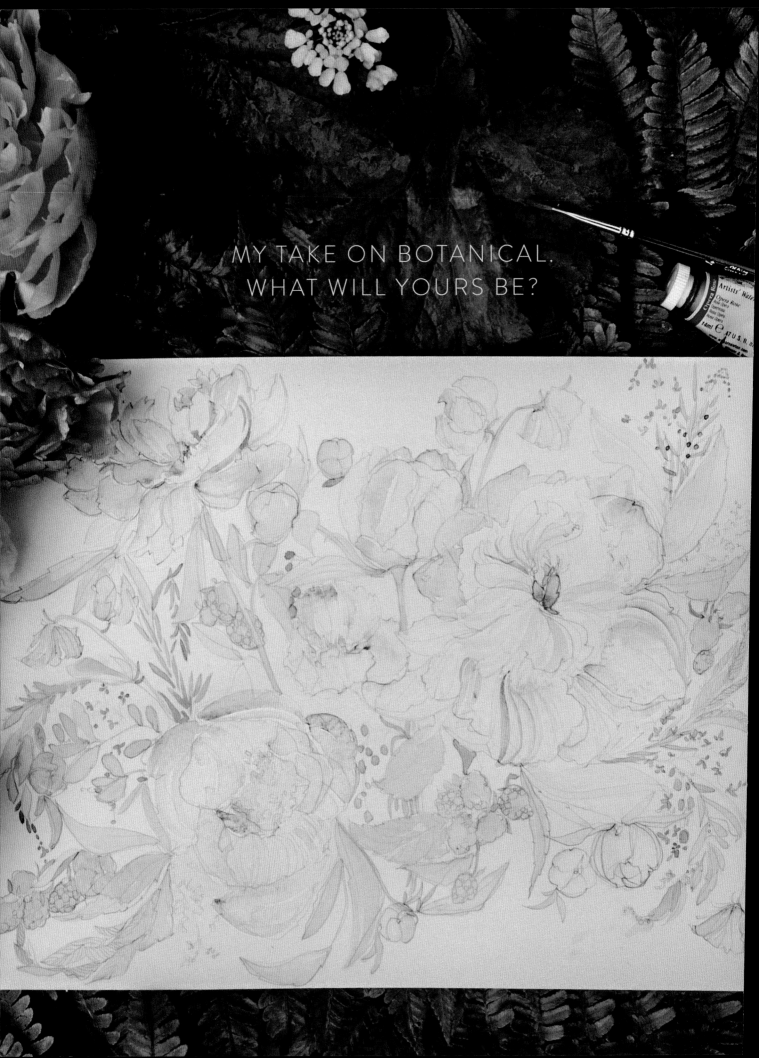

MY TAKE ON BOTANICAL.
WHAT WILL YOURS BE?

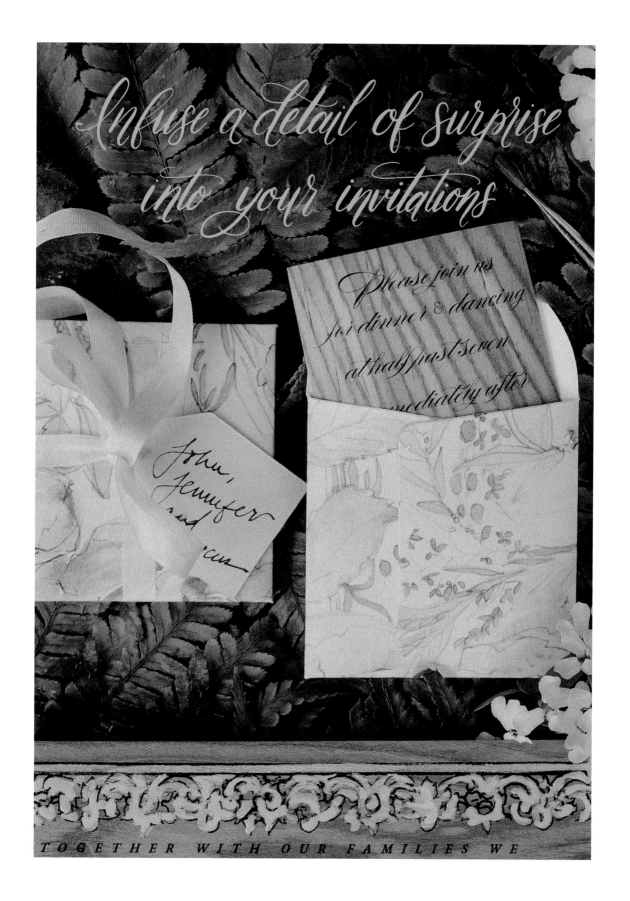

THINK LIKE A PAINTER

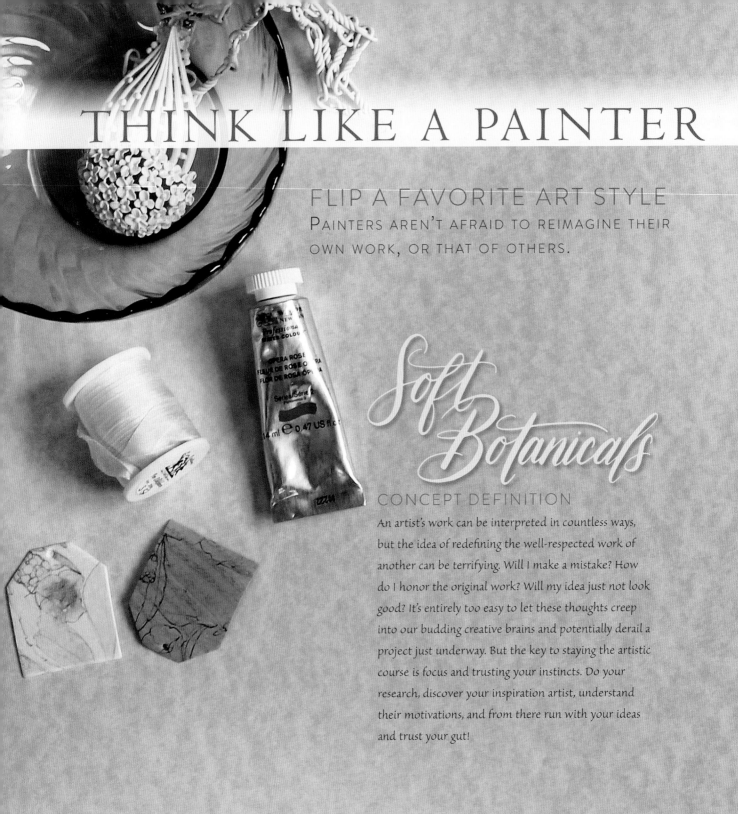

FLIP A FAVORITE ART STYLE
PAINTERS AREN'T AFRAID TO REIMAGINE THEIR OWN WORK, OR THAT OF OTHERS.

Soft Botanicals

CONCEPT DEFINITION

An artist's work can be interpreted in countless ways, but the idea of redefining the well-respected work of another can be terrifying. Will I make a mistake? How do I honor the original work? Will my idea just not look good? It's entirely too easy to let these thoughts creep into our budding creative brains and potentially derail a project just underway. But the key to staying the artistic course is focus and trusting your instincts. Do your research, discover your inspiration artist, understand their motivations, and from there run with your ideas and trust your gut!

TANGIBLE DESIGN IDEAS INSPIRED BY THE DEFINITION
Flower farm backdrop; delicate watercolor blooms; soft, sheer color palette with minimal contrast

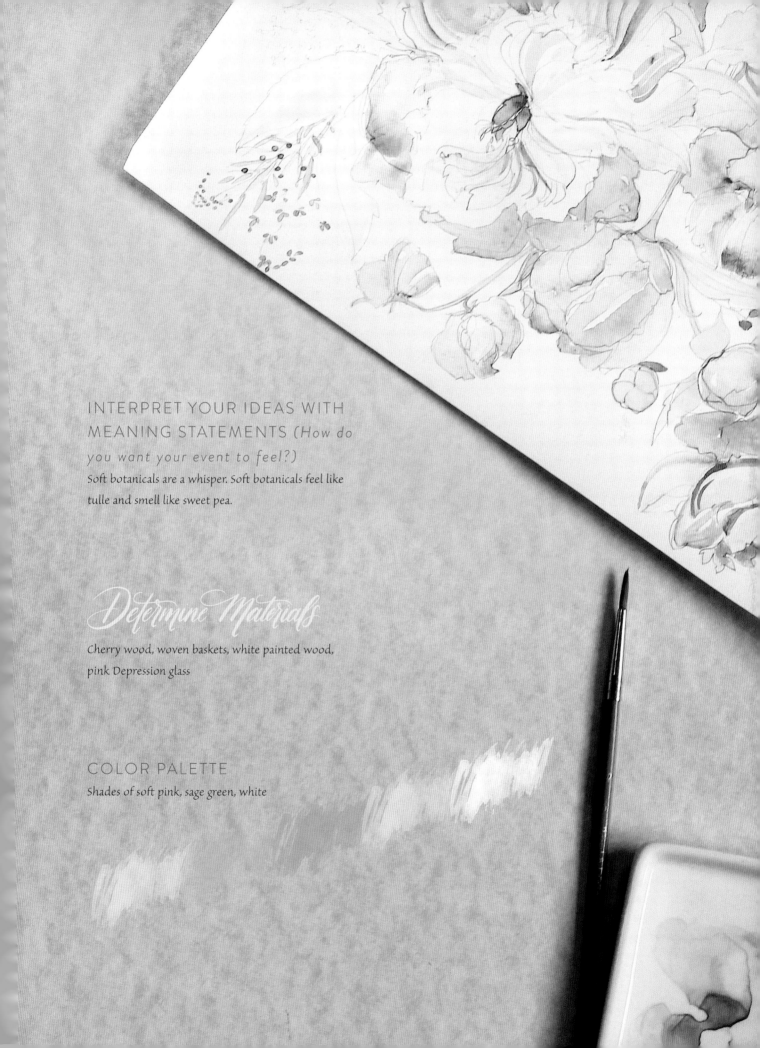

INTERPRET YOUR IDEAS WITH
MEANING STATEMENTS (*How do
you want your event to feel?*)
Soft botanicals are a whisper. Soft botanicals feel like
tulle and smell like sweet pea.

Determine Materials

Cherry wood, woven baskets, white painted wood,
pink Depression glass

COLOR PALETTE
Shades of soft pink, sage green, white

Watercolor
Harvest

USE ART PALETTES AS TABLE DECOR.

Affordable palettes filled with simple colors swirled around on
the surface make a curious alternative to a table runner.

Real life example by contemporary Dutch still life photographer Bas Meeuws.

A Watercolor Harvest

So how do you think like a painter while planning what could
be the largest party of your life?

GOOD QUESTION. And I have an answer for you. Artists (painters, musicians, filmmakers, sculptors, etc.) are the heartbeat of our culture. Artists dream for us, they elaborate and embellish, they dare to see what isn't real, and often what should be real. Artists give us permission to think in the imaginary and create lives and spaces that reflect exactly who we are or eventually want to be. If we're open to looking and listening, artists offer us the tools to think critically, be more observant, and experience our world with a heightened set of senses.

Your celebration isn't just another party, it is a gathering deserving of more than you might realize. Frida Kahlo, an iconic painter to whom I've dedicated a chapter in this book, would transform simple dinner gatherings into epic evenings rich with splendidly stunning food, conversation, and lovingly set decor. To her painter's sensibilities, every evening had the potential to be an epic event and, as such, she orchestrated every detail to connect her guests through sight, smell, and sound:

For Frida, setting the table was a ritual, whether she was unfolding the white openwork tablecloth from Aguascalientes, or arranging the simple plates that she has customized with her initials, or setting out Spanish Talavera plates and handblown blue glasses and heirloom silverware. It was as if the shape and color and sound that was particular to each individual object endowed it with life and an assigned place in her harmonious, aesthetically pleasing world. (from *Frida's Fiestas: Recipes and Reminiscences of Life with Frida Kahlo*)

Your celebration table is ready to be set, and I'm hoping to arm you with the instinct to gather pieces heavy with meaning, beauty, and history. When emotions align with a committed style, then intersect with a confident eye for what excites, delights, enlivens, and transforms you all at once, you are no longer setting a table or decorating, you are living in an artist's composition—your composition.

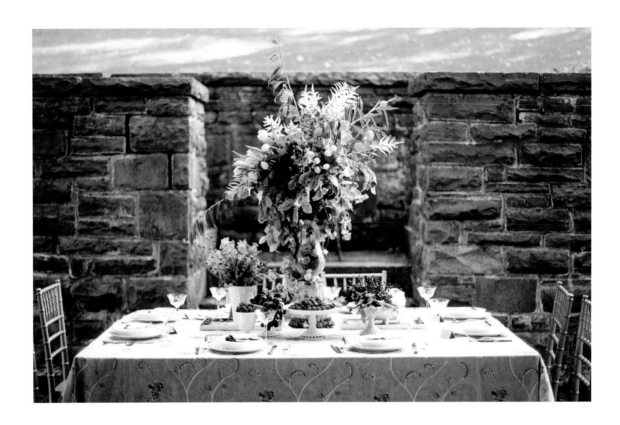

I had the honor of speaking with colleague Beth Helmstetter of Beth Helmstetter Events to discuss the intricacies of setting a thoughtful celebration table. Artistry not only applies to linen colors and flower choices, but to lighting, guest comfort, and gifting. Beth urges us to see the Anatomy of a Celebration Table from many angles, some of which you might not readily consider!

In your own words, how is the design of a celebration table a lot like a painter's canvas? And why are the similarities helpful to understand?

Design and art are always a similar process, especially when speaking of the art of entertaining and table design. As a designer, I am not only intentional about texture, color, and lighting, but I'm also considering how the guest will experience the final design. Is it beautiful enough to make them feel honored? Unique enough to keep them interested? Personal enough to be approachable? And approachable enough to keep them engaged? These are all questions I ask myself when creating a table special enough to mark one of life's major celebrations, and I imagine similar questions a painter might ask of his work.

Describe what you believe to be a powerful table design. What must be included, what can be omitted? What details do guests resonate with most? What will guests remember most when they walk away from a design?

Table design is not only about the visual impact but also how the guest will interact with each detail. A well

designed table takes into consideration the table's events, from drinking to conversing to dining. Also consider the appropriate level of lighting to facilitate all table activities and the guests' visual experience. A well designed table is experienced in layers. Upon first look, the guest takes in the elements all at once, but as they get closer they see the intentions of the design. I personally consider twelve different elements in every table design, including:

1 Linens are the palette that is your wedding table design and make all the difference. They subtly communicate the formality level of the event depending on the texture and pattern. They are also a great way to pull together the dinner tables with the rest of the environment.

2 But, before we select linens, table shape is an important decision. Long tables are often more communal and intimate. Square tables always feel a bit modern and even edgy depending on the rest of the details. And rounds are traditional and timeless. No matter what, though, the table shape is one of the first decisions as it dictates everything from the style of centerpiece and tablescapes to linens and overlays.

3 Chairs are right up there with linens in terms of importance. Many people don't think they matter, but considering how many chairs are at a table, they can greatly impact the overall design. Chairs should blend with the design rather than stand out. Guest comfort should always be a factor as well.

4 The centerpiece is a given and usually the first (and sometimes the only) thing couples think about. The centerpiece size, shape, and composition are not only dependent on the aesthetics of the design, but also the size, shape, and other elements that are making up the rest of the dinner table.

5 When gifts and favors are to be presented at the dinner table, the presentation matters more than ever. A perfectly lovely dinner table where every element is intentionally designed can be tainted with an organza satchel filled with M&M's®.

6 Lighting on the dinner table is always important whether it is as simple as adding votive candles or a bit more complicated like pin spotting each centerpiece. Work with your planner, florist, or lighting designer to come up with the best options for your dinner tables.

7 The napkin fold is one area that many couples don't think about. Much like chairs, the napkins should blend and make sense with the rest of the design. And don't underestimate the textile the napkins are made from. This is the one element guests are guaranteed to touch and feel, so it's nice to make that experience a good one.

8 The napkin treatment is one of my favorite touches. It's a special treat at each seat and obviously finishes the table. Fabric wraps, lace, twine, ribbons, fresh flowers, herbs, or even just a personalized dinner menu can all be sweet touches that add another engaging layer of creativity to the design.

9 Plates and the materials they are made from, be it ceramic, porcelain, pewter, etc., are a great way to communicate the level of formality for the day. The perfect charger can elevate the table as well as finish off the place setting perfectly.

10 & **11** Glassware and flatware are the same scenario as china. While more basic flatware and glassware usually blends into the background, unique glass and flatware can be an unexpected way to show guests every single detail on the table was thought out. It's not often that they see a blush pink goblet or gold

flatware, and anyone who appreciates design will definitely gush over this added level of detail.

12 The stationery, including place cards, dinner menus, and table numbers are the final area that should be well thought of, essentially the cherry on top. Paper products add a level of refinement and detail that is often overlooked, and every guest loves to see their name in print, making this one last finishing touch that will get guests to interact with the table design.

What do you see as the biggest roadblock for couples looking to create a truly impactful table design? How can couples resolve this?

Many venues often include what they deem to be appropriate: linens, chairs, china, glassware, and flatware. When on a budget, this can be a great bonus for couples, but can often be detrimental to great design. When designing a table, it's great to start from the table shape and textiles and build up from there. If a couple is boxing themselves in by thinking they need to use the venue's china, that just so happens to have a dark green design all over it, then they are letting these irrelevant details either dictate or tarnish what could otherwise be a great opportunity to be creative and intentional.

When a couple comes to you with loaded Pinterest boards, what do you say to them first?

I often take note of what they like and don't like in the Pinterest boards and try to push them beyond taking an existing design to create something unique for themselves. If I hit a roadblock with them in initial discussions, I use our design sessions to not only show them the design they think they like, but also to show them what the design could be with a little more thought and creativity. Usually touching and feeling the elements we pull together, as well as showing them how being intentional in every detail of the table design can elevate their day, opens them up to see what else we can do to create a beautiful table together.

Beth Helmstetter is the owner and principal event designer at Beth Helmstetter Events. She has created multi-day celebrations everywhere from Bali and Paris to the Philippines, Central America, and throughout the United States. While Beth obsesses over every guest's touch point and detail throughout the event experience, every moment is executed in an effortless way, ultimately creating an intimate and approachable environment that is reflective of her clients.

Beth has been recognized in *Forbes, Harper's Bazaar, Travel & Leisure,* and *Martha Stewart Weddings* as a leader in the industry as well as one of the best planners in the United States. Her work has been seen in *Vogue,* *Town & Country, Martha Stewart, Bride's,* and more. She has also been mentioned in *People* Magazine, *US Weekly,* E! News and other media for her work with high profile clientele.

The only thing that rivals Beth's love for weddings and design is giving back. In 2016, she started an initiative that combines these two passions called The Good Beginning. The Good Beginning is an online donation registry where couples can register for donations to their favorite organizations in lieu of or in addition to a traditional gift registry.

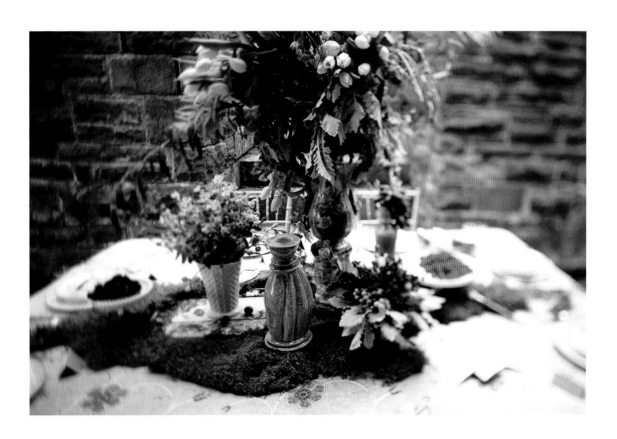

Think about creating an asymmetrical centerpiece display for a sense of movement and liveliness! Take your cues from the arrangements seen in compositions by still life painters.

Never underestimate the visual power of combining fruits and flowers. Painters have understood this for ages!

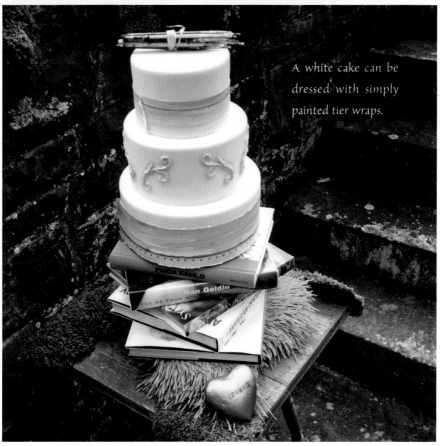

A white cake can be dressed with simply painted tier wraps.

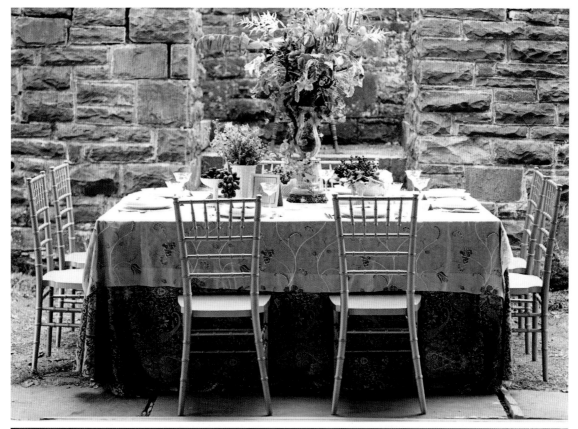

Still Life with Peacock Pie, 1627, Pieter Claesz (1596/1597–1660), Dutch

Skip the mass-produced and incorporate pieces with a distinctively handmade vibe into your decor. Painters plan ahead and calculate every brushstroke they place on the canvas. Plan ahead with décor by giving yourself time to collect pieces full of history and meaning.

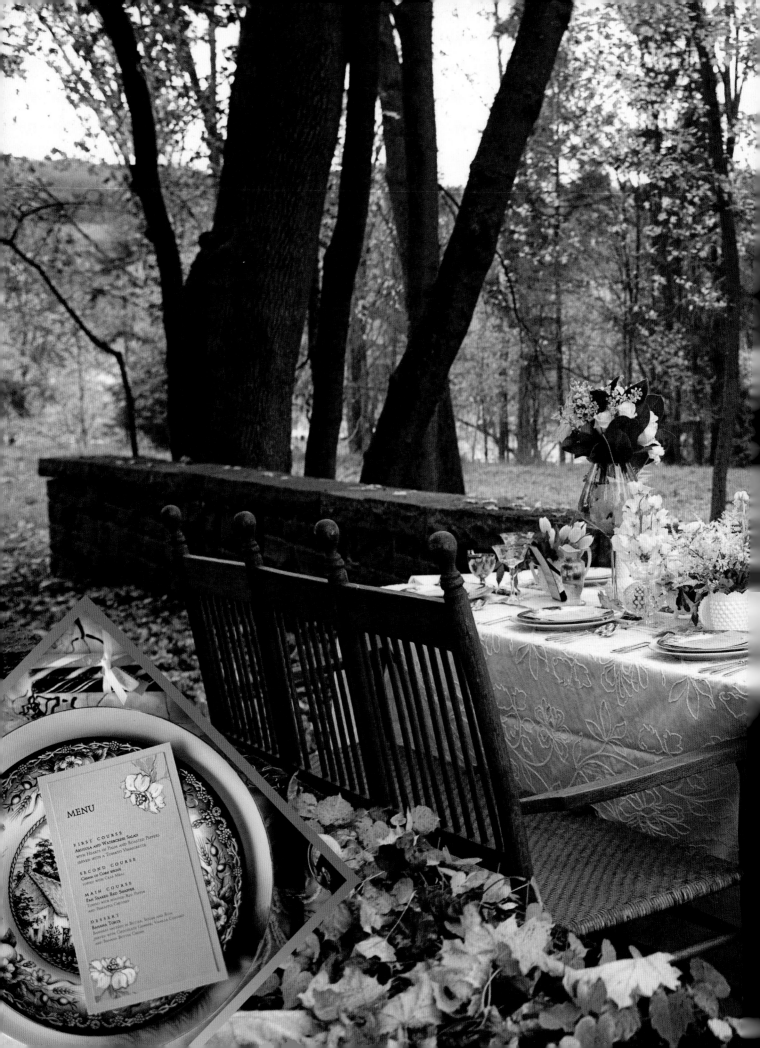

MENU

FIRST COURSE
ARUGULA AND WATERCRESS SALAD
WITH HEARTS OF PALM AND ROASTED PEPPERS
SERVED WITH A TOMATO VINAIGRETTE

SECOND COURSE
CREAM OF CORN SOUP
TOPPED WITH CRAB MEAT

MAIN COURSE
PAN SEARED RED SNAPPER
TOPPED WITH ROASTED RED PEPPER
AND PINEAPPLE CHUTNEY

DESSERT
BANANA TORTE
BANANAS SAUTÉED IN BUTTER, SUGAR AND RUM
SERVED WITH CHOCOLATE GANACHE, VANILLA CUSTARD
AND SPANISH PEANUT CREAM

Painted Revelry

Consider setting even just the head table with family heirloom china.
Here, Grandma's china honors your own history as you eat your first
married meal. Talk to your photographer about capturing fine art-style
still life compositions of your bouquet. Talk to your photographer about
capturing fine art-style still life compositions of your bouquet.

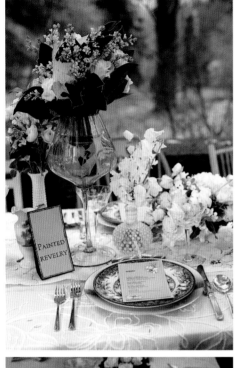

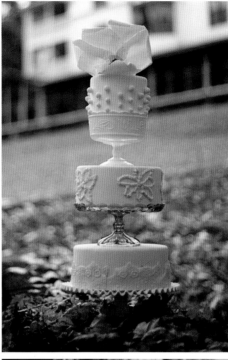

Give a few tables some extra love and attention— like you would your dinner table during the holidays.

CAKE DISPLAY BECOMES SCULPTURE!

Painters see endless opportunities to express themselves. Think like a painter and find moments often overlooked to add artistic flair to your décor.

Hand-painted runners for a few choice tables. Soft simple flowers, dots, and washy effects are easy to master, even for beginners!

Table linens with patterns mimicking artist sketches. Real life example from French artist Henri Matisse.

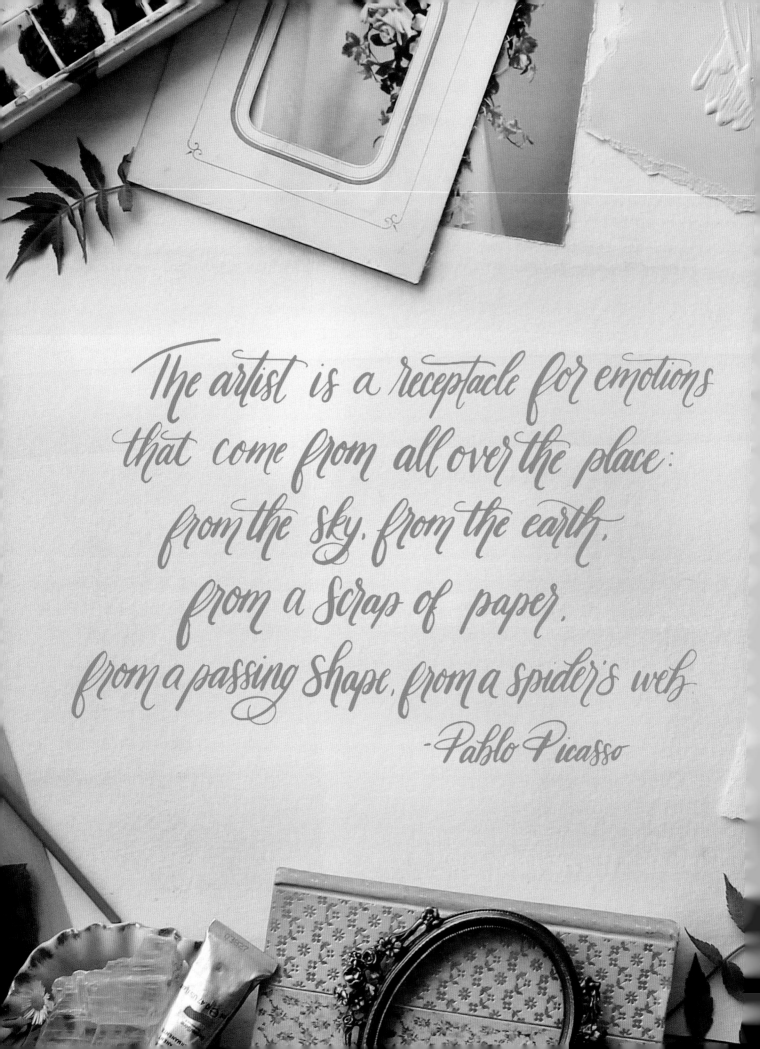

The artist is a receptacle for emotions
that come from all over the place:
from the sky, from the earth,
from a scrap of paper,
from a passing shape, from a spider's web
-Pablo Picasso

Inviting Artful

STATIONERY DESIGN

There seems to be so much pressure to find and envision one of the most elusive details of wedding planning—the perfect wedding invitation.

When we assign the description of "perfect" to something, we really mean: this thing, this inanimate object, this single piece of paper needs to speak effortlessly of our personality, style, likes, dislikes, culture, and countless other parameters.

Painters throughout time have been known to seek perfection, but in that journey many would discover the gift of simplicity in the mindful act of editing their emotions and thus, their artwork. The same holds true in stationery design. The moment you're able to strip away the most unnecessary, distracting details from your vision, is the moment when your expression is most powerful.

Do you need to be a skilled artist to imagine thoughtful invitations? Absolutely not. Do you need to know art history and be able to identify famous works? No. You simply need to appreciate the power that art holds to impact our lives and surroundings. I invite you to, however, think like an artist outside of the sea of sameness in design, to take what you've experienced in this book and let it inform each step in your planning adventure. May you turn the last page here feeling energized to think with eyes wide open, energized enough to recognize the nuances of what your heart and mind see, and uncover the many ways to act on your discoveries.

Look to your favorite painters, films, fashion designers, or art movements, not to copy their genius, but to glean creative sparks. Absorb how they used color or shape or moody shadows to convey the look you were drawn to in the first place. Pay attention to subject matter. What objects did they paint and how could those objects have a place in your invitation design?

Move away from thinking in trends and more towards a thought process that examines color, composition, balance, texture, mindfulness, and surprise. Painters turn the done-before into the never-done with just a few thoughtful decisions. Think about how Dali transformed classic oil paintings into curious compositions simply by making them look melted. Or imagine how mundane O'Keeffe's paintings might appear if her blooms were all "normal" scale and not oversized. So now think about how you could transform the expected invitation . . . how will you put a painterly spin on your invitations? This chapter will give you a peek into the creative process of envisioning an artistic and unexpected invitation while still honoring tradition. Consider the pages ahead a sort of case study for creative invitation thinking.

As an event planner, one of the first questions I ask my wedding clients is "tell me your story." I listen to how they met, the trips they've taken, special moments they've shared, artwork or movies they love, the proposal, all so I can paint a picture of who they are. When we begin to conceptualize invitations, we defer to the couple's story. Is it romantic? Is it serendipitous? And we think about what colors or mood that brings to mind. We discover what makes them unique as a couple, so then each element of their story plays to and inspires their custom suite.

Invitation inspiration is everywhere, so dive in and familiarize yourself with the options, but ensure your final inspiration references are refined to only the suites you absolutely love. Stationery design should nod to the formality, vision, and emotions your guests will experience. What will they see, feel, smell What do you want them to remember? Here's an example: You both love a particular song, you envision a palette of soft blush and cream. You dream of a tearful exchange of poetic vows outside at dusk—so now use these whimsical thoughts and visions to mirror in your custom invitation suite.

Paper is one of the first components of the wedding that guests interact with, so to keep your vision intact, always keep in mind the integrity of your inspiration. Trust your invitation stylist and avoid the temptation to become over immersed in the many details and options.

–JENNIFER ZABINSKI
Founder and president of Jennifer Zabinski Events

ABOUT
JENNIFER ZABINSKI

Named one of *Harper's Bazaar's* Top Wedding Planners in the United States, Jennifer Zabinski uses her trove of knowledge to make each of her events special, bringing forth her clients' visions with ease. Jennifer graduated with honors from Cornell's prestigious School of Hotel Administration. Shortly following, she found herself working in California for the Ritz-Carlton and then the Four Seasons Hotel, catering to high-profile clients from across the world and building her foundation for her future in the industry. Jennifer founded JZ Events in 2011; the chic meets modern boutique planning company caters to a high-profile clientele list, with events mostly in New York, on the West Coast and destinations in the Caribbean. Over the years, JZ Events has planned hundreds of celebrations, spanning from weddings to birthdays to galas to intimate dinners for two. Jennifer and her creative team have done it all and no event is ever too small!

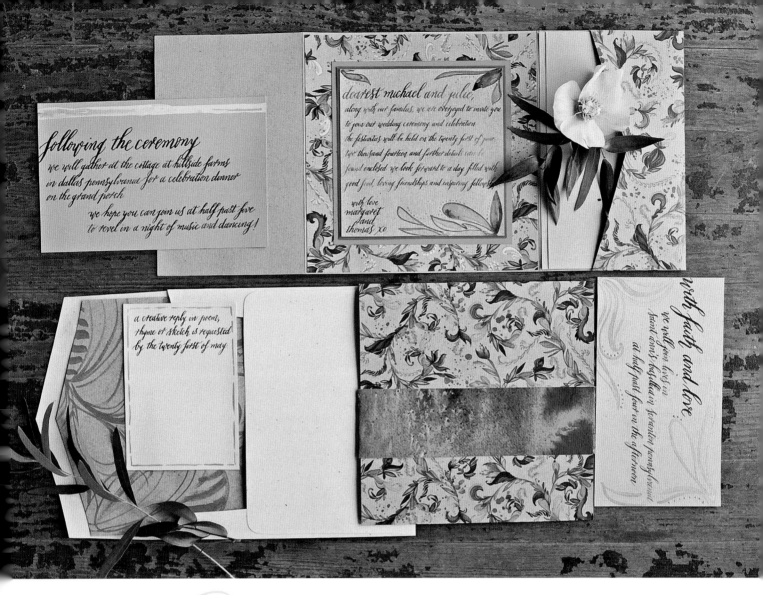

Youthful Florentine

Florentine patterns traditionally conjure thoughts of stately Italian landmarks or that fussy stationery you see sold in fine paper boutiques. Wanting to put a youthful spin on an iconic Florentine pattern, we began with color, bold tones (brighter than expected), and abstract brushstrokes. Mingling rustic kraft papers with hand-gilded touches pays homage to both past and present sensibilities.

THE VISION

Florentine patterns are traditionally used in highly formal stationery designs, where all elements point to a regal, ballroom style celebration. Here our Florentine pattern is transformed into a more casual/rustic aesthetic with the introduction of kraft paper and textural watercolor finishes.

DETERMINE MATERIALS

Earthy papers, a watercolor bellyband where color explodes across the surface, are unexpected compliments to the more tedious Florentine pattern. Bright gold inks, abstract flourishes, and traditional calligraphy fuse tradition with bolder expression.

CALLIGRAPHY

by Meant to Be Calligraphy

Fiore pattern in collaboration with Envelopments®

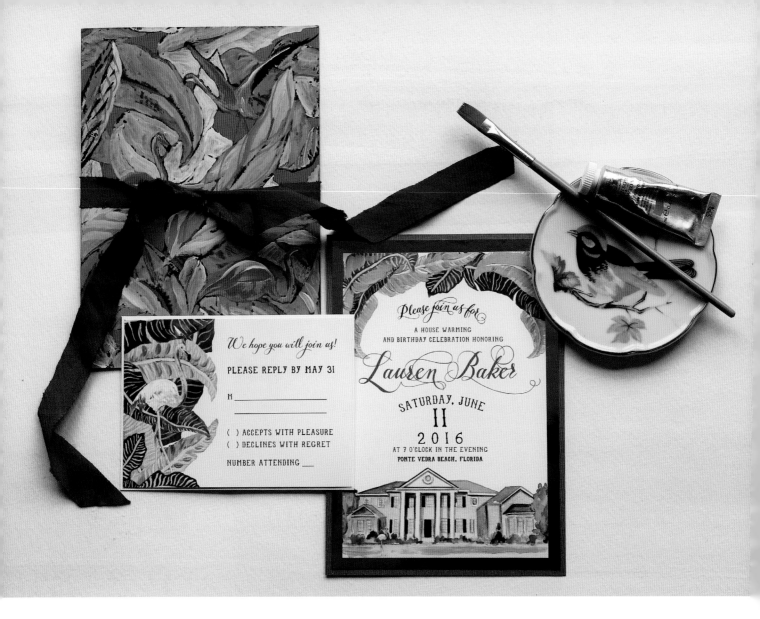

Please join us for
A HOUSE WARMING
AND BIRTHDAY CELEBRATION HONORING

Lauren Baker

SATURDAY, JUNE
II
2016
AT 7 O'CLOCK IN THE EVENING
PONTE VEDRA BEACH, FLORIDA

We hope you will join us!

PLEASE REPLY BY MAY 31

M _____

() ACCEPTS WITH PLEASURE
() DECLINES WITH REGRET

NUMBER ATTENDING ___

West Palm Beach Glam

Lauren's Palm Beach party just wouldn't seem right without a heartfelt nod to the one and only Lilly Pulitzer® (1931–2013). One cannot think of palm fronds and flamingos without thinking of the whimsical, spirited designs of this iconic American artist. For added personality, the home of our party girl was illustrated in watercolor to add a stately flair overall.

THE VISION

Pulitzer is known for bright but solid colors in over-the-top patterns. Our interpretation took the idea of strong color and applied a painterly finish to soften the effect and create a slightly more formal vibe.

DETERMINE MATERIALS

Texture here was important to reference the overlapping palm fronds indigenous to Florida . . . the gloss of their finish and how each overlaps another came to mind as we painted the folder meant to hold the invitation card. Gold mirror stock made an appearance for a touch of glam.

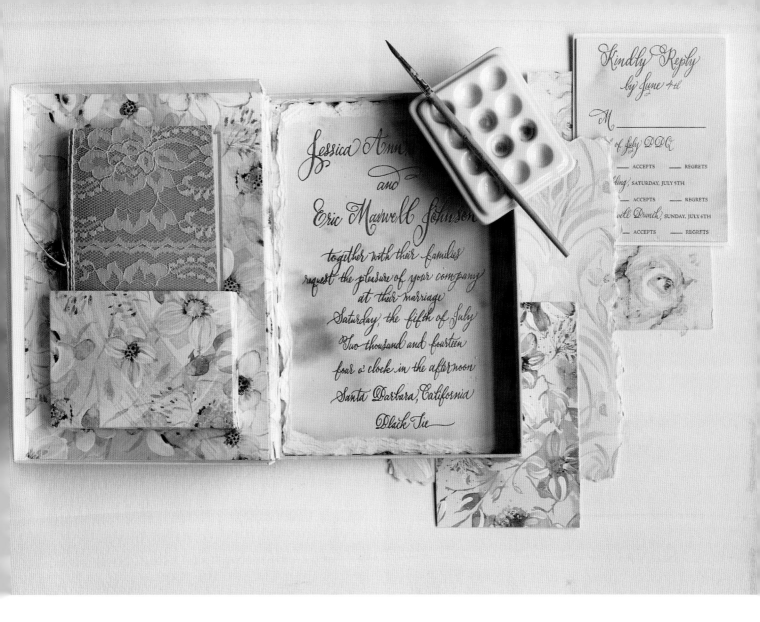

Within the invitation image:

Jessica Ann

and

Eric Maxwell Johnson

together with their families
request the pleasure of your company
at their marriage
Saturday, the fifth of July
Two thousand and fourteen
four o' clock in the afternoon
Santa Barbara, California

Black Tie

Kindly Reply
by June 4th

M_____

of July DDG

____ ACCEPTS ____ REGRETS

____, SATURDAY, JULY 5TH

____ ACCEPTS ____ REGRETS

____ Brunch, SUNDAY, JULY 6TH

____ ACCEPTS ____ REGRETS

Great Expectations

Charles Dickens' (1812–1870) classic has been reimagined in countless ways, but the inspiration here was the 1998 movie adaptation starring Ethan Hawke and Gwyneth Paltrow. One particular scene where wallpaper is ripped off the wall to become drawing paper for a young artist, became fodder for the stationery suite.

THE VISION

What would a wedding invitation from Ethan and Gwyneth's characters look and feel like?

DETERMINE MATERIALS

A suite of floral patterns was developed to mimic the Baroque style wallpaper seen throughout the movie. Since the wedding color palette was soft and muted in tone, hand painting each piece individually became an integral detail to add depth without boldness. Additionally, torn edges and gold foil made a big impact overall.

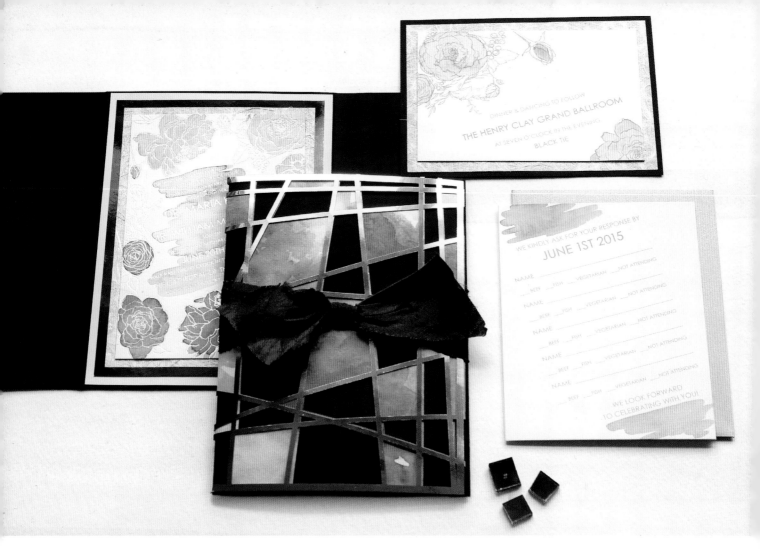

Piet Mondrian

Composition, oil on canvas, 1921,
Piet Mondrian (Dutch,
Amersfoort and New York)

Jacques and Natasha Gelman Collection, 199

Mondrian (1872–1944) was a painter born in the Netherlands, best known for his work in the neoplasticism movement where grid-like compositions were created on stark white backgrounds using black grid lines and primary colors alone. The invitation here is loosely inspired by Mondrian but with a regal and glitzy spin.

THE VISION

How to translate the modern starkness of Mondrian to a more romantic and artful expression was our mission here.

DETERMINE MATERIALS

Mirror paper against a strong watercolor backdrop played a key part in infusing this look with a bit of glitz. Mondrian's angular shapes and the use of a grid-like composition is repeated from the invitation's laser cut wrap to the angled layout of the response card.

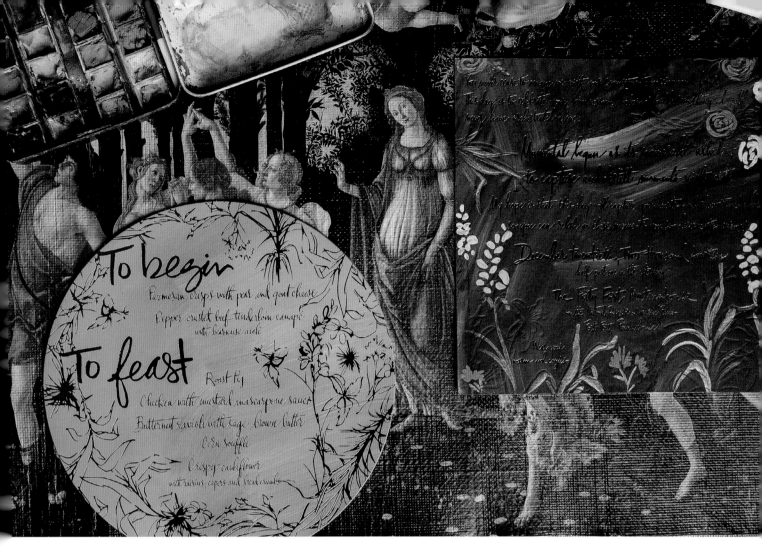

To begin
Parmesan crisps with pear and goat cheese

Pepper crusted beef tenderloin canapé
with béarnaise aioli

To feast
Roast Pig

Chicken with mustard mascarpone sauce

Butternut ravioli with sage, brown butter

Corn soufflé

Crispy cauliflower
with raisins, capers and bread crumbs

Sandro Botticelli

The Adoration of the Magi, tempera and
oil on panel, c. 1478–1482, Sandro
Botticelli (Italian 1446–1510)

Botticelli famously painted in an ethereal yet highly detailed style for Florence's
most elite benefactors. His masterpiece *Primavera* inspired this invitation in
color palette and intensity of mood.

THE VISION

So much of Botticelli's work is alive with velvety textures and vibrant color. Our
invitation vision samples the color and subject matter of this painter's work but
with a significantly simplified approach.

DETERMINE MATERIALS

Each invitation was brushed with rich shades of green before the text, printed in gold
foil, was complete. The effect hearkens back to the velvety background peeking out from
Botticelli's expansive painting. Stylized blooms painted on the invitation loosely reference
the four hundred plus varieties of flora Botticelli documented in *Primavera.*

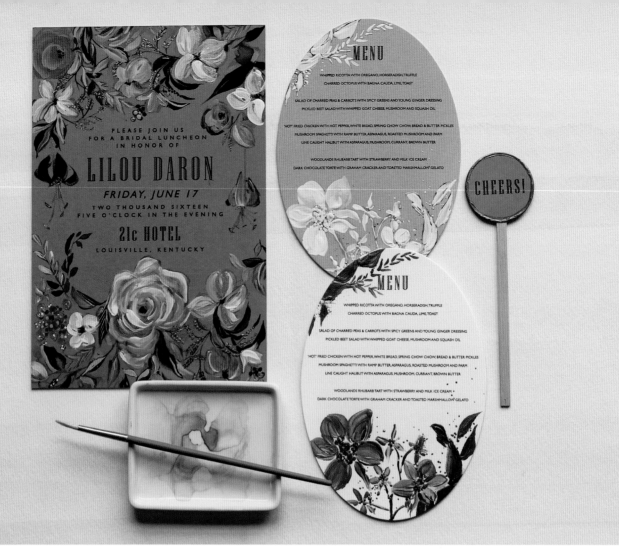

PLEASE JOIN US
FOR A BRIDAL LUNCHEON
IN HONOR OF

LILOU DARON

FRIDAY, JUNE 17
TWO THOUSAND SIXTEEN
FIVE O'CLOCK IN THE EVENING

21c HOTEL
LOUISVILLE, KENTUCKY

MENU

WHIPPED RICOTTA WITH OREGANO, HORSERADISH, TRUFFLE
CHARRED OCTOPUS WITH BAGNA CAUDA, LIME, TOAST

SALAD OF CHARRED PEAS & CARROTS WITH SPICY GREENS AND YOUNG GINGER DRESSING
PICKLED BEET SALAD WITH WHIPPED GOAT CHEESE, MUSHROOM AND SQUASH OIL

'HOT' FRIED CHICKEN WITH HOT PEPPER, WHITE BREAD, SPRING CHOW CHOW, BREAD & BUTTER PICKLES
MUSHROOM SPAGHETTI WITH RAMP BUTTER, ASPARAGUS, ROASTED MUSHROOM AND PARM
LINE CAUGHT HALIBUT WITH ASPARAGUS, MUSHROOM, CURRANT, BROWN BUTTER

WOODLANDS RHUBARB TART WITH STRAWBERRY AND MILK ICE CREAM
DARK CHOCOLATE TORTE WITH GRAHAM CRACKER AND TOASTED MARSHMALLOW GELATO

CHEERS!

MENU

WHIPPED RICOTTA WITH OREGANO, HORSERADISH, TRUFFLE
CHARRED OCTOPUS WITH BAGNA CAUDA, LIME, TOAST

SALAD OF CHARRED PEAS & CARROTS WITH SPICY GREENS AND YOUNG GINGER DRESSING
PICKLED BEET SALAD WITH WHIPPED GOAT CHEESE, MUSHROOM AND SQUASH OIL

'HOT' FRIED CHICKEN WITH HOT PEPPER, WHITE BREAD, SPRING CHOW CHOW, BREAD & BUTTER PICKLES
MUSHROOM SPAGHETTI WITH RAMP BUTTER, ASPARAGUS, ROASTED MUSHROOM AND PARM
LINE CAUGHT HALIBUT WITH ASPARAGUS, MUSHROOM, CURRANT, BROWN BUTTER

WOODLANDS RHUBARB TART WITH STRAWBERRY AND MILK ICE CREAM
DARK CHOCOLATE TORTE WITH GRAHAM CRACKER AND TOASTED MARSHMALLOW GELATO

Dutch Masters

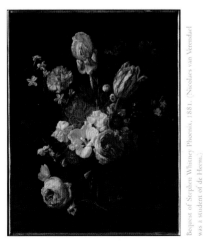

A Bouquet of Flowers in a Crystal Vase, oil on canvas, 1662, Nicolaes van Verendael (Flemish, 1640–1691)

Bequest of Stephen Whitney Phoenix, 1881. (Nicolaes van Verendael was a student of de Heem.)

Johannes de Heem (1606–1684) was known amongst painters of the Dutch golden age for his exquisite still life compositions, many of which included sumptuous flowers and fruits. Here, the invitation calls upon de Heem's style of applying brushstrokes in a fresh and modern voice.

THE VISION

Floral compositions of Dutch Masters' paintings by greats such as Vermeer, de Heem, Steen, and Hals were epitomized by moody color palettes and hyperrealistic techniques. For this invitation, the goal was to infuse a youthful energy and light into their painterly style we chose to mimic.

DETERMINE MATERIALS

Richly colored paper is a key choice to create contrast and pop when painted brushstrokes are applied to the surface. Layering various colors creates depth and shape to mimic, very simply, the modeling of shape de Heem used in bringing his subject matter to life. Gold finishes lend a subtle nod to historical frames seen often in museums.

CREATIVE TEAMS

Chapter 1
GEORGIA O'KEEFFE'S WHITES AT GRAND DEL MAR

PHOTOGRAPHER / Jill Thomas Photography

STYLING / Kristy Rice

VENUE / The Grand del Mar, San Diego, CA

FLORAL DESIGN / Kathy Wright and Co.

HAND-PAINTED STATIONERY / Momental Designs

SWEETS / Sweet and Saucy Shop

LINENS / La Tavola Fine Linen

RENTALS / Ribbons and Rust

GOWN / Alisa Benay

HAIR AND MAKEUP / 10.11 Makeup

HAIRPIECE / Desla Couture

PAPER BOUQUET / Momental Designs

Chapter 2
ANDREW WYETH'S PAINTERLY PASTORAL

PHOTOGRAPHER / With Love and Embers

STYLING / Kristy Rice

VENUE / Hillside Farms, Dallas, PA

FLORAL DESIGNS / Sullivan Owen

HAND-PAINTED STATIONERY / Momental Designs

FOOD / The Soup Chic

RENTALS / Maggpie Vintage Rentals

GOWN / Tara LaTour

HAIR AND MAKEUP / Tatum Neiderhiser

MODEL / Kaitlin MacCallum

Chapter 3
PANTONE'S RADIANT ORCHID WITH MUCHA

PHOTOGRAPHER / Alexandra Whitney

STYLING / Kristy Rice

VENUE / The Horticulture Center, Philadelphia, PA

FLORAL DESIGN / Papertini Floral and Event Design

FLOWERS PROVIDED BY / FiftyFlowers.com

HAND-PAINTED STATIONERY / Momental Designs

CALLIGRAPHY / Michele Hatty Fritz of Meant to Be Calligraphy

FOOD / The Soup Chic

SWEETS / The Couture Cakery

ATTIRE / Monique Lhuillier

MAKEUP / Beke Beau

VINTAGE RENTALS / Magpie Vintage Rentals

ACCESSORIES / Lulu Frost

CUSTOM WOOD TABLE / Skilltree Designs

UPHOLSTERY AND WALLPAPER / KristyRice.com

BRACELET TABLE RUNNER / Paloma's Nest

MODELS / Kaitlin MacCallum and Ashley Brooke

Chapter 4
JOHN SINGER SARGENT AT BILTMORE ESTATE

PHOTOGRAPHER / With Love and Embers

STYLING / Kristy Rice

PLANNING ASSISTANT / Kelley Nudo

PLANNER / Ashley Baber Weddings

VENUE / Biltmore Estate, Asheville, NC

FLORAL DESIGN / Lily Greenthumb's Floral Design

FLOWERS PROVIDED BY / FiftyFlowers.com

HAND-PAINTED STATIONERY / Momental Designs

CALLIGRAPHY / Michele Hatty Fritz of Meant to
 Be Calligraphy

HOOP ART "PLACE CARDS" / Thimble & Thistle

EXOTIC WOOD MONOGRAMS / Skilltree Designs

FOOD / Biltmore Estate

RENTALS / East West Vintage Rentals

GOWN / Claire Pettibone

HAIR / Emily Wells of Emily Anne Hair

FILM / Blueberry Creative

MAKEUP / Wendy Ballance of Blush Asheville

MODELS / Erin Gittens, Kayla Britt, and David Trull

Chapter 5
OUR MUSE, MR. SALVADOR DALI

PHOTOGRAPHER / Sanderson Images

STYLING / Kristy Rice

STYLING ASSISTANT / Jessica Zielen

PRODUCTION / DPNAK Weddings

VENUE / Lavish Boutique, Scranton, PA, and YMCA,
 Wilkes-Barre, PA

FLORAL DESIGN / Dorian Butovich, Central Park Flowers

HAND-PAINTED STATIONERY / Momental Designs

CALLIGRAPHY / Moya Minns, MM Ink

SWEETS / Lisa, Delicious Desserts

LINENS / La Tavola Fine Linen

RENTALS / Maggpie Vintage Rentals

GOWN / Carol Hannah

HAIR / Lisa and Danielle, Lavish Salon

MAKEUP / Beke Beau

JEWELRY / EXTASIA

PAPER BOUQUET / Momental Designs

FLOWER BELT / Twigs & Honey

MODEL / Kaitlin MacCallum

Chapter 6
MONET'S WATERCOLOR GARDEN

PHOTOGRAPHER / Greg Finck

STYLING / Kristy Rice

PLANNING AND DESIGN / Fête in France
 Wedding Planning

VENUE / Domaine des Evis, La Chapelle-Fortin, France

FLORAL DESIGN / Tasha Carrington, L'Arrangement

HAND-PAINTED STATIONERY / Momental Designs

FOOD / Alexandra Couret

SWEETS / Synie's and Popelini, Paris

RENTALS / Vaisselle Vintage and Gien

GOWNS / Plum Pretty Sugar and Ivy & Aster

HAIR AND MAKEUP / Trine Juel

MODEL / Megan Alexie

Chapter 7
MAXFIELD PARRISH IN RED ROCK COUNTRY

PHOTOGRAPHER / With Love and Embers

STYLING / Kristy Rice

PLANNER / Forevermore Events

VENUE / Sand Hollow Resort, Hurricane, UT

FLORAL DESIGN / Bloomers Flowers and Decor

HAND-PAINTED STATIONERY / Momental Designs

CALLIGRAPHY / Moya Minns, MM Ink

SWEETS / TwentyFive Main

LINENS / KristyRice.com

RENTALS / Refined Vintage Events

GOWN / Watters

HAIR AND MAKEUP / Julie Thomas

MODELS / Brandi Pahl and Alexandra Holland

Chapter 8
THIRTEENTH CENTURY-INSPIRED WITH GIOTTO

PHOTOGRAPHER / Francesco De Tito Photography

STYLING / Kristy Rice

PLANNER / Sposiamovi

VENUE / Grand Hotel Convento di Amalfi,
 Amalfi, Italy

FLORAL DESIGN / Capri Flor

HAND-PAINTED STATIONERY / Momental Designs

CALLIGRAPHY / Kelle Anne McCarter of designsgirl

SWEETS / Capo D'Orso

RENTALS / Wedding Solutions

GOWN / Claire Pettibone and Tara LaTour

MENSWEAR / Carlo Pignatelli

HAIR AND MAKEUP / Beyouty

HEADPIECE / Momental Designs

WOOD VESSELS & RING BOX / Skilltree Designs

MODEL / Gloria Ascolese and Francesco Aiello

MUSICIANS / weddingmusic.it

Chapter 9
FRIDA KAHLO IN BLOOM

PHOTOGRAPHER / Danielle Coons Photography

STYLING / Kristy Rice

PLANNER / Candice Mock of Patchwork Planning

VENUE / Hayfield House, Lehman, PA

FLORAL DESIGN / Splints and Daisies Floral Design

FLOWERS PROVIDED BY / FiftyFlowers.com

HAND-PAINTED STATIONERY / Momental Designs

CALLIGRAPHY / Kelle Anne McCarter of designsgirl

FOOD / Grico's

CAKE / The Couture Cakery

FAVORS / Ah! Some Chocolate

LINENS / La Tavola Fine Linen

RENTALS / Forget-Me-Not Vintage Rentals

WOODEN LASER CUT LETTERS / Laura Hooper
 Calligraphy

Chapter 10
EDWARD HOPPER AT
CONGRESS HALL

PHOTOGRAPHER / Hudson Nichols Photography

STYLING / Kristy Rice

PLANNER / Shannon Wellington Weddings

VENUE / Congress Hall Hotel, Cape May, NJ

FLORAL DESIGN / Fresh Designs Flora and Events

HAND-PAINTED STATIONERY / Momental Designs

CALLIGRAPHY / Kelle Anne McCarter of designsgirl

SWEETS / Nutmeg Cake Design

GOWN / Sarah Janks

HAIR / Ariel Katrina Hair

MAKEUP / Kristyn April of Shimmer & Spice

MODEL / Michaela Byrd

FILM / Saltwater Studios

RENTALS / Party Rentals, Ltd.

Chapter 11
A SPIROGRAPH LOBSTER BOIL
WITH ANDY WARHOL

PHOTOGRAPHER / With Love and Embers

STYLING / Kristy Rice

VENUE / Twin Ponds, Harding, PA

FLORAL DESIGN / Papertini Floral and Event Design

HAND-PAINTED STATIONERY / Momental Designs

FOOD / Grico's

LINENS / La Tavola Fine Linen

MUSIC / Coal Town Rounders

Chapter 12
MORAN'S YELLOWSTONE

PHOTOGRAPHER / John Cain Sargent

STYLING / Kristy Rice

PLANNER / Emily Clarke Events

VENUE / Yellowstone Under Canvas, West
 Yellowstone, MT, and Yellowstone National Park

FLORAL DESIGN / Sarah Campbell, Intrigue Design
 and Decor

HAND-PAINTED STATIONERY / Momental Designs

CALLIGRAPHY / Kelle Anne McCarter of designsgirl

CAKE AND ART COOKIES / Jasmine Lilly, owner and
 baker at Whipped

RENTALS / P.O.S.H. Couture Rentals

LINENS / La Tavola Fine Linen

GOWN / Claire Pettibone and Tara LaTour

MODEL / Terasina Bonanini

PRODUCTION ASSISTANT / Brittany Sargent

Chapter 13
DOROTHY DRAPER'S GREENBRIER

PHOTOGRAPHER / Carla Ten Eyck and Joel Callaway

STYLING / Kristy Rice

VENUE / The Greenbrier Resort, White Sulphur
 Springs, WV

PLANNER / Emily Clarke Events

FLORAL DESIGN / Gillespie's Flowers and
 Productions, Inc.

HAND-PAINTED STATIONERY / Momental Designs

CAKE / Chef Jean-Francois Suteau

LINENS / La Tavola Fine Linen

RENTALS / Gillespie's Flowers and Productions, Inc.

GOWNS / Kate McDonald, Claire Pettibone, and
 Vera Wang

HAIR AND MAKEUP / Studio G Hair Salon

JEWELERY / Lulu Frost

MODELS / Laura Richter Tuckwiller and
 David Tuckwiller

FILM / Michaels Video and Wedding Cinema

Chapter 14
SOFT BOTANICALS WITH THE
BAUER BROTHERS

PHOTOGRAPHER / Katie Stoops Photography

STYLING / Kristy Rice

VENUE / Love 'n Fresh Flowers Farm, Philadelphia, PA

FLORAL DESIGN / Love 'n Fresh Flowers

HAND-PAINTED STATIONERY / Momental Designs

FOOD / The Soup Chic

CAKE / The Couture Cakery

LINENS / La Tavola Fine Linen

RENTALS / Maggpie Vintage Rentals

GOWN / Chaviano Couture

HAIR / Tatum Neiderhiser

MAKEUP / Beke Beau

MODELS / Kaitlin MacCallum and Katherine McMaster

Chapter 15
THE ANATOMY OF AN ARTFUL
CELEBRATION TABLE: A
WATERCOLOR HARVEST

PHOTOGRAPHER / Darker Shades of Brown

STYLING / Kristy Rice

VENUE / Hillside Farms, Dallas, PA

FLORAL DESIGN / Dorian Butovich, Central Park Flowers

HAND-PAINTED STATIONERY / Momental Designs

SWEETS / Truly Scrumptious Cake Studio

LINENS / La Tavola Fine Linen

ACCESSORIES / Paloma's Nest

RENTALS / Big Top Rentals

REFERENCES

Atkinson, Sam, and Ian Marcousé. *The Business Book*. London, Munich: DK, 2014.

Bowes, John P. *The Trail of Tears: Removal in the South*. New York: Chelsea House, 2007.

Brown, Clint. *Artist to Artist: Inspiration & Advice from Artists Past & Present*. Corvallis, OR: Jackson Creek, 1998.

"A Conversation With Robert Frost (1952)." Bela Kornizer, correspondent. NBC News. NBC Universal Media. November 23, 1952. *NBC Learn*. Web. January 19, 2015.

Couchman, Judith. *The Art of Faith: A Guide to Understanding Christian Images*. Brewster, MA: Paraclete, 2012.

Dali, Salvador. *Ship with Butterfly Sails*. 1937. Oil. N.p.

Dijek, Claesz Van. *An Ontbijtje Still Life of Three Cheeses on a Silver Plate, Apples and Nuts in a Wan-li Porcelain Bowl, Mulberries and Olives in Wan-li Porcelain Dishes, a Half Apple and Apple Peel*. 1610. Oil on Oak Panel. N.p.

Draper, Dorothy. *Decorating Is Fun! How to Be Your Own Decorator*. New York, NY: Pointed Leaf, 2007.

Funicello, Annette, and Patricia Romanowski Bashe. *A Dream Is a Wish Your Heart Makes: My Story*. New York: Hyperion, 1994.

Giotto. *Madonna and Child*. 1320. Tempera on panel. National Gallery of Art, N.p.

Hopper, Edward. *Ground Swell*. 1939. Oil on canvas. Corcoran Collection, Museum Purchase, William A. Clark Fund.

Hopper, Edward. *The Long Leg*. 1930. Oil on canvas. The Huntington Library, San Marino, CA.

Hunt, William Morris. *W.M. Hunt's Talks about Art with a Letter from J.E. Millais*. London: Macmillan, 1878.

Kahlo, Frida, Carlos Fuentes, and Sarah M. Lowe. *The Diary of Frida Kahlo: An Intimate Self-portrait*. New York: Abrams, 2005.

Kendall, Richard. *Monet by Himself: Paintings, Drawings, Pastels, Letters*. London: Time Warner, 2004.

Kimble, Drew. Skinnyartist.com. Skinny Productions, 2016, http://skinnyartist.com/the-paralysis-of-perfectionism/, accessed June 28, 2016.

Kuh, Katharine. *The Artist's Voice: Talks with Seventeen Modern Artists*. New York: Da Capo, 1999.

Leavy, Patricia. *Method Meets Art: Arts-Based Research Practice*. New York: Guilford, 2015.

Matisse, Henri. *Dessin á La Plume* (Fluer De Lys). 1941. Pen and india ink on paper. Executed in Nice.

Meeuws, Bas. *Untitled*. 2013. Photograph. Kunstinzicht, Netherlands.

Monet, Claude. *Les Nympheas*. N.d. Musee L'Orangerie, Paris. Web. July 5, 2016.

Monet, Claude. *Woman with a Parasol - Madame Monet and Her Son*. 1875. Oil on canvas. Collection of Mr. and Mrs. Paul Mellon, N.p.

Moran, Thomas. *The Grand Canyon of the Yellowstone*. Oil on canvas. Smithsonian American Art Museum, Washington, DC.

Moran, Thomas. *Minerva Terrace, Yellowstone*. 1872. Watercolor and gouache over graphite on blue paper. Florian Carr Fund, n.p.

Moss, Hugh M., and Peter Suart. *The Art of Understanding Art: A New Perspective*. London: Profile, 2015.

Novak, Barbara. *Next to Nature: Landscape Paintings from the National Academy of Design*. Ed. Annette Blaugrund. New York: Harper & Row, 1980.

O'Keeffe, Georgia, Richard Marshall, Yvonne Scott, and Achille Bonito Oliva. *Georgia O'Keeffe: Nature and Abstraction*. Milano, Italy: Skira, 2007.

Parrish, Maxfield. *Grand Canyon*. 1902. N.p.

Petty, Tom. *Wildflowers*. Warner Bros., 1994, compact disc.

Rilke, Rainer Maria, Anita Barrows, and Joanna Macy. *A Year with Rilke: Daily Readings from the Best of Rainer Maria Rilke*. New York: HarperCollins, 2009.

Rivera, Guadalupe and Marie-Pierre Colle. *Frida's Fiestas: Recipes and Reminiscences of Life with Frida Kahlo*. New York: Clarkson Potter/Publishers, 1994.

Saint-Exupéry, Antoine De, and Richard Howard. *The Little Prince*. San Diego: Harcourt, 2000.

Sargent, John Singer. *Frederick Law Olmsted*. 1895. Biltmore House, Asheville, North Carolina. Print.

Siddiqui, Moid. *Leading from the Heart: Sufi Principles at Work*. New Delhi: Sage, 2014.

Spalding, Frances. *Vanessa Bell: Portrait of the Bloomsbury Artist*. London: I. B. Tauris, 2016.

Spirograph. Digital image. *Wikimedia*. N.p., October 5, 2011. Web. July 5, 2016.

Story, Louise. *What Adams Saw Through His Lens*. Digital image. *The New York Times*. April 27, 2008. Web. June 29, 2016. www.nytimes.com/2008/04/27/travel/27journeys.html.

Toropov, Foma. *The Still Life with Flowers and Fruits*. 1846. Photograph. Russia.

Turner, Elizabeth Hutton, and Marjorie P. Balge-Crozier. *Georgia O'Keeffe: The Poetry of Things*. Washington, D.C.: Phillips Collection, 1999.

Turner, Frederick W. *John Muir: Rediscovering America*. Cambridge, MA: Da Capo, 2000.

Van Gogh, Vincent, and Mark Roskill. *The Letters of Vincent Van Gogh. Selected, Edited and Introduced by Mark Roskill*. (Fourth Impression). London: Collins, 1972.

Verganti, Roberto. *Design-Driven Innovation: Changing the Rules of Competition by Radically Innovating What Things Mean*. Boston, MA: Harvard Business, 2013.

Walther, Ingo F. *Picasso*. Cologne: Taschen, 2000.

Wyeth, Andrew. *Camden Hills*. 1930. Watercolor. Camden Hills, Maine.

Wyeth, Andrew. *Christina's World*. 1948. Watercolor. Museum of Modern Art, New York City.